The Trickster Shift

DISCARD

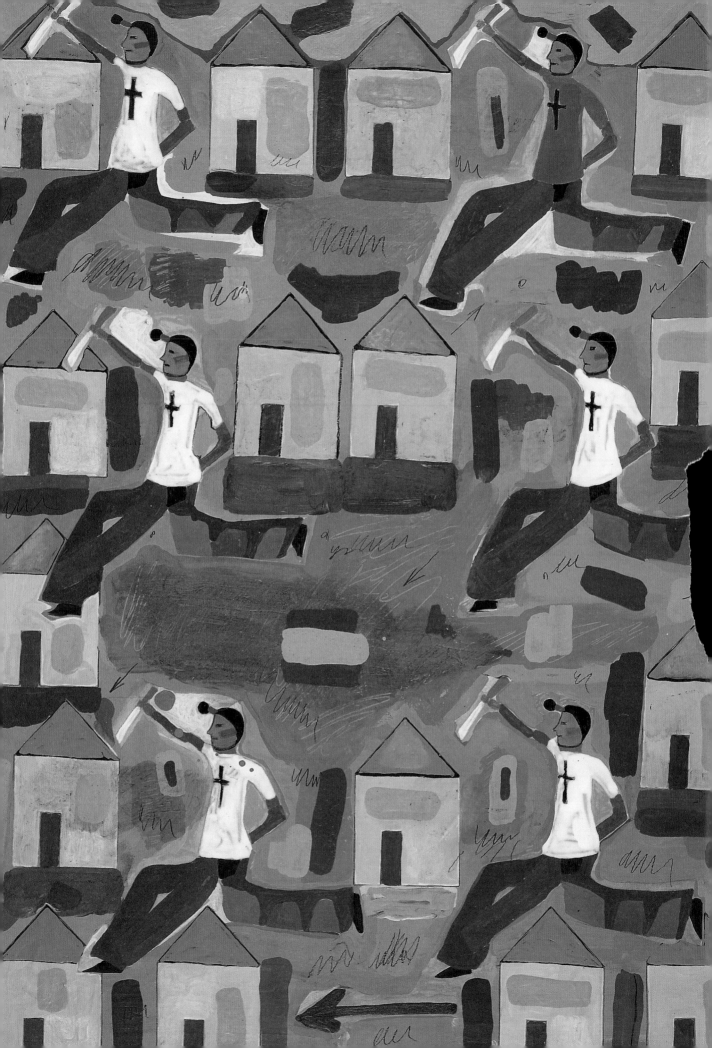

Allan J. Ryan

The Trickster Shift
Humour and Irony
in Contemporary Native Art

UBC Press · *Vancouver / Toronto*
University of Washington Press · *Seattle*

Printed in Canada on acid-free paper

ISBN 0-7748-0704-0

Canadian Cataloguing in Publication Data

Ryan, Allan J. 1945-

The trickster shift

Includes bibliographical references and index.
ISBN 0-7748-0704-0

1. Indian art – Canada. 2. Trickster in art. I. Title.
N6549.5.A54R92 1999 704'.0397071 C99-910111-0

This book has been published with the help of a grant from the Humanities and Social Sciences Federation of Canada, using funds provided by the Social Sciences and Humanities Research Council of Canada. It has also been published with the assistance of the Canada Council for the Arts in the form of two grants, one from the Writing and Publishing Section of the Council and one from Project Assistance for Initiatives in Contemporary Visual Arts and Architecture. As well, UBC Press acknowledges the kind assistance of the Albert and Elaine Borchard Foundation, Bearpaw Publishing, the H.S. Foley fund, and Dr Carey C. and Mrs Janet Womble.

UBC Press also gratefully acknowledges the ongoing support to its publishing program from the Canada Council for the Arts, the British Columbia Arts Council, and the Department of Canadian Heritage of the Government of Canada. We also wish to acknowledge the financial support of the Government of Canada through the Book Publishing Industry Development Program (BPIDP) for our publishing activities.

p. ii, George Littlechild, *I Looked Out My Teepee One Day and All I Saw Was This*, detail, 1987, acrylic on paper, 76 x 56 cm.

Set in Utopia and Thesis
Printed and bound in Canada by Friesens
Designer: George Vaitkunas
Copy editor: Camilla Jenkins
Indexer: Annette Lorek
Proofreader: Gail Copeland

UBC Press
University of British Columbia
6344 Memorial Road
Vancouver, BC V6T 1Z2
(604) 822-5959
Fax: 1-800-668-0821
E-mail: info@ubcpress.ubc.ca
www.ubcpress.ubc.ca

Published simultaneously in the United States of America by the University of Washington Press, P.O. Box 50096, Seattle, WA 98145-5096

ISBN 0-295-97816-3

Library of Congress
Cataloging-in-Publication Data

Ryan, Allan J.

The trickster shift: humour and irony in contemporary native art / Allan J. Ryan.
 p. cm.
 Includes bibliographical references.
 ISBN 0-295-97816-3 (alk. paper)
 1. Indian art – Canada. 2. Indian paintings – Canada. 3. Tricksters in art. 4. Art criticism – Canada. I. Title.

E78.C2R93 1999
704.03'97071–dc21 99-17663
 CIP

For my wife, Rae, and our two sons, Noka and D'Arcy

Contents

Acknowledgments

The research for this book was funded in part by the Social Sciences and Humanities Research Council of Canada.

Numerous people deserve special mention, those whose work appears in this book and the many who made time in their busy lives to indulge my passion for humour and irony and who shared their knowledge, experiences, and images with me.

The visual artists: Carl Beam, Rebecca Belmore, Bob Boyer, Joane Cardinal-Schubert, Vincent Craig, Beau Dick, John Fadden (Kahionhes), Harry Fonseca, Viviane Gray, Chuck Heit (Ya'Ya), Richard Hill, Robert Houle, Phil Hughte, Peter B. Jones, George Littlechild, Jim Logan, Perry McLeod-Shabogesic, Gerald McMaster, David Neel, Shelley Niro, Ron Noganosh, Jane Ash Poitras, Edward Poitras, Bill Powless, Diego Romero, Ken Syrette, Carson Waterman, Lyle Wilson, and Lawrence Paul Yuxweluptun.

The writers: Peter Blue Cloud (Aroniawenrate), Karen Duffek, Curtis Jonnie (Shingoose), Charlie Hill, Thomas King, Ian McLachlan, Fraser J. Pakes, Harry Robinson, Buffy Sainte-Marie, Amelia Trevelyan, Wendy Wickwire, and Alan Wilson.

For their insights into Native humour and participation in discussions that helped to clarify the focus of this book, thanks as well to Carol Acoose, Maxine Bedyn, Lance Belanger, Shirley Chee Choo, John Clifford, Gary Farmer, Vern Harper, Tom Hill, Basil Johnston, Amos Key, Elisabeth Langford, Gloria Miguel, Daniel David Moses, Ruth Phillips, Don Philpot, Arthur Renwick, Eric Robertson, Pierre Sioui, Vanessa Vogel, and Winston Wuttunee.

For sharing their professional expertise and resources, as well as their much appreciated support of the project, thanks are due to Barry Ace, Janeen Antoine, Anne Beckett, Jean Blodgett, Susan Campbell, Louis Campeau, Gilles Chemla, Daneva Dansby, Maria DeCambra, Harold J.T. Demetzer, Karen Eckhart, Dolores Elliott, Holli Facey, Gail Fikis, Lindy-Lou Flynn, Maria Gaida, Peter Gerber, George Harris, Judy Harris, Victoria Henry, Pat Hess, Patricia Holdsworth, Joanne Jackson Johnson, John Kurtz, Sue Lagasi, Bill McLennan, Don Marks, Roger Matuz, Daniel Medina Jackson, Monique Mojica, Richard Pearce-Moses, Ron Nadeau, Denise Quitiquit, Deborah Smith, Doreen Vaillancourt, Jennifer Webb, Norma Wieland, and Suzanne Wolfe.

Thanks also to Scott Smith and the staff at the *Tekawennake-Six Nations and New Credit Reporter* newspaper and the Woodland Cultural Centre for assistance in locating materials; and Alnoor Karim and his staff at Copies Plus for their efficient service and superb colour photocopies used in the early drafts.

For their crucial endorsement of the original research proposal I wish to thank Robert Baker, Samuel Corrigan, and Leigh Syms. For their suggestions in response to my initial inquiries into the subject of irony, thanks to Jay Powell and Elvi Whittaker.

For reading and commenting on earlier versions of the manuscript, thanks to Millie Creighton, Regna Darnell, Margery Fee, Marjorie Halpin, Aldona Jonaitis, Bruce Miller, and Robin Ridington.

Special appreciation to Linda Hutcheon for her personal friendship and enthusiastic encouragement, as well as for her theory of parody. I also wish to thank Gerald Vizenor for his enthusiastic support of the book, for commenting on the manuscript, and for his theory of trickster discourse.

I am especially grateful to Walter Askin, Bill and Betty Beling, Samuel W. Corrigan and Bearpaw Publishing, Gerald G. Purdy, the Roman Catholic Archdiocese of British Columbia, the late Wilber Sutherland, and Carey and Janet Womble for their assistance in securing or providing financial support for the publication of this book. Without this support the book would not have been published.

I am indebted to Carl Beam, whose use of the term 'the Trickster shift' at the opening of the *Indigena* exhibition helped to establish the central theme of this book and to provide its title.

I wish to thank Jean Wilson of UBC Press for her enthusiasm from the beginning for this book, Camilla Jenkins for her meticulous editing of the final manuscript, and George Vaitkunas for his elegant book design.

For hospitality and assistance during the periods of field research, thanks are due to Ann Beam, Clint Buehler, Jerrilynn Harper, Craig MacAulay and Suzanne de Répentigny, Lynn McMaster, Terry Martens, Joan and David Matsui, Chel Niro, Evelyn Ryan, Mike Schubert, and Homer and Joan Sellar.

Finally, I wish to thank my wife, Rae, for her unflinching commitment to this project and for her invaluable assistance and comments at every stage of this book's complex development. The book is unquestionably richer for her many invisible contributions, and I am deeply grateful to her for each and every one.

The following four essays by the author have been adapted or excerpted for this book: Gerald McMaster – Maintaining the Balance, in *The cowboy/Indian Show: Recent Work by Gerald McMaster,* exhibition catalogue (Kleinburg, ON: McMichael Canadian Collection, 1991), 8-18; Postmodern Parody: A Political Strategy in Contemporary Canadian Native Art, *Art Journal* (Fall 1992): 59-65; Classical Aboriginal Reflections, in *Jim Logan: The Classical Aboriginal Series,* exhibition catalogue (Whitehorse: Yukon Arts Centre, 1994), 1-17; I Enjoy Being a Mohawk Girl: The Cool and Comic Character of Shelley Niro's Photography, *American Indian Art Magazine* (Winter 1994): 44-53.

Introduction

> *That the trickster and the clown have become*
> *major metaphors for the artist in this century*
> *with its increasing self-consciousness of the creative process is no accident.*
> *They have been artists for a long time.*
>
> Barbara Babcock, anthropologist

> *Clowns are rarely asked what they're up to, and seldom listened to when they're asked.*
>
> Barbara Babcock

In May 1989, the Vancouver Art Gallery mounted the exhibition *Beyond History,* a collection of new works in mixed media by ten Canadian Native artists: Carl Beam, Bob Boyer, Joane Cardinal-Schubert, Domingo Cisneros, Robert Houle, Mike MacDonald, Ron Noganosh, Jane Ash Poitras, Edward Poitras, and Pierre Sioui.[1] In the catalogue to the show, co-curator Tom Hill wrote that 'the shared cultural origins and parallel ideologies' of these ten artists 'form an aesthetic' (Duffek and Hill 1989, 5). The following May, Joane Cardinal-Schubert created a whimsical installation for a show at Galerie Articule in Montreal, Quebec, commemorating the artists in *Beyond History.* She called it *Art Tribe.*

With good reason. These individuals – and a select group of others who share the same aesthetic – have much in common. Together, they constitute a loose alliance of socially active, politically aware, and professionally trained individuals of roughly the same age, who have, over the last fifteen to twenty years, exhibited with one another, written about one another, lectured on one another, curated exhibitions for one another, and to varying degrees influenced one another. In this they might be said to resemble a 'school' of art rather than a 'tribe.' Not surprisingly, their work often addresses many of the social and political problems facing Aboriginal peoples today. What may be surprising, however, is the wry and ironic humour that permeates much of their art. One may well ask if this is part of the aesthetic too. If so, is it merely the shrewd deployment of a familiar critical strategy, or does it reflect a broader cultural sensibility that would probably be lost on most non-Native viewers, and possibly on some Native viewers as well? Moreover, if such a sensibility is indeed present, would it necessarily manifest itself in the finished artwork? Or might it remain an aspect of practice alone?

..

1 Throughout this book the terms 'Native,' 'Aboriginal,' 'indigenous,' 'Indian,' and 'Métis' are used to refer to Canada's original inhabitants and their descendants. In recent years 'First Nations' has become a preferred term of self-reference in some circles, to underscore claims to a separate identity and inherent sovereign status.

These pivotal questions set this study in motion and led to a series of animated and illuminating conversations across Canada from January 1990 to November 1991 with various members of the extended 'Art Tribe,' as well as with Native elders, linguists, actors, performance artists, curators, and art historians.[2] Emerging from these conversations was the conviction on my part that there was indeed a sensibility, a spirit, at work and at play in the practice of many of the artists, grounded in a fundamentally comic world view and embodied in the traditional Native North American trickster.

In fact, several artists cited the Trickster as a direct influence on some aspect of their work. Most also agreed that a distinct comic and communal attitude does exist that can legitimately be labelled 'Native humour.' Transcending geographical boundaries and tribal distinctions, it is most often characterized by frequent teasing, outrageous punning, constant wordplay, surprising association, extreme subtlety, layered and serious reference, and considerable compassion. These qualities are amply illustrated in the words and images gathered together in this book under the headings of self-identity, representation, political control, and global presence.

2 The artists whose work is featured in this book are primarily Canadian. The questions posed and themes addressed are, however, reflective of a sensibility found throughout Native North America. Several significant national and international events anchor historically the period during which the initial research was conducted. Their presence is registered in both the conversations excerpted and the works reproduced in this study. Among the more notable are Elijah Harper's stunning defeat of the Canadian government's Meech Lake Accord; the Mohawk stand-off at Oka, Quebec; the war in the Persian Gulf; the 1992 Canadian constitutional referendum; the sweeping success of the film *Dances with Wolves;* and the 1992 Columbus quincentenary celebrations that precipitated the exhibitions *Indigena: Perspectives of Indigenous Peoples on Five Hundred Years* at the Canadian Museum of Civilization, Hull, Quebec, and *Land Spirit Power: First Nations at the National Gallery of Canada* in Ottawa, Ontario, to which several of the artists who were interviewed contributed.

Included as well in the book are excerpts from later interviews, with Métis artist Jim Logan in January 1994 and Plains Cree artist George Littlechild in November 1996.

By genetic memory maybe ...
our minds have the ability to think laterally.

Jane Ash Poitras, Cree/Chipewyan artist

Hypertext is very different from more traditional forms of text ...
Reading, in hypertext, is understood as a discontinuous or non-linear process
which, like thinking, is associative in nature,
as opposed to the sequential process envisioned by conventional text.

John Slatin, computer researcher

A Note on the Structure of the Text

This study has been conceived as a 'trickster discourse,' to use the term coined by the American mixed-blood Anishinaabe writer, Gerald Vizenor (1989, 9). It is a discourse *among* tricksters, *about* tricksters, and even *as* trickster, in the sense that the 'trickster is a comic discourse, a collection of utterances in oral tradition' (Vizenor 1989, 191). At once open-ended, unfolding, evolving, incomplete, the discourse is imagined in numerous verbal and visual narratives and a multiplicity of authoritative voices. Charged with a playful spirit and what architect Robert Venturi calls a 'messy vitality' (1968), it finds expression in multilayered communication and simultaneous conversation, in surprise connection and 'narrative chance' (Vizenor 1989, x). It defies univocal representation.

In the following pages quotations and notes are used extensively to disburse the narrative voices and reflect the intertextual nature of the discourse. Neither quotation nor note should be considered a secondary or subordinate text. At various points in the conversation, other voices intersect with the principal narrative. In 'a space where texts can talk to each other' (Babcock 1984, 107) non sequitur, song, poem, prose, and personal anecdote enrich and enliven the discourse. In some instances notes take the form of extended annotation and include illustrations. In this they constitute a kind of hypertext or hypermedia, forms of non-sequential writing and visualizing that until recently were primarily associated with literary studies and computer science (Delany and Landow 1991). More important, the text honours and participates to some degree in a non-linear process of representation shared by many of the artists interviewed.

More than invocations of authority, the quotation and the footnote
are the means of transforming a monological performance into a dialogue,
of opening one's discourse to that of others.
They are also the literate way of interrupting and commenting on one's own text,
of acknowledging that reading and writing, like any cultural performance,
involve appropriating, absorbing, and transforming the texts of others.

Barbara Babcock, anthropologist

Art Tribe
Joane Cardinal-Schubert

In conversation on 13 November 1991, Cardinal-Schubert explained the evolution of *Art Tribe*, the installation she created for her *Preservation of a Species* exhibition at the Galerie Articule in Montreal, May-June, 1990. The Blood artist showed me several Polaroid photographs she had taken when the installation was later remounted in Calgary.

I went in a shop in Calgary ... and I bought ten magic slates. It was the whole idea of writing ... that whole idea of 'blackboard' ... I thought, 'This is the contemporary slate.' It's the magic slate that you can just make [the writing] disappear [on]. But what I did was I wrote on the slate in felt pen so that you couldn't erase the names. The names are indelible. And then they were given a seal of approval [symbolized] by the little gold seal on the side and that little diploma-like ribbon cut kind of on an angle. They were on black ... tissue attached in one spot so that any air movement caused it to kind of lift up and go 'rattle, rattle.' And it was all crinkly; it's a matte black tissue. And then over top of the magic slates I had this little piece of netting exactly the size of the slate, and it had tiny little sparkles in it and it had little stars, so it was like we were the stars – elevated – but we were still the 'ten little Indians.' The Canadian Club sign ['Different from All Others'] was at the top in the middle, and below that was a diploma, just a white piece of paper ... It was like the diploma of credibility or whatever – academia.

So out of that diploma came all this IV tubing, and it had red neon tape wrapped around it every so often like a notation device. And that IV tubing went down into the light. I couldn't get a red bulb so I just painted the light-bulb [with] red acrylic paint. And I was in Simpsons Sears and I found all these plastic Indians in a box – they're still selling them – so I bought those plastic figures and I painted them all black. There was a cowboy driving a wagon, there were all these Indians all over, some cowboys on horses – I put them on backwards on the horse ... because they were screwed up. It's just a funny little thing.

And that little box had a seal on it so it was mysterious. It was just a little lacquered cardboard box, kind of nice looking, and I put the seal on it and then I put a whole bunch of gold pins in it – little gold pins that are acceptable ways of pinning things together. And then I had a prayer book – and I found that in an antique shop when I was walking around Montreal. And I found the light in an antique shop. I wanted a

light. Actually, I don't even think I thought about the light until I was in the antique shop and I saw the light. And it was a tree. And I wanted the idea of the 'tree of life,' and the 'family tree.' All that kind of stuff is all connected to that. And I thought, 'This is incredible!' I think I had to pay eighty-five bucks for that stupid light …

I had to have an extension cord 'cause there wasn't a plug where I was putting this piece, so I thought, 'Well, I'll incorporate the whole extension cord into the piece.' So, of course, it was a *white* extension cord and it was plugged into power. So there was a funny little thing about that … That's just tissue [on the Canadian Club sign] with a gold seal covering the … '5 cents' on it. So it has some ribbon … and it says 'Artist as Artifact' [laughs].

[*Art Tribe* was remounted when] the New Gallery here was doing that show called *Fear of Others*. It was started in Vancouver and went right across the country. It was dealing with racism. They had originally asked me to be in that show but I didn't have time. They asked me at the last minute. Whoever was organizing it in Vancouver was embarrassed to call me up and ask me to be in the show at such a late date. And I said, 'I'd like to be in it but I'm too busy right now.' So when it came to

Calgary – the thesis of the whole show was to include some local people, one or two local people of the gallery's choice – so the gallery called me up here and they said, 'Do you have something you can put in this show?' And I said, 'Well, I can put my *Art Tribe* in.' I explained it to them and they really liked the idea, so I zipped down there with my little 'CULTURAL BAGGAGE' suitcase [Figure 72, p. 140] and [laughs] did a snap-on installation. It should have been on a black wall though. It was originally on a black wall [in Montreal]. It was a lot better …

I just snapped [these photographs] with a Polaroid just as a document. And I thought it was funny to put this write-up on the wall – this explanation of what the piece was about – because that's never really done. It's usually in the catalogue but it's not part of the piece. I said to [a] reviewer in Ottawa that I was taking back my right to explain what the piece was about, and not leaving it up to critics or historians to try and put together what I was thinking about when I was doing it. So it's just a funny little irony, I guess …

There's a lot of money put towards a catalogue and a lot of times the catalogues contain a lot of words and not

too much about what the artist is doing, or thinking, or writing. In fact, a lot of people don't think that artists should even write about their work, that their writing is even valid. So there's a reaction about that, I think, and that's been going on for a while. And then there is [another] reason: that [artists] really do want to communicate directly with the viewer, and they want to eliminate this middleman, this interpreter.

The Trickster Shift

I promised myself when I got here I wouldn't try to pull any of this elder stuff on you –
like [expounding on] the cosmic wisdom of Native people.
I said, I'll leave that to the elders, and just tell people that I'm a practising artist ...
In this context, probably, nobody would recognize a shaman if they'd seen one right now.
They're looking for an old paradigm. The Trickster shift, they can't recognize that thing.
Well, I've been practising that kind of stuff for quite a while – in my own estimation of course –
I'm quite an accomplished magician, a real magician.

Carl Beam, Ojibway artist[1]

The above remarks from one of Canada's pre-eminent Native artists reveal as much about the general public's misunderstanding of contemporary Native artistic practice as they do about its understanding of Native shamanic practice. Having denied his intention to comment on the cosmic wisdom of Native peoples, Beam, in characteristic trickster fashion, does just that. By directing viewers to reject as antiquated a paradigm that sees Native art as mystical and legend bound in favour of recognizing the active spirit of the traditional Native trickster, Beam affirms a critical link between subversive practice, aesthetic production, spiritual truth, and cultural wisdom.

Celebrated Cree playwright Tomson Highway explains this complex relationship in the following way:

In the same sense that Jesus Christ stands at the very, very centre of Christian mythology, we have a character in our mythological universe, in our dreamlife as a people, who stands at the very centre of that universe, and that character is the Trickster. That little guy, man or woman – it doesn't matter because the Cree language doesn't have any gender – who essentially straddles the consciousness of Man and God, translates reality from the Supreme Being, the Great Spirit, to the people and back and forth. Without the spiritual health of that figure I think Indian people are completely screwed.

I think it's up to us, particularly as artists, people working with spiritual lives – which is essentially what artists do – they're kind of priests of a sort, they serve that kind of purpose

1 Beam was speaking at the opening of the exhibition *Indigena: Perspectives of Indigenous Peoples on Five Hundred Years,* Canadian Museum of Civilization, Hull, Quebec, 16 April 1992. A year earlier, he was less than enthused about the name *Indigena,* considering it harmless and bland, another embarrassing result of diplomatic and bureaucratic decision making. He likened it to calling an exhibition by White people *Caucasia.*

in the culture – without the revival and the bringing back of that essential character, the Trickster – Weesageechak [in Cree], Nanabush in Ojibway – I think we've had it. We're up shit creek.[2]

Gerald Vizenor, a prolific writer of contemporary trickster narratives, also locates a comic spirit at the centre of Native cultural identity.[3] In an interview with Joseph Bruchac (1987, 295), Vizenor says that

tribal cultures are *comic* or mostly comic. Yet they have been interpreted as tragic by social scientists ... not tragic because they're 'vanishing' or something like that, but tragic in their worldview – and they're *not* tragic in their worldview ... In a tragic worldview people are rising above everything. And you can characterize Western patriarchal monotheistic manifest-destiny civilization as tragic. It doesn't mean they're bad, but they're tragic because of acts of isolation, their heroic acts of conquering something, always overcoming adversity, doing *better than* whatever, proving something, being rewarded for it, facing the risks to do this and usually doing it alone and almost always at odds with nature. Part of that, of course, is the idea of the human being's divine creation as superior. The comic spirit is not an opposite but it might as well be. You can't act in a comic way in isolation. You have to be included. There has to be a collective of some kind. You're never striving at anything that is greater than life itself. There's an acceptance of chance. Sometimes things *just happen* and when they happen, even though they may be dangerous or even life-threatening, there is some humor. Maybe not at the instant of the high risk, but there is some humor in it. And it's a positive, compassionate act of survival, it's getting along.

2 Highway (1988b). In 1986 Highway, along with a small group of fellow Native writers, founded the Committee to Re-Establish the Trickster. Based in Toronto, Ontario, it sought to 'consolidate and gain recognition for Native contributions to Canadian writing – to reclaim the Native voice in literature' (Keeshig-Tobias 1988, 3). That same year, Highway became artistic director of Native Earth Performing Arts, an enterprise dedicated to staging new works by Native playwrights. It is no coincidence that a company devoted to reclaiming the Native voice would be equally committed to reaffirming the relevance of the Trickster. They are, in fact, one and the same project. And who better to spearhead such a project than Highway? As fellow playwright Tina Mason says, 'I think [the Trickster] Weesakayjack takes on different identities throughout the centuries. I seriously believe he inhabits Tomson Highway's body right now' (1991, 52).

Few would disagree. The Native Earth production of Highway's play *The Rez Sisters* won the Dora Mavor Moore Award for Best New Play in the 1986-7 Toronto theatre season and was nominated for the Floyd S. Chalmers Award for outstanding Canadian play of 1986. *Dry Lips Oughta Move to Kapuskasing,* a companion piece to *The Rez Sisters,* won four Dora Mavor Moore Awards in the 1988-9 season, including Best New Play and Outstanding Production. Both plays went on to win national and international acclaim when they were remounted. Both also feature the character of the Trickster in a prominent role.

3 Acclaimed as one of the most important Native American writers of this century, Vizenor has produced more than twenty-five books in forms as varied as fiction, journalism, haiku, and literary theory. In 1996 the University of Oklahoma Press published *Gerald Vizenor: Writing in the Oral Tradition* by Minnesota Chippewa author, Kimberley Blaeser. It is the first full-length treatment of Vizenor's extensive body of work.

Not surprisingly, Vizenor identifies a comic spirit as *the* defining characteristic of contemporary Native literature, the element that provides a work with a sense of cultural truth, or what he calls 'mythic verism' (p. 309):

It is the attitude of the characters which gives it the mythic verism and that attitude is comic ... It is something that is alive ... the way time is handled and resolved, the tension in time, and the sense of comedy or comic spirit through imagination and a collective sense that people prevail and survive, get along, get by. They're not at war with the environment, they're not rising above, and there are no subtle references to manifest destiny [and] monotheistic superiority. All of that's very subtle, but it's there and I think you can find it and I think we can focus on it and I think we can make a theory of it.

In suggesting that Native literature can be theorized on the basis of the comic attitude of characters, Vizenor seems to be saying much the same thing as Beam when he proposes a new approach to understanding the practice of Aboriginal artists. What Beam calls the 'Trickster shift' is perhaps best understood as serious play, the ultimate goal of which is a radical shift in viewer perspective and even political positioning by imagining and imaging alternative viewpoints. This is no idle intention. As Mary Douglas has noted in her classic study of joke perception, the successful joke imagines the subversion of something formal and organized (a control) by something informal and energetic (that which is controlled) so that the balance of power is changed (1968, 364-5). The joke 'affords opportunity for realizing that an accepted pattern has no necessity. Its excitement lies in the suggestion that any particular ordering of experience may be arbitrary and subjective.' 'All jokes,' Douglas says, 'have this subversive effect on the dominant structure of ideas.'

Central to the present study also is Vizenor's notion of the Trickster as 'a "doing," not an essence, not a museum being, not an aesthetic presence' (1989, 13).[4] The practice of imagining and imaging is as deserving of attention as the images imagined. But viewer beware: tricksters don't always leave tracks. Not all the works addressed and illustrated in the following pages bear a visible trickster signature or betray an obvious authorial *jest*ure. Nevertheless, they are the product of trickster practice.

While an understanding of the Trickster as a 'doing' rather than a 'being' is most relevant to this discussion, it is important not to lose sight of the 'little guy' that Highway locates at the centre of the Native mythological universe. This Trickster *is* a definite presence, albeit more energetic and peripatetic than aesthetic. It is this Trickster, too, whose countless adventures and comic exploits have entertained and educated generations of Native peoples, and whose influence has left a lasting

4 This statement may seem puzzling given the author's many works of fiction featuring a host of compassionate tricksters (Vizenor 1987, 1988, 1990, 1991). We may ask with Barry Laga, 'How do we make sense of this notion of the trickster, simultaneously a presence and an absence?' (1994, 78). I suggest that in this instance Vizenor is simply emphasizing activity – that Trickster identity is inextricably bound up in behaviour and defined by performance.

impression on the work and practice of many Native artists. Each takes inspiration from those qualities that provide the greatest amount of creative freedom: curiosity, ingenuity, playfulness, earthiness, irreverence, and resilience.[5]

In the premier issue of *The Magazine to Re-Establish the Trickster*, editor Lenore Keeshig-Tobias writes: 'The trickster is a figure found in oral cultures the world over, but he is special and central in the cultures of North America. Among his names here, in Canada, are Glooskap, Nanabojoh, Weesakejak, Napi, Raven, Hare, Coyote. Half hero, half fool, this figure is at once like each one of us and like none of us. Trickster tales are at once admonitions, instruction and entertainment' (1988, 3).[6]

According to noted anthropologist Paul Radin, in *The Trickster: A Study in American Indian Mythology* (1972, 155),

the overwhelming majority of all so-called trickster myths in North America give an account of the creation of the earth, or at least the transforming of the world, and have a hero who is always wandering, who is always hungry, who is not guided by normal conceptions of good or evil, who is either playing tricks on people or having them played on him and who is highly sexed. Almost everywhere he has some divine traits. These vary from tribe to tribe. In some instances he is regarded as an actual deity, in others as intimately connected with deities, in still others he is at best a generalized animal or human being subject to death.

Earlier, in his prefatory note (p. xxiii), Radin provides a basic personality profile of the Trickster that is still cited:

In what must be regarded as its earliest and most archaic form, as found among the North American Indians, Trickster is at one and the same time creator and destroyer, giver and negator, he who dupes others and who is always duped himself. He wills nothing consciously. At all times he is constrained to behave as he does from impulses over which

5 The Trickster is also admired for being a risk taker, rule breaker, boundary tester, and creator transformer. The less admirable character traits – such as gluttony, deception, narcissism, cruelty, and wanton sexuality – while useful for teaching proper social etiquette by negative example, rarely affect artistic practice.

6 In many Native societies Trickster narratives were, and to some extent still are, used to teach culturally appropriate attitudes and behaviour. Barre Toelken writes that among the Navajo 'one is struck by the presence both of humor and of those cultural references against which the morality of Coyote's actions may be judged ... [The humour] functions as a way of directing the responses of the audience vis à vis significant moral factors. [For example] causing children to laugh at an action because it is thought to be weak, stupid, or excessive is to order their moral assessment of it without recourse to open explanation or didacticism' (1969, 228-9).

Such an indirect approach to education appears widespread. Recalling her own childhood experience of listening to such stories, Lushootseed Salish oral historian and professor Vi Hilbert says, 'While the stories were told to me in great detail, allowing for my delicate ears, the moral was never ever explained to me. I had to figure that out for myself and I expect my students to do the same. It is my belief that most of our story tellers followed this practice' (1983, 198).

he has no control. He knows neither good nor evil yet he is responsible for both. He possesses no values, moral or social, is at the mercy of his passions and appetites, yet through his actions all values come into being.

While admitting that 'every generation occupies itself with interpreting Trickster anew' since the 'symbol which Trickster embodies is not a static one' (p. 168), Radin nevertheless concludes that only if we view the Trickster as a psychological construct and 'an attempt by man to solve his problems inward and outward, does the figure of the Trickster become intelligible and meaningful' (p. xxiv). Needless to say, this is not the conception put forth by Vizenor and Highway. There is little sense in Radin's work of the Trickster as a comic spirit informing a communal world view.[7] He does admit that 'laughter, humor and irony permeate everything Trickster does, [and that] the reaction of the audience in aboriginal societies to both him and his exploits is prevailingly one of laughter tempered by awe' (p. xxiv), yet apart from their obvious entertainment value the overall importance of these elements goes largely unrecognized.[8] Irony, in particular, seems to have

7 Nor is there much sense of a comic spirit informing Radin's text. This is deadly serious prose. It is little wonder that Vizenor writes, 'social science subdues imagination and the wild trickster in comic narratives' (1989, 187) and concludes that 'anthropologists, in particular, are not the best interpreters of tribal literatures' (p. x). He is not alone in his assessment. Barbara Babcock (1984, 102), citing Conrad Hyers (1973, 18), says, 'Unfortunately for those who make us laugh, "analysis has a way of failing to participate in the very spirit which it would analyse, and therefore not only involving itself in an ironic self-contradiction, but in a violation and negation of that which it is attempting to do justice."' Babcock then asks, 'Can analysis participate in the comic spirit? Can one do what one describes?' In his essay 'Ethnicity and the Post-Modern Arts of Memory,' anthropologist Michael M.J. Fischer offers a cautious 'yes.' He writes, 'Considerable potential still exists ... to construct texts utilizing humor and other devices that draw attention to their own limitations and ... do so with aesthetic elegance, and are a pleasure to read, rather than with pedantic laboredness ... Subtlety [however, as in the subtlety of Trickster humour] is a quality that seems often (but not necessarily) to run counter to the canons of explicitness and univocal meaning expected in scientific writing' (1986, 229).

8 This might well have been avoided had the role of the narrator been examined more closely and the relationship between narrative artist and audience been better understood. In his essay 'Trickster Discourse: Comic Holotropes and Language Games,' Gerald Vizenor stresses the need for academics to move beyond the simple gathering of tribal texts. In a critique of anthropologist Victor Barnouw, who collected trickster tales among the Wisconsin Chippewa in the 1940s, Vizenor writes, 'Barnouw listened and recorded what he heard but there is no evidence that the anthropologist responded or participated in a narrative discourse on the trickster ... There is no discourse with the narrative artist' (1989, 198-200). No doubt Radin and countless other collectors adhered to a similar professional procedure.

escaped the attention not only of Radin but of many other analysts as well.[9] This is unfortunate, for an appreciation of irony is not only crucial to understanding Trickster's attraction as hero and role model but, I would argue, to understanding Native culture in general and contemporary Native artistic practice in particular.[10]

Lawrence Sullivan is one analyst upon whom irony's import is not lost. He re-examines Radin's classic study of the Winnebago Trickster cycle in his 1982 article 'Multiple Levels of Religious Meaning in Culture: A New Look at Winnebago Sacred Texts.'[11] Sullivan makes a compelling argument for regarding the Trickster as the quintessentially ironic figure, the embodiment of the word 'irony' (pp. 238-9):

Irony binds widely separated opposites into a single figure so that contraries appear to belong together. In Trickster chaos and order, sacred and profane, farce and meaning, silence and song, food and waste, word and event, pretended ignorance and pretended cunning, stone-life and flesh life, male and female, play and reality, compose not only an ironic symbol but a symbol of irony.

Trickster's character and exploits embody the process of ironic imagination. His dynamism of composition mocks, shatters and re-forms the overly clear structures of the world and the overly-smooth images of the mind ... In him the double-sidedness of reality reveals itself ...

9 Like the Trickster, irony can be extremely elusive. It has been variously defined as 'something which is the opposite of what is actually said' (Quintilian 1966, in Cole 1981, 295), 'a mode of speech of which the meaning is contrary to the words' (Johnson 1755, in Enright 1986, 5), 'saying one thing and figuratively meaning the opposite' (Cole 1981, 295), and 'a riddle and its solution possessed simultaneously' (Kierkegaard 1841, in Enright 1986, 3). Picking up on this notion of double voice or double vision, Allan Rodway perhaps expresses it best with a photographic analogy, saying that 'irony is not merely a matter of seeing a "true" meaning beneath a "false," but of seeing a double exposure ... on one plate' (1962, 113).

10 Luiseno performance artist James Luna is not alone when he says, 'I think we Indians live in worlds filled with irony and I want to relate that in my works' (1992, 192). It is a sentiment shared by many of the artists discussed in this book and is already recognized as a prominent feature in the work of several Native authors, Vizenor among them. Michael M.J. Fischer writes, 'Recent Amerindian autobiographies and autobiographical fiction and poetry are among the most sophisticated exemplars of the use of ironic humor as a survival skill, a tool for acknowledging complexity, a means of exposing or subverting oppressive hegemonic ideologies, and an art for affirming life in the face of objective troubles. The techniques of transference, talk-stories, multiple voices or perspectives, and alternative selves are all given depth or expanding resonances through ironic twists' (1986, 224).

11 Recorded in 1912 by Sam Blowsnake and gathered together in Radin (1972), the Winnebago Trickster cycle is probably the best known and most widely studied collection of Native American Trickster stories.

What Trickster's play reveals [is] how ludicrous is every vision of life constructed of hierarchies without ironic wholeness or formal arrangements without communication between one form and another. He reveals how static is the vision of life built on earthy corporeality without passage to [the] sacred spirit of metamorphosis.

Just as the mere mention of the Trickster by a narrator can trigger in an audience 'the expectation that this particular performance will cause important ideas to come alive in exciting ways' (Toelken 1969, 225), so too does the presence of the Trickster signal that some aspect of the story will require ironic interpretation. Nowhere is the cultural need for, and appreciation of, ironic competence more clearly demonstrated than in a 1987 essay by Dell Hymes in which the author describes an infrequent two-step pattern of ironic verbal exchange that he discovered in the Clackamas Chinook texts collected by Melville Jacobs in the 1920s.[12] Close analysis of 'Bluejay and His Older Sister,' a tale in which the Trickster, Bluejay, interprets all of his sister's directions literally instead of ironically, leads Hymes to conclude that the myth draws upon the verbal pattern 'to highlight metalinguistic incompetence, incompetence in ironic exchange, and at the same time to entertain and instruct in the consequences of lack of competence. That the pattern is so used in a myth is evidence of its familiarity, even centrality, to the culture. In the

12 Through a method of linguistic analysis he calls 'the ethnography of speaking,' Hymes recognized 'the need, descriptively, to identify the specific means which serve ironic function in a particular group of speakers, and comparatively, to go beyond identification of irony as an effect to identification of its role in the communicative economy of groups' (1987, 297).

Hymes is not the first to identify such a need. Lakota author Vine Deloria Jr said much the same thing almost two decades earlier in his 1969 book, *Custer Died for Your Sins: An Indian Manifesto.* In the opening lines to the chapter 'Indian Humor,' he challenges academics to abandon (or at least revise) their usual mode of cultural enquiry, saying, 'Irony and satire provide much keener insights into a group's collective psyche and values than do years of [conventional] research' (p. 146). That is, research that ignores the import of the comic spirit. Deloria goes on to say, 'It has always been a great disappointment to Indian people that the humorous side of Indian life has not been mentioned by professed experts on Indian Affairs.' Unfortunately, few of the professed experts for whom these words were intended felt sufficiently challenged – or sufficiently slighted – to shift radically the focus of their work. This, however, is beginning to change. Again, Michael M.J. Fischer offers some cause for optimism: 'Irony and humour are tactics that ethnographers have only slowly come to appreciate, albeit recently with increasing interest. A number of analyses now exist of previously unnoticed or misunderstood ironies (either intended or unintentionally revealing) in past ethnographic writing.... Increasingly attention is being paid to the uses of laughter among ethnographic subjects ... [and] ... ethnographers are pointing out the rhetorical devices they employ' (1986, 229).

myth cultural confidence and ironic competence are intertwined' (p. 333).[13] Given the widespread distribution of trickster tales among North American Native communities, it is more than probable that ironic competence is just as widespread.[14]

In an interview with D.M. Dooling (1979, 55), Joseph Epes Brown describes how the traditional Native American clown, as earthly counterpart of the Trickster, regularly 'opens a door, in a very subtle and effective way, into a realm of greater reality than the realm of the ebb and flow of everyday life.'[15] He says that this is accomplished essentially by two means:

There is first of all the element of shock. [Sacred] clowns among the Pueblos [of the American Southwest], for example, in the context of their ritual dance dramas, engage in, among other activities, sexual types of display which normally are quite taboo in such societies, and this causes a rupture with the ordinary everyday pattern of life. It does that by immediately catching the attention; it helps the people forget their petty little concerns about the routines of daily life. It shocks them out of that. Secondly, once that awareness, that alertness and openness, has been achieved through the initial shock, then it is possible to communicate on another level through the use of humor ...

I see it as a technique to translate the formal rite or to break through it into an area of deeper meaning and deeper awareness on the part of the participant. It is you might say a shattering of the structure of the rite in order to get at the essence of the rite. It seems

13 'Bluejay and His Older Sister' is by no means the only tale to stress the importance of linguistic and ironic competence. Dell Skeels provides two further examples from the Nez Percé in which Coyote 'misunderstands Fox, accepting the literal meanings of the words when Fox uses them figuratively and each time loses his food' (1954, 61).

14 Not only is irony 'a specific culture of the spirit,' as Sören Kierkegaard asserts (in Babcock 1984, 450), but it appears to be the specific spirit of a culture as well. Hymes believes that the two-step pattern of ironic exchange, along with other comic and ironic configurations, still functions as a vital and viable method of coping with a changing world. He writes, 'I would like to stress this power of patterns of verbal humor, against difficult and even desperate circumstances, a power still evident in Indian country' (1987, 329). The power of humour that still flourishes in Indian country is by no means limited to verbal patterns of expression; it becomes even more potent when combined with and transformed by a remarkable variety of visual patterns.

15 Note the striking parallels to Barre Toelken's explanation of the way in which Coyote tales are understood among the Navajo: 'Coyote tales are not simply entertainment ... [T]hey are phrased consciously in such a way as to construct an interesting surface plot which can act as entryway to a more subtle and far more important area of consideration ... The telling of, and listening to, Coyote stories is a serious business with serious consequences, no matter how much the humour might lead an outsider to feel otherwise' (1969, 222).

to ridicule, thus destroy, but it does this so that deeper truths contained within the rite can come forth and reveal themselves.[16]

In her decidedly unorthodox assemblage/essay, 'Arrange Me into Disorder: Fragments and Reflections on Ritual Clowning,' Barbara Babcock affirms the same connection between the sacred and the shocking: 'Comedy may be a spiritual shock therapy which breaks up the patterns of thought and rationality that hold us in bondage and in which the given and established order of things is deformed, reformed, and reformulated; a playful speculation on what was, is, or might be; a remark on the indignity of any closed system' (1984, 103).

The clown 'creates a reflexive and ironic dialogue, [and] an open space of questioning,' she adds (p. 107). As a 'sophisticated form of sociocultural self-commentary' and 'transcendental buffoonery,' Pueblo ritual clowning is no less than 'irony writ large' (p. 107). To quote Dell Hymes once again, 'cultural confidence and ironic competence are intertwined' (1987, 333).

One of the most distinctive features of ritual clowns, according to Arden King, is their ability to interact creatively with chaos and the unknown – to 'withstand contact with nonorder.' 'If clowns survive the encounter with nonorder, then so too may all humans,' he writes.[17] More important, through humour they can propose 'an entirely new way of structuring human existence ... [nothing less than] ... another way of human *being*' (1979, 146-8).[18] These abilities, King believes, have made the clown an ideal role model for leaders of 'revitalistic' and nativistic movements.[19]

..

16 Jane Ash Poitras offers a remarkably similar description, albeit more personalized and impassioned, of the way in which sacred knowledge is accessed through humour. See p. 106 for a description of her experience as a first-time participant in an all-night peyote ceremony conducted by members of the Native American Church.

17 'What happens to him happens to us,' Paul Radin says of the Trickster (1972, 169). The same can be said for the sacred clowns, who represent 'each of us at our worst moments and what we might become during our best,' to quote Ron McCoy (1988, 15). McCoy adds that the delight makers, as archaeologist Adolf Bandelier named the Pueblo clowns almost a century ago, 'embody human contradictions and frailties while epitomizing our greatest spiritual aspirations.' Hopi poet Ramson Lomatewama suggests that the clowns are mirrors: 'Like mirrors, they reflect all aspects of life, the good as well as the bad, the joy as well as the sorrow, the courage as well as the fears. They reflect life as it is, particularly its choices and consequences' (1988, 12).

18 Cf. Mary Douglas's remarks on joke perception, p. 5, above.

19 For a survey of the anthropological literature on humour in religion, see Mahadev Apte (1985). For a short list of works on Native American clowning, see the Suggested Reading section of the References.

I contend that many contemporary Native artists possess the same ability to interact with non-order through humour and irony and likewise can and do serve as role models for their ability to combat ignorance and imagine other ways of being human. It is a calling of no small consequence. As warrior diplomat Third Proude Cedarfair says in Vizenor's novel *Bearheart: The Heirship Chronicles,* 'The tricksters and warrior clowns have stopped more evil violence with their wit than have lovers with their lust and fools with the power and rage' (1990, 15).

In the interview with Bruchac cited earlier, Vizenor himself says that 'a comic spirit demands that we break from formula, break out of program, and there are some familiar ways to do it and then some radical or unknown ways' (1987, 290). He adds, tellingly, 'I think it's a spiritual quest in a way.' The visual artists whose works are examined in this book break from formula and break out of program in both familiar and radically unexpected ways. They are major practitioners of what Michael M.J. Fischer aptly calls 'the fine art of the trickster' (1986, 227). For indeed, a trickster spirit unquestionably informs their art, which is often 'radical in action [and] disruptive in the social and cultural values' (Vizenor in Bruchac 1987, 294). But then, that's hardly surprising. After all, as Vizenor points out, 'that's a trickster's business.'

The Re/Creation of Identity

We are what we imagine.
Our very existence consists in our imagination of ourselves.
N. Scott Momaday

[Native] people are going to have to start using their imaginations ...
and start creating their own image of themselves ...
to reaffirm what we are.
Shelley Niro

For Native artists seeking to undermine the power and authority of cultural *signs* through the power of their collective imagination, it is the sign 'Indian,' with 'its predetermined and well-worn path between signifier and signified,' that seems most in need of deconstruction and rehabilitation (Owens in Vizenor 1990, 250).[1] It is, after all, the sign 'Indian' that resonates down through the years in travellers' journals, dime-store novels, and Hollywood movies; in countless images of feathered braves and savage warriors, solemn chiefs and mystical shamans, lusty maidens and sombre matrons, alternately imagined as primitive, noble, fearsome, honoured, captured, conquered, vanquished, and finally, *vanished*.[2]

1 The 'sign' and 'signification' are the core concepts of 'semiotics' (sometimes called the 'science of signs'), first set out by the Swiss linguist Ferdinand de Saussure in his *Course in General Linguistics,* published in 1916. Signs express ideas, and thereby participate in a process of signification. Each sign has two components: an acoustic (or visual) component called the 'signifier' and a conceptual or mental component called the 'signified.' Employing a common 'sign system' or communication code, the sender of a message 'encodes' meaning in a sign, which is then 'decoded' by the listener or viewer within the context of specific social relations and processes.

When irony and parody are considered, the reader or viewer must first be able to recognize the signs or markers of 'the encoded presence of "double-directed" discourse' (Hutcheon 1985, 92) for a work to be perceived as irony and parody. Such signs or markers (or clues) may be overt or covert, depending on how competent the encoder decides the decoder is, or how direct the communication is intended to be.

In *Narrative Chance: Postmodern Discourse on Native American Literatures,* Vizenor writes that the tribal Trickster is variously conceived as 'chance and freedom in a comic sign ... [and] an encounter in narrative voices' (1989, 13); 'a sign, a communal signification that cannot be separated or understood in isolation' (p. 189); and 'a semiotic sign for "social antagonism" and "aesthetic activism" ... but not "presence" or ideal cultural completion in narratives' (p. 192).

For more on semiotics, see Barthes (1967, 1973), Culler (1981), Eco (1976), Hodge and Kress (1988), Matejka and Titunik (1976), de Saussure (1974), and Scholes (1982).

2 For bibliographic references on White conceptions of Indians in literature and film as well as Native responses, see the Suggested Reading section of the References.

Many of the images that proliferate in the popular media and still punctuate scholarly texts date from the last century, the work of numerous frontier painters and photographers who sought to record for posterity the colourful participants in what they perceived to be a quickly passing cultural parade.[3] In recent years, however, this body of imagery has been criticized for being less a visual document than a collective Euro-American exercise in creative historicizing, one that has left the image of Native peoples languishing in a state of perpetual nostalgia and peripheral existence.[4] Rectifying the situation has not been easy. In a 1988 article Saulteaux artist and curator Robert Houle lamented that few cultural institutions afforded Native artists the opportunity to counter such imagery: 'Somehow we are not allowed to come into the 20th century. We are not allowed to interpret our own reality, the way our communities respond to everyday life. We are regarded as living museum pieces. This is perpetuated by even the most lavish, most knowledgeable, professional representations of our cultural heritage' (1988, 60).

Despite frustration over the shortage of exhibition venues, interpretations of contemporary reality were by then being created at an ever increasing pace, and finding an ever widening audience.[5] Moreover, several artists were beginning to playfully exploit the perception of Native peoples as living museum pieces. Images only recently regarded as demeaning clichés and romantic idealizations were by the 1980s being reclaimed, redeemed, and reinvested with new meaning. Over the last decade and a half Canadian Native artists have become particularly skilled at representing cultural stereotypes in humorous and ironic fashion to reveal not only their ideological underpinnings but also the way in which historical misconceptions have hindered cross-cultural understanding and interaction. Needless to say, there is also great satisfaction to be derived from merely portraying the ironies of everyday life and revelling in pure play. This is no less a trickster's agenda.

Grand River Mohawk artist Bill Powless is one of those who take definite delight in pure play and ironic juxtaposition, with seemingly little interest in provoking political debate.[6] The bemused individuals depicted in *Beach Blanket Brave*[7] and *Home of the Brave*[8] (Figures 1 and 2), for example, surrounded as they are with the

3 For further references on frontier painters and photographers see the Suggested Reading section of the References.

4 See, for example, Lippard (1992), Lyman (1982), and Truettner (1991).

5 In 1982, for example, the University of Regina's Norman Mackenzie Art Gallery mounted *New Work by a New Generation,* curated by Robert Houle. The following year museum director Tom Hill opened *Indian Art '83,* the first in a series of annual juried shows of contemporary work at the Woodland Cultural Centre in Brantford, Ontario. In 1984 the Norman Mackenzie Art Gallery featured the work of Bob Boyer and Edward Poitras in *Horses Fly Too,* curated by Norman Zepp and Michael Park-Taylor. That same year the Thunder Bay Art Gallery exhibited *Altered Egos: The Multimedia Work of Carl Beam,* curated by Elizabeth McLuhan. This was followed in 1986 with *Stardusters: New Work by Jane Ash Poitras, Pierre Sioui, Joane Cardinal-Schubert and Edward Poitras,* curated by Gary Mainprize.

trappings of popular culture – a rubber inner tube, newspaper, and Speedo bathing trunks in the former, a can of Pepsi, paper cup, and pink flamingo lawn ornament in the latter – are meant to express Native participation in contemporary consumer society and possibly their bewilderment with it. Yet both also foreground lingering stereotypes, in their images and titles, that prevent non-Natives from fully appreciating and accepting such participation.[9] Moreover, *Home of the Brave* may even be 'trying to teach us that Indians have the right to be tacky too' (Green 1989, 66)![10]

6 Powless has said that his paintings are not really political, but merely poking fun at things to produce a reaction. At craft shows and gallery exhibitions where his works are displayed he particularly enjoys watching the faces of non-Natives who are unsure how to react – unsure whether or not a piece is supposed to be humorous, unsure whether or not they are allowed or expected to laugh or smile. This is obviously one of the pleasures of creating this kind of work.

7 One can recognize in this painting the echo of the earliest depictions of Native peoples, rendered in Graeco-Roman terms. As Fraser J. Pakes has noted (1985, 4-5), in the images dating from the sixteenth to the early eighteenth century

the Indian stands before us as an ideal ancient, with a Herculean body type and cast in a classical pose ... [In this] Golden Age of Greece revisited ... there was no sense of some barbarian culture. All is grace and beauty and order. Indicative of the pervasiveness of this imagery is the fact that, in 1763, a visitor to Rome on viewing the Apollo Belvedere exclaimed, 'My God, how like it is to a Mohawk warrior' [Coen 1969, 40]. Also indicative is the portrait of an Iroquois who visited England in 1710 [Sa Ga Yeath Qua Pieth Tow, one of four 'Indian kings' painted in similar fashion by Dutch artist John Verelst]. He is standing in front of an English woodland backdrop and wearing his blanket in the style of a toga.

About his own painting, Powless simply says, 'At first glance you see it as being this stately kind of thing, but then as you look at it you see it's just going to the beach!' This and all subsequent quotations in the notes and text that are not attributed to a published source are taken from interviews conducted by the author.

8 Powless believes that his love for punning and wordplay and his desire to say things differently in the titles of his work derive in part from the years he spent working as a commercial artist, a time when he developed a keen interest in the actual look and feel of words together. Across the top of the preliminary sketch for this painting are the words 'New Wave Brave,' while across the bottom is written 'Land of the Free ... Home of the Brave.' Notwithstanding the artist's remarks on the apolitical nature of his work, it is hard to deny a modest political agenda to a piece whose title puts a wry spin on the last line of the American national anthem, all the more so when the viewer is subconsciously directed to fill in the phrase 'land of the free' and then reflect on its irony when applied to the present and historical situation of Native peoples.

9 In this, the paintings work within 'the constraints of the dominant while foregrounding those constraints *as constraints* and thus undermining their power' (Hutcheon 1991, 81).

10 Powless, in fact, has several pink plastic flamingoes around his own home on the Six Nations Reserve. Proof positive that the Creator has a sense of humour, this amusing-looking bird stands as something of an alter ego for the artist, a belief borne out by its inclusion in a self-portrait as April Fool (Figure 3), created for the 1996 edition of the artist's annual calendar of pen and ink and pencil sketches.

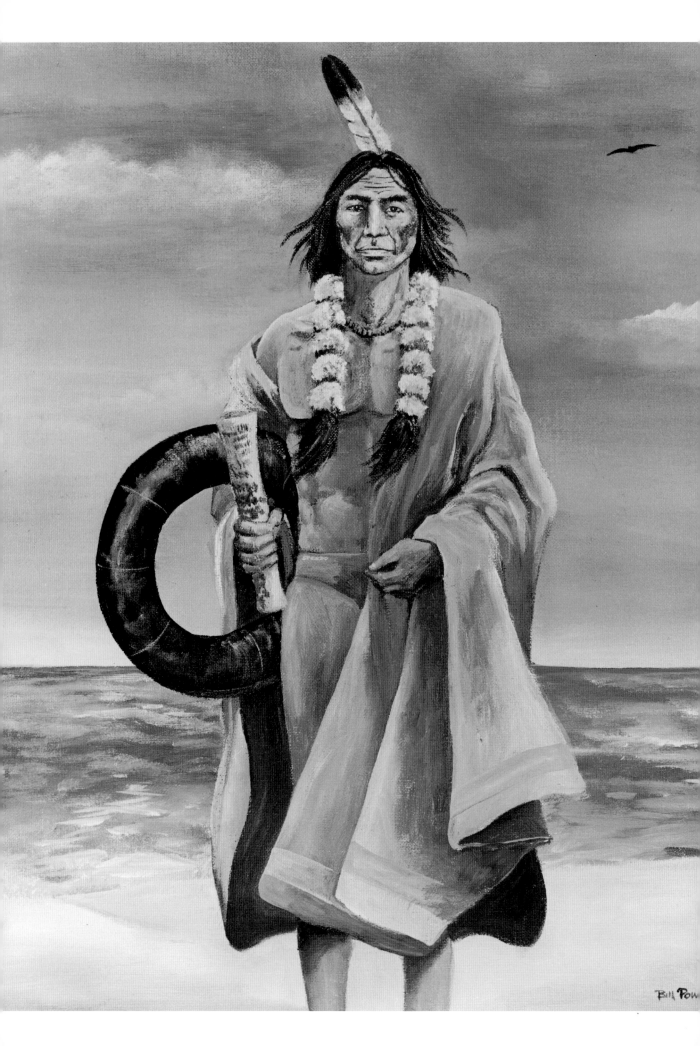

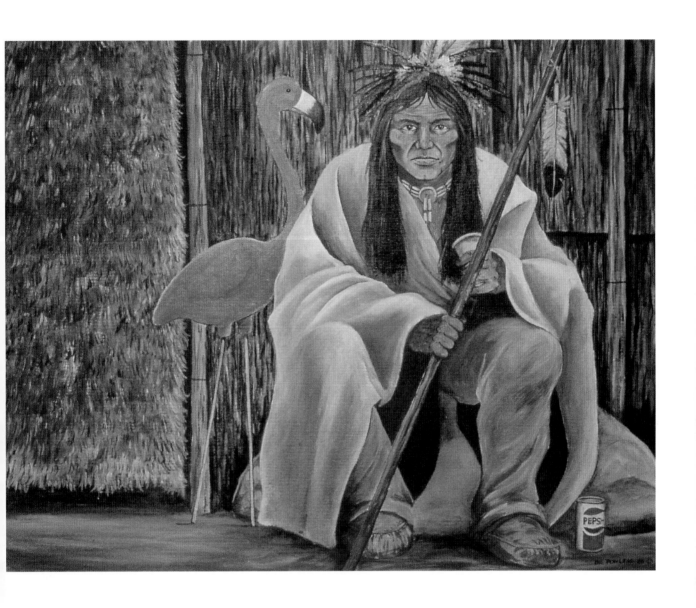

1 (facing page)
Bill Powless
Beach Blanket Brave, 1984
acrylic on canvas board, 51 x 41 cm

2 (above)
Bill Powless
Home of the Brave, 1986
acrylic on masonite, 61 x 76 cm

In *Welcome to Our Reserve* (Figure 4), Powless plays on the tensions between image and text, knowledge and ignorance, and desire and expectation by contrasting the figure of a menacing Plains warrior clutching a ball-headed club with the partially visible lettering on a large sign in the background welcoming visitors to the Six Nations Iroquois reserve in southern Ontario. On the table in the immediate foreground two small cards identify the reserve by name and invite guests to 'please help yourself' to information about the community. 'The funny part is,' Powless says with a laugh, 'you help yourself and you see the war club there. "Try it!" But it's not supposed to be scary; it's supposed to be a welcome.'

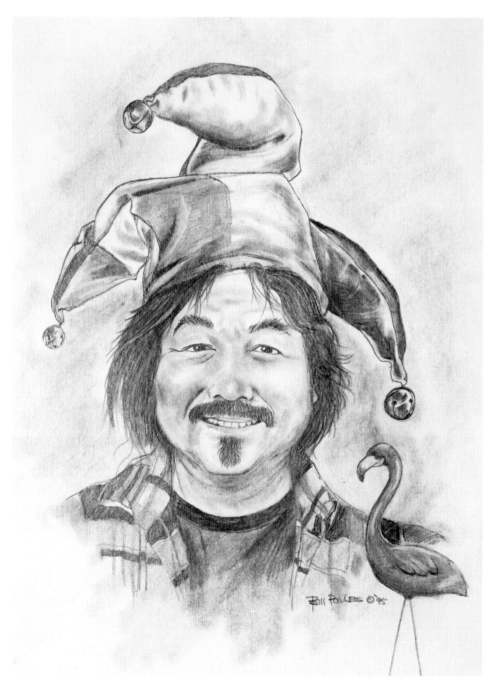

3
Bill Powless
Self-Portrait as April Fool, 1995
graphite on paper, 29 x 22 cm

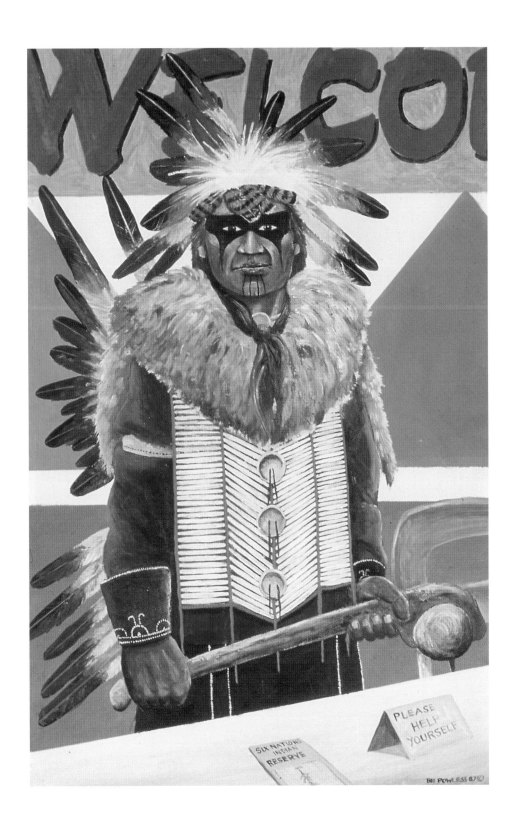

4
Bill Powless
Welcome to Our Reserve, 1987
acrylic on masonite, 81 x 52 cm

Visually, the piece presents an irresolvable paradox, a mixed message that reflects the ambiguity many Native people feel toward cultural tourism. The crux of the problem: in an effort to introduce visitors to the realities of reserve life (thus dispelling stereotypes), it is often necessary to promise colourful dancing and photo opportunities (thus fulfilling the stereotypes). Perhaps more significant and potentially more disturbing than the welcome/not welcome juxtaposition is the less obvious tension between the imposing image of the Plains warrior and the small text identifying the Six Nations Reserve. So powerful and overwhelming is the sign 'Indian,' both visually and metaphorically, that the only apparent indication of the individual's tribal affiliation is an easily overlooked Iroquoian pattern on the beaded cuffs. In this painting, then, Powless reflects not only the complexity of contemporary Native identity but the difficulty in affirming it as well.[11]

In more than one Hollywood movie and racist anecdote, the Plains Indian has appeared not as 'noble savage' or 'savage savage' but as 'bumbling fool,' laughable not for a keen sense of humour or comic disposition but for embodying cultural incompetence. Envisioned by a Native artist, however, the same image can be recovered as a healthy symbol of communal imagination and self-deprecating humour. In cartoons drawn for the local Six Nations newspaper, *Tekawennake*, Powless shows how such recovery is possible (Figures 5 and 6).[12] Figures 7 and 8 illustrate how the image of Tonto, the Lone Ranger's faithful Indian companion, has also been refashioned to similar ends.[13]

11 In the photograph that inspired this depiction of situational irony, the 'warrior' standing behind the table is actually prize-winning powwow dancer Amos Key, a friend of the artist, whose appearance in men's 'traditional dancer' dress – as opposed to traditional Iroquois dress – regularly enthrals and repels viewers in the finest Hollywood tradition. Both artist and dancer are acutely aware of this when they travel about together making goodwill presentations on behalf of Brantford's Woodland Cultural Centre, where Powless is a museum design preparator and Key is a Native language consultant.

12 Powless has created cartoons for *Tekawennake* since the late 1980s. Addressing issues of local concern and community interest – in particular, educational funding and band council politics – his cartoons not only feature the Plains Indian stereotype as a generic Indian Everyman but also present a variety of other characters defined as Native by their distinctive physical features.

For a list of bibliographic references on other Native cartoonists, see the Suggested Reading section of the References.

13 Far from being an embarrassing screen presence in need of rehabilitation, Tonto, clad in his trademark fringed buckskin, is something of a folk hero at Six Nations, having been portrayed in *The Lone Ranger* television series by local athlete-turned-actor Harry Smith, better known as Jay Silverheels. Despite the generally demeaning status of man-servant to the Whiteman accorded this character throughout the 220 episodes of the series, Silverheels is remembered for founding the Indian Actors Workshop in Hollywood 'in an effort to get more Indian people on the screen and change the negative film image of Indians' (Woodland Cultural Centre 1987, 101).

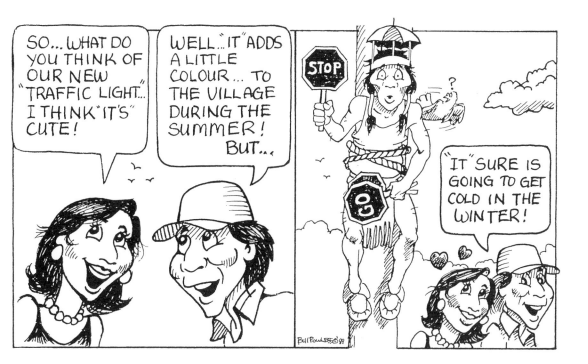

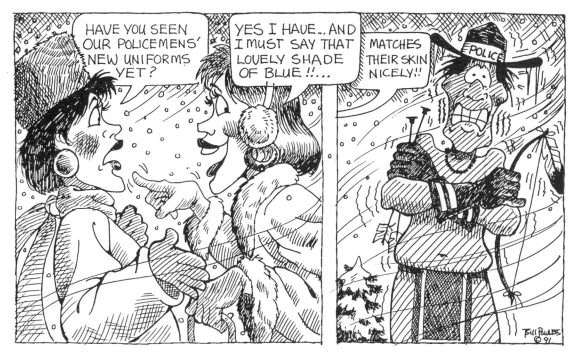

5
Bill Powless
'So ... what do you think ...'
1989
pen and ink cartoon on paper

6
Bill Powless
'Have you seen ...' 1991
pen and ink cartoon on paper

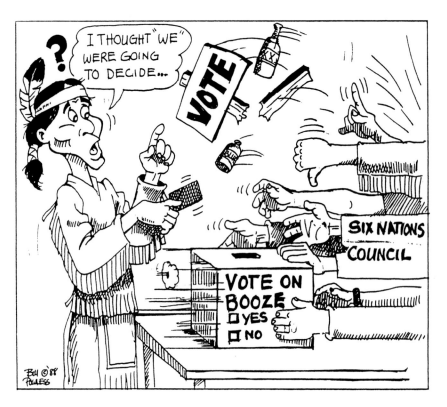

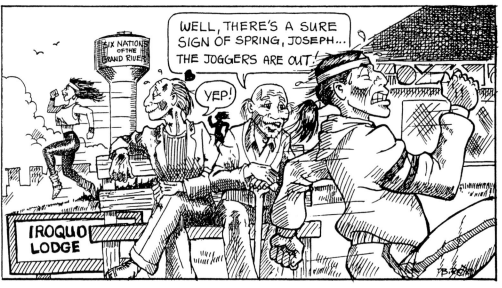

7
Bill Powless
'I thought "we" were ...' 1988
pen and ink cartoon on paper

8
Bill Powless
'Well, there's a sure sign ...' 1989
pen and ink cartoon on paper

Many of the sixteen paintings in Plains Cree artist Gerald McMaster's 1990 series, *The cowboy/Indian Show,* have the look of captioned cartoons writ large. This, in fact, is part of their appeal, imbuing them with a sense of immediacy and playful spontaneity. In works brimming with outrageous puns, ironic reference, and critical parody,[14] McMaster interrogates the cowboy/Indian phenomenon – that curious coupling of a minor blue-collar profession with a complete race of people – to reconfigure Aboriginal history and comment on contemporary intercultural relations.[15] The sign 'Indian' is reclaimed with a vengeance.

In *Counting Coup* (Figure 9), for example, the artist examines cross-cultural misunderstanding in the Old West by evoking, then reversing, the standard scenario of the stock Hollywood western. In a whimsical update of an old cultural maxim – or is it an ethnographic observation? – lettered on the painting itself, the clever Indian chief outsmarts the not-so-clever cowboy-*cum*-captain-*cum*-bumbling fool. The deed is registered here in Cinemascope framing and captured in Technicolor hues.[16] McMaster says: 'It's a little slapstick ... with the "BANG!" thing ... It's pretty slapstick. The point here is that the soldiers didn't know what the hell these Indians were all

14 A particularly useful concept for understanding the function of parody, not only in McMaster's work but in the work of many other artists in this book, is Linda Hutcheon's theory of parody, in which the term is defined as 'repetition with critical distance that allows ironic signalling of difference at the very heart of similarity' (1988a, 26). In this, irony becomes the chief rhetorical strategy of parody, and 'critical distance' becomes the critical aspect of redefinition. A professor of Comparative Literature at the University of Toronto, Hutcheon is a prolific writer on irony, parody, and postmodernism. See, for example, Hutcheon (1985, 1988a, 1988b, 1989, 1991, 1992, 1994a, 1994b). See also Ryan (1992).

15 It is a winning combination that found immediate favour with reviewers when the show opened in February 1991 at the McMichael Canadian Collection in Kleinburg, Ontario. Michael Valpy (1991, A13), for example, enthused in the *Globe and Mail,* 'Gerald McMaster is the sort of Canadian I would like to see clone himself. He thinks that there are things in the country that are actually funny ... This [show] is great. You have something that at once is funny, bridges and draws together two cultures and (with the help of the catalogue) is educational without making the head hurt ... Someone, someday, will write an acceptable history book for Canadian schools and be smart enough to include Mr. McMaster's paintings and catalogue notes.' For excerpts from other reviews see p. 40.

16 In similar fashion Cherokee author Thomas King, in his novel *Green Grass, Running Water* (1993a, 263ff), has a quartet of Trickster-like characters enter a video of an old Hollywood western and fix the ending so that the Indians triumph over the confused cavalry. It is not for nothing that Vizenor identifies 'the way time is handled and resolved' as a defining aspect of contemporary Native literature (in Bruchac 1987, 309).

about. "Why are they poking me?" He [the soldier] just picks up his gun and "Bang! You're dead." Here, it's not "Bang! You're dead," but "Bang! I got you." Europeans saw war games quite differently. War games were to annihilate people, not to play tricks on them. For the Indians part of the humour in these old war games was in humiliating your opponent. So here's the subtle humiliation.'[17]

Echoing Madronna Holden's description of Coast Salish tales that satirize the Whiteman as 'a kind of turnabout anthropology' (1976, 293), McMaster says, 'I'm using the Indian looking back at "the Other" because so much has often been the other way. Now I'm saying Indians can also see "the Other." I'm not suggesting for a moment that Native peoples are perfect, because I think they have just as many incongruities in understanding "the Other" as "the Other" has in understanding the Indian.'[18]

17 In the golden age of Great Plains warfare, acquisition of military honour was often achieved through feats of bravery that involved 'counting coup,' or touching *but not killing* one's enemy. The warrior's glory was in the enemy's humiliation. It was tribal teasing on a grand scale. In contemporary usage the word 'coup' has political connotations that give this painting added dimension. McMaster says, 'When I showed this to some people they said, "Coup! Isn't that like taking over a government?" I said, "Yeah, it could be."'

Plains Cree artist George Littlechild gives the term 'counting coup' a more stinging interpretation in his 1994 mixed-media work on deerskin, *Counting Coup (Jesus Saves)*. Incorporating a beaded medallion emblazoned with the words 'Jesus Saves,' the piece comments on 'the First Nations people's conversion to Christianity and how the missionaries counted coup with each new convert' (Littlechild 1996, 23).

18 Satirical irony is the overriding tone of a body of material examined by Madronna Holden in her essay, 'Making All the Crooked Ways Straight: The Satirical Portrait of Whites in Coast Salish Folklore.' Tailored to comment on early postcontact relations, the situational thrust and artful irony of countless songs and stories went almost unrecognized by both listeners and collectors who failed to see their own complicity. In one myth, the well-known Bungling Host is both trickster Bluejay and offending eighteenth-century visitor. In another, the Straightener is both trickster Transformer and fervent missionary. Holden says that Salish storytellers mounted 'a frontal attack on any privileged position (be it missionary or scientific) and upon that culture in which such positions ... [were] nurtured. Indeed, the implications of this Coast Salish folklore is [sic] to ascribe a radical equality to the myth *collector*, be he missionary, settler or anthropologist, and the myth *teller*. It is an equality, in fact, so radical, as to effect a kind of turnabout anthropology, switching observer and observed and setting up a second art of social science over against that belonging to our own [Western] traditions' (1976, 293).

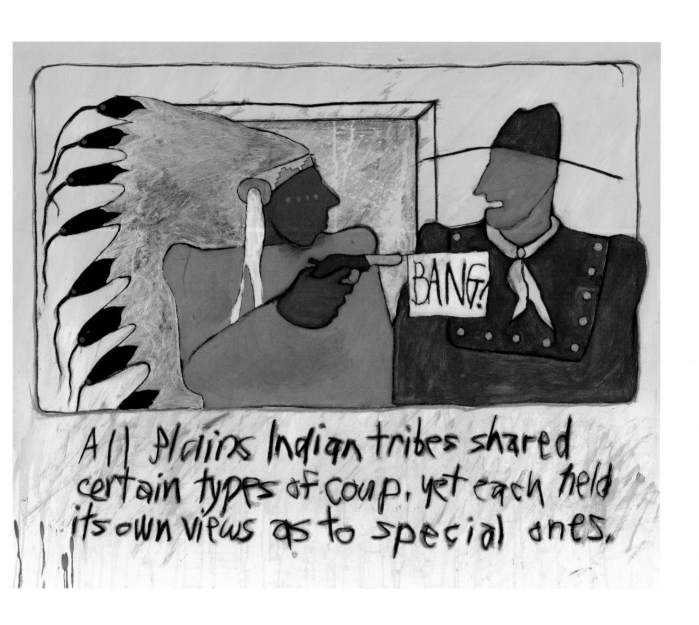

9
Gerald McMaster
Counting Coup, 1990
acrylic and oil pastel on matt
board, 96 x 116 cm

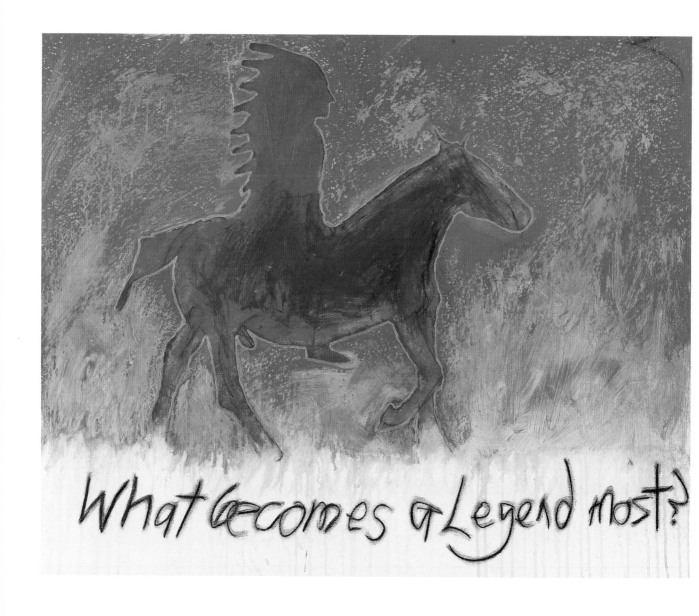

10

Gerald McMaster

*What becomes a Legend
most?* 1990
acrylic and oil pastel on matt
board, 94 x 114 cm

In *What becomes a Legend most?* (Figure 10), a popular advertising slogan used to sell fur coats is recontextualized to comment on the continuing exploitation of the Plains Indian stereotype in the thriving market for Indian art in the American Southwest.[19] McMaster explains:

I had just come back from Santa Fe, where I had an opportunity to look around at the galleries. It had been ten years since I had been back to Santa Fe. Before that ... I was in school there [at the Institute of American Indian Arts]. One of the reasons I was there was to talk with other artists who had gone through the same experience. The issue was the school itself. What responsibility did it have in teaching the artists?[20]

Santa Fe had created a style. People went there with expectations of purchasing something identifiable with the area. What was encouraged at the school was ... a sort of 'Indian Affairs mentality.' 'We have to train these Indians so they can achieve some kind of status and ability to exist in the outside world. They can't be hanging around on the reserves unemployed.' The artists were trained to sell their product.

19 McMaster's play on the word 'becomes' emphasizes the process of socially constructing and perpetuating the Plains Indian stereotype. This is also true of Ojibway artist Carl Beam's ironically titled print, *... becoming a stamp and all the thrills thereof ...,* which offers a 'before and after' portrait of Hollow Horn Bear, a Sioux whose photograph was transformed by the US Post Office into a fourteen-cent stamp honouring the American Indian. The dubious benefit to Native peoples of such an 'honour' is conveyed in the sardonic title handwritten in white ink across the face of the dark print.

20 The Institute of American Indian Arts, founded in 1962, grew out of the Studio painting program begun by Dorothy Dunn at the Santa Fe Indian School in the early 1930s. The Santa Fe painting style is characterized by nostalgic themes and pastoral scenes, executed in a highly stylized manner emphasizing ethnographic detail, precisely drawn contour lines, sterile decorative elements, and the flat application of harmonious and emotionally neutral colours. As J.J. Brody has noted, 'Though there was some encouragement of genre scenes and "home" subjects, any suggestion of poverty or social criticism was dismissed as caricature. Perhaps, as a result, the content of Studio pictures is remarkably idealized and asocial' (1971, 134). Two notable exceptions that would be dismissed as caricature under the above criteria are *Tourist Season,* by Navajo artist Quincy Tahoma (in Tanner 1973, 328) and *Land of Enchantment* (Figure 11), a piece from 1946 by Creek/Potawatomi painter Woodrow Crumbo. Today such work could be considered complicitous critique. For an overview of the major purveyors of the Santa Fe style, see Tanner (1973) and Bernstein and Rushing (1995). For a critical evaluation of the Institute's policy of stressing personal expression over cultural continuity, see Gritton (1991 and 1992).

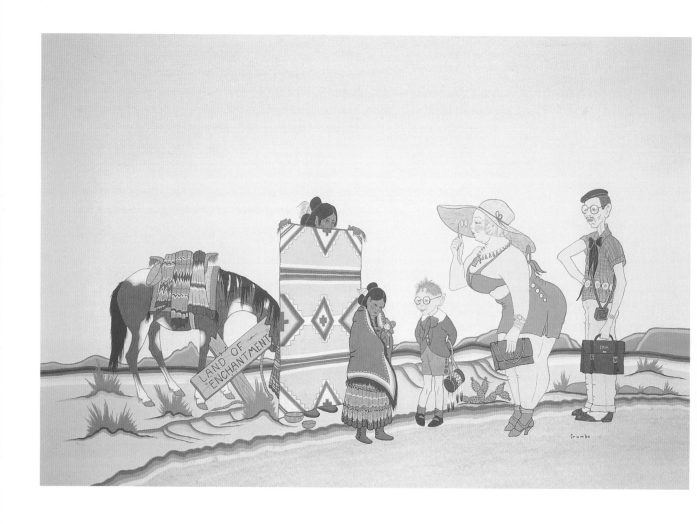

11
Woodrow Crumbo
Land of Enchantment, c. 1946
watercolour on board, 44 x 58 cm

There was a power in the market. It drew students downtown because tourists were there and it was an opportunity to sell. The students and artists from the region began to be drawn into the vortex of the market. You make ... what the tourists want. There was not too much experimentation because there was no concern about it. They weren't pumping out artists who were very critical of the material, they were just pumping out artists who could create stuff. It all looked like work that was geared to be picked up and carried away.

The point [in this painting] is a double-edged thing. What is the legend? Is it the style of painting or the image on it? This is a critique of the Santa Fe style *and* the image of the Indian. There are a lot of artists who do this image, this Indian on horseback. What does it say? It doesn't say anything except 'an Indian on horseback.' 'Be proud of the Indian on horseback.'

Of course, the Southwest is not the only region where consumer expectations and economic necessity serve to define the limits of creativity for Native artists.

In the diptych *Shaman explaining the theory of transformation to cowboys* (Figure 12), McMaster replaces the Hollywood stereotype with the mysterious and more powerful figure of the horned buffalo shaman.[21] It is a pivotal act of cultural affirmation that portrays the Indian as spiritual and intellectual, in contrast to the secular and shallow cowboys. The absurdity of the premise set out in the title merely emphasizes the gap in cultural knowledge and experience, as McMaster points out:

To me a cowboy is a very simple kind of person – he's got a job in life, maybe to break horses and to round up cattle. It's not too difficult a life to understand. To be a cowboy isn't necessarily to be an intellect. It's manual labour. It's a skill that doesn't require too many degrees. You have to have a good knowledge of what you're dealing with but it's still pretty limited – 'cow boy.' And then a cowboy in the movies was always shooting. He was the protagonist, I guess, and the antagonist, of course, was the Indian. Now, that is simple. It's a simple equation.

12 (pages 30-1)
Gerald McMaster
Shaman explaining the theory of transformation to cowboys, 1990
diptych, acrylic and oil pastel on matt board, 114 x 94 cm each

..

21 This painting recasts the theoretical enquiry first seen in McMaster's mixed-media piece, *How do you explain the theory of relativity to a 20-game winner, and still expect him to keep his concentration ... ?* (Figure 13), from his 1989 exhibition, *Eclectic Baseball,* at the Ufundi Gallery in Ottawa, Ontario. Here, in a series of ten playful works of sculpture, assemblage, painting, and what the artist calls 'arti-fakes,' McMaster interprets the game of baseball as a form of secular ritual, combining traditional Plains Indian symbols of warfare and sacred ceremony with symbols and actual equipment of contemporary baseball. Of course, verbal and visual puns abound (see Ryan 1991, 11-3). For an examination of the rituals, taboos, and fetishes that do surround the game of baseball in North America, see 'Baseball Magic,' by anthropologist George Gmelch, in Spradley and McCurdy (1997, 320-9).

13
Gerald McMaster
*How do you explain the theory
of relativity to a 20-game
winner, and still expect him to
keep his concentration ... ?* 1989
mixed media, 46 x 122 cm

But to try and understand the Indian … How do you compare the two? They just don't compare. 'Indian,' first of all, isn't the proper name to include everybody. The Indian, in this case, was supposed to be from the Prairies, but when you start looking at what an 'Indian' is it's much more complex. The Indian – whoever 'the Indian' is – is made up of several tribes and families and lifestyles. It's a whole society. So you have this gigantic society equated with a group of people who were just a small segment of Euro-American society. To try to equate an Indian with a job is just not the same. But Hollywood films and books tend to do just that. The point is that it's so incongruous.

What I did here was to show the incongruity. The life of a cowboy is generally quite pro-fane. Cowboys sit around the campfire and sing songs. The notion of intellectual conver-sation and bantering isn't really there. It's fairly simple. On the other hand, scholars and Native peoples and so many others have tried to understand what a shaman is and nobody can. We get an idea of what he does and who he is. It's so complex a field – to begin to understand what a Native person is as represented by the shaman. 'What is an Indian?' 'Well, an Indian is just this guy that runs around on a horse' – the stereotype of an Indian – but he's more complex than that.

You take one aspect of that – the religious aspect – and then you take a notion of trans-formation, which not too many people understand. The joke here [in this painting] is 'What is happening with the shaman?' 'You can't explain it.' 'How about showing some-body?' Whether or not transformation happens I'm not sure … you're not sure … nobody is sure. There's belief and non-belief playing here. Can an Indian do this? Is this possible?

One type of transformation that *is* possible, and that McMaster is fond of men-tioning for its implicit amusement, is of 'Indian' into 'cowboy.' 'It is easier for an Indian to be a cowboy than it is for a cowboy to be an Indian,' he wryly notes.[22] Moreover, the metamorphosis need not be from sacred to secular. As if to empha-size this point, McMaster created for *The cowboy/Indian Show* an enigmatic piece titled *Kaupois-uk* (Figure 14), commemorating a little-known society of cowboys that once flourished among the Plains Cree:

[The Kaupois-uk] was a mysterious group or society that we don't know too much about. Like all societies, they had their own special ways of doing things … private membership. They were a special society of cowboys. I was thinking of that particular society. Perhaps

22 In the artist's statement for this show, McMaster speaks of encountering White European hobbyists in Germany and Hungary who regularly abandon the city to 'pitch tipis and dress up in the finest replicated costumes of the nineteenth-century Plains Indian.' 'It has to be seen to be believed,' he says (in Ryan 1991, 20ff). For a firsthand look at this uniquely European phenomenon, see John Paskievich's 1995 documentary film, *If Only I Were an Indian…*, which tells the story of three Aboriginal people from Manitoba who travel to the former Czechoslovakia to meet several hundred Czechs and Slovaks who have set up a remarkable 'Indian' community.

it does exist ... I'm not sure. There is [ethnographic] reference made to the society [Mandelbaum 1979, 217], but most of these societies no longer exist. Somehow they were changed forever. Somehow the laws, the outlawing of the religion, effectively meant that these societies would forever be only in our memories.

Perhaps someday the Kaupois-uk may return again. Does anything ever really disappear? I think that there is a notion that things do reappear, that things can reappear in the future in another form, in another way. Something may have a death but it doesn't mean that it can't come back.

In *The cowboy/Indian Show* the Kaupois-uk do come back, but their return is intentionally clouded. Their appearance in this piece is a private joke dependent on private knowledge, the only ironic marker being the title, spelled out phonetically in the Plains Cree language. Yet the image is compelling. Who or what are these ghostly, cowboy-like figures rising from the landscape and silhouetted against the night sky? Were it not for the artist's commentary in the catalogue, and his desire to break down the barriers of ignorance, most viewers would remain mystified. As it is, the piece hints at cultural knowledge that is, and perhaps should remain, inaccessible. That may be the most important lesson of this painting.[23]

14
Gerald McMaster
Kaupois-uk, 1990
acrylic and oil pastel on matt
board, 114 x 94 cm

..

23 The notion of 'Indian cowboy' is obviously rife with interpretive possibilities. Hence, two further examples: Included in *Portraits of 'The Whiteman': Linguistic Play and Cultural Symbols among the Western Apache* (1979, 81), Keith Basso's classic study of Apache joking imitations of Whites, is a satirical drawing by Navajo cartoonist Vincent Craig, in which a middle-aged White couple speculate on the presumably bizarre attire worn by members of an Indian cowboys association. The man is shown reading aloud to his wife from the *Daily Star-Redneck News*. In 1983 Gerald McMaster first addressed the historical reality of Indian cowboys in *Mamas, Don't Let Your Babies Grow Up to Be Cowboys* (Figure 15, p. 39), a large graphite drawing based on a photograph of Métis artist Edward Poitras's grandfather at the age of eighteen. The playfully ironic title is taken from a popular country and western song by Willie Nelson often performed by Native singers at local talent nights on northern Saskatchewan reserves. It could be argued that the immense appeal of such music in Native communities has as much to do with a cultural appreciation for the clever and sometimes outrageous wordplay in the song titles and lyrics as for the hardluck stories and rural tales they tell.

On a related note, Agnes Grant describes how this musical genre has found its way into the cycle of trickster narratives told in northern Manitoba. She writes, 'Country and western music is very popular in the north. Hank Williams' song "Your Cheatin' Heart" is heard on every radio station. I have heard various versions of a story where a Windigo [cannibal spirit] bested Wee-sak-ee-chak in a contest. The trickster, always a poor loser, is still complaining about the unfair tactics of the Windigo, and his wailing of "Your Cheatin' Heart" can be heard across the north' (1988, 140).

For a look at the flipside of this phenomenon, that is, the manifestation of the trickster spirit in country music, see the songs of Shingoose (Curtis Jonnie), pp. 36-7.

For more on Indian cowboys, see Baillargeon and Tepper (1998).

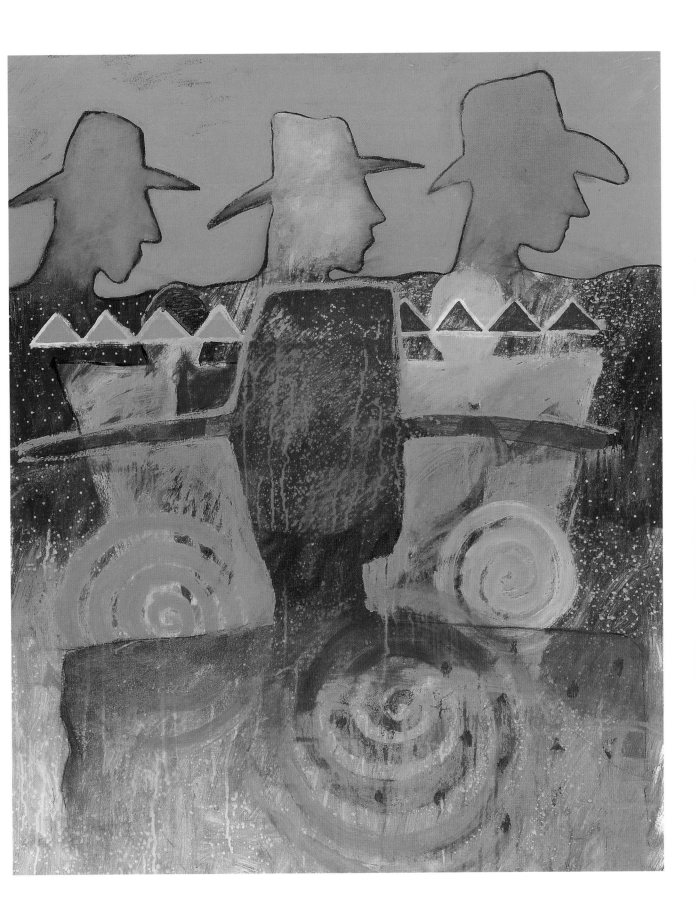

Coyote Sings Country
Shingoose (Curtis Jonnie)

Following the lyrics to 'Indian Time,'
'Natural Tan,' 'Reservation Blues,' and
'It's Hard to Be Traditional' is part of a
conversation with Curtis Jonnie in
Toronto, Ontario, 3 July 1991, in which
he discusses two of the songs.

Indian Time

Have you heard about the Indian man
Who lived back in the woods?
He liked to hunt and trap
Life was easy, life was good
One day he met an Indian girl
Upon a trail
They fell in love and she said,
'Let's get married right away'
He said, 'OK, but I got to check
On my trapline'
She's been waiting for a year
He's on Indian time ...

Chorus
Living on living on living on
Living on Indian time
You can set your watch to mine
Living on living on living on
Living on Indian time
You'll never be too far behind
When you're living on
Indian time

Chorus

Indian time has often
Been misunderstood
Some think it's bad
Some think it's good
Just like the old story

About the turtle and the hare
It isn't if you win or lose
It's how you make it there
Me, I'm like the turtle
Like to take my sweet time
And you know who was the first
To cross the finish line.

Chorus

Indian time is really
Just a state of mind
You can save it
You can lose it
You can even fall behind
Just when you think you've got it
You watch it slip away
Anyway you use it
You're living for today
But us Indians never worry
We've got time on our side
We've been here 10,000 winters
And we're still alive.

Chorus

Natural Tan

When I was young
I wanted to be a cowboy
So I could be on the winning side
But drinking milk
And eating tons of white bread
Didn't change the colour of my hide
Now as I grew up
I made an observation
Everybody else wanted to be brown
Telling me without a reservation
That I was the envy of the town
Cause ...

Chorus
I got a natural tan, I'm a natural human
I got a natural tan, I'm a natural man
I got a natural tan, I'm a natural human
I wouldn't trade the way I am
Oh, I got a natural tan

Naturally, I'm glad I'm aboriginal
It's such a popular minority
I don't have no use for suntan lotion
I never have to lie on a crowded beach
Frying in the sun and roasting

Ain't my idea of having fun
Give me some shade and a margarita
And don't stay in the sun too long

Chorus

When I was young
I didn't want to be an Indian
But that's what I turned out to be
Growing up and living in the white
 world
Didn't wipe out my identity
It took a while to surface
But it was there all along
Waiting to be discovered
To show up in this song
Oh ...

Chorus

Alternative last verse
Some folks may think this song is racist
But really it's about being free
'Cause it don't matter what colour your
 skin is
As long as you're a good human being
Imagine if none of us were different
Oh, how boring life would be
I won't try to be like you are
But you're welcome to try to be like me
'Cause ...

Chorus

Reservation Blues

Chorus
I've got those Reservation Blues
I traded my moccasins
For those whiteman shoes
I got both feet in two canoes
I've got the Reservation Blues

I left all my family back on that Rez
I've been gone so long I don't know
 who I is
How did I get myself into such a mess?
Life in the city, I'm caught in that race
I'd give it all up for a slower pace
But when I get blue it's all I can do
Reservation Blues

Chorus

Assimilation, it's all I hear
This life I'm living ain't nowhere near
The one my grandfathers lived
For thousands of years
My life's in a conflict, I'm caught in
 that swirl
I'm trying to live the best of both worlds
But when I get blue it's all I can do

Chorus

It's Hard to Be Traditional

Chorus

Well, it's hard to be traditional
When you're living right downtown
People tend to look at you funny
Every time you come around
They like to make fun of you when
 you dance
Especially when it rains
It's hard to be traditional
When you're living in the nuclear age

For instance,
Where do you go when you want
 a sweat?
Well, you head down to the YMCA
They got a great steamin' sauna there
But they look at you weird when
 you pray
Instead of rocks they got a little box
Of electric coils and wires
And when you throw the water on and
 start to sing
Someone always hollers, 'Fire!'

Has anybody seen good old Mother Earth
 around lately?
That's 'cause she's living at the public
 park
But they'd never let you hunt or trap
 in there
And it's always closed at dark
Yes, and all the animals are fair game
But they're living in a cage
And if you ever tried to skin one
Well, they'd have you on the next
 front page

Chorus

Way before the hippies grew long hair
We were wearing braids
But then around the turn of the century
All of us got shaved
(Or was it saved? I don't know)
But now long hair is coming back again
Just when I got used to it short
It's gotten so you can't tell these days
Whether you're a girl or a boy

What do you get when you rub two sticks?
Well, you get a raging fire
But it's just as easy to flick your Bic
And nobody would be the wiser
Oh, it's hard to stay true to your roots
And only your hairdresser can tell
Whether or not you're traditional
 and the rest can go to ...

Chorus

['Indian Time' was written] to educate
non-Natives. That kind of humour is to
try to get people to ask those questions:
'What does that mean?' 'Why do you
use it in that form?' 'What were you
trying to say?' I use [humour] to provoke
curiosity. In that curiosity is the
doorway to understanding it. [In this
song] I juxtapose Indian reality with
mainstream reality. 'Who's going to win
the race, achieve their goals?' Aboriginal
people have been here ten thousand
years living on 'Indian time.'

For the album [*Natural Tan*], what I
wanted to convey in that song ['Natural
Tan'] was a sense of identity and pride
that I felt growing up, discovering. The
last verse tried to say that when I was
young I didn't really want to be an
Indian because I was the brunt of every-
body's jokes. Regardless, that's what I
turned out to be. Growing up and living
in the White world didn't change any-
thing. I still ended up me, here, now. As I
grew older, I realized that there wasn't
anything I could do to change the
reality, except to change my under-

standing of it and be at one with it, be
at ease with what I am, or who I am.
What I was basically trying to say was,
'You have to accept yourself.'

The other version [of the last verse] was
more preachy: 'I'm glad I am who I am
but you may not be glad [who you are]
and you can be like me if you want to
be.' It had a different twist to it, talking
down to people, rather than trying to
stay at a level where you can exchange
ideas without being confrontational. For
the album, I felt that [the original verse]
worked a lot better because I was trying
to reach out to a non-Native audience. I
don't like to alienate the audience right
away, and say, 'Our way is the best way.'
It sounds like all the other Christian doc-
trines: 'There's only one way and you
don't have it so, obviously, I've got it,
and for $24.95 I'll show you the way.'

In the beginning, when we were more
like angry young men, we just wanted
confrontation. We just wanted to bash
heads with the establishment ... Of
course, as you get older, you realize you
have a responsibility to everyone, not
just to the ones that you like. All of
that opened the doors of acceptance
and understanding. Those [angry] days
are over.

Vern Harper, the Plains Cree elder who offered words of humour and healing at the opening ceremonies for *The cowboy/Indian Show,* found an immediate affinity with McMaster and his work. Interviewed several months later, he cited some of the reasons:

[Gerald] looked at humour in the way I did. He laughed at the things I did [and] he didn't laugh at some of the things I didn't laugh at ... He's got the wildness [of the Plains Cree] in him, but he's refined it ... [And] Gerald has the Coyote spirit in him. I recognized it in him. So he's a trickster, he has some trickster in him. He's cunning ... In Plains Cree, too, maybe it has something to do with spiritual things. It feels at times we have an inside joke about something ...

The thing too with the Plains Cree is riddles, riddles our people used to do. We've lost a lot of that. The riddles teach you to think, to figure things out for yourself.[24] That's what I like about some of his stuff ... I still try to do that humour with riddles and stuff. Some will get it right away, others won't. They just scratch their heads. I want people to think, to figure things out, not always have the punchline, create their own punchline, figure out the mysteries of life. Humour is one of the very important parts of the mystery of life. And that's where I identify with him, he has the ability to see things and feel things with humour.

But also, he likes to challenge people and that's what I liked about his work. I picked up on that challenge. That's another thing Indians like to do – challenge each other. A lot of us have been dispirited, but when we get our spirit back we always like to challenge ourselves, not in a macho sense, but in a creative [sense] ...

I think the humour that came with me that night [of the opening] made it magical. [Gerald] put his power in, I put mine, and we made it magical together. That's why it was so good, it came so well, it was magical ... Some of the non-Native people came after and said to me just off to the side, 'Thank you for the healing' ... So it was the humour that was the healing. And I said ... 'If you weren't open, you wouldn't have got it. The fact that you're open, you got it' ... I see Gerald's work and the way he looks at things, as a healer.[25]

Like many others of his generation, McMaster has been fascinated by cowboys since childhood. In the catalogue to *The cowboy/Indian Show* (McMaster 1991, 20), he writes:

As a youngster growing up on the Red Pheasant Reserve many of my Saturday afternoons were preoccupied listening to such radio programmes as *The Lone Ranger* and *Hop-a-Long Cassidy,* as well as devouring many western comic books. I'd fantasize about

24 For more on Native American riddling, see Bierhorst (1992), Scott (1963), and Taylor (1944).

25 Harper has been profiled in two National Film Board of Canada documentaries: as a founder of Toronto's first alternative school for Aboriginal children, in Marvin Midwicki's 1978 production, *Wandering Spirit Survival School*; and as spiritual guide and traditional healer in Robert Adams's 1997 film, *Urban Elder.*

being a cowboy. Having a horse and dressing up as a cowboy was all I needed. Somehow my mother had managed to save enough money to buy me the proper attire – boots and all. Owning a gun, to shoot the bad guys, BANG! BANG! was the other dream I had. Who were these bad guys? Bank robbers, horse thieves, I guess, and ah yes, 'Indians'!

McMaster was not the only Native child with aspirations of becoming a cowboy, nor the only Native artist to reflect later on the embarrassment, if not identity crisis, that such dreams inevitably precipitated. Ojibway artist Carl Beam, similarly infatuated with cowboys, critically recalls this period in his own life in the print

15
Gerald McMaster
*Mamas, Don't Let Your Babies
Grow Up to Be Cowboys,* 1983
graphite on paper, 127 x 97 cm

The cowboy/Indian Show
Gerald McMaster

Gerald McMaster's exhibition of paintings, *The cowboy/Indian Show*, ran from February to April 1991 at the McMichael Canadian Collection, Kleinburg, Ontario, then travelled to other venues.

In *now* magazine, Deirdre Hanna wrote, 'Gerald McMaster's deft *The cowboy/Indian Show* plays on Hollywood stereotypes of Plains Indians to bring home the skewed justice and racism at the root of Canada's broken treaties and unsettled land claims ... The lush surfaces of his vibrantly coloured and deceptively humorous, text-laden paintings are at once potent and appealing ... Visual one-liners ... resonate with multiple meanings' (1991, n.p.).

In the *Toronto Star*, Christopher Hume said, 'Given the situation in Canada, it's amazing Gerald McMaster can find anything to laugh about. A Plains Cree born in North Battleford, Sask., McMaster is an artist, curator, and writer whose paintings confront the grim reality of native life yet burst with all sorts of good humor and sly jokes ... Some people – me included – might think that odd, but perhaps he's right. "There are enough angry artists out there," McMaster says. "But who listens to angry people? I feel comfortable with humor as an alternative strategy" ... McMaster draws from mass media sources with which we're all endlessly familiar. But he filters them through his own sensibilities. Like many people who find themselves strangers in their own home, he wants to change the world. This show is another small step in that direction' (1991, D14).

And in the *Ottawa Citizen*, Nancy Baele stated, 'Gerald McMaster knows how to throw a comic curve. In *The cowboy/Indian Show* ... he plays with words, making puns and caricatures of stereotypes of cowboys and Indians. But his jokes always have a serious twist ... McMaster, who grew up on Red Pheasant Reserve near Battleford, Sask., gives a lot back to his culture in this show. He takes his art into a hybrid form – part comic book caricature, part high art concerned with finely worked surfaces, and part evolution of language. Each painting has a punch line dependent on the same sense of discovery found in unlocking the visual logic of an oriental ideogram ... There is a sense in this show that McMaster is a public artist writing on the wall, of graffiti raising questions about the status quo' (1991, D7).

Self-Portrait as John Wayne, Probably (Figure 16).[26] One of twelve etchings in the *Columbus Suite* series, it features an image of Beam as a young child striking a characteristically John Wayne pose.[27] It looms large above a strip of four smaller photographs. One depicts the artist today in his trademark black (cowboy?) hat, arms folded, gaze resolute; another shows him in grade school surrounded by smiling classmates.[28] The remaining two small photos – of Beam in the guise of 'Necroman,' the ultimate emblem of transformation through death (McLuhan 1984, 6), and of an Apache Mountain Spirit dancer – allude to the spiritual, metaphysical dimension of Native identity that is all but overshadowed by the larger photograph. It is an apt visual metaphor; the play between signs is a discourse on identity, yet some signs have been vested with more authority than others. Beam says: 'People may say, "He knows now that he didn't know who he was when he was five years old." But at that time, you didn't see any positive images of Indians doing anything. I didn't want to be the guy getting shot off the horse, dragged through the fucking mud. You had to choose one or the other.'[29]

26 It is the word 'probably' that gives the title its ironic and elegiac edge, its pervading sense of passive resignation. Oddly enough, in the suite owned by the Agnes Etherington Gallery at Queen's University, in Kingston, Ontario, the artist has simply titled the print *Self-Portrait as John Wayne* (Trevelyan 1993, n.p.). While the image remains sharp its ironic edge is missing.

27 Ojibway artist Rebecca Belmore also draws inspiration from John Wayne. *True Grit (A Souvenir)*, the title of her absurdly giant self-portrait-as-a-souvenir-cushion (Figure 17), recalls the 1969 film *True Grit* and Wayne's Academy Award-winning performance as the tough and crusty frontier lawman, Rooster Cogburn. Created as an angry response to the Ontario Arts Council for using her as a token Native woman artist from one of the regions, the piece symbolizes what she learned from the painful experience: 'You have to be ready. You can't let your guard down because you gotta be careful in the political art arena.'

28 Comparison with several other prints reveals the image of Beam in cowboy gear to be a detail of a photograph of the artist with his mother and infant sister.

29 In recent years Native authors have also addressed this phenomenon with similar irony. For example, in *Green Grass, Running Water* (1993a, 202-3), Thomas King writes,

By the time Lionel was six, he knew what he wanted to be.

John Wayne.

Not the actor, but the character. Not the man, but the hero. The John Wayne who cleaned up cattle towns and made them safe for decent folk. The John Wayne who shot guns out of the hands of outlaws. The John Wayne who saved stagecoaches and wagon trains from Indian attacks.

When Lionel told his father he wanted to be John Wayne, his father said it might be a good idea, but that he should keep his options open.

'We got a lot of famous men and women, too. Warriors, chiefs, councillors, diplomats, spiritual leaders, healers. I ever tell you about your great-grandmother?'

'John Wayne.'

'Maybe you want to be like her.'

'John Wayne.'

'No law against it, I guess.'

16
Carl Beam
Self-Portrait as John Wayne,
Probably, 1990
etching on paper, 122 x 81 cm

17
Rebecca Belmore
True Grit (A Souvenir), 1988-9
sewn fabric with acrylic on canvas panel,
fringe, stuffing, 178 x 183 x 25 cm

True Grit (A Souvenir)
Rebecca Belmore

In an interview on 25 February 1991 in Toronto, Ojibway artist Rebecca Belmore discusses the making of *True Grit (A Souvenir)*, her self-portrait as a giant souvenir cushion 'looking like a ... cross between a linebacker and Michael Jackson!' Following her discussion of the piece is the artist's statement she provided when *True Grit* was installed as part of *See Jane Sew Strontium*, an exhibition of non-traditional quilts dedicated to Joyce Wieland, Definitely Superior Gallery, Thunder Bay, Ontario, 1988.

I had quit [the Ontario College of Art] and gone back to Thunder Bay, and I think I did that in '87 or '88 ... and at that time there was this big discussion going on in Ontario – specifically the Ontario Arts Council – where people were freaking out because there was a lack of representation by people of colour on jury panels, etcetera, etcetera, etcetera, and [from] the regions as well. The regions were complaining that the centralized OCA-Toronto stronghold was ignoring the regions. So people were freaking out – artists of colour, women, etcetera – about who's getting the money. So it was becoming a big discussion.

So, I was working in Thunder Bay and ... suddenly I was sort of sucked out of the North and brought down to Toronto to sit on juries and do this and that kind of thing. And I couldn't understand why, because I was just out of school and relatively inexperienced and not very well informed – very naïve, actually, when I think back to it now. And basically, I think I was being used because I'm the most politically correct thing to put on a jury – a Native woman artist from one of the regions. 'Perfect, there she is!' – to be paraded, and to cover their asses, basically. So I was angered by that. I was really pissed off when I realized what had happened to me. So, as a result, I made this cushion ... thinking, well, the next time [laughs] they need me I'll just send *this* along [laughs] ...

I was pissed off about being a token Native artist, so this piece to me is a comment about myself – questioning myself as a maker of objects, as a maker of commodities, as a maker of products. As an artist you make things. Is it for sale? And what's the price on it? And also, [I was] using myself, as a Native artist, as a commodity.

I fashioned it after souvenir cushions, like you see [of] Niagara Falls or ... Mounted Police. So in a sense, I was using myself as an object to be used to represent something, for example, when I was sitting on those juries etcetera. Or whenever [I] get invited to something, usually it's a token position.

[And] I do see myself as a football player [laughs]. I was so angered by [the tokenism] that I felt that it's a mean and ugly world out there, and it's often times not upfront with you about what [people are] really doing, and you've got to be tough to go out there and survive all the madness and try to figure it out. [You have to] come up with some ... [way] to make sense of everything. So that's why I'm projecting this image of this tough, tough [guy] ... That's how I dress – cowboy boots [laughs] and a football sweater. That's my personality. I wear big boots that make lots of noise because ... I just dig it! ... So that image is a really hard, kind of angry picture of me, I think.

And then [there's] the whole thing of it being this goofy soft cushion. So it's really quite harmless. It can project a tough image but really I'm a pussycat [laughs]. But – I guess it's the whole thing that I've learned – you have to be ready. You can't let your guard down

because you gotta be careful in the political art arena. I could go beat somebody up with that [cushion] and I wouldn't hurt them. I could knock them over. It's got the idea of a pillow fight ...

I think the humour in my work has really allowed me to slip into places where, possibly, had my work been of a different sort, maybe I wouldn't be getting exhibitions or blah, blah, blah. Or maybe I wouldn't be invited to sit on panels [laughs]. Then I'd have nothing to worry about! What's my problem?

Artist's Statement

What began as a quilt-cube, with an intricately patterned beautiful surface – to be physically entered and explored by one person at a time – became a 5'10" x 6'1" souvenir pillow, complete with decorative fringe.

I used myself as the central figure, the northern motif, the native Indian as marketable commodity, the artist as product. The souvenir is: 'Rebecca Belmore, Ojibway Performance Artist' 'Rebecca Belmore, (you fill in the blank).' I am projecting an image in *True Grit* – the artist/souvenir is strong, free, and tough. You have to be to take up a front line position. But no matter how tough you are, or how tough you project – you never win.

I could knock someone out cold with *True Grit*.

Every town up north has a gift shop. When I was growing up in Upsala I would go into the local tourist store and see all these 'things' with Native Indian people in them, on them, hanging from them. I wondered where all these things came from ... who makes *these* things? I knew people in Upsala weren't making keychains out of plastic chief's heads and totem poles ...

I found a china gum-saver in Keskus Mall last weekend. It's a little plate for storing chewed gum temporarily. A one-inch high female figure (in 'Native' costume) stands on the edge of the plate, guarding the yet-to-be-chewed wad of gum. 99¢ price tag, on sale.

There are a lot of souvenirs in the north.

Over the years Beam has produced several self-portraits, either as self-contained works or as components of larger ones. One of the best known of the former type is *Self-Portrait in My Christian Dior Bathing-Suit* (Figure 18), created in 1980.[30] As a work of 'Indian art' it is as cheeky and brazen as the image of the artist it features. Beam recalls,

> It seemed the thing that Native people didn't do. Native artists were still doing the grand themes, not autobiographical self-portraits.[31] I like the little personal things, the sketches and experiments of Van Gogh and Rembrandt, and the informal experimental work of Gauguin. *Self-Portrait …* was addressed to the forces of apathy. The handwritten script said, 'What have you done? Have you written any poems, music, anecdotes? Have you ever done anything unusual, ordinary or extraordinary?'[32] I'm surrounded by a lot of bland people who represent the forces of normalcy. They offer advice on your art career – where to market this … *Self-Portrait …* was not made to sell into the art market. It was made purposely *not* to sell in the current Indian art market as we know it. I don't consider it to be a great watercolour. It's loose and kind of competent. It was whipped off in an afternoon.

18

Carl Beam
Self-Portrait in My Christian Dior Bathing-Suit, 1980
watercolour on paper, 106 x 69 cm

30 In 1984 this painting was featured on the cover of the catalogue for the exhibition *Altered Egos: The Multimedia Work of Carl Beam,* originating at the Thunder Bay Art Gallery. See McLuhan (1984).

31 That is, nostalgic and romanticized depictions of Native history and mythology. Especially popular in central and eastern Canada in the late 1970s were the brightly coloured legend paintings and serigraphs of Norval Morrisseau, an Ojibway artist whose works were inspired by ancient pictographs and sacred birchbark scrolls. Morrisseau's surprising market success spawned a number of imitators hoping to share in the benefits of interest in the new Indian art. For many people, the Woodland school of painting, as it came to be called, was, and still is, the only 'Indian art.' See Hume (1979), McLuhan and Hill (1984), and Sinclair and Pollack (1979).

On rare occasions Morrisseau has imbued his art with a dark irony 'to spell out and comment on the injustices done to his people' (Sinclair and Pollack 1979, 115). Nowhere is this more apparent than in the painting *The Gift,* from 1975, in which a White man, carrying a pouch adorned with a Christian cross, is shown shaking the hand of an Indian man, and in the process bestowing on him and his child the 'sacred gift' of smallpox. Like the colourful circles and pulsating rings on Métis artist Bob Boyer's 1983 painted blanket *Smallpox Issue* (in Zepp and Parke-Taylor 1984, 6), Morrisseau's benign pattern of decorative dots acquires similarly deadly significance once the same historical reference is revealed.

32 The actual text, which differs somewhat from Beam's recollection of it, reads: 'autobiographical work done in 1980 to validate my presence and to make sure that the work always remains explicitly autobiographical in nature, even if I have to state it in this way. As far as I'm concerned I'm the artist (among other things) so this is my work. THIS IS MY WORK!! I am marking time thru my work (if it serves no other function to anyone else) and if I do this I will say tomorrow, "I was around yesterday, and here's the fucking proof," "Where's yours?" babble, babble, verbiage, etc. Carl Beam, 1980, TORONTO'

19
Ron Noganosh
*I Couldn't Afford a Christian
Bathing-Suit,* 1990
oil, cardboard, Plexiglas, 142 x 86 cm

In spite of Beam's typically understated assessment of his own abilities, this painting helped redefine the parameters of contemporary Native aesthetic practice in Canada. He rejected portraying 'Indian myths' in favour of portraying 'myths of the Indian.' Beam ironized and politicized images rather than romanticizing them.[33] More important, he personalized them. In this piece, the artist vigorously reclaims

33 Beam says, 'In 1977-8, when I used irony in my work to challenge the notion of "Indian" I got a response: "Native people have a sense of humour. They can be sarcastic, almost intelligent at times. That's a scary feeling. Any time, they'll be demanding equality – political equality."'

20
Viviane Gray
*Carl, I Can't Fit into My
Christian Dehors Bathing Suit!*
1989
mixed media, 193 x 61 x 193 cm

the mythic image of the naked savage, infusing it with his own brooding persona and considerable bravado. Clad only in chic designer trunks, in a mocking gesture that calls attention to mainstream society's preoccupation with celebrity, Beam adopts a defiant warrior's stance. Long gone is the John Wayne pose. Angry eyes engage the viewer directly, exuding absolute confidence. It is, in fact, this overt display of confidence, this fierce affirmation of self-worth and personal experience – reinforced in the handwritten text superimposed on the figure – that distinguishes this piece from the many generic depictions of Native people that precede it. Beam speaks passionately of the need for other artists to create their own images of lived experience: 'In Canada we have Native artists but I haven't seen anywhere an individual – where a microscope has been taken to a Native individual ... We need to show that a Native person could in fact *be* an individual. This requires a fine focus. Instead of showing "the Indian" again, we need to see the wider focus of *being* Indian.'[34]

34 In a wry example of cultural teasing and intertextual play, Mi'gmag (Micmac) artist Viviane Gray and Ojibway artist Ron Noganosh each created works in response to Beam's painting. These were exhibited together in their 1989 collaborative exhibition *Hard and Soft,* at the University of Sherbrooke Cultural Centre in Sherbrooke, Quebec (see Anderson 1990). Noganosh's piece, *I Couldn't Afford a Christian Dior Bathing-Suit* (Figure 19), makes use of a full-length nude self-portrait, painted in the early 1980s but never exhibited, which he framed in Plexiglas ''cause Carl's always using Plexiglas, eh?' In imitation of Beam, the title is stencilled up the left-hand side and the words 'Carl, thanks a lot' written with 'little scribbles' on the bottom right. 'He does little scribbles all over his [work] so I've got little scribbles all over mine,' Noganosh says with a smile.

In her piece, *Carl, I Can't Fit into My Christian Dehors Bathing Suit!* (Figure 20), Gray inserts a linguistic twist into the title, replacing *Dior* with *Dehors,* French for 'outside,' to emphasize further the suit's limited ability to accommodate her figure. The piece consists of two panels – one vertical, one horizontal – hinged at the centre. Affixed to the vertical backboard is a full-length mirror surrounded by postcards of tropical beaches and Indians and Mounties. Across the bottom is written, 'CARL, you have a Christian Dior bathing suit. I can't fit mine! You're an inspiration but you cause such consternation. We love you.' Filling much of the horizontal panel is the traced outline of the artist's shadow – 'I look like a Gerald [McMaster] ... buffalo,' Gray says – along with a bathing suit and fashion magazines. Compared to Noganosh, 'I was very discreet,' she adds. Also, 'the reason I made it like this was because ... it's difficult to make a shadow or put things onto a floor of a gallery. So someone suggested making it into a self-contained case. And I thought, that makes sense because it's like the baggage you have with you, that you carry with you all the time, whether they're [thoughts that are] part of your culture or they're not. They're always thoughts that are part of you.'

While Gray's critique of the mainstream beauty myth is easily recognized – even if her shadow is not – the reference to Beam's painting is oblique at best and very much an in-joke. The same can be said for Noganosh. Knowing this, the two artists positioned their twin parodies across from each other in the exhibition gallery to suggest a symbiotic relationship all its own. In February 1991 Beam had heard of but not yet seen these pieces. He nevertheless said, 'I might do another piece myself in response to theirs!'

A decade after producing the Christian Dior painting, Beam reprised the pose in two almost identical photographs that served as the basis for several works, all bearing the ironic title *Burying the Ruler* (Figures 21 and 22).[35] Appearing older and heavier but no less imposing, the artist stands casually in the midday sun, naked from the waist up save for his signature black hat and holding in his right hand a twelve-inch ruler as if it were a spent or confiscated weapon.[36] Like the earlier Dior piece, this is a memorable, perhaps even archetypal, image of personal conviction and grim defiance, devoid of artifice yet charged with meaning. Viewers are invariably drawn into a dialogue on matters of global and cultural concern. 'A preoccupation with the tensions between Western scientific thought (and its focus on power over nature) and contemporary or past Aboriginal cultures informs much of his work' write McMaster and Martin (1992, 119). Like few other artists, Beam confronts the viewer in a manner that demands a response.

The image in Figure 21 is framed and overlaid with various geometric and analytic constructs, one of which appears to plot personal, possibly emotional, peaks and valleys over several years. The general direction of the plotlines from left to right across the picture plane is progressively downward. About this particular piece Beam says: 'The title works two ways: It's useful to look back in the past to consider the imposition of charts, order, and other peoples' ideas, [but] how do you identify with a superimposed grid system and assess the impact of information and charts?'

In an earlier conversation with Ian McLachlan, Beam spoke of the limitations imposed by linear thinking on the development of cross-cultural understanding: 'Native people are always seen as being back there in an anthropological past. If that's where they get placed, anything contemporary can't be authentic. It's paradoxical that the more linear you are in your thought processes, the less effective you are at thinking. Well, I don't want that linearity' (McLachlan 1990, 11). Beam put this even more succinctly in his artist's statement for *Indigena: Perspectives of Indigenous Peoples on Five Hundred Years,* the 1992 exhibition at the Canadian

35 For other versions of this image, see McMaster and Martin (1992, 120-1), Nemiroff, Houle, and Townsend-Gault (1992, 106), and Rhodes (1992, 7, 21, 28, 29).

36 As an instrument of linear measurement the ruler is a potent symbol of political, intellectual, and scientific hegemony, signifying as it does a certain straightness and rigidity of thought. Historically, the process of surveying and sectioning Aboriginal lands was the first step in expropriation and colonial settlement. And lest we forget, the ruler was also a favoured instrument of corporal punishment in Indian residential schools, used to punish those who dared to speak their Native tongue or engage in other forbidden cultural activities.

As a metaphor, 'straightness' itself is often used to suggest linear thinking and singular perception, and not surprisingly, all that is un-Indian and un-natural. The 'straight and narrow' is indeed 'straight' and 'narrow.' See, for example, Holden's article, 'Making All the Crooked Ways Straight: The Satirical Portrait of Whites in Coast Salish Folklore' (1976), and Coyote's endeavours to fix the unnatural straightness of a river in Thomas King's short story, 'The One about Coyote Going West' (1992b).

BURYING THE RULER

Carl Beam, 1991

21 (facing page)
Carl Beam
Burying the Ruler, 1991
photo emulsion and ink on paper,
104 x 75 cm

22
Carl Beam
Burying the Ruler, 1991
photo emulsion and acrylic paint on
wooden cabinet, 39 x 19 x 15 cm

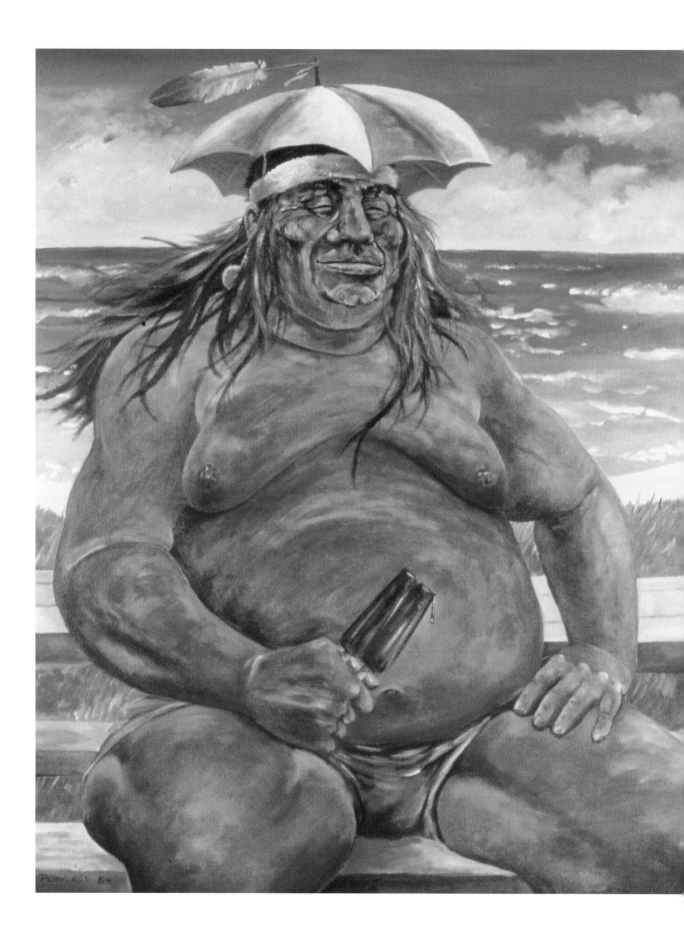

Museum of Civilization in Hull, Quebec (in McMaster and Martin 1992, 120). Mounted on the wall to the left of his three-panelled version of *Burying the Ruler*, the complete statement read, 'After five hundred years people should realize the world is round.'

The cabinet version of *Burying the Ruler* (Figure 22), is something of a sly joke, but again not without serious purpose. Since more people buy furniture than buy art, Beam reasons, perhaps he should make his art appear more functional! He is of course only half kidding, viewing the absence of Native design in Canadian furniture as a symptom of a broader cultural malaise: 'We need to get rid of the fear of "Native" and incorporate it into the overall fabric of the country. Then Canada would be a more exciting place to live in. It could affect architecture, interior design, landscape, dress. Right now, everybody's the poorer for its absence. The connection is rarely made between carpentry/woodworking and art/painting. Those people never meet, even though some woodworkers swear they're artists! The connection between colour, line, and sculpture is still made in Mexico and New Mexico.'

Not all efforts to depict Native integration into the overall fabric of the country have been appreciated. This is especially true where humour has been used to present a more accurate and naturalistic image. A case in point is the wonderfully whimsical painting *Indians' Summer* (Figure 23), again by Mohawk artist Bill Powless. Unlike the pieces by Powless examined earlier, which interrogate the stereotype by surrounding it with jarring symbols of popular culture (Figures 1 and 2, pp. 16 and 17), this piece seeks demystification primarily through inversion of the stereotype itself. Undoubtedly it is a particularly thorough inversion, undercutting many of the well-known hallmarks of heroic Indian portraiture. The proud warrior's physique has ballooned to immense, almost obscene proportions; the familiar leather loincloth has become a pair of red bikini briefs; the telltale beaded headband is now a trendy, yuppie sweatband; and the flowing feather headdress an absurd umbrella beanie, its single floating feather a modern cliché.[37] Gone but not forgotten are the symbols of status and military prowess: the pipestem, the fan, the decorated hatchet. In their stead is a vaguely phallic summer confection. Melting. Despite such comic turns and transformations, a basic human dignity, even nobility, still abides. Divested of all manner of exotic trappings, this self-satisfied image of contemporary reality gently confounds the viewer and all but demolishes romantic fantasy.[38]

23
Bill Powless
Indians' Summer, 1984
acrylic on canvas, 177 x 97 cm

37 The image of this umbrella beanie must have made a lasting impression on Powless. It reappears five years later on the Indian brave directing traffic in Figure 5, p. 21.

38 In concept, *Indians' Summer* is reminiscent of Luiseño artist Fritz Scholder's well-known 1971 painting, *Super Indian, No. 2* (in Turk 1972, 15), which depicts a seated powwow dancer in buffalo headdress clutching a double-dipped strawberry ice cream cone. Powless's work, however, was inspired by a bather whom the artist observed while visiting Manitoulin Island, Ontario.

At least that was the intention. But romantic fantasy dies hard – and not only in the non-Native community. When this painting was used to promote the *Indian Art '85* exhibition at Brantford's Woodland Cultural Centre it created a minor furore on the Six Nations Reserve. Witness the following exchange from the pages of the local newspaper, *Tekawennake,* between 'an offended Indian' (p. 3) and Tom Hill, director of the Woodland Cultural Centre (p. 5):

May 29, 1985
Obese is sick!

To the Editor:
Art is beautiful in many ways, shapes and forms, but the advertisement for Art '85 falls way short of humor [and has] creativity suitable only for a freak show. I see nothing but disgust every time I see this dumb looking Indian with his belly blown up like a balloon and his boobs hanging and this stupid umbrella hat on his head. The Indians through the years have been stereotyped as being fat, lazy, illiterate and just plain stupid, even in cartoons. In conclusion, what is this artist trying to prove? This is 1985, the human body is beautiful but obese is sick.

June 5, 1985
'You're right, Obese is sick'

Dear Editor:
You're right with your headline 'Obese is sick.' Also, 'the offended Indian' who wrote the letter in the May 29th *Teka* is correct that the image on the poster also reflects some of the negative stereotypes. The poster image is taken from an original work of art painted by Bill Powless and is included in the *Indian Art '85* Exhibition. The painting titled *Indians' Summer* is taken from an original sketch of an Indian gentleman Bill Powless met last summer at the Festival of Sharing [on Manitoulin Island]. No doubt, Bill Powless took artistic liberties with the portrait by exaggerating the massiveness of the character, highlighting the umbrella hat and melting popsicle and painting the portrait in colours which are unnatural – but all for a reason.

By presenting such a grotesque and irreverent image, the artist is asking the viewer to consider a number of questions. Has our contemporary Indian culture deteriorated to an Umbrella Hat 'Indianized' with an eagle feather, an earring and long black flowing hair? The obesity of the gentleman and the melting popsicle are also visual symbols for the viewer to consider. We are so blinded by negative stereotypes which have been created by non-Indians that we ourselves have difficulty looking at ourselves as Indians. For example, some Indian viewers have been convinced that the obese gentleman in the poster is actually holding a bottle of beer as opposed to a melting popsicle.

Our Indian artists have come a long way in 1985 by being confident in presenting paintings in exhibitions which are filled with ideas for the viewer to consider as opposed to

pointless images of 'Indians in Sioux war bonnets riding off into the sunset.' Our Indian artists have now reached international standards, primarily because of their inventiveness and their transmission of ideas with[out] which, to be sure, [their success] could not have been attained. It should be noted ... [that one] of the world's greatest art[works] ... Picasso's anti-war painting titled *Guernica,* [was] so filled with ideas and its image so disturbing to the viewers that Picasso had to leave the country for fear of his life.

Art is not always beautiful. Art reflects reality which is not always beautiful. Bill's painting, which became our poster, is his way of painting reality and pointing out to us our constant[ly] changing contemporary Indian culture. Bill sold the original painting to a prominent art collector in Ottawa and the *Indian Art '85* poster was the most sought after poster at the recent Canadian Museums Association Conference in Toronto. The poster is now a collector's item.[39]

Recalling the commotion this painting created at the time, Powless says:

The Indians on the reserve here didn't like it at all. My son got ... called down ... The kids were telling him that their mother and dad didn't like it [because] it made people think all Indians were fat. It was like they wanted the stereotype of the 'noble warrior,' slim and trim and nothing else [laughs quietly]. The White people, they weren't sure whether to laugh or not. I could see them. I just liked to stand ... and look at their reactions to seeing the thing. Some people just broke out [in laughter] – you know, they couldn't help it. And some people weren't sure whether they were supposed to laugh or not. I could see them trying to hold it back. I like to watch the reaction to some of these things.

The artist adds that a poster of the painting was hung in the local nursing home to remind residents of what they did *not* want to look like!

39 Hill says that there was a lot more public response to the painting than what was reported in the newspaper: 'There were calls to our board of governors. I met with people here in person. There was a great deal of concern that maybe the piece was perpetuating the stereotype – an unflattering stereotype. I was quite surprised.' In 1988 Hill again had to fend off criticism from within the local community, this time from band members fearing that he and his co-curator, Deborah Doxtator, were making fun of Indians in their kitsch-laden show, *Fluffs and Feathers: An Exhibit on the Symbols of Indianness* (Figure 24). In response, Hill affirmed that they were, indeed, making fun of Indians, but not real Indians, only the superficial and romanticized ones that exist in White imagination. See Bentley Mays (1992), Doxtator (1988), and Greer (1989).

Fluffs and Feathers: An Exhibit on the Symbols of Indianness
Tom Hill

In conversation on 1 October 1991, Seneca artist and museum director Tom Hill discusses the issues and controversies surrounding the show *Fluffs and Feathers: An Exhibit on the Symbols of Indianness.* Co-curated by Deborah Doxtator, the popular exhibition was first shown at the Woodland Cultural Centre in Brantford, Ontario, in the fall of 1988. In 1992, a scaled-down version travelled to the Royal Ontario Museum in Toronto. See Bentley Mays (1992).

I've always been fascinated with kitsch in cultural tourism. In fact, I've even, at one point, collected a little bit of it, before I was here [at the Woodland Cultural Centre] – just 'Indian kitsch' – because I always felt [that] if anything was in the poorest taste it was in the Niagara Falls tourist shops. So I was always interested in that. I was always interested in the superficiality of it as well, that it never, ever touched the heart and soul of what I thought I was all about as a person or as an entity ...

So there was that interest, that enquiry. Another part of it was straightforward. People arrived here [at the Centre] and expected to see 'Indians,' and did not ... In talking about this I met Deborah Doxtator ... and she too had expressed an interest [in the subject] ... And so I talked to her about it, [and] said, 'Here

are some ideas. Can we put a show together?' And she thought, 'Yes, we could,' and away we went and began to pursue it. She then began to develop a kind of thesis. As things started coming in we started to ... discuss how we were going to put this into place in the gallery, what it really meant, [and] how it was going to work as people moved through it ... As Deborah was putting the material together, I was sitting down with her and discussing with her the interpretation, like, 'How do we tell the story?' Okay, you're talking about, for instance, [how] curiosity cabinets became the basis of museum collections, which became the basis of some stereotypes ... How do I tell that story in a museum? So, we worked very closely on that, developing that together. Finally, [when] the catalogue came together ... we tried to design the exhibition relating to the catalogue ...

All we were asking when people [came through was that they] be able to detect a stereotype – to understand it when they hear it, or when they see it, or when they do it – that [they think], 'Wow, maybe we shouldn't be doing this, or if we should, understand it.' That's all we can ask ... We thought people would go through [more quickly]. The permanent collection is forty-five minutes if they take it [all in] and read it, and ... then we usually try and say, at least for the small gallery, another half an hour. But once they got into *Fluffs and Feathers* it took them anywhere between another forty-five minutes to over an hour, which is interesting. It was the first time we ever had that happening. So people were coming in when that show was on [and staying] around two hours ...

It was amazing though, when we did the *Morningside* [CBC national radio] show, [that the interview] did go over to the States. I didn't even realize how many people arrived here from the United

States to see the show. So it got amazing coverage, and then what was interesting, it was one of the more popular [radio] shows in terms of people calling in [to the station] for more information. So they replayed it again in their summer hours ... And as a result of that, that's how we received many of these people enquiring [about touring the show] ...

[But] there were [also] people who were very concerned because they didn't know how to read it. Let me put it this way. The regular community of museum goers – the local community coming into it – were uncomfortable in certain areas ... They thought I was making fun of the craft industry, what they're involved in, in terms of the crafts. They were uncomfortable with that. They also thought I was making fun – and I *was* [laughs] – of the notion of 'Indianness.' But what I was really questioning was that that notion is not *our* notion. So we have the right to make fun. It's a notion that non-Native people have thought Indians are all about and should be [about], and we have fallen into it.

People on the reserve [got upset]; Indian people [were] coming in [to my office]. When the show was on I had a number of delegations sitting in here. I had the head of the craft group, [who] felt this exhibit may not be the kind of exhibit [we should have]. A couple of them complained to my board, again saying, 'What are you doing here? Now, explain this again, we don't quite understand what is going on here. Why are you asking people to dress up like Indians [in this exhibit]?' And we would often use – this is interesting – the word 'costume.' And they would say, 'We don't wear costumes. We wear "outfits."' I said, 'Okay, that's fine, let's say "outfits," put on "Indian outfits."' 'But,' I said, 'I would rather [have visitors] put on an

Indian "costume" because that's exactly what it is.' And if you look at the word 'costume,' it's really in reference to custom; it's a variation of the word, 'custom.' But of course [in] English now, it is really [used] in reference to Hallowe'en costume. I was brought on the carpet for that. At least, I had to go up and defend myself on that one because people thought we were making fun – like, 'What right did I have to make fun of myself as an Indian?' They didn't understand it, they didn't understand it. Once they went through it – it's very interesting – a couple of people came in and said, 'Oh, now I see what you're doing' [laughs], or, 'Now, I understand.' Then I'd say, 'Well, maybe I'm not making the point here well enough.'

See, I can't do an exhibit just for Indians, although that's my mandate in a sense. I have to do an exhibit that's a happy medium. So that was the most important part of it. Our priority is for our community. The band council gives us x number of dollars ... [so people from] this band, with their band number, can come in free to the exhibit. So, they

have a right to then go to ... our board and go, 'Holy —, I think something's going on here!'

The other interesting thing [is that] at our dances day, 'Kawliga, the Wooden Indian' is a very popular song. It still is. You can go to a local dance on our reserve and 'Kawliga, the Wooden Indian' [by country music legend Hank Williams] will be played [laughs] – I don't understand what's going on! – and everybody will get up and dance to it and have a hoot. And so [local people] come in and hear this [song] in this context with something else that is taking a real swipe at Indians. I just remember the guy that was head of the legion – and he would have heard 'Kawliga' – he came in and he asked about that. Now, he just couldn't understand it, and he said, 'Well, you know,' – and this is interesting – 'I never listened to the words of "Kawliga." It just has a good beat, and I just like to dance with it.' And then when he started listening to what it [said], 'Wow,' he says, 'You're right, it is kind of a stereotype, it is kind of that, a "wooden Indian."'

24
Gallery overview
Fluffs and Feathers: An Exhibit on the Symbols of Indianness,
Woodland Cultural Centre
Brantford, ON
September-December 1988

Around the same time that Powless created the pencil sketch for *Indians' Summer* he also did a drawing of a Native woman, but it was several years before he converted it into a painting. He remembers, 'I showed [the sketch] to my wife and she didn't like it at all. She said: "Women have a different feeling when they see something like that." So it got me thinking about it. I thought, "Well, this guy's comfortable with himself, maybe a woman too [would] be comfortable." I had her jogging, so she was kind of working on losing the weight. She had these spandex pants on [laughs].' It was not until 1991 that Powless transformed the drawing into the painting *Runs with Roosters* (Figure 25), which was subsequently included in the Woodland Cultural Centre's *First Nations '91* exhibition.[40]

This time, however, there was no controversy, for at least three reasons. First, the sociopolitical climate had altered considerably since the mid-1980s. Native people across Canada were now involved in a high-profile struggle for self-determination and self-government and asserting a renewed cultural confidence at the same

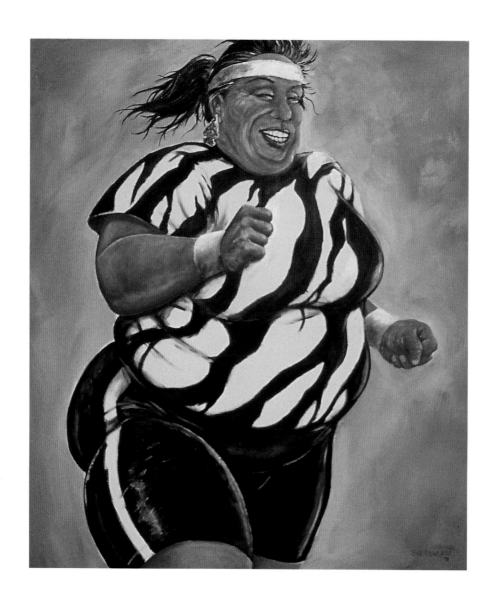

25
Bill Powless
Runs with Roosters, 1991
acrylic on canvas, 114 x 102 cm

time. The woman in this painting is bubbling over with self-assurance and energy. Second, self-deprecating humour and ironic reference to contemporary subjects had by this time appeared more frequently in the Centre's annual art shows. Third, local residents had become more accustomed to and accepting of Powless's humour through his newspaper cartoons. Still, he was apprehensive:

I thought the Native women would be upset with it. They just kind of panned it I guess, 'Let it sit there and it will go away.' That was my wife's reaction. She said, 'People aren't going to like this.' But it's something I wanted to do ... rather than the picture of the 'Native maiden.' Maybe that's what I should have named it [laughs]. It was given that name [*Runs with Roosters*] because it was [done] right around the time that [the movie] *Dances with Wolves* came out.[41] So it's kind of her 'Indian' name. And the spandex is up to date. I don't know where the stripes came from – the zebra stripes just happened to appear on her as I was working on it ... The boobs were kind of small at first so people were saying it looked like Tom [Hill]. So I made the boobs bigger and put lipstick on her. Still they said, 'Ah, it looks like Tom in drag!' I think people had a good time with it anyway – they thought it was funny. They thought it looked like Tom. People kept on saying it. They were laughing as they said it.

..

40 This image could well be considered archetypal in that it embodies a definite *attitude:* a comic, healthy, and healthful world view, actualized through active embrace of the moment. (Cf. Figure 8, p. 22, for treatment of the same subject in cartoon form.) Six Nations was not the only reserve where the fitness craze took hold. In the spring of 1988, the late dancer/choreographer René Highway, brother of Tomson Highway, spent three weeks in Thompson, Manitoba, videotaping forty half-hour aerobics shows in the Cree language. The program, *Se Sa We Tan*, was later broadcast throughout the North on the Native Communications television network. The program's premise was simple: We are a healthy people who have got out of shape, and we now need to get back into shape.

41 In an article that appeared in the *Toronto Star* following the film's sweep of seven Academy Awards, including Best Picture of 1990, Thomas King wrote, 'I should confess up front that I liked much of *Dances with Wolves* ... I was especially taken by the unexpected humor and joking that imagined Indians as human beings' (1991, G1). A good deal of the film's humour originates with the character of Kicking Bird, the wise and witty, if absent-minded, Sioux medicine man played with considerable aplomb by Six Nations actor Graham Greene. Following Greene's nomination for a Best Supporting Actor Academy Award, Bill Powless paid tribute to the hometown hero with a drawing in the local *Tekawennake* newspaper (Figure 26). Interestingly, in 1970 fellow Canadian Native actor Chief Dan George was nominated for the same award for his warm portrayal of Cheyenne sage Old Lodgeskins in the film *Little Big Man* (Penn 1970). Without question, it is the humour that makes each of their roles so memorable. For more on Greene, see McLeod (1992).

Hill himself says: 'Everybody thought it was a hoot, there was not a [negative] response at all.' What fascinated him were the people who wanted to photograph the painting, but he thinks 'they didn't see the issues relating to it.' The issues? Powless explains: 'You think of people when they're overweight – they're not happy with themselves – and the idea that I wanted to get across here [is that] she's comfortable, happy with herself. [She's] big but there's an inner beauty. It's not physical.'

Capturing that inner beauty of Native women on film is one of the major projects of Mohawk photographer and film maker Shelley Niro, whose witty self-portraits and comical studies of family members impart a playful energy and familial affection missing from many archival photo collections. Moreover, her work is a welcome corrective to all those humourless depictions of nubile princess, nurturing earth mother, sultry vixen, and servile squaw that have long been fixed in the popular imagination. Niro brings these fanciful notions of Native identity into sharp (and sometimes soft) focus to illuminate their deficiency.

For example, in *The Rebel* (Figure 27) – a hand-tinted photograph of the artist's mother, June Chiquita Doxtater, lounging coyly atop the trunk of the family car, an AMC Rebel – Niro skilfully combines and then undermines the stereotypes of Indian princess and earth mother. It is a memorable and engaging image.

26
Bill Powless
Home Boy, 1991
pen and ink drawing on paper

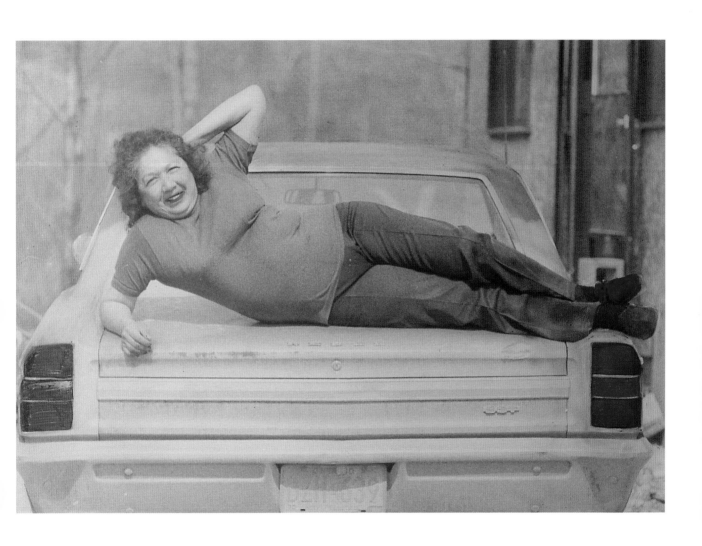

27
Shelley Niro
The Rebel, 1987
hand-tinted black-and-white
photograph, 17 x 24 cm

Native women, especially those in their middle years, have rarely been portrayed with such candour and confidence, nor with such comic sensibility. Niro says that her mother loves to have fun and would do anything for a laugh. On another level, *The Rebel* challenges prevailing definitions of beauty and femininity while foregrounding the debatable marketing strategy of using sexy women to sell sexy cars. In this, it offers a completely alternative perspective on cultural practice.[42] Playfully enticing yet quietly seditious, *The Rebel* is aptly titled.[43]

Regarding the selection of this photograph for inclusion in the show *Changers: A Spiritual Renaissance,* a 1989 travelling exhibition of work by Canadian women artists of Native ancestry, Niro says:

[Curator] Shirley Bear was saying that when the jury was looking at the slides, and they saw this picture of my mother, they all said immediately that they recognized somebody in their own family who's like that. I think it's true. It could be British Columbia [or] New Brunswick. [Native] people identify with each other in a way that is kind of fun. So I think it kind of strengthens that unity feeling ...

...

42 Mohawk actor Gary Farmer says that 'indigenous women don't take themselves nearly as seriously as indigenous men do ... but they take issues more seriously.' This may be why he feels 'their humour is much more layered.' Museum director Tom Hill commends Niro's work for being 'so multi-layered,' noting that 'she's very knowledgable of what's taking place right now in her community on all the political issues – on the women's front, on the Native front, on the arts front.' Niro herself has reflected on the process of layering in her work:

When I'm working on something, I try not to be intellectual about what I'm doing. I try to keep that right out of it and try to keep down to the simplest of ideas and the simplest reaction. And then as it goes on, it tends to get a little bit layered. And then when I'm finished, it *is* intellectual. But it doesn't start out that way. I try not to be a social critic. But when it's finished – when it's framed, when it's matted – then it is a critique. I don't think I'm really aware of what I'm doing when I'm doing it.

Cherokee artist Jimmie Durham says that this layering is, in fact, the defining aspect of a widespread Native American aesthetic: 'I believe that the acts and perceptions of combining, of making constant connections on many levels, are the driving motivation of our aesthetic ... There is a distinct Indian aesthetic which challenges and interfaces with that of the European' (1986, 2). Humour is simply part of this aesthetic.

43 In 1991 *The Rebel* was featured on the front of the *Canadian Journal of Native Studies* 11 (2), as its first foldout cover. That same year, Coyote could be seen adopting a *Rebel*-like pose in a cheeky drawing by Rebecca Belmore (Figure 28), which appeared as a double-page spread in a special issue of *Canadian Theatre Review* devoted to Native writers and performers (68: 50-1).

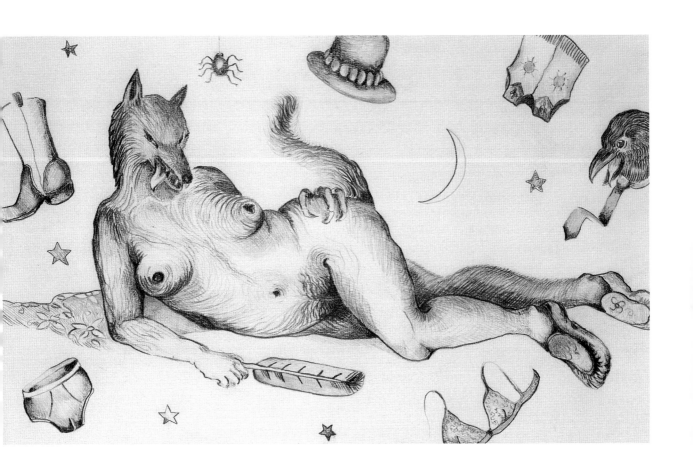

28
Rebecca Belmore
Coyote Woman, 1991
graphite on paper, 33 x 50 cm

Sometimes [I] go to conferences, and I just find that a lot of people ... come together and it feels like an extended family. And they share the same kind of stories. They share the same kind of feelings, humour, in a lot of ways ... Sometimes it happens in such a way that it makes your head spin ... You think, 'What's going on here?'

With *The Rebel*, Niro affirms and seeks to communicate two crucial but often overlooked aspects of Native experience – pride and fun. She explains: 'In a lot of my work I try not to stress the down side of Native life. I know a lot of non-Native people stress the poverty and suicides and all the down things, [but] in a lot of my work I try to show that we're not always like that. There is a strong sense of fun. There's something else going on ... besides dragging your knuckles on the ground [laughs].'

The artist features her mother once more in *The Iroquois Is a Highly Developed Matriarchal Society* (Figure 29), a set of three photographs of Mrs. Doxtater seated beneath a hairdryer in her daughter Beverley's kitchen. The image on the left is repeated on the right, creating the impression of lyrical, playful movement. (After all, the Trickster is a 'doing,' not a 'being.') In another context the title might seem little more than an impersonal cultural fact,[44] but here it is given a comic and quite personal reading, made all the more so if one knows that Niro's sister Beverley is the family 'hair sculptress.' The piece happily celebrates an aspect of contemporary Native women's experience, and Niro hopes that such images will encourage the more conservative members of her own community to free themselves from stoic and restrictive stereotypes that are not of their own making. She says that the title 'sounds so serious, and I think sometimes some people start believing these things they hear and they start thinking that they have to be so stiff. It *is* a matriarchal society, but you can loosen it up a bit too. And it comes from your mum.'[45]

Despite the attention generated by her first comic studies, Niro was not keen on the idea of intentionally creating humorous photographs, believing that they would surely seem artificial and lack spontaneity. She much preferred images that 'just happened.' Her solution to this dilemma was to set up a situation in which humour *would* just happen – where the artificial could become the ironic. To this end, she enlisted the help of her three sisters, Bunny, Betsy, and Beverley, who donned an assortment of tacky 1950s fashions, then mugged for the camera while

44 Cf. McMaster's ethnographic update in *Counting Coup* (Figure 9, p. 25).

45 The simultaneous affirmation and transformation of Iroquois tradition goes beyond the interplay of title and photographic images, extending to the framing as well. Here, the pattern of dots perforating the black matte (by means of a dental drill) not only picks up the curve of the hairdryer but replicates the 'skydome' and 'celestial tree' designs found in traditional Iroquois beadwork on velvet and broadcloth. See Figure 30 and Carson Waterman's *The Senecas Have Landed, No. 2* (Figure 56, p. 114).

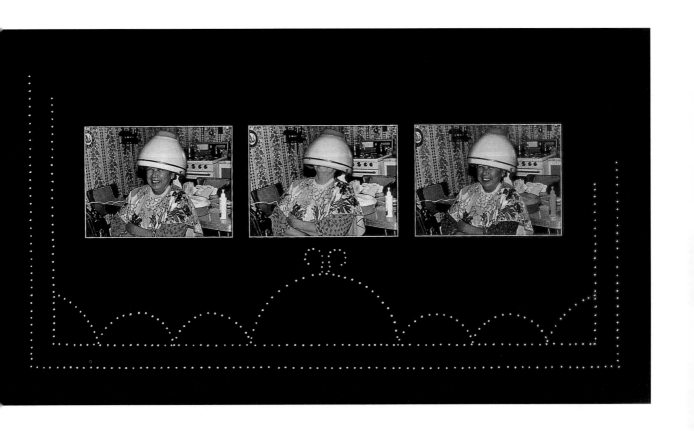

29
Shelley Niro
The Iroquois Is a Highly
Developed Matriarchal Society,
1991
three hand-tinted black-and-white photo-
graphs mounted horizontally in a single
matte, 20 x 25 cm each photograph

Niro clicked the shutter, first in the attic of her home then later in the parks and public spaces of her hometown of Brantford, Ontario. The resulting series of hand-coloured photographs was titled *Mohawks in Beehives*.[46]

Like many of the other works in the series, the signature piece, *Mohawks in Beehives I* (Figure 31), is all about attitude. Niro notes that the women 'look like

46 When the series was displayed at Ottawa's Ufundi Gallery in December 1991, it caught many viewers by surprise. Not everyone knew how to respond to such unconventional images, but Gerald McMaster, in his capacity as Curator of Contemporary Indian Art at the Canadian Museum of Civilization, Hull, Quebec, bought a complete set of the fourteen photographs for the national collection. *The Rebel* and *The Iroquois Is a Highly Developed Matriarchal Society* were purchased at the same time. In a memorable segment of Madeleine McLaughlin's 1995 television documentary, *Mirror of the Heart: 9 Native Photographers,* Niro is seen at a Brantford, Ontario, gallery discussing the series with several family members.

Victoria Henry, proprietor of the now-defunct Ufundi Gallery, devoted a chapter to Shelley Niro in 'The Polemics of Autobiography in First Nations Art,' her unpublished 1993 MA thesis in Canadian Studies from Carleton University, Ottawa. In 1994 Henry and Niro co-curated *From Icebergs to Iced Tea,* an exhibition of photography and film by First Nations and Inuit artists for the Thunder Bay Art Gallery, Thunder Bay, Ontario, and Carleton University Art Gallery, Ottawa, Ontario. See Henry and Niro (1994).

30
Richard Hill
woman's dress with beaded skydome and celestial tree motifs, detail, 1973-4
glass beads and satin ribbon on black velvet

they're in total control. They have this look about themselves. [There's] almost a punk rock feeling to it – but they're not punk-rockers ... They don't look tough but they look ... "cool." They're not pushing people away but they're keeping their distance.'[47] It is a critical distance, to be sure. With *Mohawks in Beehives,* Niro continues to challenge aesthetic convention and misrepresentation with images that project the same mixture of pride and fun that distinguish *The Rebel* and *The Iroquois Is a Highly Developed Matriarchal Society:* 'In these pictures, I'm not just choosing "beautiful" women. They're just day-to-day people, and they just put on a little bit of make-up and put their hair up a little bit and they're having fun ... The people in the pictures aren't necessarily what beautiful women [look] like today ... I just like the idea of putting the picture[s] in such a way that there's no shame ... and I find [Native] femininity or sexuality is something that's really never shown or talked about or affirmed.'

In *Portrait of the Artist Sitting with a Killer Surrounded by French Curves* (Figure 33), probably the best-known piece from the *Mohawks in Beehives* series,[48] Niro joins her sisters in front of the camera. The 'killer' in the title is a sly reference to the cigarette held by the artist. And the French curves? An allusion to the female form? Or to the sweeping arcs of star-like dots on the jet black matte? Perhaps. But for Niro the French connection is more personal, more immediate: 'This is my Oka piece, I guess,' she says.[49] More than the affirmation of familial bonding or the visual record of tribal peoples prevailing in good humour in a comic world, this self-portrait and

..

47 Working with images from this and other photo sessions, Niro would later extend her titles into narrative and poetic texts handwritten on the photographs themselves. See, for example, *In Her Lifetime* (Figure 32). The complete text of this piece reads:

In her younger years she was quite carefree, laughing, singing, dancing ...

She would look out to the horizon and let her thoughts drift out with the never-ending tide.

As maturity set in she became depressed over the fact that soap operas had no ending, country music reminded her of soggy cornflakes, and she could never find the matching sock to the one she held in her hand ...

Native issues would never be resolved in her lifetime.

She would give herself a shake and realize Christmas was six months away, the kids would be out of school soon and Friday was just a day away.

48 Chosen to promote the Woodland Cultural Centre's *First Nations Art '92* exhibition, this quartet of 'painted ladies' was featured on a poster, T-shirt, and catalogue cover. The photograph has since been reproduced along with ten other images by Niro in Ryan (1994b).

49 For eleven weeks in the summer of 1990, from 11 July to 26 September, armed Mohawk warriors confronted provincial police and the Canadian military at Oka, Quebec, to protest the planned expansion of a municipal golf course onto traditional Mohawk burial grounds and the failure of the federal government to settle outstanding Native land claims. The incident was covered extensively by the national and international media, prompting sympathy protests across the country and around the world. In the aftermath, a profound sadness and anger pervaded the Canadian Native community. This was especially so in the various Iroquois reserves and communities.

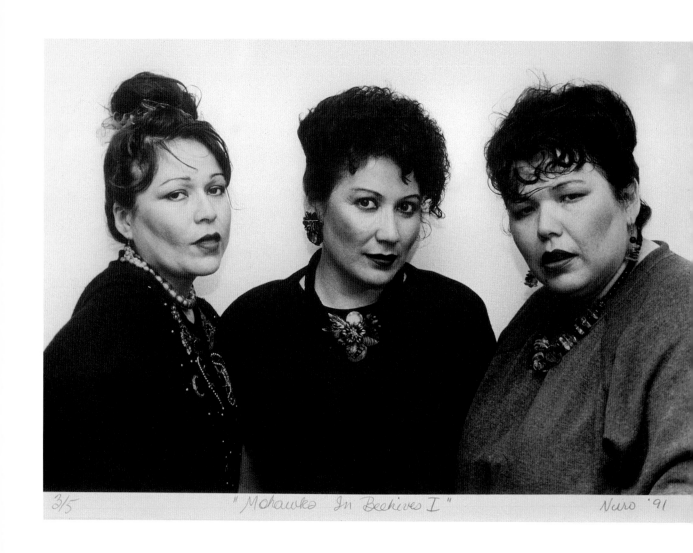

"Mohawks In Beehives I" 3/5 Niro '91

31
Shelley Niro
Mohawks in Beehives I, 1991
black-and-white hand-tinted photo-
graph, 20 x 25 cm

In her younger years she was quite carefree, laughing singing, dancing . . .

she would look out to the horizon and let her thoughts drift out with the never-ending tide.

32

Shelley Niro
In Her Lifetime, first and
second frames, 1991
six hand-tinted black-and-white photo-
graphs with handwritten text mounted
horizontally in a single matte, 20 x 25 cm
each photograph

the other photographs in the series constitute a personal and collective antidote to the numerous images of Mohawk warriors and of women and children under siege that saturated the media for so long. In the fall of 1991, Niro recalled the genesis of the series:

This was really done after a pretty depressing summer, pretty depressing fall, absolutely depressing winter – if you watched the news [on the Gulf War] or read the papers. I don't know about you, but if I feel this way so must a bunch of other people. So this is my way of being able to deal with those sorts of things. Being able to deal with a feeling of absolute dread – the sky is falling – and I felt like I was really being pushed up against a wall. So it's a psychological exercise in [spoken quietly] 'surviving'[50] ...

And I guess it really comes down to [being] almost like Indian clowns. We're putting ourselves in the position where we're going to make other people laugh. It almost takes on that clown feeling.

..

50 Niro is not alone in viewing humour as a means of survival. Aboriginal peoples have employed humour's preservative power for a long time. Mohawk actor Gary Farmer explains:

Because Native communities have gone through probably the worst situations in North America that any peoples have gone through they had to have the ability to laugh. If they didn't, they wouldn't be existing today. So humour has been a means of survival, the only means ... For the last two hundred years they've had everything taken away from them, their ability to think, practically. Everything: what language they could speak, what religion they could do, and the things they couldn't do. It was all set out for them. They couldn't even make money in order to create a decent living for themselves. All those decisions were taken away from them. The only thing they had was their ability to continue to laugh their way through life because if they didn't ... they would vanish.

Oneida stand-up comedian, Charlie Hill, offers a similar assessment in an interview that appeared in the Aboriginal newspaper *Nativebeat* (Uncompromising 1993, 11). He says: 'I think it's our humour that has helped us to survive. When the situation is the most grim, that's when you see Indian people making jokes about it, just for the survival.'

Further to this, in the opening lines of her essay 'An Old Indian Trick Is to Laugh,' Ojibway writer Marie Annharte Baker states: 'To be able to laugh at oneself is one of the greatest gifts of an Aboriginal heritage. For even the one who is the teensy bit Indian, the gift of this self-clowning is humungous. Sometimes our laughter is our only weapon. In spite of efforts to declaw, detooth, detail the Coyote or trickster within us, we continue to find something about our oppression as Aboriginal people funny' (1991a, 48).

Lakota author Vine Deloria Jr would no doubt agree. In his book, *Custer Died for Your Sins: An Indian Manifesto* (1969, 169), he concludes the chapter on Indian humour by saying, 'When a people can laugh at themselves and laugh at others and hold all aspects of life together without letting anybody drive them to extremes, then it would seem to me that the people can survive.'

Vizenor perhaps is the most succinct when he says that for Native people humour is simply 'a compassionate act of survival' (in Bruchac 1987, 295).

33
Shelley Niro
*Portrait of the Artist Sitting
with a Killer Surrounded by
French Curves,* 1991
hand-tinted black-and-white photo-
graph, 28 x 36 cm, full matte shown

(I'm a) High-Tech Teepee Trauma Mama
Rebecca Belmore

Following the lyrics of '(I'm a) High-Tech Teepee Trauma Mama,' Rebecca Belmore discusses its evolution as song and performance in conversation on 25 February 1991, Toronto, Ontario.

Chorus
I'm a high-tech teepee trauma mama,
a high-tech teepee trauma mama.
Plastic replica of Mother Earth
Plastic replica of Mother Earth.

Souvenir seeker,
you may think you can buy me – *cheap!*
Plastic woman
Long black hair.
Shy woman.
Silent. *WHOOP!*

Chorus

Souvenir seeker,
hang me from your keychain.
Watch, while I dangle in distress.
Fe-e-e-l like you know our way.
Come on! Let's walk.

Chorus

I am not, I repeat
I am not, an American movie.
Nor am I related to Running Bear, yaah!
I come from a place, yaah!
Somewhere just north of here.
I bet you met an Indian who came from
 there, once!
Am I right? *WHOOP!*

Chorus

Souvenir seeker,
I know you are not a bad person
Free me from this plastic,
Come on, let's talk!
Trinkets may have bought our past,
but now our eyes are open.
We can see a long way,
very far ahead.
Come on, souvenir seeker.
Free me from this plastic!

Chorus

HOWUH!

That piece, the original '(I'm a) High-Tech Teepee Trauma Mama,' that performance, I did originally at [The Ontario College of Art] in first year where in 3D class we were given self-image [as a project]. We had to present who we were or who we thought we were, so I sort of did the stereotypical environment with ... a totem pole, which is obviously not Ojibway ... and I did a dance where I mixed traditional music with songs from the '70s like 'Running Bear' ... There was a ghetto-blaster, a television set, and I took imagery from the movie, *Little Big Man* – where they annihilate the village, where there's lots of screaming, shooting women and burning tipis and shooting kids, and I re-edited it so that each woman dies about nine times. So it's graphically violent. Graphic violence against Native women taken out of the

context of the film is even more graphic. It's really gross. [In a photograph of the performance taken at the time] you can see everybody's looking at the TV instead of me. And so the whole performance piece is just a dance where the ghetto-blaster dictates how I dance. So I did that at OCA.

And then when I quit [college] and I went home [to Thunder Bay] trying to figure out what the hell I was going to do with my life, with this 'art' stuff, I did it in my studio for an audience – the same performance piece. And for me, the whole experience of finally taking my plastic teepee home, taking my stereotyped environment, my self-image, basically, the interrogation of who am I, after being at art school, was such a [pause] ... because my family was sort of coming down on me 'cause I quit school. They were upset that I quit 'cause the one who pushed on to post-secondary [education], she quits, she's come home. And I was afraid that they would be really disappointed in me. So when I did the performance piece, how I felt afterwards was so elated 'cause I knew that I had done the right thing. Coming home to perform for a Native audience is what I needed to do. I needed that criticism from the commu-nity: 'They will either validate my work or they'll tell me I'm full of shit.' And

that whole sense of feeling that I [had] come to the right place. Coming home was a good thing 'cause I used to think that I wanted to go to New York City, just like everybody else in Toronto. The art system sort of teaches you that the way up is to New York [laughs]. But, anyways ... with that performance, having done it here in Toronto at school, finally taking it home and having the audience understand or relate to the piece was amazing for me.

And so I ... tried to think of myself and what I was trying to do with my work, etcetera, and that's when I came up with the title for the piece, '(I'm a) High-Tech Teepee Trauma Mama,' 'cause it has the TV and the ghettoblaster and it has the traumatic deaths of the women on the television screen. And so the song is based in that piece ... The song is sort of a culmination of my own self. It's like an artist's statement ... I call it my anthem, and it basically sums up where I get my strength and where I think I'm headed – my position as an individual in society ...

I wrote it for [a] workshop thing we did in Thunder Bay, and I wrote it [with Allen Deleary from the band, 7th Fire] the day before we had to perform it in public. So it was really raw and it was really new. I had to keep the paper up there with me 'cause I didn't know the words. But it was fun for me because a

couple of friends of mine went next door to Mike's Milk during the perform-ance or shortly after the performance – and there were young teenage girls in Mike's Milk, young Native girls – and the woman said, 'You should have heard them, Rebecca, they were [singing] "(I'm a) High-Tech"' [laugh] ... the young women. So that made me feel like, 'That's great! That's what it's about. That's what it's for.'

Reflecting on her performance with 7th Fire a few days earlier at the Canadian Museum of Civilization in Hull, Quebec, Belmore said:

I thought it was the perfect place to do the song – the museum. It was meant for that stage [laughs]. It's funny 'cause I think that rather than being an actress or getting into acting I'd rather get into music, even though I don't know how to play anything and I don't know what 'four bars' means. I don't understand that but I think I would love to be able to ... [do] ... rock videos [laughs]. Even before going to art school I always thought, 'I wish I knew how to play something. I should learn how to play the guitar. I should learn how to do this 'cause I'd rather sing.' Even though I can't sing very well ... I always romanti-cize that whole rock image [laughs] – rock and roller.

34
Shelley Niro
Love Me Tender, first frame,
1992
hand-coloured gelatin silver print,
sepia-toned gelatin silver print, and a
gelatin silver print in a hand-drilled
overmatte, 36 x 28 cm each photograph

Niro's talent for clowning is given fuller expression in her 1992 series, *This Land Is Mime Land,* in which she explores the dual impact of popular culture and family history on the development of identity – her own identity. To this end, she combines three distinct images in each of the twelve panels constituting the series: in the first frame, an outrageous parody of some well-known icon or prominent persona, using herself as the model throughout; in the second frame, a candid shot of a close relative culled from the family photo album; and in the third frame, a stark and simply posed self-portrait, a product, Niro says, of the images in the first two frames. Her celebrity subjects include such figures as Snow White, Elvis Presley (Figure 34), and Santa Claus.[51] Her method of impersonation is decidedly self-conscious and campy: ironically and hilariously deconstructive, exemplifying the art of complicitous critique.

Niro's take on actress Marilyn Monroe in *500 Year Itch* (Figures 35 and 36) is one of her most amusing masquerades. As Seattle art critic Regina Hackett describes it, 'In a 1950s party dress and blond wig, she reprises Marilyn Monroe's famous scene [from the 1957 film *The Seven Year Itch*], standing on a street grate with her dress rising. The electric fan at Niro's feet tells us she has been caught in the act of preparing her final prop, exposing not only her method but Monroe's' (1993, C11).[52] Were this the only image present in the piece, its effect would be comical but much less pointed than it is when seen alongside the other two photographs. For again, the artist plays with mainstream conventions of glamour and beauty with serious purpose, contrasting idealized notions of (White) femininity with familial images of Native reality. As the ultimate media construction of female sexuality – blonde, beautiful, and buxom – Marilyn Monroe is no less a symbol of male fantasy within the Native community than without. Likewise, Monroe and her bevy of latter-day clones are deemed no less worthy of admiration and emulation by Native women than they are by non-Native. What, then, are the consequences for cultural identity and self-esteem?

51 While Niro satirizes rock and roll, Rebecca Belmore utilizes it to engage souvenir seekers in a dialogue on stereotyping and Native identity. 'Free me from this plastic,' she sings, in '(I'm a) High-Tech Teepee Trauma Mama.' 'Let's talk!' (See pp. 74-5.)

52 Elsewhere in her review Hackett draws a parallel between Niro's work and that of New York City artist Cindy Sherman, who also models various personalities in mock-serious situations. The writer goes on to say that Niro's mythologized self-portraits are, in the end, nothing like Sherman's, since Sherman is still exploring identity while Niro has obviously found hers. 'No matter what guise Niro assumes,' she writes, 'it's she in there cackling at her own ruses.'

35
Shelley Niro
500 Year Itch, 1992
hand-coloured gelatin silver print,
sepia-toned gelatin silver print, and a
gelatin silver print in a hand-drilled
overmatte, 36 x 28 cm each photograph

36
Shelley Niro
500 Year Itch, first frame

Niro is not the first Aboriginal artist to recognize the appeal of such women, nor to address the discord they create for both sexes within the Native community. Seminole/Creek/Navajo artist Hulleah Tsinhnahjinnie raised the issue in her 1990 photo collage, *When Did Dreams of White Buffalo Turn to Dreams of White Women* (Archuleta and Strickland 1991, 69).[53] In the same year Jane Ash Poitras incorporated the picture of a sultry blonde into a collage of Native images titled *History 1990* (Figure 37).[54] More recently, in *Venus Myth* (Figure 38), a mixed-media work from *The Classical Aboriginal Series*, Métis artist Jim Logan combined a painting of the ancient statue of the Venus de Milo (the woman with 'the perfect body') with advertisements from women's magazines and five miniature Indian dolls with

53 For a detailed analysis of this piece see Tremblay (1993).

54 Rebecca Belmore also broached the subject of White women and Native male fantasy in *Crazy Old Woman Child* (p. 88), a site-specific performance at a Native friendship centre in northern Ontario. In this tragicomic piece, the stage act of a voluptuous Marilyn Monroe-type country-and-western singer is used to frame the story of a Native cleaning woman's relationship with an alcoholic White widow for whom she works. According to Belmore, the Native women appreciated her performance while the Native men were annoyed. (See p. 88.)

37
Jane Ash Poitras
History 1990, 1990
mixed media on canvas, 122 x 91 cm

38 (facing page)
Jim Logan
Venus Myth, 1993
mixed media on canvas, 153 x 91 cm

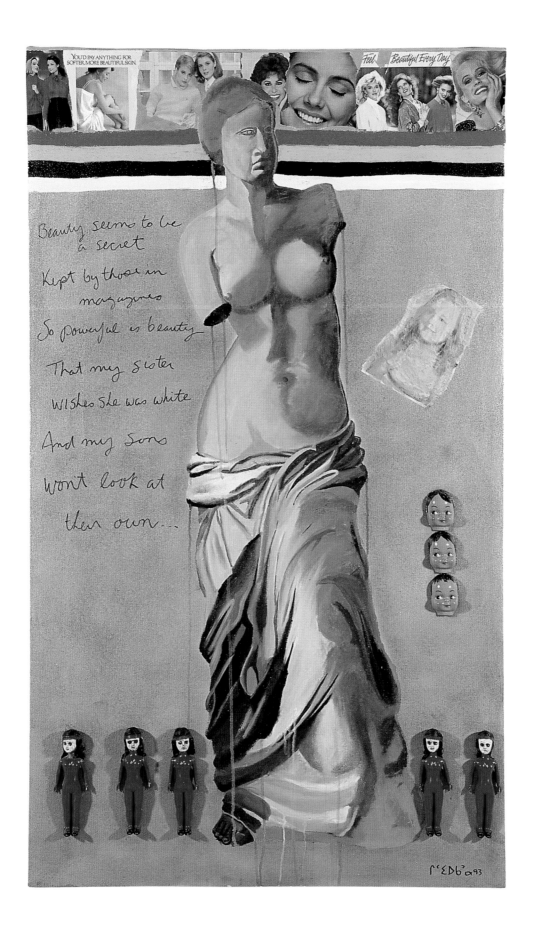

Beauty seems to be
a secret

Kept by those in
magazines

So powerful is beauty

That my sister

Wishes she was white

And my sons

Won't look at

their own...

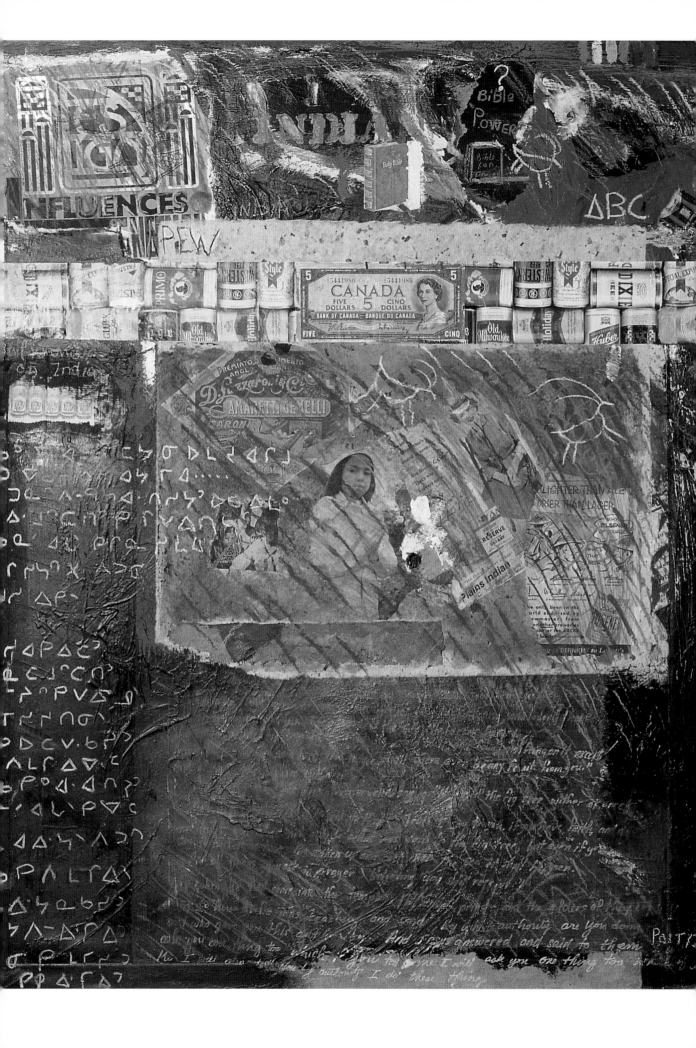

faces painted white. In accompanying text Logan writes: 'Beauty seems to be a secret, kept by those in magazines. So powerful is beauty that my sister wishes she was white and my sons won't look at their own ...'[55]

Discouraging as these words sound, it is still possible to dilute the power of such magazine imagery. In works such as *Monetary Blackboard* (Figures 39 and 40), Jane Ash Poitras 'Indianizes' and ironizes the image of a White woman by giving her a painted feathered headband. She calls this 'shamanizing the White guys.' It is a mischievous act of transformation and reverse acculturation that reaffirms the worth of Native identity by turning the White women into 'honorary Indians.' In this, the power and appeal of difference – White female difference – are symbolically subverted and diffused.

39
Jane Ash Poitras
Monetary Blackboard, 1989
mixed media on paper, 76 x 56 cm

40 (below)
Jane Ash Poitras
Monetary Blackboard, detail

55 In *Memorial Blanket for Eddy (My Marilyn)* (Figure 141, p. 257), another work from *The Classical Aboriginal Series,* Logan makes oblique reference to Marilyn Monroe, drawing a parallel between her sad and untimely death and that of his father: Monroe killed herself with barbiturates and alcohol because she couldn't handle movie stardom; Edward Logan drank himself to death because he never received the recognition he felt he deserved as a war veteran (Ryan 1994a, 13).

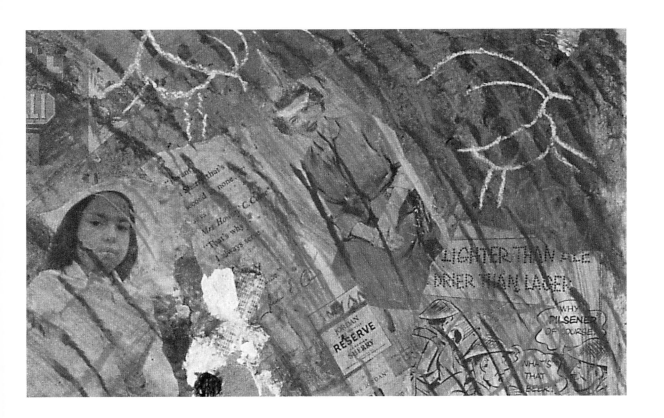

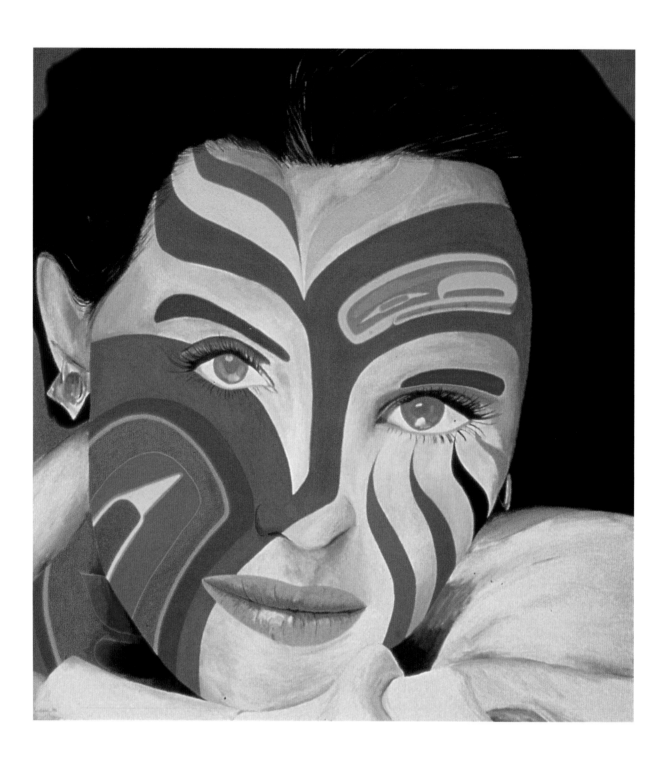

41
Lawrence Paul Yuxweluptun
Face Painting of a Woman, 1988
acrylic on canvas, 99 x 91 cm

Salish/Okanagan artist Lawrence Paul Yuxweluptun also Indianizes images of White women in his ongoing series of portraits based on photographs from *Vogue* magazine. In works such as *Face Painting of a Woman* (Figure 41), Yuxweluptun superimposes a Northwest Coast Native aesthetic on the White face of high fashion to create a work of literal and ironic double vision.[56] His painting *The Boy Toy* (Figure 42) may be a case of ironic triple vision, spoofing singer/actor Madonna, the undisputed queen of pop culture irony, while she spoofs Marilyn Monroe, who may well have been spoofing the whole glamour goddess image she helped to create.[57] Clearly, there is no closure.

In *Carl, I Can't Fit into My Christian Dehors Bathing Suit!* (Figure 20, p. 40), Viviane Gray's amusing commentary on the mainstream beauty myth, the Mi'gmag artist imagines herself as an ill-defined shadow on the ground, reflected back to viewers in a full-length mirror that at the same time cleverly implicates them in the construction of the image. As an affirmation of self-esteem, the piece is less than direct. In her mixed-media bust *Self-Portrait: But, You Don't Look Indian ...* (Figure 43), Gray is much more assertive, claiming the right to creative self-definition while refusing – through the use of a mirror as protective shield and even weapon – not only the ubiquitous 'male gaze' but that of anyone else, Native or non-Native, who would impose a limited definition of identity.[58] She explains:

Ever since I was little everybody used to say, 'But you don't look "Indian"' ... It would come in varying degrees. Sometimes I'd argue with them. Sometimes I wouldn't. And then I got to become older and more confident and it just didn't matter any more. I thought, 'What do I care what they think? They don't know what they're talking about.' And most of the time it would reflect what they knew about Indians. That's why I put the mirror [on the face], just so that it gets back to you, what you're saying. You're saying, 'But you don't look Indian.' If you look in the mirror it's as if to say, 'Well, who are you, really, to say?' ...

..

56 There is a certain degree of historical reckoning and revisionism at play here as well, in that Yuxweluptun consciously parodies the practice of nineteenth-century painters and photographers who created portraits of frequently unidentified Native women. '[They] went out and did Indians so I went out and did White people,' he says. 'I historically found them. I think that to document it was neat.'

57 Yuxweluptun's painting is based on a well-known *LIFE* magazine photograph of Madonna parodying another well-known image of Monroe. Ironically, feminists attacked the singer for supposedly 'setting women back with her "Boy Toy" charade' (Ansen 1990, 310). 'They didn't get the joke,' Madonna says. 'The whole point is that I'm *not* anybody's toy. People take everything so literally ... Irony is my favorite thing ... Everything I do is meant to have several meanings, to be ambiguous' (Ansen 1990, 310). Yuxweluptun says: 'I looked at Marilyn as a person, then I looked at Madonna as a woman, and then I said, "Well, how am I going to culturally document this woman?" So I spoofed Madonna spoofing Marilyn Monroe to culturally document this time in 1988. It's a cultural thing that this lady's out there, and I don't think Madonna would mind.'

58 This piece was also featured in *Hard and Soft,* the 1989 collaborative exhibition with Ron Noganosh.

42

Lawrence Paul Yuxweluptun
The Boy Toy, 1988
acrylic on canvas, dimensions unknown

43
Viviane Gray
*Self-Portrait: But, You Don't
Look Indian ...* 1989
mixed media, 61 x 62 cm

Crazy Old Woman Child
Rebecca Belmore

Ojibway performance artist Rebecca Belmore talks about her performance piece, *Crazy Old Woman Child,* in conversation on 25 February 1991, Toronto, Ontario.

I did a site-specific piece ... on talent night at Satellite House Friendship Centre, which is ... a cultural place for things to happen. Basically, it's just a hall and they have talent night and I was invited to come and perform. And talent night – there's like twenty-five people sign up and you have to wait in line and do your thing. So, there's everything from heavy metal air bands to finishing off with a country and western band ...

And what was happening at the time – 'cause I was living in Thunder Bay so I was in touch with what was going on, and it's a small town so you hear things – but what was happening is the band was – it was a bunch of men, macho guys with their guitars [laughs] – and what they were doing is they were starting to – because they'd been the house band for six months and they were getting tired of people who can't sing coming up and singing – so they were trying to discourage people from coming up, especially women, 'cause they were being sexist. They were saying things like, 'If you come up, well, we'll let you come up if you'll go out with me.' That kind of thing was going on [laughs]. So, this thing was happening and I was aware of it so I figured, okay you guys, I'm going to come and I'm going to perform and I'm going to do something. And they're a country band and they always have cowboy hats and cowboy boots [laughs]. They're funny, they're funny guys.

So what I did is I made this double-sided costume: I was like a washerwoman, like a cleaning lady on one side, which was the real me, and on the back I created this costume which was a voluptuous country and western star with this corset and these large, large breasts, and it was really tight. And then I had a mask which I bought at Kresge's, and it was just a White woman – a Marilyn Monroe type, [with] red, flaming hair. So I had this hat on which was basically a kerchief on this [one] side and on the other side was this voluptuous woman and it was all sewn together. And ... I recorded Tammy Wynette's song, 'Stand by Your Man' [laughs].

So I had to demand that the band get off the stage: 'Get off the stage, I'm going up. It's my turn.' So I had to fight my way up. So finally I get up, and they take their time putting down their instruments and getting off. So I waited until they were all gone and I had a little cassette deck, and so I told my sister, 'Hit it!' [laughs]. So she hits the button and I was backwards and it's really funny – it was hilarious because my movements are really weird. So it's the voluptuous woman doing this Las Vegas dance, 'Stand by Your Man,' and then ... after everybody's hooting and hollering and whistling and the audience is carrying on, I turn around – and I have a mop close by ... and there's a bucket too – and I turn around and I immediately start washing the floor [laughs] up by their guitars and cleaning the stage. And the men were ... mad at me because I was making fun of this whole country and western ... sexism.

And ... I proceeded to tell a story from the point of view of the Native cleaning woman. And it's the story of two women, but the Native woman is talking about the White woman who is her neighbour, and she lives on the hill. And she's like this alcoholic woman who has a husband who adores her and he works himself to death and he dies of a heart attack ... The White woman manipulates the Native woman into cleaning her house and doing all her chores 'cause she's not capable of doing housework. She can't function. She's like a child. And so the Native woman is talking about their relationship, their friendship. And the Native woman has nine kids and she's been abandoned by her husband. She has a black eye and so it's like two stories of two different women. And it's about love basically, but there's a lot of irony in the story. The performance is called *Crazy Old Woman Child,* which is how the Native woman describes the White woman: 'She's a crazy old woman child, and every time I think of her I can still see her, 'cause she's always drunk in her house and dancing away to country and western tunes' [laughs]. So I can still see her, and then I turn around again and I finish off the performance by dancing again [laughs and sings], 'Stand by ...' [laughs]. A lot of hip swinging and ... it's pretty funny. The women really enjoyed it. The women understood what I was saying, whereas I think the men ... were trying to not open up to the story or what I was trying to get at. But the women were like [clapping], 'Thanks!' [laughs].

I painted all the Plexiglas tubes ... [giving them] red roots, and I tried to insert [into them] all kinds of things that were part of me and part of my experience ... things like photographs and sweetgrass and lots of feathers and beads and medicines. I had fun making it [laughs]. When I showed it to my son he said, 'You're not going to show those boobs are you?' [laughs]. 'You need boob protectors.' And the fact too that the head is bigger than the rest of the body. You know how Indian people like to tease you ... If you go somewhere and you've done something really good or you've done well in something, they don't want it to go to your head. They don't want you to have a big head so they put you down in a way by teasing you.[59] I was always being told not to have a big head so ... in reality, I'm making fun of myself. But I'm also making fun of the whole social exchange

..

59　In *Custer Died for Your Sins: An Indian Manifesto*, Vine Deloria Jr (1969, 147) offers a capsule history of tribal teasing, one of the most distinctive features of Native humour:

For centuries before the White invasion, teasing was a method of control of social situations by Indian people. Rather than embarrass members of the tribe publicly, people used to tease individuals they considered out of step with the consensus of tribal opinion. In this way egos were preserved and disputes within the tribe of a personal nature were held to a minimum. Gradually people learned to anticipate teasing and began to tease themselves as a means of showing humility and at the same time advocating a course of action they deeply believed in. Men would depreciate their feats to show they were not trying to run roughshod over tribal desires. This method of behavior served to highlight their true virtues and gain them a place of influence in tribal policy-making circles.

Recalling his youth among relatives in Saskatchewan, Cree elder Vern Harper says: 'The Plains [Cree] were great teasers, and I thought it was healthy, and they thought it was healthy. The teasing thing was very important ... It was a constant, almost kind of a game, and you had to learn how to go with it.'

In a lecture at the University of British Columbia, 10 November 1992, Delaware writer Daniel David Moses discussed the teasing of visitors to his home reserve of Six Nations near Brantford, Ontario:

The first few times I take new friends home to the reserve I have to prepare them, because a large part of how we function is [through] teasing each other. If they're not prepared they're going to feel under attack. The function of teasing, it seems to me, is to help characterize you as an individual. It points out maybe a weakness or maybe just something that's interesting about you. To me, it means they've recognized who you are. A lot of people from mainstream society are used to being under attack. It takes a bit of moving around in their head to figure out what's going on, to be comfortable with it. It can be very funny but it's meant as a gesture of recognition.

This description is very similar to that given by artist Jane Ash Poitras of teasing among Arizona peyote ceremonialists (p. 106).

A slightly different characterization is offered by Gerald Vizenor who describes teasing and putdown among mixed-blood and full-blood Indians of Minnesota as 'hard play in the best sense of the word ... a compassionate duel. It wasn't competitive to win or outwit, but it was a duel.' He contrasts this with 'the play between the colonists – and I would include the government and the Church – and Indians ... [It] didn't lack compassion, but it was manipulative. You wanted to outwit. That was the motivation in imagination. You wanted to outwit either restrictions and bureaucracies or impositions' (in Bruchac 1987, 302-3).

that takes place when people tell you things like, 'You don't look this or you don't look that' ... So, it's my self-portrait, just as Ron Noganosh's [*I Couldn't Afford A Christian Dior Bathing-Suit*, Figure 19, p. 48] self-portrait is him.[60]

A few days after Gray spoke these words in a convivial midwinter gathering at her home in Ottawa that included Noganosh,[61] Gary Farmer echoed the need to engage, yet somehow thwart, the power of ascribed identity: 'The stereotypical images are ... based on some facet of truth, so in order to deal with truth we can't deny the stereotypical images that are there. We have to play into them in order to see beyond them. We can manipulate them like Bill [Powless] does and we *must* manipulate them. In order to go beyond those images we must create images of ourselves that are more real for us on our terms. And as artists we have the power to do that.' Few statements better describe the challenge facing Native artists today.

..

60 In his painting *Just Because My Father Was a Whiteman Doesn't Mean I'm Any Less an Indian* (Figure 44), George Littlechild offers a similarly indignant challenge to the imposition of identity, in this case the federal government's imperious conferring of 'Indian status' on certain individuals and the subsequent assignment to them of registration numbers. Thus the numbers 1, 2, 3 appear at the base of the building in the painting. The dislocated head on the male figure, symbolizing cultural dislocation, offers a clue why the artist, a former foster child raised apart from his ancestral community, applied for his own Indian status number and official, if belated, recognition of his Plains Cree heritage. This he was able to do following the passage in 1985 of Bill C-31, An Amendment to the Indian Act, which allowed for the restoration of Indian status and band affiliation to Indian women who forfeited these things when they married non-Indians. As the biological child of such a woman Littlechild was eligible to apply. For him, it was a necessary act of cultural reconnection. (Cf. p. 117 n. 14) Both the title and the theme of the painting recall Jemez Pueblo artist Laura Fragua's mixed-media clay sculpture of a befeathered and tomahawk-wielding preschooler, titled *Just Because You Put Feathers in Your Hair Don't Make You an Indian* (in Hill 1992, 103). Fragua's title, like those of Littlechild and Gray, reads like an anecdotal excerpt (or textual soundbite) from an animated and ongoing discourse on cultural ignorance and cross-cultural education.

61 Also present were Viviane Gray's husband, John Clifford; Ron Noganosh's wife, Maxine Bedyn; visiting Swedish scholar Vanessa Vogel; and the author.

44
George Littlechild
*Just Because My Father Was a
Whiteman Doesn't Mean I'm
Any Less an Indian,* 1987
acrylic on paper, 76 x 81 cm

3 Subverting the Systems of Representation

We will play a little trick on the Whiteman; wait and see.

Philbert Bono in the film *Powwow Highway*

To me, the strongest thing that Philbert says is that we have to trick them.

Gary Farmer, on playing Philbert Bono

Having the power to manipulate stereotypes and to create images more real than stereotypes, as Farmer suggests in the previous chapter, is of little consequence to Native artists if the power to exhibit such images remains with White administrators of cultural institutions that still value and even promote stereotypes. How, then, does an artist contend with or expose a 'system of power which legitimates certain cultural representations while prohibiting and disavowing others' (Galbo 1987-8, 40)? 'Very carefully,' one might answer, 'very cunningly.' In the same way that Native authors use ironic strategies to contest oppressive hegemonic ideologies (Fischer 1986, 224ff), visual artists employ trickster tactics to undermine institutional practice and expectation, breaking from formula and breaking out of program in ways both familiar and radically unknown (Bruchac 1987, 290). Insight into the conceptualization and actualization of some of these tactics can be gleaned from a close reading of the 'little dissident narratives' that pepper the conversation of these artists when discussing their work. This chapter examines several such narratives and related artworks.[1]

One of the most memorable accounts comes from Cree/Chipewyan artist Jane Ash Poitras, who was invited by a curator at the Provincial Museum of Alberta in Edmonton to participate in *Northwind Dreaming, Fort Chipewyan 1788-1988,* an exhibition commemorating the bicentennial of the northern Alberta reserve where

1 In his book *The Subject in Question,* David Carroll writes: 'Hundreds, thousands of little dissident narratives of all sorts are produced in spite of all attempts to repress them, and they circulate inside and eventually, or even initially, outside the boundaries of the totalitarian state. The importance of these little narratives is not only that they challenge the dominant metanarrative and the state apparatus that would prohibit or discredit them, but that they also indicate the possibility of another kind of society, or another form of social relations' (1982, 75). Like successful jokes and sacred clowns, little dissident narratives imagine alternative ways of perceiving and of living in the world.

45
Jane Ash Poitras
Fort Chip Dog Show, 1988
oil on paper, 56 x 76 cm

46

Jane Ash Poitras

Fort Chip Sewing Club, 1988

oil on board, 76 x 76 cm

Poitras was born. *Fort Chipewyan Breakfast Club,* the satirically titled and wildly vibrant series of seventeen paintings that Poitras produced for the show, was not at all what the curator expected or, in fact, desired. The problem, as Poitras explains it, was simple: 'She was so stereotypic in her thinking ... [She wanted me] to do pretty little prints of life in Fort Chip today to celebrate the bicentennial so they could sell them in the museum shop. "The tourists would really like that and see what the Indians are doing today," [she said]. And I thought, "Oh great! Let's show them what the Indians are doing today." But I gave her paintings instead, and the show went over smashingly.'

Paintings indeed. In this series of intimate vignettes, Poitras recalls, then vigorously revitalizes, familiar archival images of anonymous Indian families huddled about makeshift dwellings in a timeless locale. Rendering them in rich and vivid hues, she charges both the people and the landscape with a restless energy: community members are seen busily chopping wood, curing fish, feeding stray dogs, and socializing. In this, Poitras conveys something of the cultural dynamics that account for the community's continued existence. Apparently, this was not what the curator had in mind ...

[When] I got the show up ... she almost didn't show it ... because it didn't go along with the stereotyping presentation of her show [a companion display of historical artifacts], which was right beside that. And mine stole the show anyways. She did a big museum exhibit ... a big thing, glass case, and she's still making us look like a bunch of artifacts ... She's my age and I had such a belief in her ... When you think about how the people live in the communities it's really sad. It's Third World conditions. But that's not what she wanted me to paint about. She was going to turn it into a calendar, and then she didn't because she still wanted to see ... [pretty pictures of] dogs sitting and wagging their tails. She still wanted it to be like a 'vision' in the titles ... She didn't want the truth – but she got it!

The truth? Not content to merely rehabilitate stilted archival images, Poitras took the opportunity to add an unexpected critical edge by giving the paintings ironic titles satirizing White society's custom of institutionalizing leisure activities. Titles such as *Fort Chip Dog Show* (Figure 45), *Fort Chip Sewing Club* (Figure 46), *Fort Chip Canoe Club,* and *Fort Chip Lonely Hearts Club* make it difficult to consider the images without acknowledging, with some uneasiness, their more affluent counterparts in the dominant society.[2] By politicizing her work Poitras firmly anchors the exhibition in present-day reality. She recalls with some satisfaction:

2 In a review of the show Lelde Muehlenbachs commented, 'Perhaps the greatest contribution of this suite is the realization that this is not just [Poitras's] individual brand of humour, but rather a reflection of the rich subtleties of a widespread, social under-dog humour that relies on irony for day to day psychological coping' (1989, 37).

Poitras's clever use of ironic titles underscores the importance of titling as an effective artistic strategy. Wendy Steiner has observed, 'Titles are probably the most crucial intertextual mechanism in painting. They undercut everything that the iconicity and a-temporality of paintings achieve in the way of self-containment and completeness ... [P]robably no art is as dependent on subtexts from another art to complete its own meaning as is painting' (1985, 62).

The pictures all sold. The people loved it. Oh, they loved it! It was up for a long time ... It got a lot of PR and it was written up a lot ... It taught a lot of people a lot of things ... Intellects from other walks of life came up to me and said, 'You know, you're right, Jane.'

It was a commissioned show and I would have never done it unless I was asked by [the curator] to do that, but we had to bring it down to her level so that she could understand it, right? ... I painted them very pretty ... I showed her a couple [and she said] 'Oh, isn't that sweet.' I said, 'Yeah, isn't it just beautiful, look at this nice blue.' 'Oh, there's blue in there. Oh, you use that so nice.' And I said, 'Yes, didn't I?' [with] my evil little smile and my little Weesakeejak tail ... waving in the wind [laughs].

Not only confounding but foregrounding expectation is one of the major themes of Ojibway artist Ron Noganosh's sculptural assemblage, *Shield for a Modern Warrior, or Concessions to Beads and Feathers in Indian Art* (Figure 47). In conversation, Noganosh says:

A lot of people ... have trouble with ... the kind of work that I'm doing. This ain't 'Indian,' right? They've got this 'IT'S NOT INDIAN!' trip ... The shield that I did, the full title is *Shield for a Modern Warrior, or Concessions to Beads and Feathers in Indian Art*. They're always saying, 'Where's the beads?' 'Where's the feathers?' 'And where's the leather?' Okay, you want it, here it is! This is what I'm putting in here ... And then, on the front of that [piece is] ... part of a hubcap from a Firebird. That's the Indian's pony [laughs]. He's always got an old car or an old truck so he's gotta get movin', eh? That's part of it. [And then] there was the beer cans. I woke up one morning, I was in a parking lot in Hull. Where am I? I don't know. Too drunk to drive home, I guess. Slept in the car, right? Wake up, rubbing the dirt out of my eyes and I looked down and there's a flattened-out beer can. Hmmm [laughs]. So I got thinkin' about it, put it in the car, took it home and I started lookin' for more of them ... and that's where that started to come from.

As for the concept of a contemporary shield, it seems that Ruth Phillips, art historian and now director of the University of British Columbia Museum of Anthropology, was an unwitting catalyst. She says: '[Noganosh] did that when he was taking my survey of Native art [at Carleton University] ... I always spend a lot of time on Plains Indian shields because I love them ... We were doing that part of the course, [and] I was thinking, "What is a shield for a modern Native person?" And he thought, "Well, it's alcohol," and then he put the rest of it together. He does respond [to], or play off, representations that are out there.'[3]

47
Ron Noganosh
*Shield for a Modern Warrior,
or Concessions to Beads and
Feathers in Indian Art*, 1984
metal, beer cans, feathers, 125 x 59 cm

3 In 1991 Noganosh created two more shields in what may be an ongoing series. With its fine leather fringe, appended furs, and designer label distinction, *Shield for a Yuppie Warrior* (Figure 48), is a sly dig at fashionably hip Indian haute couture. *That's All It Costs* (Figure 49), a far more serious piece, is a blanket indictment of the Hudson's Bay Company's decision to close their northern trading posts – on which numerous Native communities have depended for supplies for over 300 years – in favour of moving their investments to the United States. It is a powerful visual statement, with its metallic head office tower, mired in silver coinage, rising from a Hudson's Bay blanket background, while the fate and future of both Indians and animals are literally and metaphorically left hanging. That the fringed American flag is soiled is no accident but a further comment on the sullied state of corporate ethics. The title puts a bitter twist on the department store chain's familiar promotional jingle, 'That's all it costs at the Bay.'

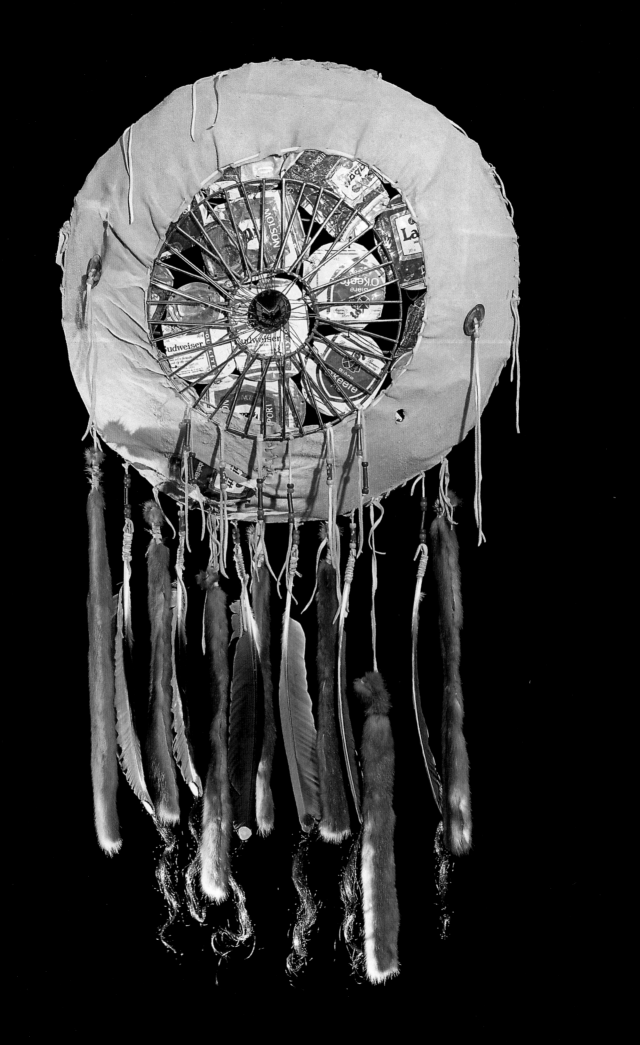

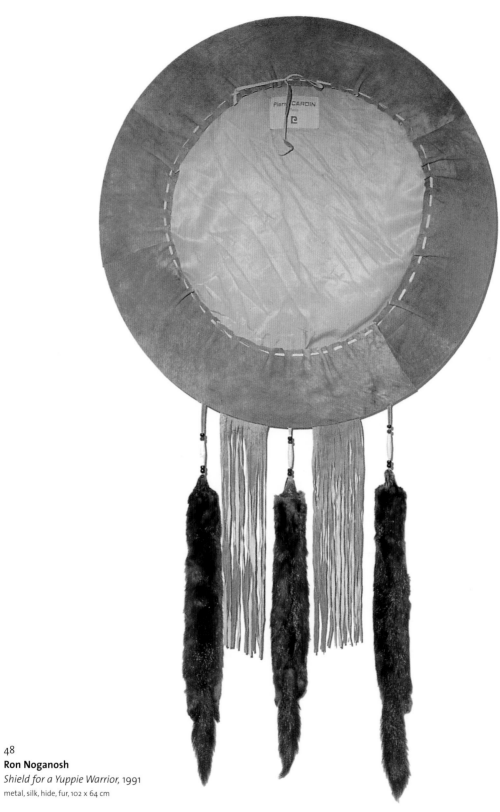

48
Ron Noganosh
Shield for a Yuppie Warrior, 1991
metal, silk, hide, fur, 102 x 64 cm

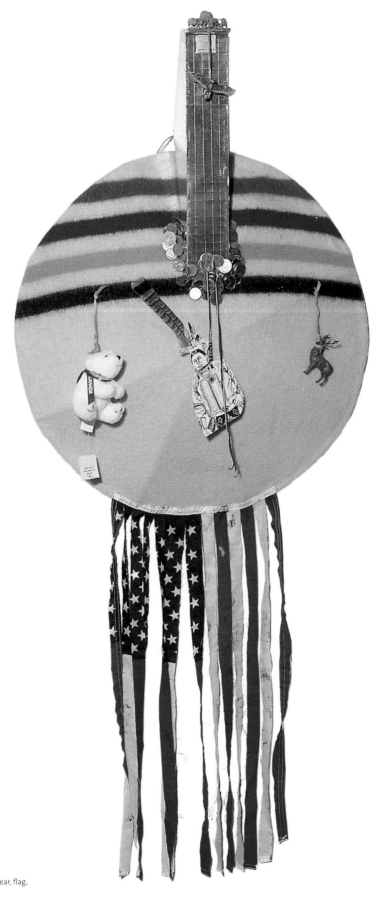

49
Ron Noganosh
That's All It Costs, 1991
blanket cloth, plastic, stuffed bear, flag,
102 x 64 cm

Point of View
Ron Noganosh

I am, according to the Government of Canada, a *real Indian*. The number that has been assigned to me is B047957. My band number is 99. This has helped me to find my place in society, for, without this information, I would, in all probability, not know that I am a *real Indian*, says the government.

I spent my youth on the Shawnaga Indian Reservation, attending various and sundry schools, after which I was pronounced a *civilized, real Indian*. Upon completing a graphic design course at George Brown College in Toronto in 1970, I was officially declared a *civilized, real Indian artist* and was let loose upon an unsuspecting world.

Thereafter I obtained gainful employment in diverse occupations ranging from car washer to screen washer, and discovered that jobs for *civilized, real Indian artists* were not profuse. During this time, caught up in the notion of being a *civilized, real Indian artist*, I began making wildlife prints of a realistic nature, and this approach continues to this day.

In 1980, I entered the Fine Arts Program at the University of Ottawa, and became an art teacher at the CEGEP de l'Outaouais in Hull, Quebec. At the university, I began to explore the ecological, political, economic, and social issues which confront people in their everyday lives, through the medium of sculpture, using found objects. Perhaps, I am becoming a *mystical, civilized, real Indian artist* ... say the reviewers.

Their pronouncements have led to exhibitions in Ottawa, Toronto, New York, Chicago, Phoenix, Paris, Denmark, Finland, Tokyo, Australia, and New Zealand. My work has been acquired by the Canadian Museum of Civilization, the Indian Art Gallery of Indian and Northern Affairs, and private and corporate collectors. Someday, I may even be a *rich, mystical, civilized, real Indian artist*.

What makes this particular piece both visually compelling and socially relevant is the ironic play between flattened beer cans and ersatz warrior's shield. By virtue of irony's peculiar double vision, Noganosh is able to advance the notion of alcohol as shield and protection without denying its grievous role in cultural erosion. As critical parody, it is a grim semiotic sign of the times – far more than a simple fusion of the 'noble warrior' and 'hopeless drunk' stereotypes. Traditionally, a shield's protective power was believed to be more spiritual than physical, with the protective spirit frequently symbolized on the shield's surface. So, too, Noganosh incorporates symbols of the protective 'spirits' with no less concern for sacred survival: 'It's protection from the technology. It's protection from the society, the foreign society that we're [being] ... forced into. If [people] can't deal with the society, they duck out of the reality in alcohol.'

Further to this, Viviane Gray relates a story told to her by Anishinaabe elder Wilfred Pelletier:

I remember him saying this once, it really struck me, he [said], 'You talk about the drunken Indian, but you know what the drunken Indian is doing? He's protecting himself ... [If] you're dealing with spiritual powers, if someone is trying to enter your spiritual sphere and harm it, if you're aware of that then you have a hard time protecting it, but if you're camouflaged or if your senses are dulled by alcohol then you're not as aware of what is going on, and therefore that person cannot harm you.' I thought, 'My God, that's interesting. I never thought of it that way.' [He also] said that's why a lot of Indians used hallucinogenics. It was really as a protection so that you distorted your senses, so that you couldn't be attacked from the other side.

While Noganosh considers the use of humour and playfulness to be a definite aesthetic strategy – 'If they stop and laugh I got their attention, and then maybe they'll take the time to look around at it a little bit more and see what's going on' – it is also a calculated response to the pervasive seriousness and tragic world view that he sees in mainstream artistic practice and the gallery system that affirms it:

I know a lot of artists and a lot of them are so damned serious ... They're running around thinking they're Michelangelo! What the hell! Running around trying to make *the* essential art piece – the one that's going to survive, that's going to be the next *Mona Lisa*. But, hell ... half the people don't have the dedication to do that kind of work. So how can you take yourself seriously? It's pretty hard if you're sitting around planning to take yourself that damned seriously. I don't think you have time to do any work [laughs]. Hey, have some fun! Shit! *Life*'s not permanent; why worry about making *things* that are permanent? I make sculptures. I take them apart. I'll take a piece off one and use it on another one if I don't like it or it don't work.

Noganosh's rejection of permanence and the sanctity of the art object is also a rejection of aesthetic closure. More often than not, his works are in the process of construction and deconstruction, both becoming and unbecoming. (The Trickster is a 'doing' not a 'being.') As well, the very practice of recycling found objects to produce art objects that are subsequently exhibited, admired, purchased, and collected has its own satisfaction. It is another way of teasing the Whiteman. In 1985

Noganosh summed up his creative philosophy in a predictably (un)serious artist's statement accompanying works on display at the Ottawa School of Art Gallery: 'These pieces have been created from the deep dark depths of my noble savage brain. Using objects I have found scattered haphazardly across my path in my numerous travels, I have moulded them together to bridge the generations of cultural difference and catapult them into the present. By renewing this ugliness called garbage and giving it life and meaning, I am continuing the beliefs of my people, who knew that everything has a place and a spirit. I hope that this feeling will be transferred to the viewer.' On reflection, Noganosh adds: 'I find it great that most of the garbage I'm using to make my sculptures with are things that Whitemen have thrown out – White people have thrown out – or the whole society as a whole has thrown out! That, itself, is teasing ... because they can sit and make the same thing if they wanted to [laughs]! They don't have to pay me five grand for it, or ten grand, or whatever they're paying me.'[4]

Teasing the Whiteman can also take the form of private performance and a trickster's dance around bureaucratic expectation. At the centre of one such performance is Métis artist Bob Boyer's painted wall hanging, *The Batoche Centennial* (Figure 50), commissioned to mark the 1985 anniversary of the final Métis military defeat at the Battle of Batoche.[5] In disturbing fashion, Boyer evokes the violence of that historic confrontation on a sullied satin ground that is at once a pioneer quilt and a Native starblanket. Framed by four appliquéd Union Jacks, the words 'O CANADA OUR HOME AND NATIVE LAND' can, with difficulty, be detected on the surface, but there is no harmony in the opening lines of our country's national anthem.

..

4 Noganosh's wife, Maxine Bedyn, offers a more culturally grounded reason for her husband's creative use of found objects: 'I think Native people have very inventive minds, much more so than other people I've met. Anyone on a reserve can fix a car or make things go, [things] that people in the city might not be able to do. And Ron is able to take that and apply that to things that he's making in art and sculpture.'

5 During the 1885 North-West Rebellion, Batoche, Saskatchewan, was the seat of the short-lived Métis provisional government established by Louis Riel, who served as president, and Gabriel Dumont, who acted as military commander. It was also the site of a major military conflict between Métis and Indian 'rebels' and government troops. When the settlement was eventually overrun the spirit of resistance was broken. Riel was subsequently jailed and later hanged for high treason, while Dumont fled to Montana, later returning under a general amnesty. Beal and Macleod write: 'The rebellion had profound effects on western Canada. It was the climax of the federal government's efforts to control the native and settler population of the West. Indians who had thought themselves oppressed after the treaties of the 1870s became subjugated, administered people. The most vocal members of the Métis leadership had either fled to Montana or were in jail. It took native peoples of western Canada many decades to recover politically and emotionally from the defeat of 1885' (1988, 1,513).

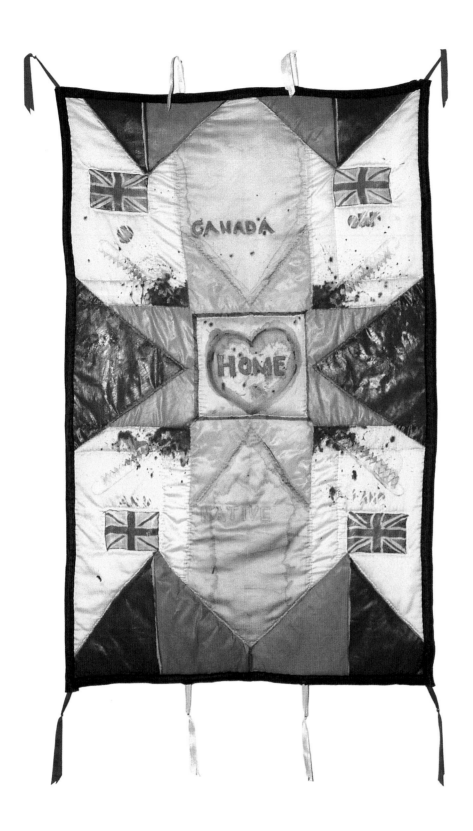

50
Bob Boyer
The Batoche Centennial, 1985
oil over acrylic on satin quilt, with nylon
flags, 150 x 92 cm

The Batoche Centennial is a powerful visual and political statement, but its production was pure performance. Boyer explains:

1985 was the hundredth anniversary of the Batoche whatever it was. I don't call it a revolution or a rebellion or anything ... It was shortly after the Conservative government was elected in, and the funny thing [that] happened [was that] they wanted to celebrate the hundredth anniversary of 1885. But I could tell very quickly that it wasn't going to be a popular thing with the non-Indian public. And so I think what [then-prime minister Brian] Mulroney did was, he decided to defuse it and say, 'Well, this was a time in 1885 when cultures put their mark on Saskatchewan.' I don't know what the hell it was, anyways, but they said, 'Submit all these designs and we will buy X number of paintings, or X number of work[s].' ... Well, I always wanted to do a quilt ... so I figured, 'This is a good time to do one, and also I'm going to ... really go for the jugular with this one and see what these people who are organizing this little thing are going to do.'

Now, I saw the production of the piece being more important than the actual piece, in a sense ... It was my own little performance that I was doing with the jurying committee and with the government. Nobody except myself was a participant. Well, no, I told my friends ... around town ... and they were all aware of what my little performance was – and that was to put this jury in a position, that I was going to do something that was a quilt ... a painted one. It wasn't something that was necessarily what they were looking for. And I also wanted to go for the jugular in terms of 1885 and what it really meant.

My thoughts were, 'What's this jury going to do?' They may dislike it ... but if they say, 'No,' are they going to knock out ... from this show the only descendant from the 1885 Rebellion that they'd asked? And if they do [accept it], are they only doing it *because* I was the only descendant from the 1885 Rebellion? Ultimately, they decided to accept the submission and the idea for me to go ahead and do it, but during the whole thing it was my own little performance. Taking my own stand and putting them in a position, in a quandary, like, 'Do they really want this thing?'

They said they liked it [but] ... one never knows with juries what goes on in their minds and what's the reasoning behind it. All kinds of strange reactions happen, and some of them have nothing to do with the art ... I think there were a lot of [artists who] just took advantage of the situation and decided to make paintings and sell them to the government, where[as] I thought there was ample opportunity in the circumstance to do something [more].

Clandestine performance is also at the heart of *Appropriate, Appropriate,* a photo-based painting created by Jane Ash Poitras for a Vancouver exhibition in the spring of 1991. On the beach at English Bay a few days prior to the show's opening, Poitras described how this piece reflected the type of humour she experienced among Native ceremonialists on a recent visit to the American Southwest:

This is an example [of] what I learned in the peyote tent. There's this big thing going on about appropriation, right, and I go and I think about it, and I think about it, and I go, 'Well, what is this appropriation? Why am I worried about it?' And then I realized, 'Oh, well, I'm thinking consciously, I'm letting them get to me.' So I go, 'Okay, spirits, what is it?' And the answer is this [drawing in the sand with a stick]: [I've] got a work of art, a

nice work of art, right, I've got a photograph – the spirits showed me this, right, this is what they showed me – I've got a photograph, but it's a photograph *I* took, and I've blown it up really nice, [and] it looks really professional. Nobody in the world knows I took this photograph. So I sign it with a name, and I got the name, too, in a dream. And it's 'Amy.' I've got it written down in my 'spirit book' – Amy something. I'll look it up for you. So ... I put it in the middle of my work of art. But everyone thinks that this photograph that I've pasted in is somebody else's 'cause it's got a name here. That's very professional. Then I take my big paintbrush and I go, 'APPROPRIATE, APPROPRIATE, APPROPRIATE' across the top. And then I sign my name down here [at the bottom] and I put a few other drawings here. Everyone's going to look at that and say, 'Look at that, "APPROPRIATE, APPROPRIATE" and she used somebody else's photograph!' But I haven't told anyone that it's my photograph, and I'm appropriating myself! And they're going to come and say, 'Did you ask permission from that photographer to do that?' And I'll ride it. I'll let the media ride it. I'll let all the artists ride it, and I'll let the secret out later ... [But] the peyote people and the shamanic consciousness people, they'll know. They'll know me so well, and they'll laugh – like, you know, when Edward Poitras says, 'The Indians know.' That's an example right there.

Whether or not the Indians and peyote people would actually recognize such a ruse, or whether Poitras might have been overestimating public interest in or sensitivity to the matter of artistic appropriation, is immaterial. The trickster mindset and motivation are of paramount interest here. And it is the Trickster's transformative power that Poitras draws on and most particularly relishes when creating her trademark mixed-media collages (see Figures 37 and 39, pp. 80 and 82):

I have fun with being a trickster in my work ... The Trickster is somebody who is always playing tricks. He's always doing things. He's always fooling people, right? So, I'm a trickster. I take this old piece of map, right? I transform it into a work of art, right? This piece of paper was never intended to be ... in a frame on acid-free board, right? ... I kind of like the idea of taking stuff, like taking garbage ... and making art out of it – transforming it – being a transformer. And in a way that's what tricksters are. They take things and they transform them.

People probably don't realize that but I just recycle. You're taking things from your whole life or your environment and you're putting them in a situation – hanging it up on a museum wall where thousands of people are gawking at it, right, and going, 'Wow!' and they're going, 'Ooo!' and all this kind of stuff. And if you were to tell ... people, 'Oh, well, I picked up this piece of newspaper off the ground and I threw a little ink on it and I signed it with my name and now everyone's gawking at it and making big profound statements about it' ... but because *I* did it and because it's in this museum frame and it's encased in this glass shrine, right, they relegate it to a level of greatness, right? Only thing is, it isn't that great [laughs]![6]

6 Such a statement can only be understood as rhetorical irony used to make a point.

Peyote Humour
Jane Ash Poitras

In the summer of 1991, Cree/ Chipewyan artist Jane Ash Poitras visited the Salt River Indian Reservation, near Phoenix, Arizona, where she participated for the first time in a peyote ceremony, conducted by members of the Native American Church. In a Vancouver interview, 21 August 1991, the artist explained how humour functioned in the context of the all-night ritual.

For a sampling of humorous anecdotes regularly told over breakfast following ceremonies like that attended by Poitras, see Howard (1962). A genre of humour unto itself, such jokes depend on familiarity with the peyote ritual and thus 'serve to bind together those whose knowledge makes the circumstances of the joke intelligible' (p. 11).

[What I learned] was that their ... humour is a *camouflage*. Wow! Like it's a camouflage. What happens is that when Indian people use humour – you see, most people will look at it and just see the surface of it, but you've got to go deeper below the levels of the real, deep, deep into the humour, and you find knowledge beyond the profane. You find sacred knowledge ... If your mind is open to the shamanic consciousness then the humour teaches you an incredible amount of knowledge ... The humour is a language, it's a sacred language.

And so there I was, right, and there's Norm [the Roadman, the head priest] going on really loud, 'cause I have these painted shirts I paint, and he says, 'You know, I think she thinks she's a clown. I think we've got a clown with us. Maybe one of those ... Hopis.' They put each other down with their humour and they take your whole ego away. They want to take your ego away because once they take away your ego then you are open to be transformed and transcend into the higher realm. But you cannot enter the higher realm with an ego. And so I let them take away my ego ... They joked about it. A person who was proud would have gotten a little bit upset and said, 'Well, just wait a minute' or become defensive. I said nothing. I just laughed and I acted like I never heard it, and it didn't bother me. So here, they're making fun of me, and he kept on repeating it through the whole night to all the guys. He'd say, 'She's a clown, she's a clown,' because of the way my shirt was painted. And I let him get away with it. I kinda laughed and I thought, 'Okay, these guys think I'm funny, eh?' ...

Getting back to this humour thing, they kidded everybody else too, you see, they joke with each other, and they poke fun at each other ... You humble a person, right, but then at the same time, if they tell a funny story ... if you're in the right sort of consciousness ... and especially with the peyote that opens your mind ... then you really learn a lot ...

They poke fun at everything they do and they poke fun at themselves ... [and] I found out that it was a way – like little kids say, 'Include me, include me because I want to be loved and I want to be one of you guys.' And it's a way of loving you. If they say nothing about you that's the greatest insult, but [if] they talked about you openly you obviously have made some impact on their minds. And the fact that they're including you in their humour – 'cause we were totally outsiders – they are welcoming you. They have all done peyote before, they all know each other, they're all old buddies from the old school days ...

See, these Indians [never] had to be educated as to how to be an Indian. They always *were* Indian. [It was] never beaten out of them. They told the missionaries to go fly a kite. They held on tenaciously ... to their belief system, and would not give up their belief system and ... go believe that the Catholics or the Mormons were better. They just looked at these guys ... and maybe through their humour had this coded language that those guys couldn't understand. And that's what held them together.

What happens with the humour ... and it's a camouflage too ... is the fact that they hide behind it. They can trivialize something that's very important ... I think they used humour to find out about me and to find out what kind of personality I was. Then they found out, 'Hey, she's okay, she's pretty ... cool, she's cool, she's with it.' I used to be a very vain and very proud person and ... I think after last summer I gave that up.

It's just that that's all the talk and the excitement and the fun of it. The fun part is that I can be the Trickster of the artists, right? And be there and say, 'Piece of paper, we are going to make you a saint! And we're even going to give you a name! And we are going to ... [put] ... holy water on you, right?' But while we're [doing] that – we know everyone's going to be looking at it – let's put a few messages in there because now we've got the audience and we can teach them something, so let's ... get all the mileage we can [and] cover all our bases. We not only recycle the paper, we not only get to teach the people, we not only get to ... make it a saint and canonize it, we ... have fun intellectually bull-shitting it [too], right?

While Poitras and Noganosh take special delight in transforming pedestrian materials into works of art, Salish/Okanagan painter Lawrence Paul Yuxweluptun takes similar satisfaction in transforming limited notions of Native art, especially those pertaining to the Northwest Coast. With not a little irony, he radically relocates a Daliesque spirit of Surrealism to the Northwest Coast to rejuvenate a Native artistic practice he perceives as moribund.[7] By drawing on and blending elements of both

7 His friend Glen Woods calls this 'dilly-*Dali*ing around.' Spanish artist Salvador Dali (1904-89) is easily the best known of all the Surrealists. Flamboyant and eccentric, with a talent for staging unusual and bizarre media events, he distinguished himself as a painter, sculptor, jewellery designer, and film maker. In his paintings, Dali employed a style of detailed realism to create scenes suggestive of hallucinations and dreams. His canvases are notable for their multiple images, a deep, almost unlimited perspective, the juxtaposition of totally unrelated objects, and the depiction in a melted, softened state of objects that are usually hard and solid – as in his famous 1931 painting, *The Persistence of Memory* (Figure 51) (Gerdts 1992, 436-7). See also Alexandrian (1970) and Maddox (1983).

51
Salvador Dali
The Persistence of Memory
(Persistance de la mémoire),
1931
oil on canvas, 24 x 33 cm

aesthetic traditions – the stylized masks and formal design motifs of the coast and the dream landscape and critical/political sensibilities of the early twentieth-century Surrealists – he is able to address the social issues that concern him most: Native identity, Aboriginal land claims, and environmental destruction.[8]

Yuxweluptun's method of engaging the viewer is both sly and effective. The cartoon-like figures that frolic and dance across many of his canvases have an immediate appeal, exhibiting all the charm and child-like playfulness advocated by French poet André Breton in his 1924 Surrealist Manifesto (Alexandrian 1970, 48).[9] A closer look, however, often reveals such figures to be involved in less than frivolous activities. In *Hole in the Sky* (Figure 52), for example, two individuals, one of whom is White, are shown gamely – and vainly? – trying to patch the hole in the earth's ozone layer. In the foreground a sickly and suffering Mother Earth stands weeping in the midst of a clearcut forest. Like broken sticks of hard-rock candy, the surrounding stumps reveal an indelible Native imprint at their core.

52
Lawrence Paul Yuxweluptun
Hole in the Sky, 1989
acrylic on canvas, dimensions unknown

..

8 An intriguing doubleness should be noted here. Yuxweluptun's attraction to Surrealist forms and philosophy – 'propounding an alternative set of values' – parallels and inverts the Surrealists' fascination with the art of the Northwest Coast and its seeming ability to represent both the conscious and subconscious worlds simultaneously. See Cowling (1978) and Jonaitis (1981).

9 In this, his first manifesto, commonly regarded as 'Surrealism's birth certificate' (Atkins 1990, 156), Breton defined Surrealism as 'the spontaneous exploitation of "pure psychic automatism," allowing the production of an abundance of unexpected images' (Alexandrian 1970, 48). Artists were called to behave as 'modest recording devices' in the creation of a 'super-reality in which all the contradictions which afflict humanity are resolved as in a dream' (p. 48).

Reflecting on Surrealism's influence on his own work, Yuxweluptun says:

I read the manifestos by Dali and the other ones in the early 1900s and I looked at their early sketches, their studies ... but I found that I wanted to write my own, paint my own manifestos and ... use the art ... for educational purposes ... It takes a long time to write a manifesto. I don't write manifestos; I'm doing them. I think that Surrealism did not cover the political ideologies of other cultures, so that when I say that I [transform] this into a symbolic manifesto then that's something that's new ... If you look at the history of Surrealism and how it came about, I think that culturally Surrealism was in Native West Coast design already, imbedded into an intellectual position. I think when we talk about a bear in a symbolic sense it is a surrealistic concept – in a two-dimensional form or in a three-dimensional [form].

Surrealism notwithstanding, one of the most valuable lessons that Yuxweluptun learned while studying Western art history at Vancouver's Emily Carr College of Art and Design in the early 1980s was that student work rarely received the recognition it deserved. Planning four years in advance, he quickly set aside several of his favourite drawings for conversion into paintings after graduation. It was a move that required some nimble and tricky footwork. He recalls: 'In my critique I would show what I [had] and then they'd look at my sketchbook and say, "Well, why aren't you doing this?" [I would say], "It's not for this time" ... I jumped around and jumped hoops to get around that, and did one or two pieces in a different style to grasp my marks and still graduate with honours without even doing my masterpieces.'

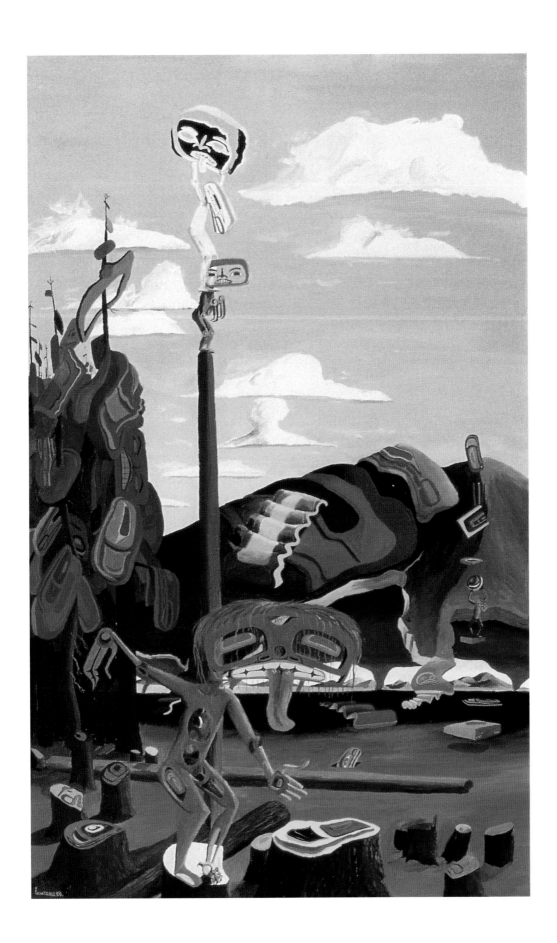

For all the emotional impact of such jarring juxtapositions, it is Yuxweluptun's ironic use of colour that constitutes his most cunning and calculated seduction. His liquid landscapes ripple and ooze and erupt with a terrible and terrifying brilliance. He says:

You can always go head on at something, and try to wrestle it to the ground and choke it to death as opposed to setting a trap for it, and opening it up and catching it off-guard ... I use a pretty colour and ... the [gallery] context to capture [viewers' attention] ... You bait the worm and see if the fish will bite ... Some of the stuff that I deal with, [like] the norm of a clearcut, is very depressing when you start walking through it. The reality, after seeing it so many times, it becomes boring to paint it the way it actually looks ... I try to glorify this clearcut, to jazz it up ... [so that] when it first hits you, it kicks you in the teeth. [It's to convey] the shock that first hit me in my memory of it, but over the years the clearcut becomes a norm ... Let's be realistic about it, it looks like somebody nuked this province [of British Columbia] already in the upper Prince George region. I have no disillusion [sic]. I'm trying to jazz it up so people will go, 'Gee, does it really look that good out there? Maybe we should actually go out there and take a look at these clearcut zones. Maybe Lawrence does see something out there that we should go out there and really take a look at.'

Yuxweluptun's transfusion of Surrealistic lifeblood into the heart of Northwest Coast art not only allows him to address contemporary social concerns but affords him the added opportunity as a painter to contest what he considers to be the unduly elevated status accorded coastal carvers, especially totem pole carvers. In *Hole in the Sky,* for instance, he playfully constructs a *floating* totem pole to illustrate the power of Native beliefs: 'What kind of spiritual energy can suspend these elements in midair?' he asks.[10] It is one of several paintings that feature whimsical and idiosyncratic 'poles' comprising precariously balanced individuals and assorted symbolic and geometric elements.[11] 'It's that old trickery/treachery of visual illusions,' he says. 'I can do things that [carvers] can't do':

[Carving] is structured on the wood. It's a very confined structure, but I find reservations a very confined structure so I like to deal with the reality of right now ... [Painting] gives me the option to carve 'where no Indian has gone before' ... 'What's a treaty?' ... An Indian carving doesn't explain this. The British Royal Proclamation – 'Can you carve it?' ... How would you carve a 'cut-off land claim'? That's what interests me ... Somebody's got to stir this pot ... I found that there was a whole set of problems that had to be addressed not

53
Hoesem-hliyawn
Hole-through-the-Sky pole
Kitwankool, BC

10 The title of the painting itself recalls the well-known *Hole-through-the-Sky* pole by Tsimshian carver Hoesem-hliyawn at Kitwancool, British Columbia (Figure 53). See Barbeau (1929) and Vastokas (1973-4, 128-9).

11 See also *Throwing Their Culture Away* (Figure 54), and *Red Man Watching White Man Trying to Fix Hole in Sky* (in McMaster and Martin 1992, 159), a second painting dealing with ozone depletion in the earth's atmosphere.

within the realm of how Indian art was being made. There was nobody doing it. 'How do you carve a land claim?' I was just making a point ... I couldn't carve a land claims Royal Commission in a West Coast design. And I go [to the carvers], 'Can you guys carve it?' I said, 'Carve me a beer bottle; put it on a totem pole.' 'Carve me a car and call it a Thunderbird.' So [my work's] got all these social things that have to be dealt with. There's a lot of area that hasn't been covered and I don't think that you can do it always in wood.[12]

Clearly savouring the role of renegade activist and maverick visionary, Yuxweluptun aligns himself with the futuristic crew of the starship *Enterprise* on the popular *Star Trek* television series. In mock imitation of the opening prologue he says: 'I'm doing new things that nobody's ever done before, go[ing] where no Indian has gone before.'[13]

...

12 At least two Northwest Coast artists have proven that it is possible to address such subjects through carving. See the references to David Neel's work (p. 232 n. 57) and Ya'Ya Ts'itxstap Chuck Heit's red cedar houseposts (Figures 127 and 136, pp. 235 and 250).

13 Yuxweluptun may well be the first Native artist in North America to exhibit a work created in 'cyberspace.' A highlight of the 1992 show *Land Spirit Power: First Nations at the National Gallery of Canada* was his virtual reality installation, *Inherent Rights, Vision Rights,* which evoked the spiritual space of a Salish longhouse (Nemiroff, Houle, Townsend-Gault 1992, 220-5). The piece was later reinstalled at the Morris and Helen Belkin Art Gallery in Vancouver, British Columbia, in 1995 as part of Yuxweluptun's mid-career retrospective, *Born to Live and Die on Your Colonialist Reservations.* See Townsend-Gault, Watson, and Yuxweluptun (1995).

Yuxweluptun is not alone in drawing inspiration from *Star Trek.* Shelley Niro imagines herself as a member of the starship *Enterprise* crew in *Final Frontier* (Figure 55), from her 1992 series of portraits and parodies, *This Land Is Mime Land.* It is a savvy image only slightly ahead of its time. In 1995 in what could be considered an instance of art imitating art, Native actor Robert Beltran was cast in the role of Commander Chakotay, the first identifiably Aboriginal

54 (facing page)
Lawrence Paul Yuxweluptun
Throwing Their Culture Away,
1988
acrylic on canvas, 91 x 66 cm

55 (right)
Shelley Niro
Final Frontier, first frame, 1992
hand-coloured gelatin silver print, sepia-toned gelatin silver print, and a gelatin silver print in a hand-drilled overmatte, 36 x 28 cm each photograph

56
Carson Waterman
The Senecas Have Landed, No. 2,
1982
polymer acrylic on canvas, 61 x 46 cm

officer on *Star Trek: Voyager,* the fourth and most recent incarnation of the long-running television program.

Like Yuxweluptun, Beltran may also feel that he is going where no Indian has gone before. In this, he would be only half right. Others have blazed a trail through the heavens before him, envisioning Native peoples in circumstances both extraordinary and extraterrestrial. In the 1982 painting *The Senecas Have Landed, No. 2* (Figure 56), by American Seneca artist Carson Waterman, a scientific mission in space is consecrated in unexpected fashion by an Iroquois ceremonial drummer. In *Wouldn't It Be Funny?* (Figure 57), his whimsical painting from 1983, American Mohawk artist John Kahionhes Fadden reveals that alien beings visiting Earth from their home on the other side of the universe bear a startling resemblance to human beings alienated from their homes here on this side of the galaxy. Curiously, Thomas King tells a similar tale in his short story, 'How Corporal Colin Sterling Saved Blossom, Alberta, and Most of the Rest of the World as Well' (King 1993b, 47-63). In it, alien blue coyotes descend to Earth in bright blue spaceships to reclaim their indigenous kin and spirit them off to a better world. One grateful brother from Alberta is overheard to say, 'What took you so long?'

Still, the most surprising disclosure may be that Coyote's son was a pioneer in the field of lunar exploration. As Okanagan elder Harry Robinson (1989, 92) explained it to Wendy Wickwire in 1981 in the story 'Coyote Plays a Dirty Trick,' the accepted version of the first lunar landing is in need of a major rewrite:

And now, it says,
I've got the paper written here,
 and it says there on that paper.
It says in 1969 the first man that's on the moon,
 that's Armstrong.
He was the first man on the moon.

But they did not know
 Coyote's son was the first man on the moon!
And Mr. Armstrong was the second man on the moon.
So the Indians know that,
 but the white people do not know what the Indian know.

Not all Indian,
 but some.
So, that's the way that goes.

And Mr. Coyote, the Young Coyote,
 was up to the moon at that time,
 before Armstrong.
See?
Armstrong get up to the moon in '69.
But Coyote's son,
 a long time before Christ.
Then how long Christ, since he was born?
1981 since he was born.
Then before that he was up to the moon.
And the white people,
 they say he's up to the moon the first man.
But he is not the first man.
Coyote's son was the first man.
So, nobody know that.
Maybe someone know.
Not around here.
Maybe long ways from here.

57
John Kahionhes Fadden
Wouldn't It Be Funny? 1983
acrylic on canvas, 64 x 53 cm

Not all 'Native' carving on the Northwest Coast is the work of Northwest Coast Natives. In his 1980 etching *Ode to Billy Holm ... Lalooska ... Duane Pasco ... & Johnathon Livingston Seagull* (Figure 58), Haisla artist Lyle Wilson examines the position and authority of non-Native carvers such as Duane Pasco and John Livingston and of those with dubious Native ancestry, like Lelooska, who actively participate in the Northwest carving tradition. What, he asks, is their role in shaping this tradition (Duffek 1989, n.p.)? Wilson also questions the status of non-Native scholars such as Bill Holm, whose 1965 book, *Northwest Coast Indian Art: An Analysis of Form,* has become the authoritative reference on the 'northern style' for both Natives and non-Natives. To suggest an alternative perspective, a reversed image of Holm's book cover has been incorporated into the print – 'turned around on purpose' in true trickster fashion (Durham 1986, 1) – along with a hand-drawn facsimile of the artist's government Indian Status card.[14] Walking a fine line that separates these two images of authority is a masked figure, possibly the artist. He appears to be moving with caution through unfamiliar territory.[15]

The use of reversal to advance an alternative perspective can take many forms. Where Wilson employs a mirror image to reflect on the academic construction of Native artistic practice, Métis artists Edward Poitras and Jim Logan employ a positive-negative strategy to interrogate the exclusive and exclusionary nature of

14 Lippard says that '"turnaround" is a literal synonym for "revolution"' (1990, 202). On several occasions, cards symbolizing conferred status and identity have been the subject of critical aesthetic reflection. In 1984, for example, Six Nations artist Clifford Maracle affixed his actual Indian photo-identity card to his painting *Changing Reserve* (in Scott 1985, 39), to personalize his outrage with the squalor he saw around him and his humiliation at having to live as a numbered ward of the federal government. In *Treaty Card,* a mixed-media wall installation that formed part of the 1993 exhibition *Three Lemons and a Dead Coyote* at the Ottawa School of Art, Edward Poitras interrogated his paradoxical legal status as a 'Métis with an Indian treaty card' by replacing the 'official' photograph on his laminated status card with one in which he was wearing clown make-up. This, of course, rendered the card void, and by extension, the status it bestowed. As Gerald McMaster (1995) observes, this simple act of alteration is in itself a very Coyote-like, very Trickster-like act of subversion. Finally, in her 1989 mixed-media collage *Gold Card Indian,* Jane Ash Poitras contests a different form of conferred status, that of preferred customer and privileged consumer. In the lower half of this piece, next to the words 'ECONOMIC VS SPIRITUAL DEVELOPMENT,' Poitras has arranged in the shape of a cross four then-current gold credit cards sent to her in recognition of her success as a Native artist. At the centre of this gold cross is a small photograph of a white cross that stands at the head of the artist's mother's grave. Set against a stark black background, it is a poignant image.

15 This is, of course, a good example of complicitous critique. Even as Wilson questions the status of these individuals and images, he affirms it merely by acknowledging them.

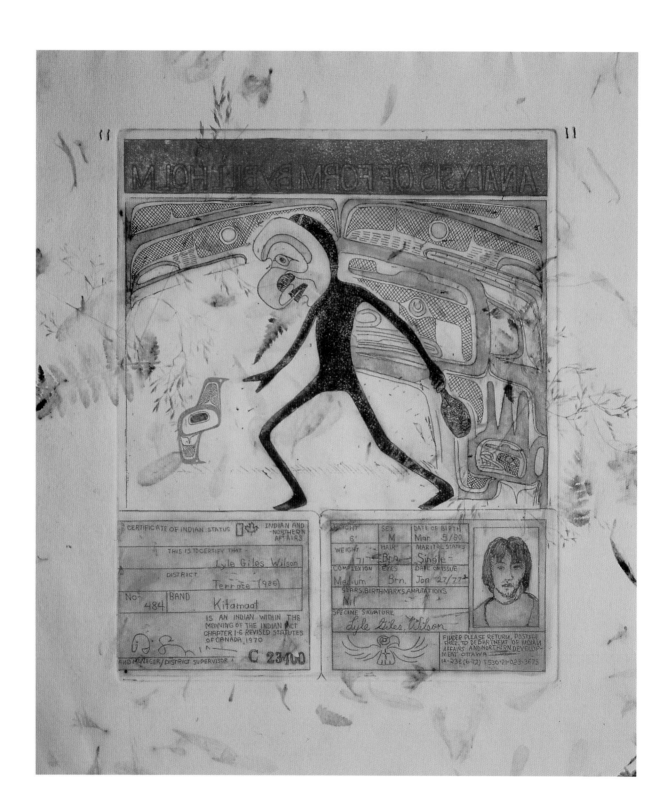

58
Lyle Wilson
Ode to Billy Holm ... Lalooska ...
Duane Pasco ... & Johnathon
Livingston Seagull, 1980
etching on handmade paper, 28 x 24 cm

the Western canon. One of the most memorable components of Poitras's *Et in America ego,* a 1989 Vancouver installation that combined elements of Greek and Hopi mythology, was a photocopy of *Et in Arcadia ego,* a painting by the French master Nicolas Poussin, in which Poitras 'whited out' all the human figures (Figure 59). It remains a stark and telling metaphor. Poitras recalls, 'I was trying to alter it in such a way as to take out the "European" and somehow maybe put in some kind of "Indian" content.'

In truth, he was creating a *space* for Indian content, for the *possibility* of Indian content. In *The Classical Aboriginal Series* (1992-3), Jim Logan actually provides the content (Ryan 1994a). With a brush dipped deep in irony, he imagines a Native presence in myriad familiar but unexpected places. His brazen appropriation and Indianization of more than twenty beloved masterworks of Western art calls attention to their social construction *as* masterworks and to the ethnocentric nature of

59
Edward Poitras
Et in America ego, detail, 1989
mixed-media installation

their collective vision: 'I started thinking about ... how I'd been taught to admire Western art ... I went through art history in school and was taught how glorious European art was. It seems to be the standard to judge all other art, and I question that ... *Is* it the standard, and [if so] *why* is it the standard? ... What makes the masters masters?' Logan suggests that it may, in part, have something to do with the Judaeo-Christian values that much of the art embodies and helps to perpetuate. Not surprisingly, many of the images he parodies have Christian or biblical themes. 'I picked a lot of those [paintings] particularly because European culture is so influenced by Christianity, [and] that [has] had such an effect on us. There's such a connection there,' he says.

There is indeed. In his series Logan's critique of the combined impact of Christianity and European culture on Native America is as profound a theme as the hegemony of Western art history. At any given point there are at least two, and frequently more, critical/political discourses unfolding together. In *The Annunciation* (Figure 60), for example, Logan reworks a scene depicted many times over the centuries but draws an intriguing parallel between the announcement of Christ's coming birth to Mary by an angel and the bringing of God's word to North America with Christopher Columbus.[16] Linear time is collapsed as both stories are told simultaneously: the angel appears on a New World beach; three ships stand on the horizon.[17]

To illustrate how dissimilar the view from shore might be from that aboard ship, Logan overlays the image of Columbus's tranquil arrival with a second version of the same event rendered in traditional pictographic style. In the new version the first person ashore is shown brandishing a weapon. The visual tension established by juxtaposing these two perspectives clearly mirrors the historical tension. Still, Logan maintains that this is a 'very simple painting.' It is a tricky simplicity, to be sure. *The Annunciation* is one of several paintings in this series created 'especially for Native people in the Catholic faith, where they haven't seen a lot of imagery where *we're* divine, where *we* are Mary and where *we* are Jesus. There seems to be a psychological gap. When you're brought up as a minority looking at all the structure of the Church [and] all the imagery of the Church, and realizing that you're not there, it leaves you feeling that you're not supposed to be there – that maybe you're not as important as the Italians or the Spaniards who happened to paint themselves in these glorious positions of divinity.'

16 Logan's version of the archangel Gabriel's visit to Mary bears a close resemblance to Fra Angelico's fifteenth-century fresco in the Church of San Marco in Florence, Italy. A particularly inspired touch is the transformation of a curved archway into the sweep of an overhanging palm tree.

17 This certainly puts a new spin on the old English carol, 'I saw three ships come sailing in on Christmas Day in the morning.' Moreover, the way that time is handled and resolved in this painting recalls Vizenor's comments on 'mythic verism' in contemporary Native literature, p. 5 of this text. See also p. 210 n. 36; *Chronos 1* (Figure 106, p. 203); and *Unreasonable History* (Figure 140, p. 255).

60
Jim Logan
The Annunciation, 1992
acrylic and gold leaf on masonite, 61 x 61 cm

61
Jim Logan
Jesus Was Not a Whiteman,
1992
acrylic and mixed media on canvas,
100 x 84 cm

About his transformation of El Greco's painting *The Saviour* into *Jesus Was Not a Whiteman* (Figure 61), Logan says: 'I wanted [Native people] to be able to see Christ as Indian and have the imagery put in their minds that he could be Indian. He definitely wasn't Spanish. He definitely wasn't German. He didn't look like Salvador Dali's image of Christ. But if they have the licence to do that then I have the licence to make him Indian! So I made him an Aboriginal Jesus.' To make the point, Logan has affixed to the surface of the painting several feathers, along with – in a nod to ecclesiastical and tribal enterprise – numerous bingo chips, some bearing letters that spell out the name Jesus in English and others marked with the letter X, its Cree and Greek equivalent.[18] This trickster mix of sacred and satiric is germane to Native spirituality. An Aboriginal Christ would undoubtedly be amused.

18 The intense passion for bingo that enlivens – and enriches? – many Native communities is reflected in the frequent reference to the game in recent indigenous literary and visual artforms. Examples include the play *The Rez Sisters* (1988a), by Tomson Highway; the novels *The Heirs of Columbus* (1991), by Gerald Vizenor, and *The Bingo Palace* (1995), by Louise Erdrich; the short film *Bingo* (1991) by Marjorie Beaucage; the mixed-media sculpture *Bingo Dauber Fetish, Indian Brand Series, Part II* (1994), by Peter B. Jones (Figure 62); and the comic strips *Soupbone and Skawndawg* (1992), by Ken Syrette (Figure 63), and *Baloney & Bannock* (1992), by Perry McLeod-Shabogesic (Figure 64).

62
Peter B. Jones
Bingo Dauber Fetish, Indian Brand Series, Part II, 1994
mixed-media stoneware, 53 x 15 x 15 cm

63
Ken Syrette
Soupbone and Skawndawg,
'Djermawgo ...' 1992
pen and ink cartoon on paper

64
Perry McLeod-Shabogesic
Baloney & Bannock, 'Hockey game? ...'
1992
pen and ink cartoon on paper

A Rethinking on the Western Front (Figure 65), the most complex religious painting in *The Classical Aboriginal Series* and arguably Logan's own little masterpiece, can be viewed as the inevitable consequence of the artist's efforts to present Aboriginal people as divine. In a wonderfully comic turn that flips the Sistine Chapel ceiling on its head to bring Michelangelo's depiction of the creation of Adam down to earth, Logan envisions not only God the Father as Native but also Adam, Eve, and all the generations to come. It is a splendid act of celestial inversion, affirming the doctrine of divine creation but with a trickster's twist.

Logan also takes the opportunity to contrast his revised and, some might say, partisan view of creation with Darwin's scientific, and supposedly objective, theory of evolution. He considers, in particular, the less than objective way in which Man's walk through history has been presented:

When I went to school they always had these diagrams in our social studies books that showed Homo Erectus as being dark, very dark ... Black, if you didn't know better. Peking Man would be slanted eyed for some reason. He'd be there as the next one in the evolutionary chain. Then they would have Neanderthal, which you could probably say had some Jewish features ... Coming after him would be Cro-Magnon Man, and 'Jeepers,' this fellow looked like our people! He could be a Sioux or a Cree, a Plains Indian. All these people would be naked, hairy, but when it came to representing Homo Sapiens, modern man, it would be a short-haired White man strutting along!

These five figures, still carefully labelled, now stride across the top of Logan's painting, walking single – Indian? – file into the future. An arrow with the ironic notation 'gee is this me' points to Cro-Magnon Man. Written in the stars above their heads are the words, 'Sorry Charlie D. I don't believe in such a theory. My Elders say I/we were created.'

No doubt one of the reasons Logan dismisses Darwin's theory is the more satisfying explanation contained in a comic anecdote told to him by his father when grade-school classmates began calling him 'caveman' and 'Cro-Magnon man.' In response to Jim's question 'Are Indians cavemen?' his father replied, 'When God made man he had to cook him in an oven. The Black man he cooked too much, and the White man he didn't cook enough. Us Indians he cooked just right.' Logan says: 'I just smiled, it made me feel good. It made me feel that we're all the same batter, we're all the same make. It's just how we come out. There's no difference.'

So appealing did Logan find this particular story – resonating as it does with cultural and universal truth – that decades after first hearing it he included it in this painting, lettering it, much as a child might, below the image of Adam. It is an especially appropriate action in that it allows the viewer to draw an intriguing, though possibly unintentional, parallel between the artist's relationship to his father in memory and to his Father in heaven. In this, the artist has chosen to remember and perpetuate a simple childhood story as part of his father's legacy, a small slice of comic wisdom passed down from father to son in the oral tradition. Its purpose is to foster personal and cultural self-worth while combatting racism and ignorance and promoting the maintenance of a healthy, humorous, and

balanced perspective on life. It is, like many trickster tales of old, a concise guide to appropriate conduct and survival.

Similarly, in Logan's make-over of Michelangelo, a Native Creator/God would most assuredly pass on the gift of humour to his first-born son, first man of the First Nations. It is this that *A Rethinking on the Western Front* so aptly captures – the centrality of a comic spirit to Native American spirituality, identity, and world view. The humour in this piece is more than mere subversive scribbling in the margins of the great master narratives, whether scientific, philosophic, religious, or artistic. It is this, certainly, but there is something more. The humour here embodies a profound spiritual balance as well. In contrast to some of the other works in *The Classical Aboriginal Series,* Christian and Native symbols achieve some degree of synthesis and a measure of visual harmony. It seems no accident that Turtle Island is seen rising again and that the beak of the Thunderbird, looking suspiciously like a red Trickster raven, touches the hand of God at the moment of humanity's creation.[19]

The same satirical spirit, or spiritual satire, that permeates the religious paintings in this series informs many of Logan's more secular parodies as well. It goes to the heart of the Native presence he seeks to affirm. A case in point is *The Diners Club (No Reservation Required)* (Figure 66), his cheeky replay of Edouard Manet's well-known painting, *Le Déjeuner sur l'herbe* (Luncheon on the grass) (Figure 67). Much of its appeal turns on the delightful gender, racial, and dress reversals of the figures in the Manet original. Logan's punning play on the title is a delicious bonus, adding to the enjoyment and layering the reference even further.

As one might expect, several serious themes are interwoven in this painting, not least a concern with Native spirituality: 'I wanted to make it contemporary and yet I wanted to show a traditional feel [in] it also, in the sense that religiously, or spiritually, a lot of our young people are becoming spiritually renewed ... That's why I have a pipe there. That's why on their chests you'll see scars from the Sun Dance ritual or ceremony.' What may not be so obvious is the homage to traditional Native women that Logan also intended to convey: 'Some of our societies, Native societies, were matriarchal and the woman carried a lot of power within the political system, so I wanted to put that sort of idea in the painting – that the women here have the power ... If there's anybody to be subservient to the other, or lower than the other, or with less power than the other it would be the naked men rather than the clothed women. Clothing seems to suggest power. I don't know why, but it seems like if you're nude you're vulnerable. If you've got clothes on you've got power.'

19 In the creation mythology of many woodland tribes the earth was formed on the back of a great turtle from a small clump of mud scooped up from the floor of a watery world by a small, brave animal. For this reason the Earth is known as Turtle Island. On the Northwest Coast the Thunderbird is considered to be the most powerful of all mythic spirits.

65
Jim Logan
A Rethinking on the Western Front,
1992
acrylic on canvas, 167 x 244 cm

66

Jim Logan

The Diners Club (No Reservation Required), 1992

acrylic on canvas, 89 x 135 cm

67
Edouard Manet
Le Déjeuner sur l'herbe, 1863
oil on canvas, 213 x 269 cm
Musée d'Orsay, © Photo RMN

Perhaps this is why Manet's painting created such a furore in Paris of the 1860s; he dared to show a naked woman lunching on the grass with two clothed men. Few people of the time realized that Manet had patterned his composition on a much earlier work, *The Judgement of Paris,* an etching based on a study by Raphael, in which *all* the figures were unclothed (Janson 1977, 16). Manet 'took the liberty of leaving the female nude and clothing the men,' Logan says. 'I just reversed that thinking and said, okay, I'll put the women clothed and leave the men nude!' Still, there is more to this than mere playful reversal. Logan adds, 'I guess I really wanted to see things as perhaps a woman artist would look at things. I happen to be interested in that sort of view, in feminine art, and looking at what they're doing in their own art. I look at the National Gallery collection and read that out of the artworks that depict nudes 85 to 90 percent of them are women, rather than male. That, to me, has to be cured. It's not politically correct. Maybe this painting is more politically correct because the males are nude. These are questions that I often think about.'

In the process of redressing (and undressing) history, Logan has also relocated his dinner party to more familiar terrain, the homeland of the Cree on the northern Plains. 'I made it a Canadian landscape,' he says. Moreover, the figures are seen enjoying a Diet Coke – no alcohol, please – and appropriate regional Native foods – a bowl of saskatoon berries – 'rather than the feast that they had in the original.'

Like the other works in this series, *The Diners Club* combines a healthy (and healthful) respect for Native tradition with a healthy irreverence for European art history. In this, Logan has imagined a Native utopia where past and present are in perfect balance and cultural inclusion is never an issue. It is a comic vision of no small import. Logan has clear expectations for the paintings:

What I'd like [Native people] to get out of this [series is] a realization that ... there is a place for us in the mainstream of whatever field or profession we want to be in, whether it's art, religion, [or] dentistry. Whatever you want, we can be there ... I want to say the same thing [to non-Natives] ... Hopefully, they'll come out with the idea that you can't dominate some body, some people, some thing without it eventually turning on you.

In a sense, this work is like a turning point for me personally. I'm not going to take any more teachings without really investigating what's being said. I'm just not going to take to heart what I hear, whether it's from an anthropologist or an art teacher, or anyone ... I'm going to have to come to my own conclusions ... and evaluate things myself. This is basically an art education for Jim Logan, I guess.

Just as Logan telescopes time to envision a classical Aboriginal presence, so Blood artist Joane Cardinal-Schubert performs a temporal shift to 'talk through history' to one of her heroes, the renowned Canadian painter Emily Carr, who died in 1945.[20] In her 1991 series of mixed-media works, *The Birch Bark Letters to Emily Carr,* Cardinal-Schubert pays tribute to the artist she has long admired while assuming a fictive intimacy with her that grants added significance to the warm and chatty letters she incorporates into each piece. It is a shrewd method of creating an awareness of contemporary Native concerns in the viewer, and likewise a means of imagining institutional access and acceptance.[21] In conversation, Cardinal-Schubert elaborates:

> I think what they're about is that if I can talk to Emily Carr about these issues then, in a funny way, non-Native people will [respond]: 'Well, she's talking to Emily Carr. Well ... Emily Carr, geez!' Emily Carr is somewhat revered [laughs] ... There's probably a lot of [other] people saying, 'Oh, what the hell is she doing? Why does she think she can write letters to Emily Carr?' – even though Emily Carr is dead, right? But in the same instance, they're going to pay more attention ... It's a device to get people to listen, and to pay attention ... The neat thing about these letters [is] that I can ask questions in them. I'm not making statements so much as I'm saying, 'What if?' or 'What about?' or 'Why?' ... Because we have so much importance attached to words ... we tend to read them – we even read graffiti – so I'm fairly confident that people will read the words.

..

20 Born in 1871 in Victoria, British Columbia, and a longtime resident of that city, Carr is best known for her paintings of coastal Indian villages and freely expressive landscapes that capture the large rhythms and terrible grandeur of the western forests, beaches, and skies (Shadbolt 1988, 366). In her later years Carr turned her talents to writing. The Emily Carr Institute of Art and Design in Vancouver is named for her.

21 Acceptance has been hard won. This show might have been mounted much earlier had the funding come through. Edmonton art critic Elizabeth Beauchamp (1991, D13) explains the situation:

While many artists of 20 years standing wouldn't broadcast the news that they'd been turned down – yet again – by the powerful Canada Council, the wily artist turned that indignity into art. When the idea for a body of work based on her long-held fascination with the famous Canadian artist Emily Carr was refused, Cardinal-Schubert promptly wrote a sharply ironic poem and sent Xerox copies across the country. Covertly titled 'oh Canada,' it was later published by the University of Lethbridge, Whetstone Press and entered the growing saga of western (not to mention native) alienation from the eastern-controlled Canada Council.

The reasons finally given for turning down an artist who has been included in five nationally focused group exhibitions sponsored by the Council are almost hilarious. According to Cardinal-Schubert, she was told they'd never heard of her. Which kind of makes you wonder if those doing the choosing get out to galleries much. There was also another absurdly patronizing, even more puzzling explanation. Someone from the Council remarked to Cardinal-Schubert, 'We're afraid if you go to B.C. you may start painting totems.' But – thankfully – it takes more than bureaucratic foolishness to stop a good project and so Cardinal-Schubert got on with it – grant or no grant.

oh Canada
Joane Cardinal-Schubert

Not so many
months ago
I applied

To the Canada Council
Arts B Grant

To study
Canadian Painter
Emily Carr.

Wanted to use her as
my mentor
Post Humously.

Seemed like a good idea....
The RCA used her
Posthumously....
Even awarded her
An Accolade.

Good painting
they said
the jury
said

Loved your Warshirts.
(they shortlisted me)

But ...
they said
the jury said

We were worried
if you went to
B.C.
You might end up
painting the totems
Red

What of it
I thought
It is art historica.

now I know better
Next time
I will apply to
go to visit
the pyramids....

oh Canada

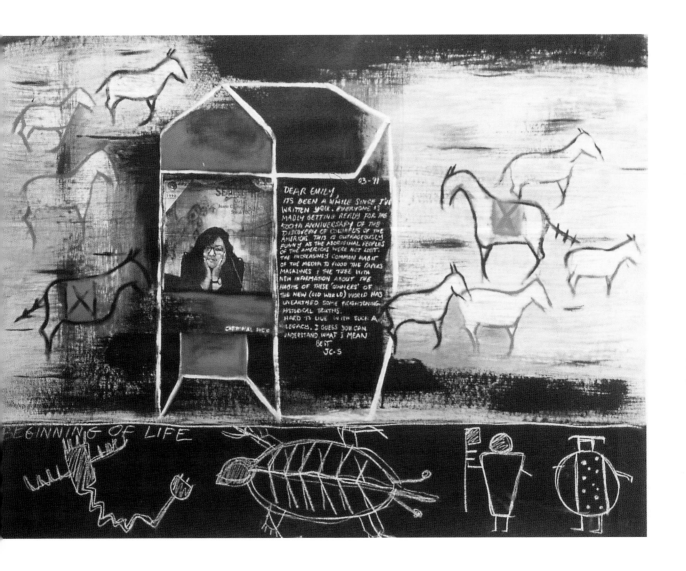

68
Joane Cardinal-Schubert
Beginning of Life, 1991
acrylic and conte collagraph on rag
paper, 102 x 127 cm

The text for *Beginning of Life* (Figure 68), from this series, reads:

Dear Emily,

It's been a while since I've written you. Everyone is madly getting ready for the 500th anniversary of the discovery of Columbus of the Americas. This is outrageously funny as the Aboriginal peoples of the Americas were not lost. The increasingly common habit of the media to flood the papers, magazines & the tube with new information about the habits of these 'owners' of the New (Old World) World has unearthed some frightening historical truths. Hard to live with such a legacy. I guess you can understand what I mean.

Best
JC-S

One of the transplanted Old World habits that Cardinal-Schubert finds especially offensive is the institutional capture and collection of cultural property, most notably Native cultural property that she believes rightfully belongs with the peoples who created it. An added source of continued distress is curatorial insensitivity toward and mistreatment of such property, particularly sacred objects. Living with such a legacy, however, has prompted her to create some of her most poignant and politically pointed art: works of serious parody, for the most part, that have their genesis in firsthand knowledge and personal experience. An incident that took place in the early 1970s, for example, inspired her to create the plaster sculpture *Contemporary Artifact – Medicine Bundles: The Spirits Are Forever Within* (Figure 69). She remembers:

I was in the Glenbow [Museum] in '73 and [curator] Julia Harrison took me in the back and showed me the collection they had. She opened this cupboard and I went, 'Eahhh!' because it was a power bundle and they had taken everything out of it and lined it up on the shelf, and they had little museum numbers on it. Well, [as a curator] that was my job to do that – but with contemporary artworks, not with cultural items.[22] I just went, 'How can you have this?' She said, 'Oh, well this was done before me.' I said, 'Can't you do anything about it, like give it back?' So that bugged me. Anyway, when I did this one [piece] I put a hand on it to say, 'This is protected.' Like a firmness ... With the plaster I could make a bundle that nobody could open and take anything out of.

A much larger project, the 1988 six-piece wall installation *Preservation of a Species: The Warshirt Series* (see Figures 70 and 71), was created after viewing historical Plains garments in the storage vaults of the Canadian Museum of Civilization in Ottawa. Recalling her visit, Cardinal-Schubert says:

They asked me: 'What do you want to see?' And I said: 'I want to see Blackfoot, specifically, warshirts from this period, pre-1880.' So they go to their computer and they whip out [data] and they Xerox all these cards – acquisition cards with numbers and stuff

22 Cardinal-Schubert served as Assistant Curator of Art at the University of Calgary Art Gallery in 1978 and at the Nickle Arts Museum, University of Calgary, from 1979 to 1986.

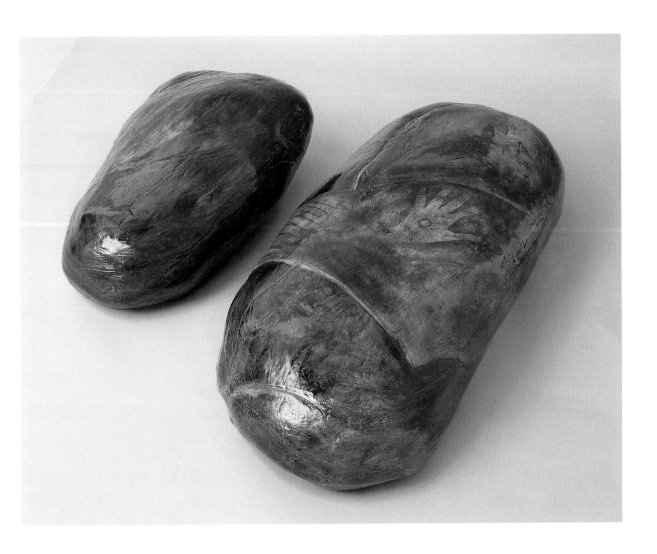

69
Joane Cardinal-Schubert
*Contemporary Artifact —
Medicine Bundles: The Spirits Are
Forever Within,* 1986
plaster on wire mesh, oil, graphite, urethane,
69 x 38 x 24 cm and 104 x 46 x 18 cm

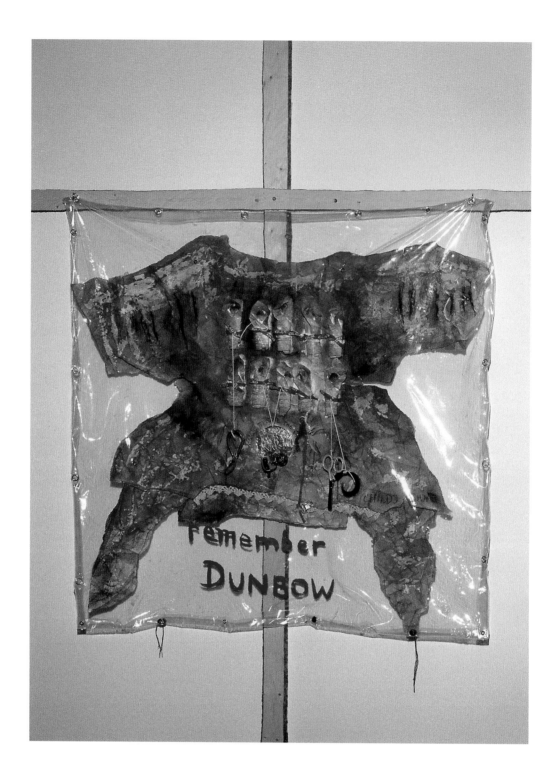

70
Joane Cardinal-Schubert
Remember Dunbow,
Preservation of a Species:
Warshirt Series, detail, 1988
wall installation, oil, conte, charcoal on
rag paper, found objects, clear vinyl,
wood, 102 x 91 cm each

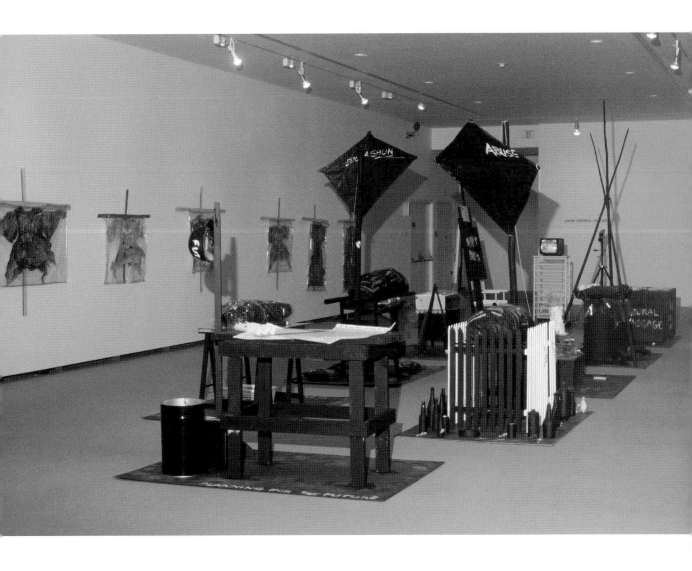

71

Joane Cardinal-Schubert

Preservation of a Species: Deep Freeze, 1988-9

installation, wire mesh, plaster, oil, varethane, found objects; with

Preservation of a Species: Warshirt Series

– and we finally go down and we find the pieces. And they're all in these map-case drawers and they're all in these plastic bags. But when this museum person is showing them to me the plastic's really clouded so she's going like this [pressing] on the beadwork. And I'm going, 'Eahhh!' It's like I'm back looking at the power bundle, looking at them all taken out. I'm just horrified, [but] I just don't give her a clue that I'm horrified. Then she might get careful and not show me anything. So she shows me all these shirts and then I just go out of there with this big impression. And I come back home – it's a while – and I get this idea [for] these shirts and I want to make them really fragile looking and help-less. It's not really fair to give them a human quality but ... just really fragile. And then I would use the lodgepole pine because it's the part of the home. So you take that and you desecrate it by making it into a cross, which is from another culture, another religion, an imposed thing.

Cardinal-Schubert's six 'warshirts,' vigorously re-imagined on paper, sheathed in plastic and suspended from pine crosses, give new definition to Linda Hutcheon's notion of irony as 'repetition with critical distance' (1988b, 26). With titles such as *Then There Were None* and *Is This My Grandmothers* [sic], the warshirts speak elo-quently of a culture crucified for the sake of colonial ambition, in the name of colonial religion. Cardinal-Schubert says: 'I had a good time making a reasonable facsimile of the real thing [laughs]. Okay, you won't let me have them, then I'm still going to tell the story. I want to expose this!' *Remember Dunbow* (Figure 70) was the first piece created for the series. While showing a slide of the work in her studio, Cardinal-Schubert explained the personal significance of the appended objects:

That little piece of crochet, that was really the start of these shirts. It was a combination of finding that crochet in my grandmother's sewing machine, looking at it and going, 'I didn't know my grandmother did this stuff,' and thinking, 'Gee, if I didn't have this I wouldn't know this about her.' And then I put that together with, 'How do people feel that don't have their things?' And these things [the original shirts] belonged down on the Blood reserve, right? And they're in Ottawa and I'm the only one in four days in the whole damned country who comes to look at these things – 'cause I register when I come in and there's no other name. I'm checkin' the dates. So then that little bit of crochet on there just did something [laughs] – it did a twist. The other things are comical, like there are my kids' scissors, and there's a piece of my hair, and there's [my son] Christopher's baby spoon, and then there's [a] round thing there that's sort of like ... the chief's medal, except it's disguised because it says 'Big Buck' on it. [laughs] I was thinking of 'bucks' – Indians being called 'bucks' – but it's a deer head on it, really, and it's just a cover for chocolate. It's things I had around.

[And there's] an old button from the first coat I had ... my 'going-away coat' when I was first married. [And there's] a suspender clip and I think there was even a garter in there somewhere. [There's] an old buckle from an old watch from the '60s, and it says 'Remember to Save the Children' on there. And then I had these GLAD twist ties. It was a way of fastening those babies onto the back – 'ten little Indians' – and they're all black because they have 'black lung' for the Lubicon TB outbreak. 'Dunbow' is that [Indian resi-dential] school ... out here on the Blackfoot [reserve]. It's another one of Father Lacombe's little joints.

In *Remnant II,* another shirt from the series, Cardinal-Schubert recontextualizes the computer data she was given while visiting the national museum. Across the yoke of the garment she inscribes in heavy black pencil the catalogue information currently deemed relevant to this cultural remnant. It begins, 'PURCHASED FROM CHRISTIES AUCTION ... '

Reflecting on the *Preservation of a Species* concept, Cardinal-Schubert says:

It's a comment on the museum's treatment of Native people, all this comment about, 'Well, these have to be preserved!' And I came to the resolution, simply by living on that land I lived on when I was a kid, that things change, they always change, and ... there was a promise in that change. And the cycle, there was a promise in it ... So I don't understand the meaning of the whole collecting mentality ... These things were taken away from people and were not allowed to simply die their natural death ...

When I tell people about that, [I explain] it like [this]: If you had a gold watch in your family and you had heard about this and you knew it belonged to your family and you went into a museum and there it was, you would be outraged. You would go, 'But that's mine! That's my family's! A part of my life is missing 'cause I didn't have access to that.' And not only that, but if you take an item like a gold watch and you show it to an old person they go, 'Oh, I remember when,' and this whole text comes out. So I said, last [spring] in the *Interventing the Text* [conference], 'You have participated in a five-hundred-year-old book burning of Native peoples' literature because these artifacts may stand for a paragraph or more [of] text, or maybe a whole book. And what you've done is take that away, put it in a museum. There's no access to the stories that go along with that. [They're] lost. They don't get passed on because people don't have the item to trigger them – like a signpost.'

In 1989 *Preservation of a Species: The Warshirt Series* was exhibited along with the installation *Preservation of a Species: Deep Freeze* (Figures 71 and 72) in the show *Beyond History* at the Vancouver Art Gallery. As the title suggests, *Deep Freeze* continues Cardinal-Schubert's critique of institutions that consign Native peoples to a freeze-dried past while freezing out those who would propel their culture into the future.[23]

23 An equally chilling parody of museum practice is *Still Life,* 1990 (Figure 73), the ironically titled clay and stoneware sculpture by Onondaga artist Peter B. Jones, which contests the callous display of Native human remains as if they were so much ancient pottery.

Sometimes, in order to prove that you are still alive, you first have to play dead. This is exactly what Saulteaux artist Robert Houle did in 1985 when he created his own mock museum installation, *Everything You Ever Wanted to Know about Indians from A to Z* (Figure 74). The work comprises twenty-six painted linen 'parfleches,' made in the manner of traditional Plains Indian rawhide carrying bags, laid out on a long, narrow, wall-mounted display stand. Stencilled along the top of the stand in alphabetical order are the names of twenty-six tribes. Below each name is a parfleche bearing a corresponding letter of the alphabet. Skilfully conceived, the piece simultaneously critiques every museum exhibition that has ever promised the ultimate Indian experience and every new set of encyclopaedias purporting to contain the last word on Native Americans. In both cases, what grates most is the implication of closure. As Houle has noted, 'What the White administrators of our cultural heritage seem to forget [is] that we are still living these cultures' (1988, 60).

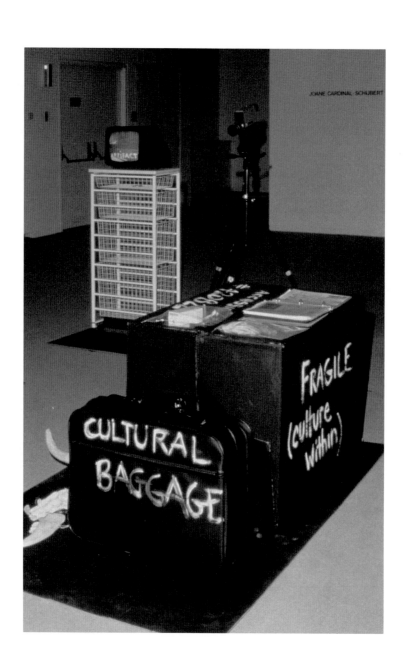

72
Joane Cardinal-Schubert
'Cultural Baggage,' detail
Preservation of a Species:
Deep Freeze

73
Peter B. Jones
Still Life, 1990
stoneware, clay, 51 x 47 x 19 cm

74
Robert Houle
*Everything You Ever Wanted
to Know about Indians from
A to Z,* 1985
acrylic, rawhide, wood, linen, approxi-
mately 46 x 993 cm, each parfleche
41 x 25 cm

As a former curator with insider knowledge of exhibition practice, Cardinal-Schubert takes great pleasure in flouting and frustrating established rules and regulations. She describes with relish a discussion she had with the staff of Calgary's Glenbow Museum concerning an earlier version of *Deep Freeze* that featured paper sculptures of oil-soaked birds and symbols of drug and alcohol abuse:

They said, 'Oh, we can't display that.' And I said, 'Why not?' And they said, 'Well, you know, a needle.' I said, 'It's a toothpick.' I started laughing. And then the conservation staff came in, and they had one of those guns where you glue everything down, and I knew this would bug [them]. And this is like an anti-museum piece – so was the one in Vancouver – 'cause I told them they could walk on it and touch everything. So it's fun. And they saw that needle and they went, 'Oh no!' Then they gave me this gun and they said, 'Glue it down.' And I said, 'Why?' I said, 'If they steal it I'll just sit in front of the TV and make some more ducks with newspaper' [laughs].

In fact, several components of the Vancouver installation of *Deep Freeze* were created from newspaper and tape 'because it's so anti-museum and it's so anti-conservationist.'[24] The piece also featured two rather ominous-looking black paper kites:

We used to make those kites when we were kids out of newspaper and two sticks, and it's like, 'Go fly a kite!' But they're also like banners. They're humorous, too, because flying a kite's pretty innocent, but then you put 'ABUSE' on it and it's a double whammy. It's a big surprise ... I also did it to interfere with people's perception because [the words on the kites are] out of their peripheral [vision]. It's a device I'm using a lot. I notice that I do it to make them feel slightly on edge – like when you can just see something peripherally out of the corner of your eye, then you kind of [suddenly look up] 'cause you don't know if it's going to fall on you or not.

In addition, a video camera and monitor with 'ARTIFACT' written on the screen in white paint allowed viewers to experience personal and cultural objectification firsthand. On a nearby black suitcase, 'CULTURAL BAGGAGE,' lettered in the same white paint, provided one of several visual and textual counterpoints.

..

24 Cardinal-Schubert's penchant for physically deconstructing and reassembling works in altered form does not endear her to those who invest art objects with a certain sanctity and who value product over process. Nor does her decidedly 'unprofessional' practice of assigning different works identical titles. She says with a grin: 'People are going to have fun with all that: "No, this is the one." "No, but it says it's this size." [When I was a curator] I was in charge of the permanent collection and we had a big problem identifying works. If we didn't have the size, the title, the media, we couldn't figure out which works were which pieces. And they all had different numbers on them. So part of that is [laughs] I'm mad at the system. It's funny [but] nobody's going to laugh for a few years.' Compare Ron Noganosh's story about teasing a conservator at the Canadian Museum of Civilization, p. 271.

The frequency of acrid humour in Cardinal-Schubert's work might lead viewers to conclude that its presence is the result of a deliberate aesthetic strategy. They would, however, be mistaken. The artist insists that 'the humour is not a strategy. The humour is just there ... I can't do anything about it. It's been with me for a long time ... It's a part of who I am. And I got into a lot of trouble for my sense of humour, all my life. It always seemed to go too far [laughs] ... If I say something, just a statement about anything, I always put a twist on the end of it, I notice.'

Not surprisingly, Cardinal-Schubert's fondness for mischief and counter-convention spills over into her public speaking:

I hate artists' talks because they're about the 'thing,' not about why they made the thing or all the things surrounding the thing, or what's behind it [laughs]. So I made up my mind that I was not going to talk about any art theory or history or anything other than my own *personal* thing ... I don't talk about the work so much as experiences I've had that would parallel things that I'm doing in the work, exactly the way I've been talking to you, Allan ...

I do the same thing with these [talks] as I do with my installation pieces. [At the Ontario College of Art] I went up on the stage and I had that 'CULTURAL BAGGAGE' suitcase, and I went like this, 'Boom!', and everybody went, 'Te-he-he-he-he!' And then the first thing I said was really heavy duty. And then they all felt guilty for laughing. And then I said something funny, so then they went, 'Oh, it's okay to laugh.' And then there was a point where they didn't know whether to laugh or not to laugh. Then they decided it was okay to laugh. And after you sort of relax a little bit, when you've been speaking a fair amount, then you begin to pick up stuff coming back. It's really interesting. It's actually fun. I never thought I would say this about public speaking. God! It's performance, I know it is ... [and] there's no safety net in this kind of stuff.

Each performance, like each installation, is likely to include fragments of earlier ones. In the course of our conversation, Cardinal-Schubert read me the text of one of her favourite and most amusing performance pieces. As a modern-day allegory it summarizes much of her creative philosophy:

'I knew things would change. Things *have* changed, but I have affected that change. I play in my studio. I play in the galleries looking under rocks and logs. I stir things up. I lift things, looking under rotting carcasses. I watch people cleaning the art chickens, spilling out their guts, picking out their hearts, livers and gall bladders, holding them up, turning them in the light, trying to understand how their functions fit into their shapes. I read their reports they write about their discoveries – about *their* discoveries. Sometimes I enter into the art chicken house. I once came close to being the one whose tailfeathers were all pecked out by the other art chickens, but I acted in an unexpected way. I didn't run. I turned around to face them, exposing my weakest part, my eyes.'

Then I wrote, 'I am looking and I am seeing with the eyes you taught me to use.'[25] So, I think that's funny. It's horrific but it's funny. When I was a kid I used to watch my mother cleaning chickens.

..

25 This statement appears in another one of Cardinal-Schubert's *Preservation of a Species* installations, *Preservation of a Species:* DECONSTRUCTIVISTS *(This is the house that Joe built),* 1990, exhibited in *Indigena.* See McMaster and Martin (1992, 135).

'Art chickens' aside, probably the best-known museum-critical performance by a Canadian Native artist took place during the winter of 1988 when Ojibway performance artist Rebecca Belmore installed herself as *Exhibit 671B* (Figure 75) alongside the Trans-Canada Highway outside her home town of Thunder Bay, Ontario.[26] Wrapped in blankets and seated within the framework of a mock museum display case, she silently proclaimed herself a 'living artifact' as the Olympic torch bearer and attendant media passed by en route to Calgary, where the Glenbow Museum's exhibition of historical Native artifacts, *The Spirit Sings*, was being touted as the flagship cultural event of the Winter Olympics.

Many believed that the exclusion of contemporary work from the exhibition perpetuated the notion of Native peoples and Native art as quaintly and inextricably historical.[27] A more volatile and controversial issue concerned the sponsorship of the exhibition by Shell Canada, a company to whom the government of Alberta had awarded drilling rights on lands claimed by the Lubicon Lake Cree. Negotiations to settle their claims had dragged on for years and left the community impoverished. Anthropologist Charlotte Townsend-Gault writes: 'The components of Rebecca Belmore's museum installation for the museum without walls – frame, pose, gender, site, audience, and the temperature, punitive only to those who lack the skills to cope with the Canadian winter – combined to make it more than art-smart and therefore comfortingly co-optable. Mutely eloquent, it fused the apparently stultifying hopelessness of the Lubicon situation with an ironic refusal of a "history" without time, social context, or human beings' (1991, 66).

Like Belmore and Cardinal-Schubert, Carl Beam also examines museum practice through critical parody, but in a different manner again. His self-contained shadow-box installations, *Big Koan* (Figure 76) and *Chronos 2* (Figure 77), both from 1989, ironically recall the form and function of ethnographic displays that locate Native peoples in natural history galleries, there to be endlessly analyzed and theorized along with other carefully classified exotica. A less obvious contrast is created between Euro-American scientific enquiry and Native American intuitive understanding. It is a theme that runs through much of Beam's work.

..

26 An in-joke, 671B is the Liquor Control Board of Ontario number for Brandevin, a locally favoured cheap wine. Belmore says that after the performance was written up in the Thunder Bay newspaper she went to the shopping mall 'where everybody hangs out drinking coffee – all the people who are unemployed and all the Native people – and a lot of them were laughing 'cause they said, "Hey, 671B!" So they got the joke [laughs].'

27 In direct response, *Revisions,* a counter-exhibition of contemporary Native art curated by Helga Pakasaar, was mounted at the Walter Phillips Gallery in Banff, Alberta, during January 1988. Among the featured artists were Cardinal-Schubert, Edward Poitras, and Jimmie Durham. A catalogue to the show was later published. See Pakasaar (1992).

Seriously Speaking
Rebecca Belmore

Ojibway performance artist Rebecca Belmore talks about using humour to convey serious messages, 25 February 1991.

I think [in] a lot of my work I use humour very strategically – as a tool. And when I perform – I perform in gallery spaces which [have] a predominantly non-Native audience, but I also perform a lot in [Native] friendship centres and a space where there's lots of 'skins' [laughs]. And just the difference – like doing the same piece in one place, say the non-Native space, they don't know when they're allowed to laugh. They're afraid of laughing 'cause they're afraid they're going to commit a taboo or … 'cause they don't feel comfortable. Or it's too dangerous maybe for them to laugh. Whereas in a friendship centre – I love working there because … people just howl in their seats, and there's ranting and booing or hissing, carrying on in the audience. So it lets me know that they're alive. 'Hello, is there somebody out there?' And there is.

And a lot of time, the work I'm doing has a serious message somewhere in it but there's a lot of humour. I think I use it as a tool to get people to feel comfortable, to not be afraid. So, it's a sneaky way, I think, of bringing people with me and allowing them to come in. And then laughing at ourselves – 'cause I think as Native people, to laugh at our-selves has been a source of strength, because when things get really bad at least you can laugh about it. I guess it's a healing thing, the humour. Definitely.

I come from a big family and we're always trying to outdo each other with jokes and bugging. There's lots of teasing. It never quits … I have seven brothers and two sisters so when we get together at Christmas its like a contest to see who can outdo [the other, to see] who wins! – 'cause somebody's got to win. [It's] a contest [to] see who can be the funniest and get the most laughs …

[When] I do work in a non-Native space and have non-Native people watching me … I think the humour works in a different way, in that it's not … a natural thing. Those costumes were quite ridicu-lous that I was wearing [when I per-formed at the Canadian Museum of Civilization] – the 'horse dress' and the 'power dress,' the 'electric dress' – so people are kind of taken with the nov-elty … And the humour works – the way I think it works – I'm not sure 'cause I didn't ask anybody that [laughs] – the way I think it works is that what I'm trying to say to people is, 'This is funny. Let's laugh! This is really stupid. This is quite silly. These stereotypes are really, really silly, aren't they?'

And so, in a sense, I'm trying to say it's okay that we've made these mistakes – 'we' meaning the collective Canadian culture [that] stereotypes Indians in this way. So, it's okay, we can laugh at this because we know how ridiculous this stereotype is. 'Ha ha ha ha ha, isn't that ridiculous!' … So, in that way I guess what I'm trying to do, what I'm trying to say is, 'It's okay,' from my perspective. The history that I've been taught has been ridiculous – who Native people are, what their contribution to Canada has been – and I'm giving them a chance to agree with me. So it's like, 'Yes, it is ridiculous.' And so the humour helps me to do that, and then at some point I can suggest something else, something more serious beyond the humour. So I use the humour as a mask almost.

I think I'm using it as a way to make people laugh, but I have something serious to say as well 'cause it's not all funny. I'm not just trying to make people laugh. I'm trying to make them think … And I guess I don't see a mask for my purposes as hiding something, because I think as an individual, as a performance person I wear many masks. That's sort of my role as a performance artist – to wear different personas, whether it's acting like a fool, like the horse dress – that's kind of foolish, like the fool – but yet, in that fool there's a lot of wisdom. There's a very serious side that people may not at first glance see. So that's how I mean 'mask' …

My family are predominantly non-speakers of the Ojibway language so I can't really reflect on [linguistic humour], but at the same time I know a lot of people and I've been round a lot of people who speak the language and they're definitely laughing at something [laughs]. I don't know if they're laughing at me – that's always a fear! [laughs]. But it is interesting that cer-tain sayings – for example, around northwestern Ontario [among] the Ojibways, there's a lot of 'Aaaaayy,' this sort of sound that precedes the laughter … Like, they'll say something and I'll hear them go, 'Aaaaayy,' and then they'll start laughing. It's like this thing that lets everybody … know that it's time to laugh, almost like a cue of some sort. It's done naturally. And so as non-speakers, my family, we always tease people who speak by doing that, mocking them

almost, because we can't understand what they're laughing at. But we can make fun of them.

Taking the stereotypes and reworking them is what I do a lot ... It's so funny. It's really quite funny. And to see the humour in the stereotyping of Native people and to invite people to laugh so that we can all say, 'Yes, that's funny.'

'It's stupid.' 'What's reality?' So that's the next natural question to ask. Which is when you sort of *punch* them [laughs]. A lot of my humour ... comes from a negative thing – taking the stereotype and reworking it.

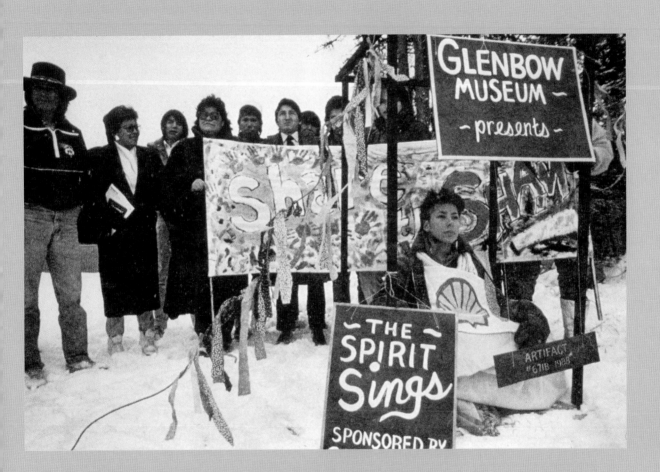

75
Rebecca Belmore
Exhibit 671B, 12 January 1988
performance, Thunder Bay Art Gallery,
Thunder Bay, ON

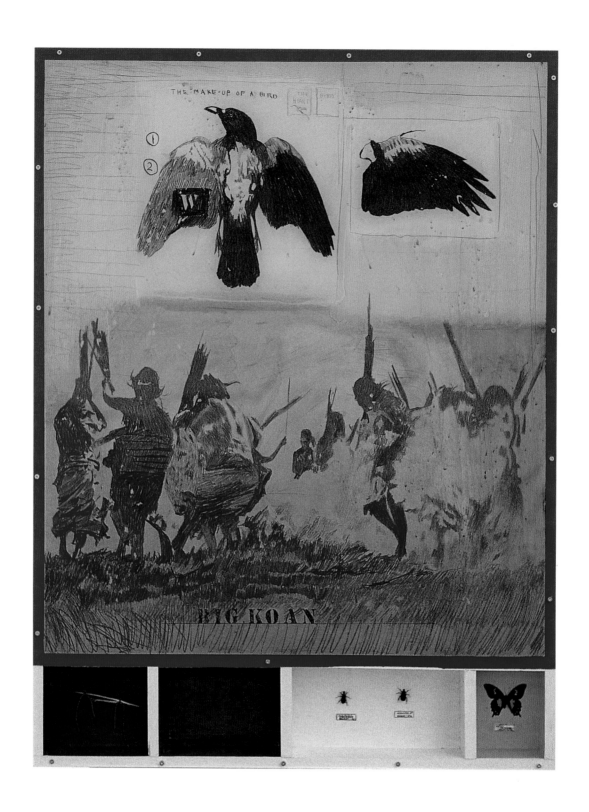

76
Carl Beam
Big Koan, 1989
mixed media on Plexiglas, 122 x 91 cm

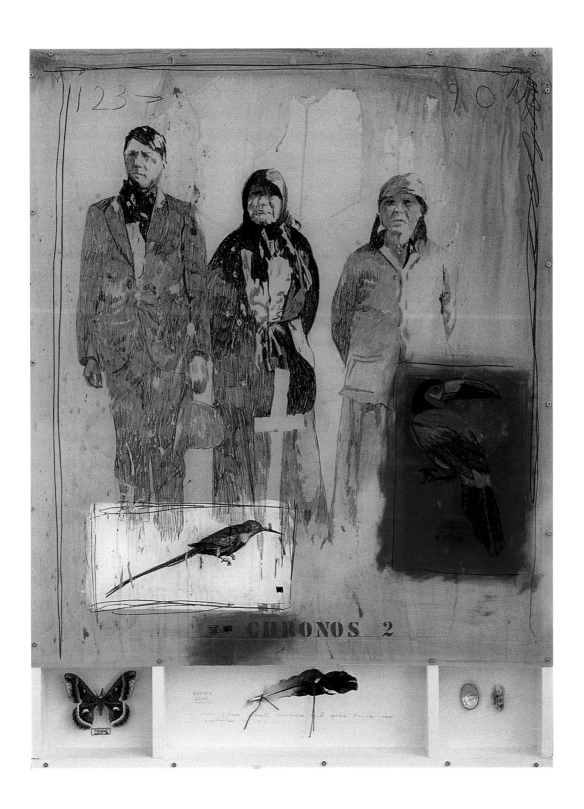

77
Carl Beam
Chronos 2, 1989
mixed media on Plexiglas, 122 x 91 cm

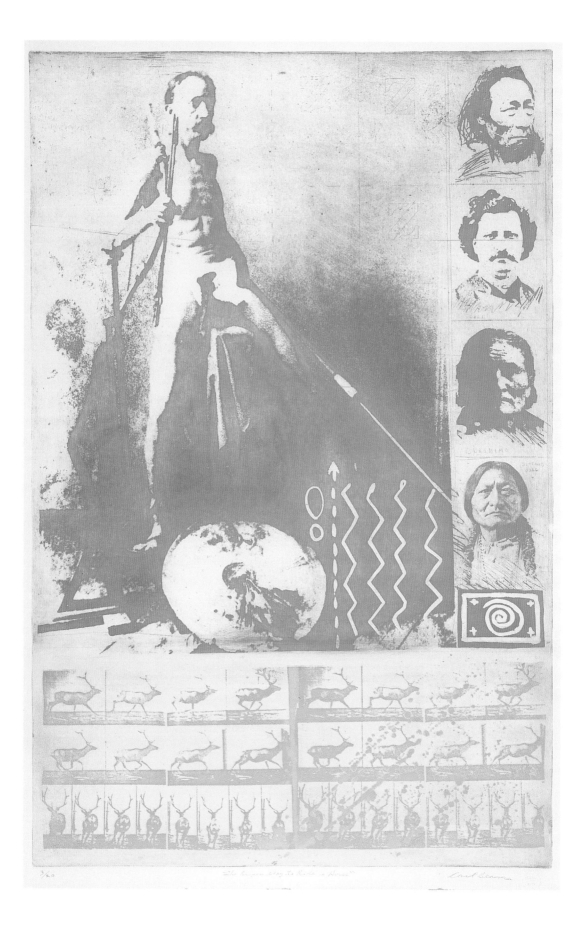

3/20 "The _____ Way to Ride a Horse" Carol Lemon

The power to make meaning from juxtaposing objects and images is at the heart of Beam's art, especially his installations. It derives more from traditional shamanic practice than from mainstream art making. Like Vizenor, who says that he's not a shaman but understands the energy (in Bruchac 1987, 299), Beam professes a similar understanding:

Installation is a shamanic activity – the technique is shamanic. It emphasizes object placement and how objects dialogue with one another ... Things have a power in and of themselves. Any [traditional] teacher would know about that, and any Western philosopher would acknowledge the idea of a peculiar emanation. The task of the artist is to set up a dialogue between objects. The underlying premise is that, if you do this thing properly it will elicit the exact response that you want from people. If you don't do it properly all you're setting up is something interesting which has no special direction.

Beam most enjoys creating pieces that challenge and engage the viewer, whether mixed-media installations or their two-dimensional counterpart:

The works are like little puzzles, interesting little games. Nobody can live with an unconstructed puzzle before them. It's a nice game. Other people don't present puzzles; they're preachy. I care about what people ultimately think ... My work is not fabricated for the art market. There's no market for intellectual puzzles or works of spiritual emancipation. I play a game with humanity and with creativity. It's superior to indoctrination ... My works are a series of notes to oneself; they're autobiographical. They let viewers in on the game of interaction ... the game of dialogue. I ask viewers to play the participatory game of dreaming ourselves [as] each other. In this we find out that we're all basically human.

With such an affinity for intellectual gamesmanship it is no wonder that Beam finds the concept of 'koan' appealing. It appears in the title of Figure 76 and several other works.[28] The dictionary defines 'koan' as a 'riddle used in Zen [Buddhism] to teach inadequacy of logical reasoning.' Beam himself sees it as 'something that subverts and forces you to look where you're going while walking, as you proceed through life.'

The critical revision of ethnographic representation evident in the installations discussed above is given more overt, even hilarious expression in the etching *The Proper Way to Ride a Horse* (Figure 78), elsewhere titled *Riding Demonstration,* from Beam's *Columbus Suite* series. His irreverent and ironic re-imaging of late-nineteenth-century anthropologist Frank Hamilton Cushing is certainly 'something that subverts.' It is a picture of sweet revenge. Commenting on this print, curator Amelia Trevelyan (1993, n.p.) writes:

Cushing and his fellows collected thousands of examples of Native material culture and put them on display, wholly out of context, in the columned stone vaults that were the

78
Carl Beam
*The Proper Way to Ride
a Horse,* 1990
etching on paper, 109 x 84 cm

28 Beam's twenty-piece *Koan Series,* 1986, was featured in the Canadian Museum of
Civilization's 1988 travelling exhibition, *In the Shadow of the Sun,* and is illustrated
in colour in the German catalogue to the show. See Hoffmann (1988, 382-3).

Natural History museums of that era. There, the objects were ogled for hours by east-erners – exotic evidence of a strange and mysterious vanishing race. In this photograph, Cushing was demonstrating the dress and gear of a Dakota Sioux warrior. Removed from the context of a scholarly text, it becomes ridiculous, if not perverse in its feeling – a grown man on a hobby horse and almost nude, an adult playing Cowboys and Indians with his clothes off.[29]

Not only is Cushing made to look foolish and misguided – all the more so when his image is viewed alongside the faces of revered nineteenth-century resistance fighters Big Bear, Louis Riel, Geronimo, and Sitting Bull – but, by extension, the entire practice of science, social and otherwise, is brought into question.[30] The time-lapse photographic study of an elk running across the bottom of Beam's print is a fleeting reminder of technology's inability to capture the true nature of the beast. Or, for that matter, any other beast. Trevelyan adds: 'How much more do you really know about ... [an elk] after scientific examination, dissection and analysis? Can you talk to him? Does he speak to you? Is what you have learned more valuable or useful than the kind of fundamental knowledge garnered by Native peoples that not only involved the ability to utilize each part of the animal to support their existence, but included a sense of their own relationship to each species and to all of nature?'

As will be recalled from the last chapter, Gerald McMaster and Carl Beam shared a boyhood fascination with cowboys, which eventually led McMaster to create *The cowboy/Indian Show* series and Beam to include *Self-Portrait as John Wayne, Probably* in his *Columbus Suite*. There is a further similarity between the two series. McMaster's painting *Cowboy Anthropology* (Figure 80) is no less an indict-ment of academic activity than Beam's *The Proper Way to Ride a Horse*.

29 More recently this image has been recontextualized in *Reminiscing Cushing* (Figure 79), one of forty-three drawings in the exhibition *A Zuni Artist Looks at Frank Hamilton Cushing: Cartoons by Phil Hughte*, originating at the Maxwell Museum, University of New Mexico, in 1994. In the book of the same title, the cap-tion accompanying this drawing reads: 'An elderly Zuni is reminiscing about Cushing and some of the funny things he did. He is talking about the time Cushing dressed as a Plains Indian and had his photo taken' (Hughte 1994, 102). In the video *The Other Side of the Story*, Hughte, who died in 1997, himself reminisces about the exhibition and the controversial anthropologist, who spent time at Zuni Pueblo in 1879-84 (Sneddon 1994). See also Jojola (1995).

30 In his article 'In Our Own Image: Stereotyped Images of Indians Lead to New Native Artform,' Mohawk artist/curator Richard Hill discusses how historical studio portraits of defeated warriors (such as those featured in Beam's *The Proper Way to Ride a Horse*) have in recent years been recovered as potent symbols of survival and 'the contemporary Indian desire to retain cultural values for the next generation' (1989, 34).

79
Phil Hughte, Zuni Pueblo
Reminiscing Cushing
black ballpoint pen cartoon on paper,
41 x 30 cm

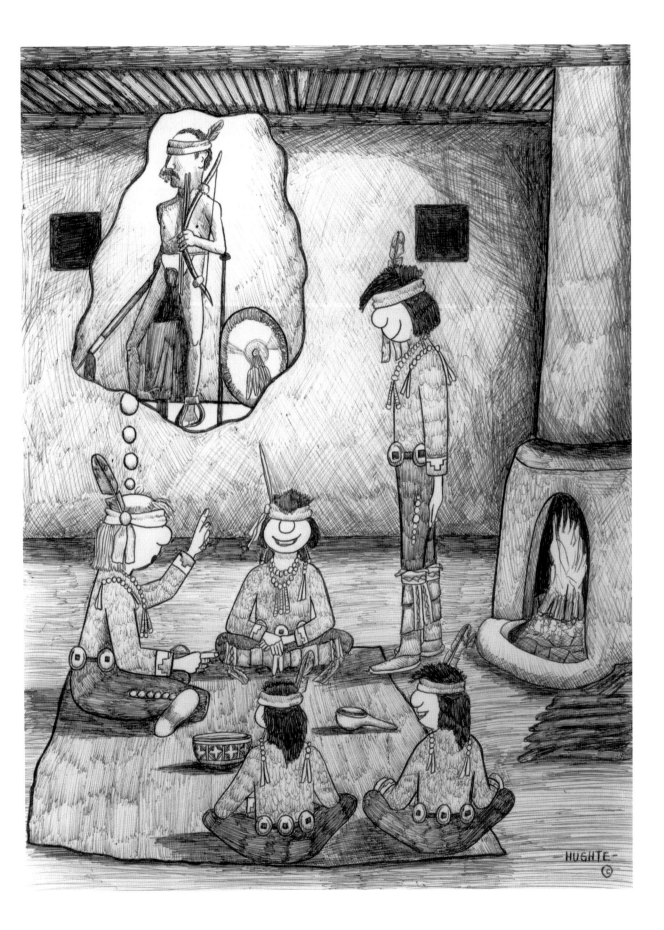

Cowboy Anthropology has the look of a page from a field study notebook enlarged for closer scrutiny and analysis. At first glance the seemingly random assortment of textual fragments and quick sketches of cowboy attire suggest the practice of anthropology as it might be applied to the culture of cowboys, as it might be practised by an Indian anthropologist.[31] This would be a novel reversal of a traditional anthropological endeavour – the study of Indians – but novelty is not the principal theme here. Critique is. And it is a hard-hitting critique that turns on ironic use of language. The word 'cowboy' is not posited as a potential *object* of anthropological enquiry but as an accurate description of the enquiry itself. McMaster says that

80
Gerald McMaster
Cowboy Anthropology, 1990
acrylic and oil pastel on matt board,
116 x 96 cm

in a lot of books about Native peoples there are rarely personalities in there. It's the study of 'Man,' not the study of individuals. It's the study of the structures. And this whole notion of 'informants' – it's always a one-sided exchange. 'Come on, give me the information.' What is there in return to give back? Here [in this painting] is the notion of 'the cowboy' going in there ... This is the notion from the Native perspective – this insensitive person using our information. Native peoples are very guarded about what they ... say to anthropologists.

[But] there's a range of anthropologists. I think there are good to bad, sensitive to insensitive. There's a certain group of interpreters. Again, there's this notion of the power structure, of control and scientific interpretation ... In the middle of this century it was the Indian agent who wielded the power. He's the one who got you admission to the reserves. Somehow there was never control by the Native people themselves. There was always the gun there. Whether it was pointed at somebody's head or whether it was invisible, there was still that notion of power.

What I'm hearing from anthropologists recently is: 'Our profession is in jeopardy but, at the same time, it can be a source of assistance to a lot of Native peoples.' The issues that seem to be raised most often at this point are litigation and land claims. What I'm concerned about is that I think anthropologists should be open for criticism. 'Anthro-apology' [lettered on the painting] – I think it has a lot of meaning. So you take criticism ... you apologize for what you've done ... What's the next stage? ... Does anthropology up and disappear? Does it continue? What's the next stage of development in anthropology? How is it going to deal with the subject? How are Native peoples going to be dealt with from now on?

31 The image includes a body of handwritten text excerpted from A.E. Hoebel's textbook, *Anthropology: The Study of Man:* 'The student who cannot put aside all chauvanistic [sic] ethnocentrism can never become a first-rate cultural anthropologist' (1972, 28). Having practised a form of 'turnabout anthropology' in his painting and writing for some time, McMaster earned an MA in the discipline from Carleton University in 1994. His thesis was titled, 'Beaded Radicals and Born-again Pagans: Situating Native Artists within the Field of Art.' Cf. Holden (1976, 293).

An even more subtle critique of anthropology and the social sciences is played out in the cosmic drama depicted in the first panel of *A Sacred Prayer for a Sacred Island* (Figure 81), the mixed-media triptych created by Jane Ash Poitras for *Indigena*. In a generous act of charity befitting a compassionate trickster, the artist portrays a quartet of winged shaman spirits descending from the heavens into the lower world on a sacred mission of recovery. The object of recovery, it turns out, is a party of renowned academics (among them Ruth Benedict, Emile Durkheim, and Edward Sapir), whose collaged photographs are shown encircled by 'shields' of personal and professional identity. With a grin Poitras says: 'They're saving the souls of these famous anthropologists because at least we owe them that for what they did for us. It's the most humorous piece. If you want your humour, it's there. If that isn't a Weesakeejak at work what is it? The Indians get it, the ones who know their traditions and their teachings. [Ojibway artist] Norval Morrisseau, if he saw this, he would giggle.'[32]

Like McMaster, Poitras is not yet ready either to give up on anthropologists or to dismiss their positive contributions. Luckily, they, or we, are not considered beyond redemption – though definitely in need of it. Like McMaster, Poitras offers anthropologists an opportunity to atone for past mistakes and work more closely with Native peoples toward mutually beneficial goals.

Deirdre Evans-Pritchard has written: 'Anthropologists have often been unaware of pointed critiques of their own behavior. They can be oblivious to "native" opinions of them, partly because people naturally avoid criticism and partly because social scientists expect to observe indigenous cultures in context – not to be observed. In this sense, fieldworkers are tourists and the two share characteristics that become the butt of Indian jokes and stories that ridicule collectomania' (1989, 91). The author goes on to cite one such story collected by Barre Toelken (1977, xi-xii). It is a little dissident narrative of the coyote kind:

81
Jane Ash Poitras
A Sacred Prayer for a Sacred Island, first of three panels, 1991
mixed media on canvas, 188 x 127 cm

..

32 Celestial intervention with similar humbling intent is also the subject of Cree singer Buffy Sainte-Marie's 1974 composition, 'Moonshot':

An anthropologist, he wrote a book
He called it *Myths of Heaven*
He's disappeared, his wife is all distraught
An angel came and got him

Off into outer space you go my friend
We wish you Bon Voyage
And when you get there we will welcome you
And still you wonder at it all.

Poitras's piece also recalls, if unintentionally, the quartet of trickster elders whose mythic adventures and benevolent actions feature prominently in Thomas King's 1993 novel, *Green Grass, Running Water*. See p. 23 n. 16.

Anthropologitis
Peter Blue Cloud
(Aroniawenrate)

'Anthropologitis,

Is what the men got accused of having
by their girlfriends, wives and sisters.

'Oh, she had honey-colored hair and
long, white legs which were ever eager
to clutch a man in need. She couldn't
help herself, she loved her "informants,"
each and every one without prejudice.

'She was like having a nice juicy melon
in the middle of winter, or like hearing
the sweet downriver flute music for the
first time.

'But as they say in college: alas and
alack, she had one fatal flaw: she re-
interpreted all of the information she
received to fit into her own thesis. Yes,
she really wanted that doctorate.

'So of course the women of the village
sent a runner to fetch me. And not
being one to turn down a challenge, I
led the runner a merry backtrack.

'One night of love became three and
four. Not to be bragging, but, what
woman can resist Coyote with such a
skilled love probe?

'So by the time I was ready to head out
of there, so was she. I led her here and
there in the mountains and desert, all
the while re-programming her. I showed
her the real meaning of existence.

'She may never get her doctorate, but
what's wrong with Coyote's Master of
Fine Love Degree?

'So, since this is my first visit to your vil-
lage, I thought I'd let you men know
that if you ever have any woman prob-
lems, I can probably help you solve it.'

'Coyote, we think you're full of shit!'
said one.

'Yes, many people think that. We're all
entitled to our own opinions, aren't
we?'

On the Warm Springs Indian Reservation in central Oregon, some people tell a story about a wandering anthropologist who came across a coyote caught in a trap.

'Please let me out of this trap; if you do, I'll give you lots of money,' the coyote said.

'Well, I'm not sure. Will you tell me a story, too?' asked the professor.

'Sure I will; I'll tell you a real, true story, a real long one for your books.'

So the anthropologist sprung the trap, collected a big handful of bills from the coyote, and then set up his tape machine. The coyote sat, rubbing his sore legs, and told a long story that lasted until the tape ran out. Then he ran off.

The anthropologist went home and told his wife about what happened, but she wouldn't believe him. When he reached in his pocket to show her the money, all he came out with was a handful of fur and dirt.

And when he went to play his tape for the other professors, all that was in the machine was a pile of coyote droppings.[33]

Evans-Pritchard says: 'Replace the tape recorder with a camera, and one has a tourist' (1989, 92). She could just as easily have said, 'Replace the tape recorder with a camera and one *still* has an anthropologist.' Like tourists, anthropologists are visitors to Native communities, and often guilty of the same irritating habits and consumer mentality. Mohawk artist Richard Hill has observed, 'Nearly all Indians have been asked to "pose" for a visitor's camera, and the visitor leaves with his personal image of "real, live Indians"' (1989, 35). Elsewhere in the same article he writes: 'Every Indian community has loads of funny stories about the tourists they had tricked, and ... the photographs which scholars published, despite their claims to the contrary, when they asked for permission to photograph. Stories about White photographers entered tribal oral histories and the camera became the latest weapon to be used against Indians ... The camera was an intrusion on Indian life. The photographs were taken for outside interests, by outside people, outside of the needs of Indians themselves.'

But not always. In 'Burlesquing "The Other" in Pueblo Performance,' Jill Sweet describes an incident in which a Pueblo clown borrows a visitor's camera to reverse the usual photographic process: 'The clown became the tourist with

33 This story is now arguably as much a part of anthropological oral history as it is of Indian folklore. Peter Blue Cloud's more recent coyote caper, 'Anthropologitis,' and Thomas King's 'One Good Story, That One' (King 1993b, 1-10) may yet achieve the same mythic status in contemporary literature. Vine Deloria Jr's devastating satire, 'Anthropologists and Other Friends' (Deloria 1969, 78-100), may be there already.

82

Harry Fonseca
Wish You Were Here, c. 1986
acrylic on canvas, 61 x 76 cm

camera while the tourist became the photographic subject' (1989, 71).[34] In the pen and ink sketch *Tourists* (Figure 84) and the pastel drawing *Strange Rituals* (Figure 85), Mohawk artist Bill Powless accomplishes similar playful reversals.[35] As effective a piece of 'trick photography' is Jim Logan's ironically titled painting, *It's a Kodak Moment* (Figure 86), which cleverly foregrounds the camera's complicity in the process of visualizing 'otherness.'

...

34 *Wish You Were Here* (Figure 82), California Maidu artist Harry Fonseca's iconic image of Coyote in the pueblo, seems to capture the spirit of this act perfectly. For a brief moment, cultural tourism is co-opted, its abrasive sting temporarily neutralized. In the several versions of this scene that Fonseca has created over the years Coyote invariably sports a flashy 'Hawaiian' shirt (see also Littlebird 1981, 11; Lippard 1990, 207). Standard tourist attire, the brightly coloured shirt may also be a sly sartorial reference to the artist's mixed Maidu Indian/Portuguese/Hawaiian ancestry. When it is patterned with watermelon slices, as in a 1988 advertisement for October Art Ltd. (*American Indian Art Magazine* 14 [1]: 88), one is hard pressed not to think of the watermelons carried about by the playful Pueblo clowns. This doubled trickster reference is made more overt in the paintings *Koshares with Watermelons* and *Koshare with Cotton Candy,* in which Coyote assumes the persona of the clowns themselves (in Wade 1986, 268).

To explore the comic dimension of lived reality better, Fonseca has created a distaff counterpart to his hip and handsome macho Coyote. Affectionately named Rose (Figure 83), her amusing adventures and exploits are every bit as outrageous and entertaining as those of her shameless male soulmate. On occasion the two can be seen together selling curios to tourists at the Santa Fe Indian Market, attending an opening at the Heard Museum in Phoenix, dancing a *pas de deux* at the ballet, or performing a duet at the opera. In all of this they affirm a vital and vibrant Native American presence in contemporary society. See Archuleta (1986).

While not the only American Aboriginal artist to utilize humour in his work, Fonseca, through his Coyote alter-ego, is certainly one of the better known. In 1986 the Natural History Museum of Los Angeles County mounted a major retrospective of his work titled *Coyote: A Myth in the Making.* See Archuleta (1986). In 1995 Fonseca participated in the touring exhibition *Indian Humor,* organized by American Indian Contemporary Arts of San Francisco. Notable among the thirty-seven other artists taking part were Richard Glazer-Danay, Nora Naranjo-Morse, David Bradley, Jean LaMarr, and Robert Freeman. See Bates (1995). Not included in the show but deserving of mention for their frequent use of a comic/ironic perspective are Jimmie Durham, Bob Haozous, James Luna, and the late T.C. Cannon. See Mulvey (1995), Kenagy (1990), Farmer (1994), and Frederick (1995) respectively.

35 Playful reversal and the puzzling habits of non-Natives have long been staples of Oneida actor/comedian Charlie Hill's popular stand-up comedy act. Speaking to an audience gathered in Winnipeg, Manitoba, for the taping of the television special *Indian Time* (Devine 1988), Hill said:

We've got to hang together – white folks and Indians – 'cause someday the government might take *your* land away. *You* might get a call in the middle of the night [knock, knock, knock!]: 'You white folks got ten minutes to get to the truck, move to the Caucasian reservation' ... Every summer busloads of tourists with cameras would be coming to your homes [saying]: 'Are you really white people? [Would] you do some of that disco and bowling stuff? I'd really like to take your picture. How do you survive in these suburbs?'

For more on Hill, see Churchill (1979) and Uncompromising (1993).

83 (facing page)
Harry Fonseca
Rose and the Res Sisters, 1982
lithograph, 76 x 56 cm

84 (above)
Bill Powless
Tourists, 1982
pen and ink on illustration board,
41 x 51 cm

Perhaps the wryest example of photographic legerdemain, and clear evidence of Coyote's command of the camera, is Edward Poitras's visual commentary on the 'colouring of North America.' *The Big Picture* (Figure 87), his large, back-lit Cibachrome photograph of three figures standing outside the New Utopia Cafe in Regina, Saskatchewan, 1991, is notable not only for its literal/metaphorical title but for the fact that Poitras did not actually take the photograph. As a conceptual artist, he came up with the idea for the piece but his friend, Don Hall, tripped the camera shutter. (So who is the photographer?) As Poitras's sole contribution to the *Indigena* exhibition, the piece quietly celebrates the continuing racial reclamation of the continent from its colonial past, while muddying any fanciful notions of artistic authenticity. It is a well conceived and nicely executed bit of trickster mischief.

In all of the cases discussed in this chapter, Native artists have challenged the representation of Aboriginal 'otherness,' contesting institutional structures that define aesthetic practice too narrowly and regard Native culture paternalistically. Working from within the structures themselves, the artists seek to question assumptions and expectations – what Vizenor calls 'terminal creeds' (1989, 188) – using 'the transformative tropes of parody, irony, puns, [and] paradox ... which by their very nature force an evaluation' (Galbo 1987-8, 40). At the same time, they have advanced alternative representations of both art and culture and introduced a sense of play into places where once there was none. All this turning around on purpose is clearly a trickster's business.

35 (facing page)
Bill Powless
Strange Rituals, 1978
pastel on paper, 51 x 66 cm

36 (above)
Tim Logan
It's a Kodak Moment, 1991
acrylic on canvas, 91 x 152 cm

The Big Picture
Edward Poitras

Métis artist Edward Poitras provided this artist's statement for the exhibition *Indigena: Reflections on Five Hundred Years* (in McMaster and Martin 1992, 162).

Twisted Coyote goes for coffee at the New Utopia. I stand on the curb of a street running east and west, in a city named Regina, named after the Queen after the treaties were signed. On the edge of a situation, best described as the colouring of North America. A twist in the century-old belief of the Vanishing Redman. A good colonial trick. Someone forgot to say the magic word, or was it said backwards? Backfiring, all the way to grandmother's real land. Immigrant step-children wanting to see her house, but the door is closing.

The sun shines, the grass grows, the rivers flow. Is the ink dry? Does any one have an eraser? I would like to sleep. Actually, it was my teacher who went to sleep. I can't. Too much coffee at the New Utopia. Back out on the street the sirens sing. It is named Dewdney Avenue after Edgar Dewdney, governor of the Territories, 1885. The year of the Indian and Métis Resistance, or the Riel Rebellion, depending on what side of the street you are standing, driving, or riding on.

I have a white, nine-hundred-dollar mountain bike with twenty-one gear combinations. I also have a good imagination. What do you call an Indian with a new bike? There are no mountains in Saskatchewan.

Inside the New Utopia there are many books to look at, or read, if you have the time. It's nineteen ninety-two, the quincentenary, for some lost Italian's accidental invasion of the Americas. Nothing to celebrate other than crimes against humanity, which is another story in this big picture.

Back to the street.

There is a book I am reading, *The Diaries of Edmund Montague Morris: Western Journeys 1907-1910,* Royal Ontario Museum, diary pages 145-146. 'Father Doucet tells me that Crowfoot was cunning as a fox and crafty and that Governor Dewdney (who began life as a prospector and was uneducated) was like a child in the hands of Crowfoot. He was without tact and wanted to get the Blackfoot to fight the Crees, which showed an absolute lack of understanding. Crowfoot in his heart would like to have wiped out the whites, but he was powerless. They had no means of support and the government was funding them. Mr. T.C. Wade of Victoria, the lawyer who was employed to investigate the Alaskan boundary dispute, in going over records in England, found that there was a secret agreement between the British and American governments to kill off the buffalo as that was the only way they could control the aborigines.'

Piss me off! I've been called many things before, but never have I been called an 'aborigine.'

Prior to receiving its current name, Regina was called 'Pile of Bones' (or 'Oskana Ka-ah-sustayki' in Plains Cree). Appropriate, considering its history, and this is part of my life?

So here I am, scratching my head, having another cup of coffee, wondering what the hell a couple of Indians, a Mexican, a Chinese, a White woman, and a Métis child have in common, other than being on the same side of the street in front of the New Utopia.

Twisted Coyote laughs and looks me square in the eyes and says, 'It's a post-colonial demonstration.'

We both walk out backwards more confused than ever.

4 | Subverting the Symbols of Power and Control

Coyote went east to see the
PRIME Minister.

I wouldn't make this up.

And the PRIME Minister was so HAPPY
to see Coyote
that he made HIM a member of
cabinet.
Maybe YOU can HELP us solve the
Indian problem?

Sure, says that Coyote,
WHAT'S the problem?

When Elwood tells this story, he
always LAUGHS and spoils
the ending.

Thomas King

The previous two chapters have examined various comic and ironic strategies employed by Native artists to counter outdated notions of 'Indianness' and outmoded systems of cultural and aesthetic representation. This chapter explores some of the ways in which political power and oppressive government policy have been contested and critically deconstructed. The artists' critique is at once playfully poignant and darkly satiric: an indictment of historical indifference and bureaucratic insensitivity, fuelled by anger yet tinged with a cautious optimism and hope.[1] Once more, parody and ironic recontextualization emerge as favoured modes of expression; and titles have never been so pointed.[2] Not surprisingly, what Gary Farmer calls 'toxic humour' is much in evidence.[3]

Still, toxic humour comes in varying strengths. Authority and power can be challenged in ways exceedingly sly and subtle. In 1983 Gerald McMaster created a set of three graphite drawings on paper – 'the postcard series' – which chronicle the

1 It should be remembered that satire is, by definition, a hopeful and optimistic mode of critique, in that it assumes the possibility of change in attitude or behaviour.

2 As Vizenor makes abundantly clear, while 'the trickster is as aggressive as those who imagine the narrative[s] ... the trickster bears no evil or malice in narrative voices' (1989, 13). It is a point that cannot be stressed too strongly.

3 Toxic humour, he says, is 'a form of humour based on toxicity. You have to laugh because there is nothing else to do *but* laugh at [the situation] in order to face the reality of it, in order to get past it ... If you don't laugh at it then you can't deal with it.'

travels of 'Indian Joe,' a figure conceived as an archetypal trickster/tourist who, like the artist, eventually journeyed to Ottawa.[4] There, in typical tourist fashion, he sent postcards home to friends, each inscribed with a personal message and a

When Farmer was interviewed at the National Arts Centre in Ottawa, he was in rehearsal for the role of Zachary Jeremiah Keechigeesik in Highway's 1989 award-winning play, *Dry Lips Oughta Move to Kapuskasing*. Early in our conversation he explained how he as an actor and Highway as a playwright strategically use toxic humour – in essence, a form of black humour – not so much to *undercut* serious-ness, as Zolten (1988, 135) would have it, but to *intensify* it graphically: 'For us to get to the point in that second act where the stark reality of the raping of Patsy Pegahmagahbow becomes so real ... in order to make the audience think about that realistically we had them, systematically, laughing at every possible bad scenario that could ever happen on a reservation. To me that is "toxic humour."'

In words that resonate with much of what other Native artists have expressed, he continued:

I love to make people laugh so that I can turn around and make them think. If they laugh, they're going in. They're going deeper. They're falling for the bait. It's like you bait it. It's like bait and you put it out there like a little snare, and they laugh and they laugh, and they're having a good time and they're having a good time, and they're really laughing and all of that information is getting in there. You're laying all the groundwork for all that information and then you come across with what you're really [saying] ... I mean ... the bottom. I mean we're talking about the *bottom*. It bottoms out and when it bottoms out ... it *stings* there. It burns an image in your brain. It just sits there and it'll sit there for a long time. I've seen people come to this play and they just can't figure it out. They're moved. Something is different about them from the time they came in [to] when they leave. There's something that burns there, an image that burns there, good or bad, it sits there and it makes them ponder about and think about the condition of these people [on the reserve] ... [Still] it's actually, I think, a story of hope ... As a human race we've all hit the bottom, and now it's time to move up to where there is hope in the world. We can turn all this around. It doesn't have to be like that.

Although Tomson Highway is fond of quoting, 'Before the healing can take place, the poison must first be exposed' (Longclaws 1989), not everyone saw this play as hopeful. Or for that matter, particularly amusing. Native women, especially, were appalled at the violence enacted on the young Patsy Pegahmagahbow, and insulted by the crude antics of the absurdly oversexed female Trickster, Nanabush. Saulteaux poet/activist Marie Annharte Baker writes, 'I have heard of Native women having nightmares for a week or feeling depressed after seeing *Dry Lips*; myself, I had to fight the downer I experienced ... It is a small comfort to see poison. I hope the cure doesn't kill' (1991b, 68).

4 McMaster says the series was based on the idea of

expanding your horizons through experience, and perhaps through experience you learn things. I think that Weesakeejak was like that, and ... this is perhaps what Indian people should be doing as well ... They can't go travelling all the time but I think, perhaps, based on this notion of the Trickster, and travelling and experiences, you're just not reserve-bound. You should be going out all over and meeting other Indians or anybody, and per-haps things might change ... Travel, open up your mind to different things and then you may have a different perspective on life. You're going to go through a lot of mistakes but that's where you begin to learn. And that was the whole notion of Trickster.

trickster signature.[5] His postcards, however, are not the usual capital fare. Their images do not celebrate dominion or ethnic exclusion but instead imagine symbols of the country as it could be, the nation as it might be.

In *Changing the Guard* (Figure 88), an especially apt and layered metaphor, an officer in the Governor General's Foot Guard is envisioned in braids and wearing a scalplock in place of military ribbons.[6] Behind him, the Houses of Parliament form a stately backdrop. Similarly, in RCMP *and Their World-Famous Dogs* (Figure 89), four of the five members of the military police force have their hair in braids. They are all Aboriginal. Suddenly, the popular 'Indian and Mountie' souvenir postcard is rendered passé by the 'Indian *as* Mountie' version.[7] More than the mere fusion of difference, or the echo of the Indian cowboy, these images imagine erasure of racial and cultural hierarchy. It is not for nothing that the Cree elder Vern Harper says McMaster 'has the Coyote spirit in him.'[8]

5 The friends in this case are the actual individuals who commissioned the drawings from McMaster. Here, the line between fiction and reality is effectively blurred.

6 Subtle as these visual modifications are, there is an even more elusive subversion of cultural privilege at work, or play, in the postcard's scripted message. Indian Joe's casual reference to having his picture taken by Yousuf Karsh, the internationally known Canadian photographer of celebrities and world leaders, imagines not only acknowledgment of Native achievement but inclusion in the inner circle of political decision makers as well. It is compatible with the picture created by Thomas King in his poem 'Coyote Sees the Prime Minister' (1990, 252), reproduced at the top of this chapter.

7 Plains Cree artist George Littlechild was similarly inspired to rework the well-known postcard image, but in a more overt manner. *Mountie and Indian Chief* (Figure 90), his wickedly deadpan lampoon of regimental rule, is arguably as memorable an image as any it purports to parody. Littlechild explains its creation:

Well, it was interesting, somebody gave me a postcard from Banff and it had the Mountie and the Chief [on it]. The Mountie was actually taller than the Chief so in my painting I reversed the role and made the Chief a little taller than the Mountie. And then I just started drawing and painting it in, and it was quite exciting because [of] the static pose of each individual engaging in this conversation. But it doesn't look like their mouths are even moving, so [there's] that intensity between the two individuals. [Then] I created the home of the First Nations man and the home of the Mountie and I put a little strip of mirrors between the two individuals [to ask] you, the viewer, 'How do you fit into what is going on here? What do you understand? Why is the Mountie there talking to the Chief, and why is this relationship going on?'

It's [also] demystifying the myth of the Mountie, and sort of poking fun, saying he's sort of like this clown, a little bit effeminate ... The Mountie is [supposed to be] this strong individual, the representative of the Queen of England who's here to jurisdict over the land and make order and law and peace. And here he's looking like this ... clown figure. At the time, I was feeling kind of angry because, who was this man anyway, that he imposes his wishes or his commands upon a whole race of people? And [we are expected] to sit back and say we accept that. Yeah, [in the painting] he's becoming ... like a gaudy doll, overpainted, overdone, [with] chalk-white skin, [and] with rouge and lipstick. [He's] sort of ... like a clown and not being taken seriously.

8 Both McMaster and Fonseca (Figure 82, p. 114 n 131) employ the Trickster/tourist
 concept as a comic metaphor, but to somewhat different ends. While Fonseca per-
 sonifies or gives physical form to a cultural attitude, McMaster imagines this atti-
 tude in action, portraying the subtly altered state of the world resulting from such
 action. In this, McMaster is possibly closer than Fonseca to Vizenor's concept of
 the Trickster as a 'doing' rather than a 'being.' This is a minor distinction, if, as
 Kenneth Burke attests, attitude is 'incipient act' (quoted in Hymes 1979, xvi).

88
Gerald McMaster
Changing the Guard, 1983
graphite on paper, 76 x 56 cm

89
Gerald McMaster
*RCMP and Their World-Famous
Dogs,* 1983
graphite on paper, 56 x 76 cm

190

George Littlechild
Mountie and Indian Chief, 1991
acrylic on paper with mirrors, 76 x 112 cm

The analogy of McMaster as Coyote can be extended. He has produced three critical portraits of Sir John A. Macdonald and one of Sir Wilfrid Laurier, both early Canadian prime ministers. The title of Thomas King's poem, 'Coyote Sees the Prime Minister,' therefore seems an appropriate description of this aspect of the artist's work. As the country's first prime minister and the man who introduced the legislation creating the oppressive Indian Act of 1876, Macdonald is a potent symbol of power and control.[9]

In 1985 McMaster portrayed him twice in the series *Riel Remembered,* a set of fifteen large graphite drawings on paper commissioned to mark the centennial of the North-West Rebellion.[10] The most distinguishing feature of these works is the use of proportional distortion to bring a fresh perspective to the subjects of archival photographs. It is a particularly good example of Hutcheon's concept of 'repetition with critical distance.'[11] *In His Hands He's Got the Whole World* (Figure 91) is perhaps the more memorable of the two Macdonald portraits in the series.[12] It depicts the prime minister with the large floppy feet of a circus clown and a head so small as to lack the ability to perceive the world rationally, let alone to apply sound judgment. In his right hand Macdonald holds an orb symbolizing the power he failed to exercise wisely over the peoples of the West. The title of the piece reverses the order of the words in the title of a popular gospel song to suggest that Métis leader Louis Riel was not the only leader suffering from delusions of divinity.[13]

..

9 In the three decades following the establishment of the Dominion of Canada in 1867 Native peoples were subjected to a series of increasingly repressive and essentially racist acts of federal legislation meant to facilitate the process of 'civilization.' The most comprehensive of these was the Indian Act of 1876, which consolidated many of the earlier laws respecting Indians. As a consequence of legislation, Indian identity was arbitrarily defined, questionable treaties were concluded with Indians in the West, divesting them of much of their land and forcing them onto reserves, cultural practices such as the Sun Dance and the potlatch were declared impediments to progress and subsequently banned, elected band councils were imposed to subvert traditional leadership, private property was introduced to counter communal ownership, residential schools were established to promote mainstream values, and local Indian agents were given authority over reserve management and monies. The Indian Act was not amended until 1951 (Surtees 1988). This legislation continues to exercise extensive control over the lives of Native people and in many cases still serves to divide families and communities.

10 Six images from this series are reproduced in Podedworny (1985b). Cf. Boyer's *Batoche Centennial* (Figure 50, p. 103), which commemorates the same event.

11 Hutcheon's theory of parody is discussed above, p. 23 n. 14.

12 The second portrait, simply titled *John A. Macdonald* is reproduced along with three others from the series in Hoffmann (1988, 400-3).

13 In the later part of his life Riel (1844-85) became convinced that his role as political and military leader was part of a larger, God-given religious responsibility. Referring to himself as the prophet of the New World, he believed that he had been personally chosen to found a new Catholicism in North America (Stanley 1988, 1871).

91
Gerald McMaster
*In His Hands He's Got the
Whole World*, 1984
graphite on paper, 76 x 56 cm

McMaster's third portrait of Macdonald, *Trick or Treaty* (Figure 92), is a much sharper critique of both the man and his office. Included in *The cowboy/Indian Show*, it depicts Macdonald as a dishevelled joker with a greasepaint smile. He could be a midway huckster, a vaudeville comedian, or a stand-up comic on a bad night. He is not a Right Honourable sight. Viewed against a garish backdrop, he banters with unseen patrons as glitter dust floats through the air. His words of polished insincerity are unceremoniously thrown back in his face in a symbolic 'Act' of Aboriginal defiance.[14]

In the fall of 1990, a few short weeks after the barricades at Oka were dismantled, McMaster discussed Macdonald's legacy and the issues that gave rise to the creation of this painting in words both disarming and at times disheartening:

I think a lot of Native peoples, even today, would have just as much of a problem with this guy and his policies as they did in the past ... [He was] sort of a Mulroney.[15] The attitude on policy making is perhaps quite similar and the disregard for the people. I think that politicians always have some kind of personal desire that isn't reflective of everybody. They're supposed to be our representatives, but in the end they become very self-centred. In historical terms Macdonald was very much for the expansion of the eastern government out West ... connecting up with western Canada. He is just one person Native peoples had to deal with historically.

What I did here [in this painting] was inspired by a poster of Jack Nicholson as the Joker [in the film *Batman*], so it became very Hallowe'enish – with the colours, 'trick or treat.' I felt that 'TRICK or TREATY' was actually the same word, or had the same implications. Whether they signed it or not – and a lot of Indians never did sign a treaty – it meant the same thing. There was never any advantage at all to Native peoples. It was all to their disadvantage. 'You're damned if you do and damned if you don't!' I think that there were no treats at all! So I saw it as a cruel joke.

92
Gerald McMaster
Trick or Treaty, 1990
acrylic and oil pastel on matt board,
116 x 96 cm

14 The Indian Act continues to provoke an aggressive response from Aboriginal artists. In September 1997 Lawrence Paul Yuxweluptun journeyed to England to stage *An Indian Act Shooting the Indian Act*, a two-part performance symbolically expressing his personal anger and displeasure with the Act. The two-day event, co-sponsored by the British arts organization Locus+ and Vancouver's Grunt Gallery, saw Yuxweluptun systematically shoot twenty copies of the Indian Act with an Enfield rifle at a firing range in the south of England, and a further twenty copies with three ribbon-trimmed shotguns on a private estate in the north. Along with the spent rifle shells and shotgun cartridges, the shot documents and decorated fire-arms were subsequently mounted in display cases and offered to the public for sale. For more on this event, see the Locus+ website, www.locusplus.org.uk/paul.html

15 Brian Mulroney, Canada's prime minister when this conversation took place. For Native images of Mulroney, see *Waitress* (Figure 118, p. 221), *The Same Old Shit* (Figure 120, p. 225), and *The Final Solution* (Figure 122, p. 228).

This is what it's about in real terms – that Native peoples were always damned and they always will be. Even as hard as we fight, it's going to be difficult, no matter what ... I think there'll be a lot of fights forever. Nothing's ever going to be resolved, and I think people have to accept that. They sort of accepted their fate when they signed the treaties. Sure, 'as long as the grass grows and the sun shines' – that kind of rhetoric – those are ideals, but in reality it never seems to work that way. It's like every day's a Hallowe'en.

Another thing I was going to say about this [painting] is that it kind of represents a lot of the right-wing conservatism that seems to be a popular movement today around the world. At the same time, as a result, you find there's a tremendous backlash against marginalized people – everybody who is 'ex-centric' or outside this range. This includes Indians, Native peoples. There's a big fight on. It includes censorship and other controls.

93
Gerald McMaster
Hau! The Ouest Was One, 1990
acrylic and oil pastel on matt board,
114 x 94 cm

There's this notion of maintaining traditional values within a certain group of people. There's a conformity – so everybody on the margin is suffering because of that. There's no opportunity to be individual. I think, within that, Native peoples have always been facing that situation ... of assimilation, of acculturation ... right from the time of contact. You could not be Indian. You could not speak your language. There was pressure to conform to the rest of Canada. The Indian Act is the legislation that says that. You've got to become 'Canadian,' whatever that is. You no longer should be speaking your language and practising your religion. That's the same kind of rhetoric that's being spoken today by right-wing conservatives, and it's a concern. It has *always* been for Native peoples, and I think that Macdonald actually represents that situation. Native peoples have always tried to resist, and in resisting they've faced a lot of consequences.

Now, when you think about Native peoples and what political party they trust, well, they trust no party. In the end, the political parties seem to be all the same, just because the official representative of any political party that comes into power is still the Department of Indian Affairs. And, of course, the Department of Indian Affairs is such an incompetent lot when it comes to dealing with Native affairs that it's ridiculous. And so, there's still all this notion of control of Native peoples.[16] I guess there is a sense of fatalism within that notion. Will anything ever change? I'm only a fatalist in the sense of *my* generation because I believe that for the next generation and succeeding generations there are possibilities for change. My hope of course is that each generation will come to understand.

I think Canadians, in general, are quite ignorant of our history. And whatever history we know about Canada is obviously one-sided, for God's sake!

..

16 In his book *Wordarrows: Indians and Whites in the New Fur Trade,* Gerald Vizenor
 suggests that trickery is the only viable method of dealing with such bureaucracy:
 'The Bureau of Indian Affairs [the American counterpart to Canada's Department
 of Indian Affairs] has been wished dead more times than evil, but colonial evil is
 better outwitted than dead because someone would be sure to create a more
 depraved form of tribal control' (1978, 9).

A Navajo Triple Pun

In the preface to *Laughter: The Navajo Way*, a collection of twenty-one 'humorous stories of the people,' Alan Wilson and Gene Dennison write, 'The subtlety and beauty of the Navajo language is brought to bear upon a great variety of situations with an alchemy that renders them startlingly humorous. One story in the collection evolves into a fantastic, tri-dimensional pun, utilizing double plays on three words and on color as applied to both horses and monetary designations' (Wilson and Dennison 1970, 26-8):

Áłchíní yázhí léi' jiní atiin bąąhgóó ndaanéego. Ńt'ę́ę́' shį́į́ hastiin léi' łį́į́' bił yíldlǫǫzhgo. Áłchíní na'ídéétkid jiní: "łį́į́' táa'go shits'ą́ą́' yóó ííjéé' ...ła' yistł'in dóó ła' łitso dóó la' dootł'izh. Éísh doo dawoołts'ą́ą da?" ní jiní.

Ńt'ę́ę́' ashkii yázhí ábiłní jiní: "Yistł'inę́ę shį́į́ nits'ą́ą náátdááz. Łitso dóó dootł'izh yę́ę shį́į́ gíinsi bą́ą́h hazlį́į́'go nahaaznii'."

Some small children were playing by the roadside. A man came along on horseback. He said to (asked) the children: 'Three of my horses have run away. One is spotted, another is yellow and the other is blue (gray). Have you seen them?'

A little boy spoke up: 'The spotted one fell over. The yellow one and the blue one were probably sold for fifteen cents.'

Explanation of text

This story is a display of immensely clever punning upon three Navajo words. The joke features a triple play on words involving color, quality and monetary value applied to horses. The three words with double meaning are:

1) yistł'in – spotted, a stack

2) łitso – yellow, a nickle

3) dootł'izh – blue, a dime

The *triple entendre* comes about by the fact that a stack falls over (reference to the spotted horse), that the colors yellow and blue are applied not only to horses but have monetary values, as well, and that the sum of a dime and a nickle is fifteen cents – all of which makes the three lost horses seem a worthless lot.

In trenchant words and images McMaster provides a view of Canadian history from the other side.[17] Perhaps no work in *The cowboy/Indian Show* challenges the official version of this history more forcefully and directly than *Hau! The Ouest Was One* (Figure 93). The cleverly constructed trilingual pun in the title seems to add credence to Vine Deloria Jr's assertion that, for Indians, 'the more desperate the problem, the more humor is directed to describe it' (1969, 147).[18] McMaster says:

The original *How the West Was Won* was, of course, a famous movie. You can see 'the West' in different ways – Western culture, Western Man, the West as the almighty, the right, the righteous, also the West of the imagination, and the West as seen in the movies.

As for the French connotation in the title, I just used the French term [for 'west']. And then 'Hau!' is the Lakota greeting for 'Hello!' I was picturing this group of people coming ... massive numbers of people coming out as settlers, as ranchers, as missionaries, as law

17 See Michael Valpy on the use of McMaster's paintings and commentaries for the teaching of Canadian history, p. 23 n. 15.

18 Much of the wordplay that occurs in the titles of artwork in this book seems to be firmly grounded in oral tradition, and, as such, is as central to an understanding of Aboriginal culture and humour as is the practice of teasing. In an interview with Gary Farmer, author Thomas King (1993-4, 4) confirms that connection. To him, Native humour means

very bad puns and lots of them and having to hear the same jokes over and over again. I think the majority of Natives in Canada, if they're not bilingual, they come pretty close to it. Some are even trilingual. It means you can play with language. And because many of the communities still have a strong basis in oral storytelling, play with language, punning, joking is crucial to that thing we call Native humour. I couldn't define it for you, and I'm not even sure that I could say 'There it is and there it isn't,' because it's sort of a participatory thing ... I got friends out in Lethbridge, [Alberta,] who tell the worst puns, jeeze, just some of the worst puns and some of the worst jokes. But there's a kind of communal spirit to those things. We all know what he's going to say. But we all have a good time, probably because we come together in communities. We like that play with language; we don't care how many times we hear it. But for non-Native communities, you hear a joke once, it's kind of boring, you don't want to hear it again. You want to hear something new. Always something new, always something new.

King is by no means the first to call attention to Native punning and wordplay. In a 1968 article citing the emergence of Native humour as a potent force in American civil rights activism, anthropologist Nancy Oestrich Lurie noted 'the publicizing and utilization of the kind of humor which has always typified Indian life but was usually unknown to non-Indian Americans. To me, this humor is more than minority humor and evinces an older tradition. It is strong on puns, word play in general, and stunning juxtapositions of seemingly unrelated concepts and contexts, reminiscent of the witty irony found in treaty journals of the nineteenth century and texts of certain kinds of narrative legends' (1968, 202-3).

McMaster's trilingual pun in *Hau! The Ouest Was One* recalls in particular the wonderful triple pun at the centre of a comic narrative recounted by Wilson and Dennison in *Laughter: The Navajo Way* (1970, 26-8).

For a short list of ethnographic, journalistic, and popular publications on Native humour, see the Suggested Reading section of the References.

enforcement officers, controllers, keepers of the power. And the guy in the front – it's almost as if he's wearing a gold shield on his chest, a chest protector, armour. [He is] perhaps representing the army. The three figures in the front represent the power structure – missionary, law enforcement, politician or army. Opening up the West for settlement … I think perhaps it was seen as a mass invasion, certainly from the Native perspective … not really understanding what was happening.

It's the same thing with the people in Hungary, Czechoslovakia, and Romania, who really did not know what was happening when armies invaded their countries almost in the middle of the night in the 1950s. They didn't know what was going on. I think the Native peoples were in the same situation; they didn't know what was going on.

[In the painting] they're all facing you and coming at you … automatons. You kill a few, well, there are more coming. There's no end. It's very threatening.

In a sense, this painting has a Canadian tone to it. In the 1860s it seemed that life was fairly peaceful with the Indians, the Métis, and the settlers. It wasn't Canada yet. The government of the day in eastern Canada was attempting to join the East with the West … to try and create the country of Canada which was distinct from the United States. There was a realization that the eastern government of Macdonald was attempting to push westward, to expand, to appropriate lands, and to control the peoples out there, particularly the Natives and Métis. Life seemed to be okay for a while until this greed for power and expansion of the East out to the West.

'You can no longer have the individuality or freedoms. We're going to make it *ONE*. We're going to connect it up with British Columbia and make it *one* Canada.' The 'West' was the only block to that, and all the Natives were confronting that notion of expansion.

Bob Boyer's blanket painting *A Minor Sport in Canada* (Figure 94) also offers an alternative perspective on the opening of the Canadian West, graphically portraying the violence and bloodshed that inevitably result when one society attempts to superimpose its values and lifestyle on another. Here the attempted superimposition and obliteration are both metaphorical and starkly literal.[19] The violence is palpable, the 'double cross' both visible and undeniable. Critical distance is achieved through radical recontextualization of the Union Jack, once the proud emblem of the British empire, here a discredited symbol of imperial domination vilified on a painted 'Indian' blanket.[20] At the same time this piece provides a veiled critique of prevailing attitudes in contemporary Canadian minor sport that have a direct impact on Native youth. It is a double vision that affirms the continued presence of an unjust and inequitable past.

19 Cf. a similar approach to similar ends in Boyer's *The Batoche Centennial* (Figure 50, p. 103).

20 Boyer has long enjoyed the idea of selling blankets back to the Whiteman, and his vividly painted blankets, combining Plains Indian beadwork motifs and contemporary colour-field design concepts, are among the most sought after of his creations. No doubt he was pleased and not a little amused at the irony when *A Minor Sport in Canada* was purchased by the National Gallery of Canada.

94
Bob Boyer
A Minor Sport in Canada, 1985
oil over acrylic on cotton blanket, 188 x 221 cm.
National Gallery of Canada #29757, Ottawa

Boyer recalls that the painting

started out as various responses. My friends and I had been talking over several situations. Indian kids in the States, to be on a basketball team they generally have to be twice as good as a White kid. Indian kids are often discouraged by the system. To get through the school system, often times, the Indian kid in school has to be twice as studious, work twice as hard. And I know from experience, because for a while I was a hockey scout for junior hockey teams, and I've had coaches say to me that they wouldn't have any of those damned 'wagon burners' on their teams. So again, in order to prove a point, an Indian kid in hockey has to work very hard ... I'd been talking to [Mohawk artist] Rick Hill on a similar thing ... At one time he was coaching a lacrosse team from Six Nations and they tried to get into the Ontario Lacrosse League and they wouldn't let them in[21] ...

I'd also been ... doing some research on the North-West Rebellion, and I noticed that it was young White soldiers [who were] coming out West to take up arms against the 'savages' out West here. (And because this is on tape I have to put 'savages' in quotation marks – and I'm using 'savages' from *their* point of view, not *my* point of view. Tapes never know what you're talking about.)

So these young White soldiers who believed they were going to be fighting savages were jumping on the trains in the trainloadfuls for adventure – for 'sport' – [in] the same way that those young guys used to come out on trains to venture out for sporting, for hunting animals. And there's many pictures. We know about the slaughter of the buffalos but we also know of the slaughter of other animals. We've all seen pictures of turn-of-the-century hunters with hundreds of ducks hanging on strings, twenty-five deer hanging from racks and so on. That's the sport: slaughtering and so on.

Taking, always taking. Always assuming. And in the States it was the same way. The United States cavalry, they left the East, coming out West ... It was sporting for them too – to come out West to be a jaunty thing – to come out and shoot Indians. So this whole approach to Indians has been ... from one point, where it was a sport to come out and kill Indians, and mistreat Indians and destroy the habitat of the animals ... That kind of sporting thing still occurs today, [but] nowadays they just apply different tactics and make it very difficult. It's very discouraging for Indians to try and do anything because every time you turn around there's somebody putting a wet blanket over everything.

[In the upper corners of this painting] you can see the 'Indian flag' [the feathered staff] in there, which is almost whited out, but not quite. It's going to come back. Even with the pipe [shown in the lower corners], when I did that I was thinking one of these days they're going to try and take away the pipes ... As a matter of fact that almost happened already. In one incident we were going to have a pipe ceremony for the museums conference – the

21 A few weeks prior to our conversation, Boyer discussed this painting in a talk given at the Edmonton Art Gallery in Edmonton, Alberta, in conjunction with the exhibition *Shades of Difference: The Art of Bob Boyer* (Phillips 1991.) On the plane trip home to Regina he read of an Indian team from Thompson, Manitoba, that was barred without good reason from playing in a tournament in Quebec City. 'So there you go!' he says. 'My words weren't even dead in Edmonton and I was getting on the airplane and there it was again.'

Task Force [on Museums and First Peoples] that was here in the springtime – and because no smoking was allowed in the building one of the secretaries was not going to allow the elders to have a pipe ceremony. But I went to the president of the university ... and he very quickly told her to shut her mouth and let things go on. So there you go, you see.

Boyer employs the Union Jack once more in *A Government Blanket Policy* (Figure 95), appending it this time to an image of the Stars and Stripes now 'turned around on purpose' for another view of history from the other side: 'I was thinking "blanket policy for Indians" – everyone always says a "blanket policy." So the blanket policy of course is to overcome Indians. And one of the easiest ways to overcome Indians is with policies from the government. It's frustrating for Indians. Policies, policies – they're always changing them, manipulating them.'[22] The fusion of American and British flags in this piece shrewdly signals the presence of parallel policies toward Indians.[23] Boyer adds:

22 On the subject of ironic titles, Boyer states:

I've always ... seen the irony in a lot of things, and so I suppose I can see the irony in my own paintings [laughs] and the irony in the titles ... The titles, actually, are not really meant to be humorous ... It's not my intention to be a one-line zinger kind of guy ... I want people to meditate on certain specifics ...

Naming a painting is sort of like when you know you're going to have a baby ... You spend maybe up to nine months thinking about what you're going to call that kid based on all kinds of experiences, sometimes relevant, sometimes non-relevant. But during that whole process of the nine months people ... spend a lot of timing considering, 'What's the name of this kid going to be?' But nothing really gels until you actually do have the kid. So, that's sort of the process: it kind of occurs, and it's sort of growing, and at a point in time when the painting is about done ... you end up with a title.

23 Flags feature prominently in Boyer's *Batoche Centennial, A Minor Sport in Canada,* and *Government Blanket Policy* as symbols of colonial intrusion and sovereign authority. For Boyer and many other Native artists the national anthem is an equally potent symbol of alien rule and contested allegiance. For this reason, the text to 'O Canada' is often fragmented and recontextualized in a decidedly subversive fashion. Cf. Boyer's *Batoche Centennial* (Figure 50, p. 103), Joane Cardinal-Schubert's poem, 'oh Canada' (p. 132), Shelley Niro's *Standing on Guard for Thee* (Figure 96), and *Red Heels Hard* (Figure 97), both of which depict the artist's three sisters clowning and highkicking their way about the base of a monument to the controversial Mohawk chief, Joseph Brant. *Red Heels Hard* includes a moving poetic commentary that unravels one line at a time in handwritten script beneath the six horizontally mounted photographs:

Behind us stands a monument to the late great J.B.
he brought us from Upper New York State, from the Mohawk Valley.
Carried in his jewelled bag and blown into the wind ...
we grew as Maples, Oaks & Pines along the banks of the Grand
We followed that yellow bricked road and clicked our red heels hard
but this is where we will stay forever and for thee stand on guard.

In his densely layered painting, *Oka-boy/Oh! Kowboy* (Figure 128, p. 237), Gerald McMaster plays with the opening lines of both Canadian and American national anthems, while Bill Powless, it will be recalled, gives the last line of the 'Star Spangled Banner' a new twist in his *Home of the Brave* (Figure 2, p. 17). Cf. Ron Noganosh's shredded US flag in *That's All It Costs* (Figure 49, p. 99).

95
Bob Boyer
A Government Blanket Policy, 1983
oil on cotton blanket, 122 x 196 cm

96
Shelley Niro
Standing on Guard for Thee, 1991
hand-tinted black-and-white photograph,
36 x 28 cm

we grew as Maples, Oaks & Pines along the banks of the Grand

97
Shelley Niro
Red Heels Hard, fourth frame,
1991
six hand-tinted black-and-white photo-
graphs with handwritten text, mounted
horizontally in a single matte, 20 x 25 cm
each photograph

The original treaties were signed with the Americans and with the British. And those treaties were meant really to protect the White people, not to protect Indians. That's why the Indian world's [tipis are] turned upside down under the flags. [The black letter X is for] the black spot on the North American continent brought by the White people. That's *their* black mark they laid on this continent.[24] [The three red figures on the sidebars represent] horses ... I like horses, I come from a horse-loving background ... [but] ... I see the horse as a symbol of destruction of Indian culture, 'cause it was on the backs of those horses that Europeans came. On the backs of those horses the cavalry and the RCMP came. Indian culture survived very well without horses. Did very well.

The infamous military campaign waged by the US cavalry against Plains Indians in the second half of the nineteenth century is the subject of *Small Matters* (Figure 98), a literally and emotionally compact installation by fellow Métis artist Edward Poitras that was included in the 1989 exhibition *Beyond History*.[25] Much like the title of Boyer's *A Minor Sport in Canada,* the title, with its oblique yet double-edged reference to the 'small matters' of Indian resistance and eradication, highlights the grossly diminished, if not inhuman, status accorded Native peoples at this time. In the *Beyond History* exhibition catalogue co-curator Karen Duffek describes *Small Matters* as

a series of four small fence-like enclosures nailed into the gallery wall ... [presenting] separate 'pieces of history' as memorials to the victims of ethnocide. Each wire box contains a crumpled page of text from [Dee Brown's] *Bury My Heart at Wounded Knee,* a book chronicling the displacement and extinction of Indian tribes in the United States. Beneath each box, in white letters, is a specific historical reference: 'Summer Snow,' 'The Trail of Tears,' 'Sand Creek,' and 'Wounded Knee'; the first includes a list of tribes that have vanished like snow before a summer sun. While these memorials are reminiscent of the picket fences that often encircle Native grave markers, the use of wire and nails also suggests entrapment – this history cannot be escaped (in Duffek and Hill 1989, 33).

Small Matters is deceptively simple. The artist's selective use of printed text, which by virtue of its small size requires a close reading, along with his cool and calculated application of white lettering to a white wall, evinces not only a minimalist aesthetic sensibility but also a subtlety found in the shrewdest trickster practice as well. It is the absolute antithesis of Lawrence Paul Yuxweluptun's seduction of the viewer with colour, but has decidedly similar intent. In this instance conceptual brilliance displaces chromatic brilliance. Poitras says: 'It's like a little ambush. It's an amenable piece but with big content.' Indeed. Underplaying the importance of the conceptual component he adds, 'Probably the only creative act in there is trying to crumple [the page] in such a way that you could still read it.'

24 Given the context, the black letter X could be read as the Greek letter *chi* and symbol for Christ. Cf. Logan's use of this symbol in *Jesus Was Not a Whiteman* (Figure 61, p. 122). It could also be interpreted as the Native signature on so many early treaties. *Or* as the trickster signature on a contemporary visual document interrogating such treaties.

25 Originally conceived in 1988 for a group exhibition of small-scale works in Regina, *Small Matters* was recreated in 1989 for *Beyond History* in Vancouver, and again in the summer of 1991 for a show of the artist's work in Finland.

It is an especially critical act, as it is only in reading the strategically foregrounded passages that the terrible and tragic historical ironies are revealed. None is more forceful or poignant than the Wounded Knee component, which incorporates the final page from the final chapter of Dee Brown's haunting book (1972, 418).[26] The visible text reads:

> dead Indians were left lying where they had fallen. (After the blizzard, when a burial party returned to Wounded Knee, they found the bodies, including Big Foot's, frozen into grotesque shapes.)
>
> The wagonloads of wounded Sioux (four men and forty-seven women and children) reached Pine Ridge after dark. Because all available barracks were filled with soldiers, they were left lying in the open wagons in the bitter cold while an inept Army officer searched for shelter. Finally the Episcopal mission was opened, the benches taken out, and hay scattered over the rough flooring.
>
> It was the fourth day after Christmas in the Year of Our Lord 1890. When the first torn and bleeding bodies were carried into the candlelit church, those who were conscious could see Christmas greenery hanging from the open rafters. Across the chancel front above the pulpit was strung a crudely lettered banner: PEACE ON EARTH, GOOD WILL TO MEN.

In conversation art historian Ruth Phillips said of Poitras, 'I think he's the blackest humorist of them all. To me, his work is dark to the point of depression, but for that reason it's among the strongest of all. I think he's important to your study.'[27] Whether Poitras is the blackest or the bleakest of humorists is debatable, given the work by some of the other artists in this chapter. He does, however, bring to this study and to the practice of aesthetic trickery a degree of conceptual sophistication that has few rivals.

The same juxtaposition of faith professed and faith practised that imbues the Poitras and Brown Wounded Knee 'collaboration' with so much ironic intensity is evident as well in Carl Beam's sharply titled *Calvary to Cavalry* (Figure 99), from his

98
Edward Poitras
Small Matters, detail, 1988-9
nails, wire, paper, Instasign,
75 x 176 x 5 cm

26 The slaughter of an estimated 300 Sioux, more than half of them women and chil-
dren, at Wounded Knee Creek, South Dakota, on 29 December 1890, brought a
bloody end to a half-century war waged by the American government against
Indians for possession of the American West. In 1973 Indian activists inspired by
the courage of their ancestors occupied the same site for seventy-one days in an
armed stand-off with federal agents. Ironically, a century after the 1890 massacre
the macabre photograph of Minneconjou chief Big Foot lying frozen in the snow –
the ultimate Indian victim – is arguably as much a symbol of cultural survival and
tribal tenacity as any studio portrait of Sitting Bull or Geronimo. See the discus-
sion of Jim Logan's paintings *Unreasonable History* (Figure 140, p. 255) and *The
Death of Big Foot* in Ryan (1994a). See also Hill (1989, 34).

27 J. Jerome Zolten says that creators of black humour try to 'transcend the pain and
absurdity of reality ... by deliberately plumbing the tragic for comic possibilities.
The goal is to subvert pain by undermining the seriousness of the subject ... The
black humorist tries to undercut seriousness by painting over it with the comic.
The implication is that the external will in some way alter the internal. Since
laughing is a sign that "everything is alright," then laughing in the face of tragedy
must mean that the healing process has begun' (1988, 135).

99
Carl Beam
Calvary to Cavalry, c. 1989-90
etching on paper, 122 x 81 cm

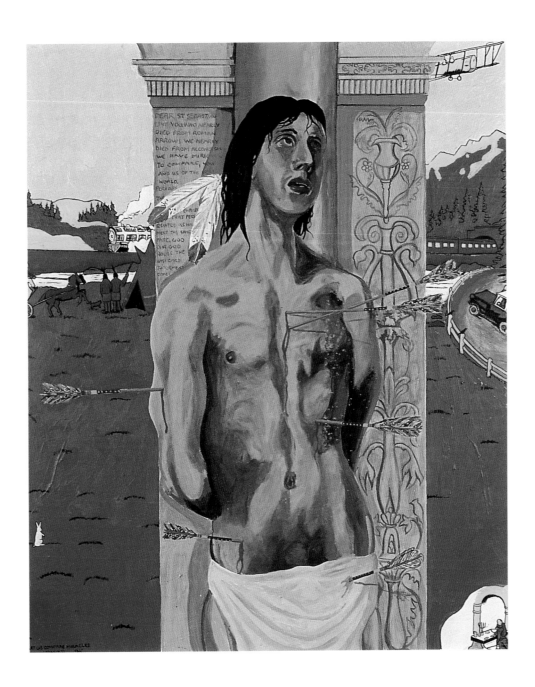

100

Jim Logan

Let Us Compare Miracles, 1992

acrylic on canvas, 100 x 84 cm

Columbus Suite of etchings. The artist's pairing of an early crucifixion scene with an archival portrait of five Native men is no less searing a commentary on the harrowing missionary-military alliance than the one by Poitras. Yet even here Beam finds unexpected common ground in human history: 'What people miss is that Christians themselves were persecuted at one time. Viewers would make that connection if they understood their own experience.'[28]

The practice of Christianizing through force while colonizing through faith is also addressed by Jane Ash Poitras in her five-piece painting/installation, *The Virgin Bullet*.[29] In the fifth and most disturbing panel (Figure 101), an appropriated image of the Virgin Mary – characteristically depicted as an idealized White woman with pale skin, deep blue eyes, and luscious red lips – is framed by a border of painted red crosses, four of which are overlaid with metal shell casings pointing downward directly above the Virgin's head. Like the title of the piece itself, it is a distressing, yet rivetting, elision of imagery. Like a volley of gunfire or a hail of bullets frozen in midflight, the shells presage impending disaster. Across the bottom of the painting, two shield-like figures barely conceal the names of two such disasters inflicted on Native peoples, 'THE TRAIL OF TEARS' and 'THE SAND CREEK MASSACRE,' both also memorialized by Edward Poitras in *Small Matters*.[30] Echoing the Métis artist's comments on his own installation, Jane Ash Poitras says of *The Virgin Bullet:* 'It's a small piece but it's a powerful little piece.'

Just as powerful, and for many of the same reasons, is the shell-shocked rosary *Dominus Vobiscum* (Figure 102), by Ron Noganosh, which also makes use of bullets to question ecclesiastically sanctioned violence not only against Native peoples but all peoples. The rosary 'beads' are .44 magnum shells, carefully laid out in a velvet-lined display case. A deeply affecting image, it will sting and burn in your brain and sit there for a long time, as Gary Farmer says.[31] In a description laced with toxic reference, Noganosh says:

28 Métis artist Jim Logan makes a similar analogy in his painting *Let Us Compare Miracles* (Figure 100), from *The Classical Aboriginal Series*. Set against a pastoral backdrop – in this case, a faithful reproduction of a popular beer bottle label – early Christian martyr St Sebastian is portrayed as a suffering Native shot through with arrows. Logan, however, says the comparison is one of recovery rather than of suffering: Just as St Sebastian made a miraculous recovery from wounds inflicted for his spiritual beliefs, so too Native people are beginning to recover from wounds incurred over a century of alcohol abuse.

29 Cf. Jim Logan's *The Annunciation* (Figure 60, p. 121), which portrays a similar theme.

30 See Brown's *Bury My Heart at Wounded Knee* (1972) for an account of the Trail of Tears, the forced removal of southeastern tribes to lands west of the Mississippi in the 1830s, and the Sand Creek Massacre, in which more than 100 Cheyenne women and children died in an unprovoked attack by the Colorado militia in 1864.

31 See Farmer's discussion of toxic humour, p. 168 n. 3.

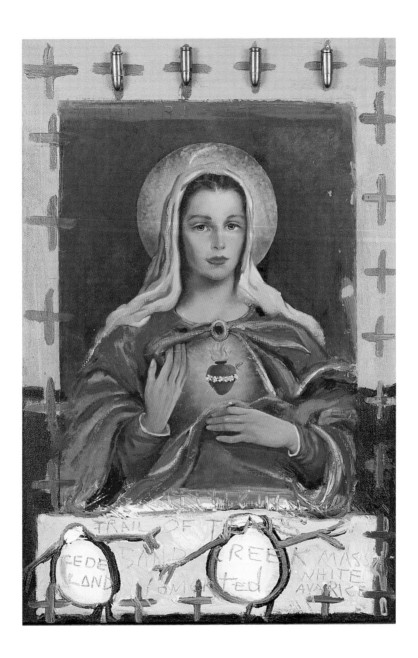

101

Jane Ash Poitras

The Virgin Bullet, fifth of five
panels, 1991

mixed media on canvas, 61 x 46 cm
each panel

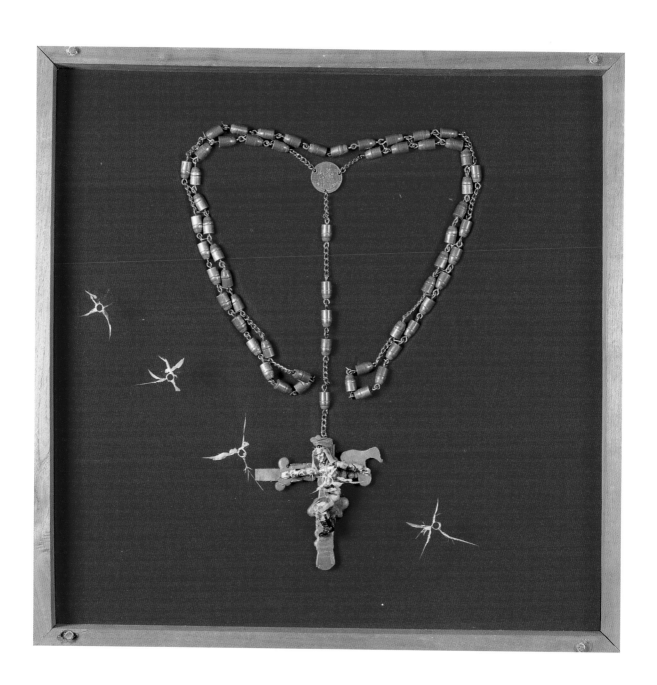

102
Ron Noganosh
Dominus Vobiscum, 1988
.44 magnum bullets, .22 casings, silver
dollar, plastic G.I. Joe doll, wood. velvet,
Plexiglas, 57 x 57 cm

It's visually appealing but there is a hell of a lot going on in it. It actually started with a Jacques Cartier [silver] dollar.[32] That was the scapular medal I put at the top. And then I made the rosary ... beads out of bullets, because of the wars – about fighting the Indians, fighting all kinds of wars. And then, of course, GI Joe's hangin' on the cross because of the senselessness of war, if you want. It's set out in a heart shape because they used to do that in the mission schools. And sometimes they'd shape them into praying hands ... I liked the heart, it went better with the bullets. I had a hell of a time getting the holes in the Plexiglas to look like bullet holes. I tried shooting it with a .22 and every time I shot it would just shatter. Tape it up. Shoot it. Blow it up. So I finally drilled it and hit it with a ball peen hammer and, 'Hey, perfect!' [laughs]. It's actually .22 casings that hold the Plexiglas into the wood. And it's made out of walnut because when they gave medals away for bravery or killing people you got a nice little walnut case with a medal in it ... [For the cross] those are flattened out bullets and melted. I was trying to make it all out of metal but it wouldn't work. I couldn't get [the melted bullets] to flow properly. I had to mount it on wood.[33]

What might be easily overlooked in the above little narrative on moral and spiritual bankruptcy is the brief mention of mission schools, the church-run residential schools where, for several decades, countless Native children were subjected to the most heinous forms of physical and psychological abuse. In *Dominus Vobiscum* the affecting placement of a child's toy soldier on the cross only hints at the extent of personal violation and suffering that took place.

..

32 A commemorative coin issued by the Canadian government in 1984 to mark the 350th anniversary of the raising of a cross by French explorer Jacques Cartier on newly 'discovered' Indian land.

33 *Dominus Vobiscum* is not the only work in which Noganosh interrogates clerical practice through critical modification of plastic figures. In his playfully irreverent sculpture *Daryl* (Figure 103), the artist ironically inverts historical convention, cloaking a symbol of ecclesiastical authority in a robe of Native spirituality. It is a little dissident act of cultural reclamation as profound as it is playful, a further example of what Jane Ash Poitras calls 'shamanizing the White guys.' Noganosh explains:

Again it was a play on words. They had a show at [Galerie] l'Imagier ... and their theme one year was 'strawberries.' So I did a [piece] ... about an Ojibway legend where [it says] that if you ate a strawberry you'd end up in the holy land, but if you didn't I guess you went to the other place – 'You're hell bound and gone!' ... That's the bishop or the pope, he's the strawberry ... So this is a Native interpretation of how to get to heaven [laughs]. It was called *Daryl* because the Expos were in the play-offs that year [laughs]! Good old Darryl Strawberry! They had [the legend] pinned up on the wall at the opening so people would know it. So it wasn't a complete [in-joke].

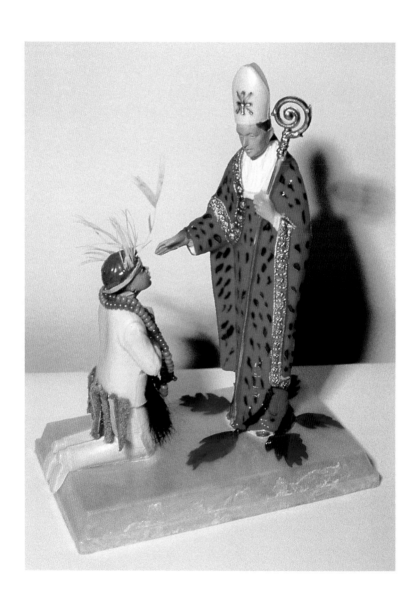

103
Ron Noganosh
Daryl, 1988
plastic, leather, hide, beads, feathers,
13 x 10 x 6 cm

In contrast, Carl Beam's *Forced Ideas in School Days* (Figure 104), is a more pointed and personal indictment of the people and policies that allowed residential schools to flourish. Both the humour and images in this piece are decidedly dark and the handwritten script exceedingly caustic. A grey pall hangs like a shroud over memory – and this print as well. The smiling students seen earlier in *Self-Portrait as John Wayne, Probably* (Figure 16, p. 42) are the central focus here, their innocent souls the prize in a spiritual battle symbolized by contrasting images of a cross-crowned dancer (also from *John Wayne, Probably*) and a cross-bound Christ (from *Calvary to Cavalry,* Figure 99, p. 192). A thin line extends from the artist's encircled face to the panel of text on the left. It reads: 'the artist as a young captive in an insane world of fools who will go down in history as the most perverted humans ever to walk on the face of the earth ... the truth unfolds slowly but surely like a tide almost ...' The text continues on the right: 'FORCED IDEAS *in School Days* / ... I remember all my friends and I going to church every day because we were supposed to *change* from being *Native* to *non-native,* probably never white ... and yet, in spite of severe brain-washing everyone did remain native ... I'm sure Christ would have enjoyed that.' Recalling these days and the creation of this print, Beam says: 'I can't remember anybody being any less Native. I did a piece where I said something like, "I'm sure Christ would have found this pretty funny." It's hilarious – like changing a dandelion into a rose – the idea that you can "de-Indianize," that you can "Christianize."'[34]

Like many others of his generation, Beam is still troubled by a multitude of unanswered questions about the philosophy behind such schools:

There's got to be a certain irony in speaking English, French, and Latin. Why couldn't they have appended Ojibway? And Ojibway history? Why couldn't there have been *one* enlightened priest? It's stupid – as if there was already proof that speaking Indian was a handicap to speaking English. The irony is to mask it in a spiritual mode. If they told me I was in prison when I was a kid it would be easier to accept. But a Roman Catholic boarding school? How could that be? There must have been another motive – but I can't locate what that motive was.

You can't really change anybody. You shouldn't. What for? I remember the powder-blue catechism book:

Question: Who made us?
Answer: God.

Question: Where is God?
Answer: Everywhere.

..

34 For a consideration of Christ's capacity for amusement and understanding of human folly see *The Humor of Christ* by Elton Trueblood (1964) and *The Comic Vision and the Christian Faith* (1981) by Conrad Hyers. See also *Holy Laughter: Essays on Religion in the Comic Perspective* (1969), edited by Hyers.

There would have been no need for indoctrination. Isn't he here too? They were violating their own principle. The fundamental reason for the downfall of religious education is that it degenerates rapidly into indoctrination. A concern with higher spirituality doesn't involve race.[35]

In a telling statement that suggests how Beam and his fellow students have been able to put the past behind them and get on with their lives, to the extent that this is possible, the artist adds: 'If we're to believe the psychologists and psychiatrists, a lot of people that go through traumatic experiences blank out details – they draw a blank. It's the mechanics of the mind. Basically, I've had a good life.' In recent years Native peoples have deliberately, but cautiously begun to recall those traumatic experiences of their youth in order to heal the long-festering wounds. It is part of an ongoing process of communal recovery. And humour, no matter how cryptic or toxic, has proven to be one way to expose, yet still maintain, some distance from the pain and the anger. It seems a necessary stage in the recovery process.

In the etching *Semiotic Converts* (Figure 105), from the *Columbus Suite,* Beam reflects on what he and his classmates may have lost and may never know as a result of their schooling experience. Ian McLachlan (1990, 12) writes that in this piece Beam

re-appropriates a group photo of fellow survivors of the harsh residential school he attended at Spanish River, all of them adults now, laughing and smiling, the past modified by nostalgia, but still organized into the inevitable rows of the official school photograph. And over them he places a large and threatening traffic light. There is no specific message to the piece, but out of the cross-referencing there comes a sense of danger that those happy-looking people might not have been fully able to escape. We learn the signs of a dominant culture so thoroughly that even when we think we're free, we may be expressing other people's meanings rather than our own – semiotic converts, in other words.[36]

As Trevelyan observes, 'the [added] reference to dripping blood and decay [in this piece] suggests the horrible mistakes made, as well as the danger of cultural deterioration due to attitudes and policies' that still persist (1993, n.p.).

104
Carl Beam
Forced Ideas in School Days,
1991
photo emulsion and ink on paper,
74 x 55 cm

35 In the context of such schools, the phrase 'Suffer the little children to come unto me' may be understood in a sense the biblical translators never intended (Luke 18:16 AV).

36 Beam frequently uses this image of a traffic light, ironically labelled in a manner reminiscent of scientific dissection and analysis, to symbolize technological control of human behaviour through the imposition of a linear concept of time. As such, it can rightly be considered a self-reflexive warning signal. As the dominant image in *Chronos 1* (Figure 106), it also recalls Gerald Vizenor's assertion that 'the way time is handled and resolved' and 'the tension in time' contribute to a sense of 'mythic verism' (p. 5 of this text). Cf. *Big Koan* (Figure 76, p. 148), and *Chronos 2* (Figure 77, p. 149).

105
Carl Beam
Semiotic Converts, 1989
etching on paper, 122 x 81 cm

106
Carl Beam
Chronos 1, 1989
mixed media on Plexiglas, 122 x 91 cm

Few policies were enforced in residential schools as stringently and severely as conformity – of appearance, language, behaviour, and belief. In his paintings *I Looked out My Teepee One Day and All I Saw Was This* (Figure 107), and *Boarding School Wallpaper* (Figure 108), Plains Cree artist George Littlechild dilutes the power of both personal and cultural memory by transforming destructive patterns of childhood experience into playful patterns of acrylic decoration. It is a cunning act of historical confrontation that creates as many spaces for healing as it does for critique. Both are necessary.

Commenting on the creation of *Boarding School Wallpaper*, Littlechild says:

I like the idea, in coming from a Plains Indian background, [of] dealing with patterning and symbols that are part of the patterns [in] the beadwork or the design, and thinking about the residential school in Hobbema [Alberta] and the shape of the building. It's this huge, long two-storey building that was actually added on to and was very ominous. But it was made out of wood so it eventually was all taken down. It doesn't exist any more. It's gone. And of course, once again, [I'm] talking about the religion that was brought, the Christian religion, the Oblates, the French order. The *Boarding School Wallpaper* [painting is] taking something very serious and making wallpaper out of it. You know, it all looks the same eventually, after a while, anyway. It's one story that blends into another because it didn't just happen in Hobbema. It happened all over North America.

Though never a boarding-school student himself, Edmonton-raised Littlechild has been deeply and directly affected by the experience. In his book of paintings and commentaries for children, *This Land Is My Land* (1993, 18), he writes: 'Indian children coming to the school were torn away from their culture, their language, their traditional ways, and their families. My mother and all her brothers and sisters went to these boarding schools, and so did my grandparents. They grew up without their families and never learned how to raise children of their own. Many boarding school survivors died on skid row of alcoholism, including my mother.'

Like Littlechild, Jane Ash Poitras was also raised in the city of Edmonton, Alberta, yet educated in a climate remarkably like that of reserve Indians:

I went to school [at] Sacred Heart in Edmonton. It was sort of like a convent school. It was kind of a residential school. It was for immigrant and Native kids. They threw us all in together and we were all going to be transformed into nice little Catholics. I grew up in an immigrant mixed neighbourhood. If you were Indian, Chinese, immigrant, and couldn't speak the language very good, you got thrown into this special school which was apart from the major school and the nuns taught you and they had all different rules for you guys because you guys were ... backwards, right? We were ... 'heathenized.' So they 'unheathenized' us, and it was all kind of ... disgusting! ... The Indians say they weren't allowed to speak their language in these residential schools but they did the same thing to the immigrant kids, 'cause I grew up with the immigrants on the skid row area in Edmonton and they weren't very nice [to any of us].

107
George Littlechild
I Looked out My Teepee One Day and All I Saw Was This,
1987
acrylic on paper, 76 x 56 cm

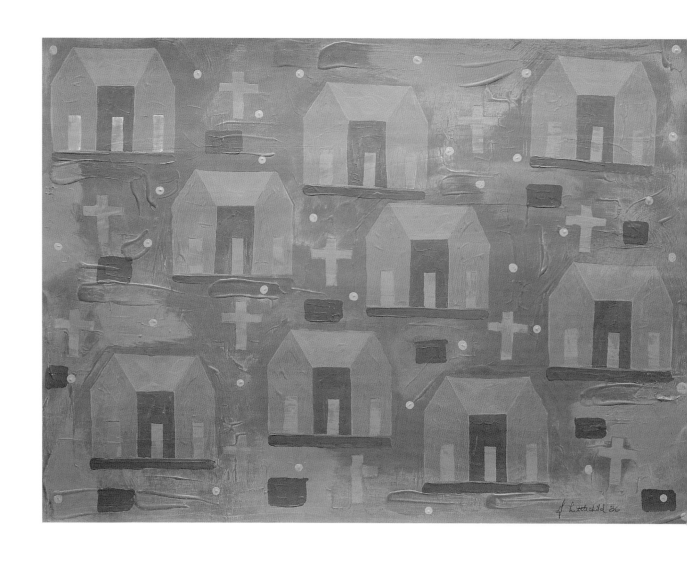

108
George Littlechild
Boarding School Wallpaper, 1987
acrylic on paper, 56 x 76 cm

A vivid memory from this period, possibly leaving the most indelible imprint on her artwork, is the image of her teacher at the blackboard. She recalls:

I just thought about when I was a child and, gee, we spent all of our time for twelve years looking at a blackboard. Looking at this black thing written on [with] white chalk ... One thing that's really neat was just the idea, when I was a child, 'God, would I ever like to write on those blackboards!' But, you know, the teacher would never allow you. Only reluctantly she would allow you. And you were only asked to write on the board when you had permission and, boy, it was a neat feeling. But you got to watch *her* write on it all day long [laughs]! Right? See her do those nice *aaa*s and those nice *numberrr*s. And see the teacher put down the notes and all that.

As an adult, and a practising artist, Poitras has usurped the teacher's position of authority to create her own teaching blackboards: a series of mixed-media collages inscribed with symbols of her own language, her own history, and her own experiences living in a multicultural world (Figures 109 and 110).[37] The work is a clever remedial exercise in viewer education as well as a crash course in contemporary Native culture. Poitras says: 'You look at the work and what does it do? People look at it and they go away and it's taught them something.' Reflecting on the series in a 1995 television interview, Poitras remarked with a smile, 'It was a wonderful twist and a wonderful irony and a wonderful way of transforming a feeling of submissiveness into a feeling of power' (in Gilchrist 1995).

In an earlier discussion of the piece *Monetary Blackboard* (Figure 39, p. 82), it was noted how Poitras frequently seeks to diffuse the power and appeal of White women by 'Indianizing,' or as she says, 'shamanizing' their images by giving them painted feathered headbands. When that White woman is Queen Elizabeth II, as she appears on the face of Canadian currency (Figures 109 and 110, *Family Blackboard,* and Figure 111, *A Sacred Prayer for a Sacred Island*), not only colonial power but also the imperial legacy of consumerism and materialism are contested.[38] It is an exceedingly subtle gesture that ironizes the whole picture, as Archuleta (1989, 60) has rightly noted in her curatorial commentary on *Family Blackboard,* and also politicizes it. Poitras says:

Royalty come over [to North America] and they give them headdresses and you see their pictures in the paper with little headdresses on. And [they] give them mukluks, and that's all just for show. But they don't really know what it means. So it's all kind of artificial and it's made trivial, something so important like that. And I think that's all really hokey. So [this is] 'hokey art.' I'm being hokey back. They put me in nice little white gloves and nice little church hats and church dresses [see Figure 39, p. 82], so now I'm putting them in nice little feathers and headbands and mukluks [laughs].

37 Cf. *History 1990* (Figure 37, p. 80) and *Monetary Blackboard* (Figures 39 and 40, pp. 82-3).

38 Cf. the discussion of Poitras's mixed-media collage *Gold Card Indian,* p. 117 n. 14.

EDUCATION
OF Indians

CHIEFS
=ROYALTY QUEEN=
KINGS

Feathered headdresses and beaded mukluks are not the only items presented to royalty. When the Duke and Duchess of York visited Alberta's Head-Smashed-In Buffalo Jump heritage site they were given a painting by Joane Cardinal-Schubert. The artist recalls with amusement her meeting with Prince Andrew and Lady Sarah:

I had a Plexiglas pin on that I'd done one of my little paintings on and she [Lady Sarah] was asking me about it … and I just stood there. I didn't curtsy. I didn't do anything. I just stood there and I looked at them and they looked at me. And then finally Andy stuck his hand out and he said, 'How do you do?' And I said, 'How do you do?' She said to me, 'You can be sure that your painting will occupy a very prominent position in our home.' And I said, 'Right! Right above your davenport?' And we started laughing.

The same royal couple figure in another little dissident narrative related to the author by Rebecca Belmore:

I have this beaver house dress … called *Rising to the Occasion* [Figure 112] and it was worn for a performance called *Twelve Angry Crinolines*. What happened was on July 17, 1987 Prince Andrew and his new wife Fergie came to Thunder Bay, and so twelve women in Thunder Bay were asked to interpret an 'angry crinoline,' and we did this silent parade on the streets of Thunder Bay. And as 'First Lady of this Land,' I got to lead this silent parade. Other women were wearing things like – one was wearing a nuclear explosion on her head; another woman was wearing a gas mask with a wedding gown and carrying dead flowers – different kinds of weird costumes. And the whole performance was based on the idea – back in March of that same year a scandal in Britain broke out where it was discovered that the Queen Mother had five cousins who were mad, who were insane,

109 (facing page)
Jane Ash Poitras
Family Blackboard, 1989
mixed media on paper, 58 x 58 cm

110 (below)
Jane Ash Poitras
Family Blackboard, detail

Within the artwork (partially visible text):
...and consideration they expect for their beliefs and rituals.
...would do well to revisit their own history and compare
...eliefs and rites of their own ancestors. They would
...similarities between North American Aboriginal
...es and those of the Celts, the Teutons, the Vikings
...r European forebears. The Judeo-Christian beliefs
...in an effort to ol...
...tinuing tragedie...
...vidence that land is not the
...ndian Affairs, and the wealth
...ot removed those traged...

111
Jane Ash Poitras
*A Sacred Prayer for a Sacred
Island,* detail of second of
three panels, 1991
mixed media on canvas, 198 x 178 cm

and were locked away in an insane asylum. And some journalist dug up the dirt and made big news for a while. And this woman [Lynn Sharman, the performance co-ordinator] ... was making the analogy that women artists suffer the same as the five cousins, the five mad cousins. So it's [about] how difficult it is to be a woman artist in a man's world ... and the erasure of Native women's art history, [how] it's non-existent, etcetera.

[The beaver house symbolizes] Canada [laughs], North America. So there are those little trinkets and trade goods stuck in the beaver lodge with pictures of Lady Di and Prince Charles with bits of birchbark woven into the [bramble]. And the headpiece is two braids, which are sticking up just to signify the anger [laughs] and the wheel is my umbrella – the invention of the wheel, civilization – and there's two fine bone china breastplates on the chest [laughs].[39]

In a sense, Belmore's involvement in the Thunder Bay parade inverts the all too common government practice of parading colourful Indians before visiting royalty

39 *Rising to the Occasion* was subsequently dismantled by the artist, then recreated in 1991 as a mixed-media sculpture for the touring exhibition *Interrogating Identity*, originating at the Grey Art Gallery and Study Center, New York University, New York City.

112
Rebecca Belmore
Rising to the Occasion
mixed-media performance in
Twelve Angry Crinolines, 17 July 1987
Thunder Bay, ON

while ignoring the darker realities of reserve life. In *The Universe Is So Big the Whiteman Confines Me to My Reservation* (Figure 113), Lawrence Paul Yuxweluptun illuminates the darkness, ironically foregrounding in the title the avarice and racist policies that have consigned (and confined) Native peoples to lives of desperation and despair on meagre fragments of their former homeland.[40] Symbolizing Aboriginal unwillingness to accept the status quo and ascribed inferior cultural status, a figure in the bottom left-hand corner of the painting is shown on the verge of leaving the reservation – perhaps forever, perhaps for a while, perhaps for an adventure,[41] or perhaps for a chance to do battle with the mandarins in positions of power and control.

Just such a scenario is envisioned by Yuxweluptun in *Leaving My Reservation, Going to Ottawa for a New Constitution* (Figure 114).[42] Undaunted by the task ahead, a lean and lanky Redman politician heads for the nation's capital carrying a briefcase labelled 'Indian Government.'[43] Littering the ground around him are symbols of a suffering people while behind him, stretching to the horizon, are miles and miles of government files on Indians. In the sky above, a rainbow, and the promise of a better day.[44] The extent to which bureaucratic reform is required is wryly symbolized by Yuxweluptun in his mixed-media portrait *D.I.A. Secretary* (Figure 117), which questions the inordinate number of blonde, blue-eyed White women in the employ of the Department of Indian Affairs. Yuxweluptun reasons that as conveyors of critical correspondence and important government funding, such women are frequently afforded more power than the chief of an Indian band.[45]

40 This is a good example of irony's ability to foreground constraints in order to undermine their power. See Hutcheon (1991, 73).

41 In this the figure is like McMaster's Indian Joe or the wanderer, Weesakeejak. See McMaster's comment about travel and experience, p. 169 n. 4.

42 Previously exhibited as *Leaving My Reservation, Going to Ottawa,* the artist says that this longer version is the proper title.

43 The articulated arms and legs of this cartoon-like figure recall the wooden puppets employed in traditional West Coast theatrical productions (Figure 115). The same analogy, however, bespeaks the dangers of becoming a political pawn and a puppet of the ruling party.

44 In *Dance Me on Sovereignty, Dance Me Outside Anywhere I Want* (Figure 116), elsewhere known as *Redman: Dance on Sovereignty,* Yuxweluptun imagines a similar scene, complete with government files and promising rainbow. A distinguishing feature of the figure in this painting is the gaping, though not distressing-looking, hole through his chest, signifying the less than complete recognition of his identity as an autonomous First Nations citizen, and his continuing status as an involuntary ward of the federal government. Needless to say, this is no dancing matter. The title playfully extends the title of a popular, though controversial, book of 'Indian' stories, *Dance Me Outside* (1977), by non-Native writer W.P. Kinsella. In 1994 the book was the inspiration for a feature film by the same name from director Bruce McDonald. This, in turn, served as the basis for *The Rez,* a 1996 CBC-TV mini-series subsequently renewed as a weekly series for the 1997-8 television season.

45 Cf. Yuxweluptun's other portraits of White women, *Face Painting of a Woman* (Figure 41, p. 84) and *The Boy Toy* (Figure 42, p. 86).

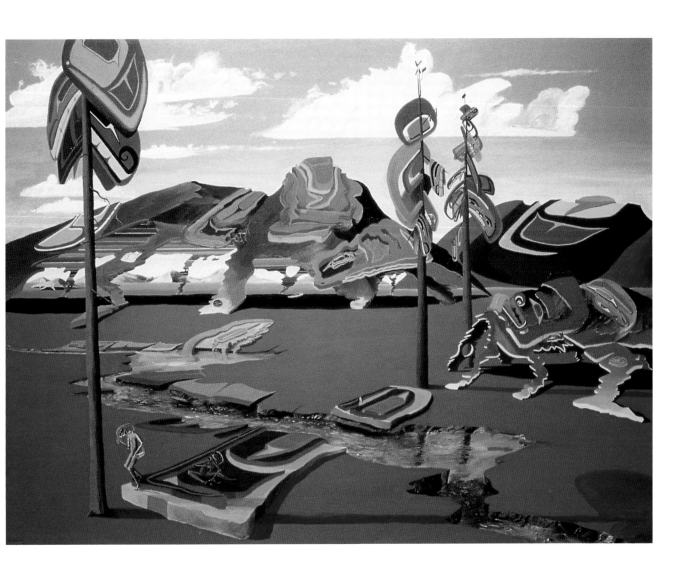

113

Lawrence Paul Yuxweluptun

The Universe Is So Big the
White Man Confines Me to My
Reservation, 1987

acrylic on canvas, 183 x 228 cm

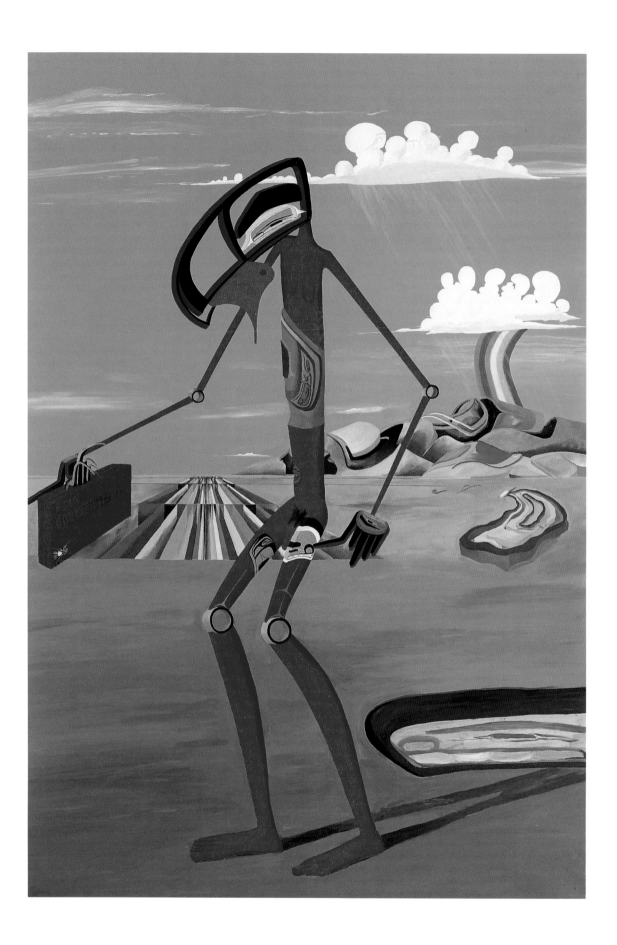

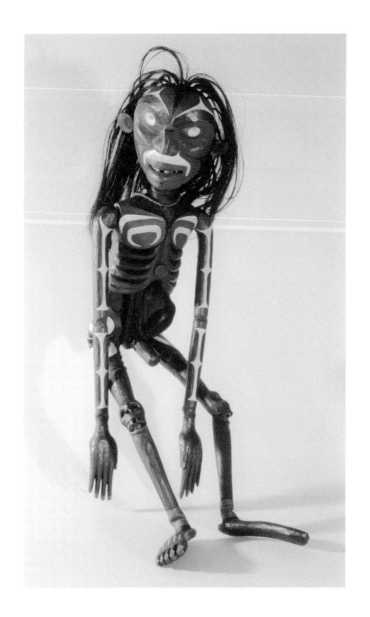

114 (facing page)
Lawrence Paul Yuxweluptun
Leaving My Reservation, Going to Ottawa for a New Constitution, 1986
acrylic on canvas, 249 x 173 cm

115
Beau Dick
articulated ceremonial puppet, pre-1981
wood, leather, paint, synthetic cloth, metal, glue, cord, thread, glass, quill, 63 x 16 x 8 cm

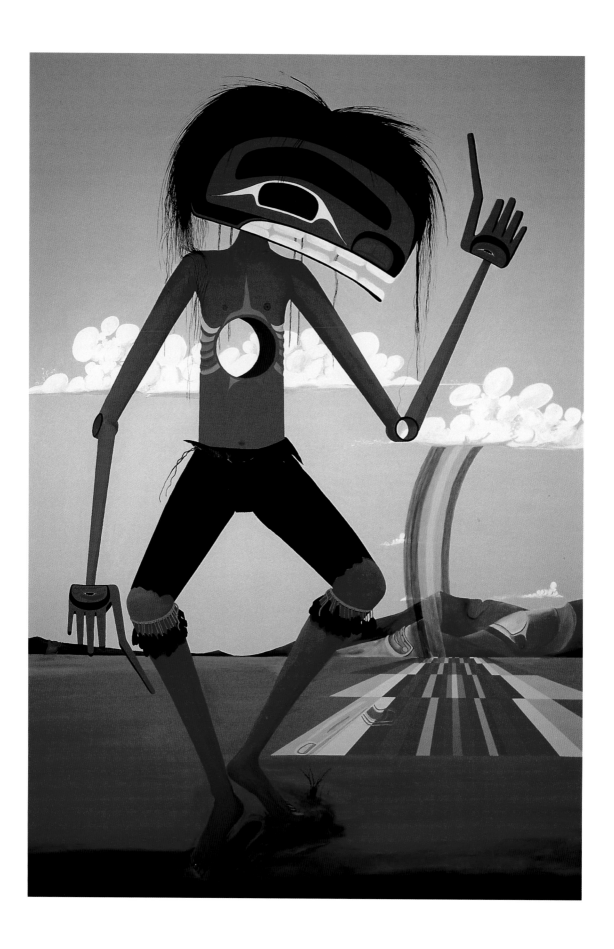

116 (facing page)
Lawrence Paul Yuxweluptun
Dance Me on Sovereignty,
Dance Me Outside Anywhere
I Want, 1985
249 x 173 cm

117
Lawrence Paul Yuxweluptun
D.I.A. Secretary, detail, 1987
acrylic on canvas with plastic wire,
70 x 160 cm

The journey for justice portrayed by Yuxweluptun in *Leaving My Reservation* has a distinct parallel in the artist's own life. In 1992 he travelled to Ottawa twice to participate in major exhibitions at two prestigious venues: *Indigena* at the Canadian Museum of Civilization and *Land Spirit Power* at the National Gallery of Canada.[46] In both cases Yuxweluptun spoke verbally and visually, textually and graphically, to the issues of cultural self-determination and ecological responsibility. His passion for these matters is explained in part by a second, more personal parallel with the warrior diplomat depicted in *Leaving My Reservation* – both his parents were for many years actively involved in Native political organizations. Yuxweluptun comes by his concern naturally, regarding his late father, Ben, as his mentor.[47] Yet in the beginning even his father did not recognize the familial and vocational continuity, prompting the artist to explain it to him in the following way:

I said that I finally got *my* briefcase but it's a crayon box. The relationship is different. He had documents in it. I have photographs. We spent years talking about politics. It's embedded into you. My father was very sharp about teaching me about politics. Politics, it's in your blood. I grew up going to the Union of BC Indian Chiefs' meetings and AFN [Assembly of First Nations] meetings. Even when I was older I went to them. It's interesting ... all aspects of it, but as an artist it's even more interesting because I can read documents, and I can analyze things ... Every year it's a new history and it has to be documented somehow. [I'm] not doing that gauntlet of Indian art galleries. Somebody has to document self-government now ... It's taken [my father] a long time to realize that a document can be closed and put into a file, and put into a book, and thrown into a library. And the pages can be lost, or the pages can be taken out, and words can be extracted from things and taken out of context. At least if you write something down in painting form, you can have a visual [impact]. You can't hide a painting. You can't put it into a big book. You can't close it.

From an early age, Yuxweluptun observed and absorbed the subtly subversive strategies employed by Native politicians when dealing with government bureaucrats. At the same time, he also witnessed master orators in action:

You learn that spokesmanship. You watch great spokesmanship – it's a flavour of language, of Indian language. [You watch] somebody that ... addresses a Department of Indian Affairs official in a Native language and totally alienates him in his bilingual reality. He has his French and he has his English, and he still can't deal with this Indian who's talking Indian to him. And so it shocks [him] into that reality that [he is] *talking to an Indian*. It's saying, 'Who's going to conform to who? Do you understand me when I'm

46 Carl Beam and Mexican expatriate Domingo Cisneros were the only other artists to have work in both shows.

47 In a chance meeting with the artist's father at a Vancouver gallery opening, I raised the subject of Native humour. He thought for a moment, then said, with a long pause, that it was 'very ... subtle.'

Three Exhibitions from the Quincentary Year

Indigena: Perspectives of Indigenous Peoples on Five Hundred Years, curated by Gerald McMaster and Lee-Ann Martin, ran from 16 April to 12 October 1992 at the Canadian Museum of Civilization, Hull, Quebec. It consisted of thirty-eight works in a variety of media – painting, sculpture, photography, video, performance, and mixed-media installation – by nineteen Native Canadian artists: Kenny and Rebecca Baird, Carl Beam, Lance Belanger, Bob Boyer, Joane Cardinal-Schubert, Domingo Cisneros, Joe David, Jim Logan, George Longfish, Mike MacDonald, Lawrence Paul Yuxweluptun, Edward Poitras, Jane Ash Poitras, Rick Rivet, Eric Robertson, Nick Sikkuark, Luke Simon, and Lucy Tasseor. The catalogue, edited by the curators, includes biographical statements by the artists and essays by Alootook Ipellie, Lenore Keeshig-Tobias, McMaster and Martin, Loretta Todd, Gloria Cranmer Webster, Georges E. Sioui Wendayete, Alfred Young Man. Artists and writers were asked to reflect on the concepts of 'colonization,' 'discovery,' 'celebration,' and 'cultural tenacity.'

Land Spirit Power: First Nations at the National Gallery of Canada, curated by Diana Nemiroff, Robert Houle, and Charlotte Townsend-Gault, was exhibited at the National Gallery of Canada, Ottawa, Ontario, from 25 September to 22 November 1992. It consisted of fifty-three works in a variety of media by eighteen Canadian and American Native artists: Carl Beam, Rebecca Belmore, Dempsey Bob, Domingo Cisneros, Robert Davidson, Jimmie Durham, Dorothy Grant, Hachivi Edgar Heap of Birds, Faye HeavyShield, Alex Janvier, Zacharias Kunuk, James Lavadour, Truman Lowe, James Luna, Teresa Marshall, Alanis Obomsawin, Kay WalkingStick, and Lawrence Paul Yuxweluptun. The catalogue contains lengthy essays by the three curators, who state that the works are meant to show how 'Native artists carry in them the memory of the land – place at its most primordial – as a spiritual and political legacy' (Nemiroff, Houle, and Townsend-Gault 1992, 13).

In the United States, Jaune Quick-to-See Smith curated *The Submoluc Show/Columbus Wohs*, a 'visual commentary on the Columbus Quincentennial from the perspective of America's first people' (Quick-to-See Smith 1992). Organized by Atlatl, a national service organization for Native American arts, the exhibition travelled to twelve venues in the United States from January 1992 to February 1994.

talking in this Native language?' And you get six or seven Natives doing that in one room to a Department of Indian Affairs official, and he's sitting there [listening to] these different languages, [and] it becomes this whole platform that is different, making the point that you're dealing with different types of Indians. We're not all the same just because we may have a reasonable facsimile of a brown colour of skin. We do have different cultures. We are different kinds of Indians. It's kind of neat. It was a good tactic as far as I was concerned.

Yuxweluptun sees himself as sharing a common purpose with these politicians: 'I like talking to the odd chief and meeting them and talking to people about the things that are going on so we have a common direction ... I like to have that continuity.'

Of course, continuity has a darker side as well. Earlier in this chapter in his discussion of John A. Macdonald, Gerald McMaster suggested that then prime minister Mulroney was merely the latest in a long line of political leaders to display a general disregard for Native peoples. Mulroney's disinterest is, in fact, one of the more significant themes in Shelley Niro's *Waitress* (Figure 118). Inspired by an upsetting personal experience of racial discrimination, Niro imagines a situation in which the artist-as-waitress is now in a position of power. Personifying national indifference to Native concerns and to all that Native peoples have lost, Brian Mulroney and his wife, Mila, are seen dancing the night away against a backdrop of flaming Iroquois masks. It is a truly combustible little dissident narrative.[48]

Mulroney is also the subject of Ron Noganosh's less than subtle figurative sculpture, *The Same Old Shit* (Figure 120), which graphically portrays government paternalism and the withholding of funds from Native bands (symbolized by the coins in the figure's left hand, kept behind his back).[49] He is implicated as well in a blanket painting 'performance' by Bob Boyer that affirmed the special economic status of Treaty Indians. Boyer explains Mulroney's unwitting involvement:

...

48 Niro's account of producing this painting is a moving story of creative catharsis and the transformative power of humour and art. See pp. 222-3.

Cultural insensitivity and governmental neglect are addressed as well in Niro's photographic triptych *Judge Me Not* (Figure 119), from her 1992 series, *This Land Is Mime Land*. Incorporating a self-portrait as a judge (a *Native woman* judge), a photograph of a family member attending a protest rally on Parliament Hill, and a second self-portrait unadorned by artifice, Niro foregrounds not only Native political concerns but also legal policies that often affect Aboriginal women directly and adversely. Like *Waitress, Judge Me Not* imagines both Native empowerment generally and Native women's empowerment specifically.

49 More than political critique, 'Brian on a Stick,' as Noganosh affectionately calls this painted wooden sculpture, can also be considered a contemporary expression of scatological humour long associated with tricksters and ceremonial clowns. Referring to the realistic feces in the figure's outstretched right hand, Noganosh says, 'I bought it in a joke store ... on Bank Street [in Ottawa]. There's two old ladies behind the counter, and I said, "Well, I'm looking for a fake turd." She said, "All the shit's over there!"'

118
Shelley Niro
Waitress, 1987
oil on canvas, 122 x 91 cm

Waitress

Shelley Niro

Mohawk artist Shelley Niro, in conversation at the Niroquois Gallery, Brantford, Ontario, 10 February 1991, discusses the experience that prompted her to paint *Waitress.*

I think [the painting] was done out of anger. I think that was the basic inspiration. But I'm trying to combat some kind of anger by not any kind of physical means but combat it with intellectual means. [The anger] comes from being a visible minority and subconsciously aware that other people see you that way, and being treated a little bit differently. I don't know if it's imaginary or if it's there ... Most of the time I can just let it go. I can just ignore it and let it pass over me without giving it too much thought. But this time I thought, 'I'm really going to think about this and really dig my teeth into it and hold onto this anger for a while and *taste* it – get the taste of it in my mouth.' I thought, 'Hhmmm, I'm going to get this woman back!' [laughs].

The woman – I just remember going into a store and the woman being really – not aggressive, but treating me in such a way that she couldn't look at me in the face, and just the way she would hand me things, like very quickly ... I'm not the type to go around saying, 'Well, she doesn't like me 'cause I'm Indian!' [laughs]. But this time I thought, 'Well, I'm going to use it – even if she doesn't mean it that way I'm going to take it

and use it.' So I started working on this painting and I was pretty angry. I didn't rationalize it into being a lighthearted [piece]. I was emotionally upset. But then I thought, 'Hhmmm, there must be something you can do with this kind of feeling. There must be something you can creatively do and express yourself and ... get back at this person' [laughs].

I sort of had her under my arm [laughs while feigning a headlock]. I was arm wrestling this woman in my head. So then I started working on this painting and I started thinking to myself, 'Why is she like this? Is it because of all these things you read in the paper about Native people being on welfare – they're taking all this money from Canadian people.' Because the Canadian people are always saying, 'Indians get everything for nothing' ... We work quite hard, and what we have is what we deserve – and I worked as a waitress before [laughs], many times. And so I started thinking, 'Well, a lot of people don't really have the right to put these kind of accusations on Native people because they do work hard.' So, again, I put myself in the role as a waitress, and I used a friend as a model for the person I'm serving. She was this White woman.

In the store she was an older woman, maybe fifty-five, so she had this staunch look about her – 'middle class White society' [laughs]. She just had it written right there in her face! As I started painting, the painting started getting

really fun: 'I'm going to be a working woman.' And again, the working-woman role sort of comes back – I don't know if it's a feminist thing or what – but it comes back to the point [that] ... the women do take charge, and you have to be pretty aggressive when you're in society and you have to make a stand. So in the painting I have me working and a bit of terror going on [laughs] ...

At the time, I was a bit shy of having models so I thought I'd just use a photograph [of my friend] and work from that ... I said, 'Now look really scared!' [laughs]. She said, 'Like this?' I said, 'Yeah.' I sort of wanted the feeling that I was a bit of a terrorist. Here I am with this glass of wine. [Spilling it is] a bit of a terrorist act I think. You can interpret the wine as blood or whatever else you want to see it as [laughs] ... You can see it as almost a religious thing too – the spilling of wine – it could come into a communion thing. It's [taking place] in any ... Chinese restaurant! [laughs] That's where I worked – it was a Chinese restaurant. That's why the use of the yellow as well, 'cause they seem to use a lot of red and yellow ... So I think I was being a bit of a terrorist here, but I wanted to be a terrorist, again, in an intellectual way, not necessarily [in] a physical or wrecking-the-place type of way. I think I just wanted to clash two different things together – that's where [the goblet] came from.

And then ... I was thinking of ... this woman ... standing there. She was so obviously unfriendly to me. And then I started thinking, 'Well, people don't have to be that way. There's nothing for them to say they have the right to act this way.' And then again, being a Native person, you think of everything that's gone, like the language, the culture, although it's starting to pick up again. And it's a question of keeping, holding onto everything.

Some of the culture's gone. Some things we'll never get back. Like the burning False Faces [in the background of the painting]. Once they're ashes you'll never see them again. The False Face is a pretty predominant symbol in Iroquois society, and we've always had these Faces around us. Even if we don't go to the Longhouse they're still always part of something ... I wanted a background that adds strength to the character in the painting. I hope that [the Faces are] in support of this person – that the strength from them comes down through [her] arm. That's how I look at it. It's sort of directed wrath [laughing and mimicking an animal roar]. Maybe I should have had little electricities coming out of her. Bzzzz!!! But after I finished this painting all those feelings of antagonism or revenge went away. After I finished it I was quite happy that I felt that way [laughs].

[As for the image of Prime Minister Mulroney and his wife, Mila in the painting], I figured they want to be the representative[s] of all Canadians. They want to be what is the most 'Canadian' ... They are *the Canadians*. And again, going back to the statements [I made] that Canadians see Native people as freeloaders or as bums or people that are taking things from Canadian people, they don't really appreciate what Native people have given up – not given up, but have lost. At the same time, they don't care. They're just having a great time. So that's why they're there.

[The Iroquois beadwork designs on the floor are meant] to show that some things might be gone, but still there's some things that we're ... standing on [that] continue. And from there things will grow. Other things will happen.

When I started doing [the painting] I was doing it for myself, and then when I finished it, it kind of scared me because of the False Faces. People are a little bit leery, like, 'Who do you think you are, [thinking] you can put a False Face in a painting?' – that sort of thing. I was not really afraid. I didn't want to hurt anybody's feelings with this painting, especially Iroquois people, so I was a little bit hesitant about that. [But] they liked it. They're a little bit confused by the imagery, like, 'What is going on?!' [laughs]. They're intrigued by it. But nobody's ever come up to me and said, 'How dare you!' or

'This is not your place.' That's what I was sort of expecting.

I think it's kind of a 'twisted' picture so people['s] ... heads go kind of 'woiinngg!!' [laughs]. There's Mila and Brian in the back having a good time and the customer is so fearful and the waitress is [gesturing], 'Up yours!' [laughs]. There's so many things going on and it's not so obvious ... If it's ... obvious, and people can say, 'Well, this is what's happening,' then they can be a little more straightforward with their remarks ... [The painting] is just an expression of myself and how I felt and how I could win a tiny battle within myself ... 'cause I'm such a wimp at heart [laughs]. It's just an expression of how I felt and how I use those feelings instead of whining and saying, 'Poor us.' I guess I wanted to be in a position of power in this painting.

119
Shelley Niro
Judge Me Not, 1992
hand-coloured gelatin silver print, sepia-
toned gelatin silver print, and a gelatin
silver print in a hand-drilled overmatte,
36 x 28 cm each photograph

120
Ron Noganosh
The Same Old Shit, detail, 1990
wood, acrylics, plastic, coins, 168 x 30 x 38 cm

This one [Figure 121] is called *No E & H Please, We're Treaty* – No Education and Health tax.[50] And that one I found very interesting because it was borrowed. Brian Mulroney borrowed that one when he had his international finance conference. And I don't think he even knew what was going on, but there it was hanging right behind the ... head table. Whenever they had the sessions they decorated the wall, and they were talking about international finance and so on [and] there's my statement about Treaty Indians behind there with the finance thing. So Mulroney and his cronies became part of a performance piece there for me.

Noganosh portrayed Mulroney once again in a devastating denunciation of the federal government's handling of the 1990 confrontation at Oka, Quebec.[51] Many Native people were enraged and sickened by the government's hardline stance on negotiations and by the decision to send in Canadian army troops and tanks to replace the provincial Sûreté du Québec (SQ). Noganosh gives voice to that rage in his mixed-media collage, *The Final Solution* (Figure 122), which draws an alarming analogy between the Canadian government's treatment of Indians and the Nazi treatment of Jews:

I had an old photograph of the Reichstag in the Second World War with masses of swastikas. Hitler, Goering, and somebody else are coming up the steps towards the camera, so I cut Hitler's head out, put Mulroney in there, [Quebec premier Robert] Bourassa's on one side, and [Indian Affairs minister Tom] Siddon is on the other side. And the Queen's looking over Mulroney's shoulder. Now there's railroad tracks that go off in the back and those railroad tracks are leading into Auschwitz[52] ... It's a collage, a composite. I've blown it up to four feet by six feet and it's mounted against camouflage cloth. I mean, that's my reaction to Oka ... There are some pieces that I do like that. There's humour in there but it's pretty black humour. These are the people who, right at the moment, are controlling what is happening to Indians. And they're acting just like

50 The title of this piece is a play on the name of the popular British television series, *No Sex Please, We're British*.

51 See p. 69 n. 49. For an insider's account of events that unfolded at Oka and Kahnawake during the seventy-eight-day standoff in 1990, see *People of the Pines: The Warriors and the Legacy of Oka* by Geoffrey York and Loreen Pindera (1991), and *Kanehsatake: 270 Years of Resistance* (Obomsawin 1993), the award-winning two-hour documentary produced for The National Film Board of Canada by Abnaki writer-director Alanis Obomsawin.

52 The 'final solution' *(die Endlösung)* is the term applied to the attempted extermination of European Jewry, which climaxed the twelve-year period of Nazi persecution known as the Holocaust (1933-45). More than four million perished in the gas chambers, disguised as showers, constructed alongside crematoria in death camps such as Auschwitz. The total number of Jews who died at the hands of the Nazis during the Second World War is estimated to be as high as six million.

121

Bob Boyer
No E & H Please, We're Treaty, 1985
oil over acrylic on blanket, 127 x 185 cm

122
Ron Noganosh
The Final Solution, 1991
photo collage on camouflage fabric,
229 x 171 cm

Nazis. And there's the Queen pussyfooting around looking over his shoulder saying, 'Gee, Canada's doing alright; look at how they're treating ... my Red children.' The Great White Mother![53]

In a four-part pastel drawing with the pointedly direct title, *FUSQ: Tanks for the Memories* (Figure 123), Bob Boyer registers his own disgust with the government's actions at Oka. In what must be regarded as one of the subtlest of subversions, the artist has scattered through the panels small and almost imperceptible letters from the tersely obscene title, '*FUSQ*,' an expression that surely testifies to the tenacity and infinite mutability of Native oral tradition! The text is all the more potent when, and if, detected. Like Edward Poitras, Boyer is past master of the subtle ambush.

...

53 One is reminded here of a comment by Louis Owens on humour in the novels of Blackfoot author James Welch: 'As Jesus Maria says in John Steinbeck's *Tortilla Flat,* it is a funny story, "but when you open your mouth to laugh, something like a hand squeezes your heart"' (1983, 142).

The grim humour that bristles in Noganosh's *The Final Solution* mirrors perfectly the humour directed at the Nazis by the peoples they oppressed. In his classic study of Czech resistance humour, Anton Obrdlik (1942, 712-5) writes:

People who live in absolute uncertainty as to their lives and property find a refuge in inventing, repeating, and spreading through the channels of whispering counterpropaganda, anecdotes and jokes about their oppressors. This is gallows humor at its best because it originates and functions among people who literally face death at any moment ... These people have to persuade themselves as well as others that their present suffering is only temporary, that it will soon be all over, that once again they will live as they used to live before they were crushed. In a word, they have to strengthen their hope because otherwise they could not bear the strains to which their nerves are exposed. Gallows humor, full of invectives and irony, is their psychological escape ... Its social influence is enormous ... [It] is an unmistakable index of good morale and of the spirit of resistance of the oppressed peoples ... I am inclined to believe that what is true about individuals is true also about whole nations [and here one could add First Nations] – namely, that *the purest type of ironical humor is born out of sad experiences accompanied by grief and sorrow.* It is spontaneous and deeply felt – the very necessity of life which it helps to preserve (emphasis added).

Likewise, John Morreall, in his book *Taking Laughter Seriously,* observes, 'The person with a sense of humor can never be fully dominated, even by a government which imprisons him, for his ability to laugh at what is incongruous in the political situation will put him above it to some extent, and will preserve a measure of his freedom – if not of movement, at least of thought ... It is because of the freedom of thought in humor, and indeed in aesthetic experience generally, that humorists and artists have traditionally been *personae non gratae* under rigidly controlled political regimes' (1983, 101-2).

For a further look at resistance humour in Europe, see Brandes (1977) and Townsend (1992).

123
Bob Boyer
FUSQ: Tanks for the Memories,
1991
mixed media on paper, four panels,
152 x 91 cm each

Not surprisingly, the Oka crisis provoked a great deal of emotional and embittered response from Native artists across Canada and beyond, who wished to demonstrate their support for, and solidarity with, the Mohawk peoples.[54] The proposed expansion of a nine-hole golf course onto sacred Mohawk land was treated with especially acrid wit. Three of the most striking examples are: *Life on the 18th Hole* (Figure 124), Kwagiutl artist David Neel's silk-screened portrait of Ronald Cross, the Mohawk warrior known as 'Lasagna,' with its grimly decorative border of 'ten little soldiers' reversing the imagery of 'one little, two little, three little Indians' in the children's nursery rhyme;[55] *Par for the Course* (Figures 125 and 126), Onondaga sculptor Peter B. Jones's ceramic interpretation of a masked warrior/guerilla golfer, with his skull-capped clubs slung across his back in a wampum-belted bag; and *Oka Golf Classic (He fell out of a tree and shot himself)* (Figure 127),[56] Ya'Ya Ts'itxstap Chuck Heit's red cedar housepost figure, which challenges Lawrence Paul Yuxweluptun's contention that Northwest Coast carvers cannot address contemporary issues in their work.[57]

54 In May-June 1991 Ottawa's Saw Gallery exhibited *Solidarity: Art after Oka,* a small collection of works by Aboriginal artists created during the stand-off or immediately after it (Martin 1991). In August-September 1991 Toronto's Workscene Gallery and A Space mounted a much larger show, *Okanata: An Interdisciplinary Exhibition Examining the Events and Emotions of the Mohawk Summer of 1990,* which featured the work of forty-six artists, both Native and non-Native. In February 1992 it travelled to the Woodland Cultural Centre in Brantford, Ontario.

55 Using a particularly entertaining allusion in a review of the exhibition, Elizabeth Leiss-McKellar writes, 'These soldiers stand with nightsticks like tap dancers in a chorus line.'

56 In a 1998 telephone conversation from his home in Hazelton, BC, the artist (who prefers to be known as Ya'Ya) discussed the subtitle of this piece and the sculpture's various historical references. Within the Native community, he said, it is widely believed that the unsolved shooting death of Corporal Marcel Lemay of the Sûreté du Québec – the only acknowledged casualty of the Oka standoff – was accidental and self-inflicted. In this version of events the young soldier was an inept sniper who tumbled to the ground from a lofty perch, fatally shooting himself in the process. This, and the larger issues it symbolizes, are commemorated in Ya'Ya's compelling sculptural interface that depicts Lemay, on the left, in military blue with golf ball eyeball, shell casing in hand, and blood oozing from a fatal shoulder wound, confronting a red-faced Mohawk warrior, on the right. The two half figures are held in tension and locked in conflict over an open space, defined physically and understood metaphorically. A large hole through the centre of the pole separates the figures. Dominating this space and ironically testifying to the gravity of the situation are several white golf balls suspended in midair on thin metal rods. Above the forehead of the doubled face a narrow headband references the historical Iroquois two-row wampum belt, symbolizing the parallel and supposedly non-intrusive paths travelled by Natives and non-Natives. At the base of the pole a stylized eagle honours the Cree politician Elijah Harper, whose surprising defeat of proposed government legislation a few months earlier had made him an instant national celebrity and earned him the admiration of Native people across the country.

See *Elijah Harper and the Deadheads* (Figure 136), a second carving by this artist that pays tribute to Harper's victory and, like this one, recalls Hoesem-hliyawn's *Hole-through-the-Sky* totem pole (Figure 53, p. 111). See also McMaster's *Oka-boy/Oh! Kowboy* (Figure 128, p. 237), in which the figure of a blood-stained cowboy soldier makes oblique reference to Lemay.

Oka Golf Classic, the intentionally ironic title of Ya'Ya's piece, acquires further, albeit unintentionally ironic overtones in light of the program set out in a flyer for a 1989 'Pow-wow in Paradise' in St Thomas, US Virgin Islands. A scheduled feature of the week-long event was a 'Mohawk Masters' golf tournament!

57 In the spring of 1993 the Vancouver Museum mounted *Spirit of the Earth*, a year-long exhibition of masks by David Neel, which dealt with a variety of current sociopolitical concerns. The show featured pieces with names such as *Ozone Mask, Clearcut Mask, Chernobyl Mask*, and *Overpopulation Mask*. Photographs of several have been published. Among them are: *Oil Spill Mask*, in Townsend-Gault (1991); *Inuit Relocation Mask*, in Tétreault (1992); *Mask of the Injustice System*, in McMaster and Martin (1992); and, along with four others, a stunningly dramatic *Mohawk Warrior Mask*, in Raziel (1993).

124
David Neel
Life on the 18th Hole, 1990
serigraph, 91 x 76 cm

125
Peter B. Jones
Par for the Course, 1991
stoneware, 49 x 15 x 14 cm

126
Peter B. Jones
Par for the Course, back

127 (facing page)
Ya'Ya Ts'itxstap Chuck Heit
The Oka Golf Classic (He fell out of a tree and shot himself), 1991
mixed media, painted red cedar house-post, 244 x 122 cm

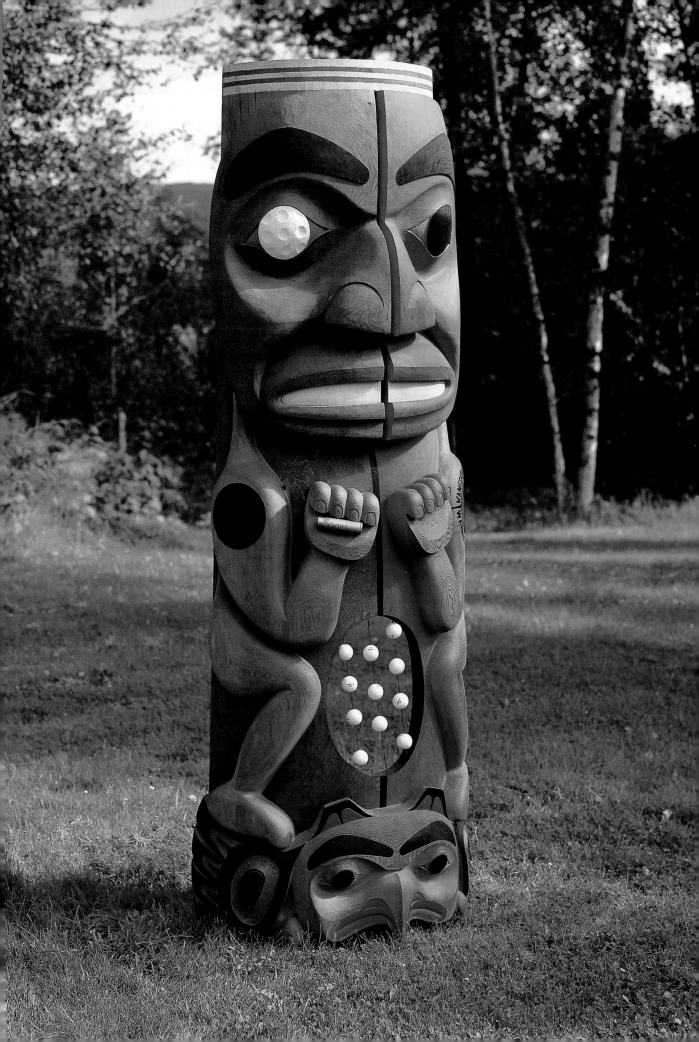

Gerald McMaster's painting *Oka-boy/Oh! Kowboy* (Figure 128), included in *The cowboy/Indian show,* is not so much a response to the Oka stand-off – although it obviously is – as a disturbing illustration of history seeming to repeat itself. It is one of the most layered and textually complex paintings the artist has created, as he explains:

I did this one just as I was reading all the news that was coming out of Oka. Here, the cowboys are the soldiers or the Sûreté du Québec ... The large figure represents the Mohawk Warriors ... just one figure ... [symbolizing] the outnumbering of these Warriors at the time ... nine to one. These people were *targets* ... The media seemed to create the divisiveness between 'soldiers' and 'Indians.' I began to think, okay, it could be like the cavalry again. They're coming in with bugles to the rescue ... saving the community ... saving everybody. But 'What community?' is really the question. In the end, you don't know who the army was saving. It was probably everybody, yet you don't read it that way.

In the painting, the text was the first thing. Then I built around it. I listed a number of ways that 'OK' could be presented. Those two letters can be used in different ways. 'Oka' and 'Oka-boy' were references to the Warriors. 'Oh! Kowboy' referred to the soldiers, the contrast that I was looking for. I was playing on different levels. Is everything 'okay' now? *Will* everything be 'okay' after this? Can the communities ever be the same again? Has this event created a relationship that can never be mended? 'Oki-napi' is a Blackfoot greeting to a friend. It means 'Okay, things are cool.' 'O Kanada' and 'O kant u see' refer to the two national anthems – Canadian and American. If you go back to Akwesasne, the reservation that straddles the border, a lot of the problems emanated from that region. And 'Oh! Kowboy' ... I was listening to a song called 'Mon Cowboy,' ... by [Quebec singer] Mitsou. It's in French. 'Oh! Kowboy' is a friendly reference to a cowboy ... 'Oh! what a big guy' ... or 'Ohhh! ... you're my cowboy!'

What McMaster does not mention specifically is the perversely playful border design which freely and numbingly repeats 'ОКАОКАОКАОКА' like a broken record or an endless protest chant. The painting's cheerful colouring merely heightens the horror.

In *No Life Like It* (Figure 129), a second painting in *The cowboy/Indian Show* inspired by the Oka crisis, McMaster reflects on the romance and racism of 'Indian fighters,' both in and out of uniform:

In this piece I was asking these questions: Why are people joining the army? Is it this 'cowboy and Indian' thing again, where 'we've got to do something about this "Indian problem"?' I quoted the army's announcement ... in *Maclean's* magazine: 'Applications to join the Canadian armed forces were 32% higher in Aug. than the same month a year ago. Spokesmen attributed the increase to the army's involvement in the Quebec Mohawk crisis ... ' Then I drew this big camouflaged helmet and on the helmet I drew feathers. The feathers were crossed out like notches. The crosses could indicate two things: they mean 'notch marks,' like 'scalp marks' in the old days – 'the only good Indian is a dead Indian' kind of thing ... which has larger ramifications – or they could be Band-Aids ... in other words, helping somehow. In the complexity of the situation this summer the army actually was a saviour to some Indian people. Some Indian people were actually glad they came in.

128
Gerald McMaster
Oka-boy/Oh! Kowboy, 1990
acrylic and oil pastel on matt board,
94 x 114 cm

What gives *No Life Like It* its incisive edge is McMaster's unexpected global reading of a distressing incident of racially motivated violence in the Montreal suburb of LaSalle. A brief explanation: in a gesture of solidarity with their comrades at Oka, Mohawks at the Kahnawake Reserve near Montreal mounted a sympathy blockade of the Mercier Bridge, a vital link between the communities on the south shore of the St Lawrence River and the city of Montreal. In late August a rioting mob of non-Natives stoned a convoy of sixty cars carrying more than a hundred Mohawk women, children, and elders across the bridge to safety in advance of an anticipated military attack on the reserve. One elderly man was struck by a rock thrown through an open car window and later died. McMaster continues: 'At the bottom of the painting I have four rocks, and the comment there ... is a double-edged sword. At the Berlin Wall the rocks represented a kind of freedom, whereas at LaSalle – shit! – they were being stoned to death! Is that irony? I don't know. Yeah! [And] 'No Life Like It' is, of course, from the army's advertisement on television. What's the adventure?'[58]

Over the course of the long summer and into the fall, Mohawk artist Bill Powless monitored Native reaction to the stand-off in a series of cartoons appearing in the *Tekawennake* newspaper (Figures 130 to 132).[59] None is perhaps more potent or critical than Figure 132, which targets the angry residents of Châteauguay, Quebec, who came out night after night with beer and binoculars to taunt those entrenched behind the barricades at Kahnawake.[60]

In the wake of discussions that saw the conflict come to a negotiated, if somewhat chaotic, conclusion on 26 September 1991, Native peoples across Canada began to reflect on the ramifications of the event for the future of Native/non-Native relations. Though opinion was sharply divided on the seemingly 'un-Canadian' and 'un-Indian' use of violence to call attention to outstanding grievances, there is no denying that the incident unified Aboriginal peoples. They denounced what they perceived to be yet another indignity perpetrated by a militarily superior but morally impoverished government of colonial interlopers. McMaster says that in

129
Gerald McMaster
No Life Like It, 1990
acrylic and oil pastel on matt board,
116 x 96 cm

58 At the 16 August 1991 opening of the *Okanata* exhibition at the A Space Gallery in Toronto (p. 232 n. 54), Rebecca Belmore staged a performance titled *August 29, 1990,* which dealt with the rock-throwing incident at LaSalle. In a brief description of the piece she says, 'There's a white sheet drenched in blood and it's violent and there's a twist of humour: it begins and ends with the words, "There's nothing like getting up in the morning and reading the newspaper!"'

59 Figure 131 illustrates another event as well. In response to Iraq's invasion of oil-rich Kuwait in 1990, a multinational military force spearheaded by the United States launched the largest air and land attack since the Second World War to drive Iraq out of Kuwait. The Conservative government of Brian Mulroney sent Canadian forces to take part.

60 Like McMaster's *No Life Like It* (Figure 129), this cartoon was actually produced after the confrontation had come to an end. The issues that prompted the crisis have yet to be satisfactorily resolved.

retrospect the conflict at Oka 'was not just over a nine-hole golf course. I think that was the success of it. I think that's what Native people across Canada are in some way or another joyous about. They were glad it happened. Native peoples in the Americas and a lot of indigenous peoples around the world thought "Alright, underdog!" So ... there were some positive sides to that.'

In the weeks and months that followed the stand-off, it was nigh on impossible to separate the legacy of Oka from the larger legacy of European exploration and conquest that was fast becoming a major focus of media attention with the impending international celebrations of the Columbus Quincentenary in 1992. As might be expected, many Aboriginal people viewed the upcoming anniversary as a time perhaps more appropriate to 'decelebration' than to celebration.[61] What, in fact, was there to celebrate – save for survival? As Saul Terry, president of the Union of BC Indian Chiefs, succinctly put it, 'We're tired of surviving. We want to live.'[62] For those in the arts, the challenge of 1992 was to convey such sentiments to the general public with conviction yet without causing alienation. Predictably humour and irony figure prominently in some of the more imaginative solutions.

Take, for example, Seneca artist/curator Tom Hill's illustrated lecture on Christopher Columbus at the South Street Seaport Museum in New York City in June 1991:

I did [it] with a real tongue in cheek because I knew Columbus [laughs], to the Americans, is like a cultural hero. So I thought, 'How am I going to touch on this thing? It's like making fun of God, to Americans, and here am I doing it right in the middle of Wall Street. Like, how do I get them even to think about my ideas or my notions?' Of course, I did it with a slide presentation and tried to tie it all together, but it worked because I did take a sense of humour to it – but based on some very serious notions. Like, the moment we'd get laughing I'd drop a line [like], 'It hasn't changed that much, you know, I'm just reading about Brazil – Indians being shot in their fields,' [or] 'New York Times has just reported ... ' or 'Time magazine has just done this ... ' and constantly bounc[ing] them back through it. There was one lady [who] came up to me after I made that talk, she said, 'I felt like a ping pong ball, back and forth, back and forth, back and forth.' But she said, 'I'm glad I fell on your side, as the ping pong ball,' which was a relief because that's where I really wanted them to go. Which is neat. She said, 'You convinced me that we've got to rethink some of these things.'[63]

[The lecture] was to comment on an exhibition called First Encounters, and I was pre-senting the Native voice here, but also my main objective was to [say], 'Let's use this time

61 In 1989, long before the public hoopla began in earnest, Ottawa's Saw Gallery mounted the exhibition Decelebration, featuring the work of Native artists Shirley Bear, Lance Belanger, Domingo Cisneros, Peter J. Clair, and Ron Noganosh. See Maracle and Fry (1989).

62 Terry's words were added as a line of text to David Neel's serigraph Life on the 18th Hole (Figure 124, p. 233) when it was used for a fundraising poster whose sale would 'contribute towards the just recognition of our Aboriginal Title and Rights and a just settlement of the land question in Canada.'

63 Cf. Joane Cardinal-Schubert's similar seriocomic approach to public speaking, p. 144.

130
Bill Powless
'We'll just have to finish our game ...' 1990
pen and ink cartoon on paper

131
Bill Powless
1990
Loony, pen and ink cartoon on paper

132
Bill Powless
'What are you going to the party as?' 1990
pen and ink cartoon on paper

to rethink this, these ideas. Are we prepared to change? And if we don't change what does it mean? And if we do change what does it mean?' So that was basically the objective of that gallery talk.

The text of Hill's lecture appeared in revised form in the September 1991 issue of the Woodland Cultural Centre's quarterly magazine, *Wadrihwa*, accompanied by a wry pen and ink parody by Bill Powless of Sebastiano del Piombo's famous painting of Columbus (Figure 133).[64]

An adaptation of the same portrait appears in Carl Beam's *Columbus and Bees* (Figure 134), from his *Columbus Suite* of etchings, which in turn forms part of his much larger body of work, *The Columbus Project*, begun in 1989 and completed in 1992.[65] In *Columbus and Bees* what may at first seem to be merely a curious

64 Writer David Gates suggests that the lettering on the original painting identifying the individual as Christopher Columbus 'was probably added, years after the fact, to a portrait of some long-forgotten Italian nobleman' (1991, 29). Be that as it may, the image has been invested with considerable historical authority over time.

65 See Beam and Young (1989) and Rhodes (1992). It will be recognized that over the course of this book several other etchings in Beam's twelve-piece *Columbus Suite* have been discussed: *Self Portrait as John Wayne, Probably* (Figure 16, p. 42); *The Proper Way to Ride a Horse* (Figure 78, p. 150); *Calvary to Cavalry* (Figure 99, p. 192); and *Semiotic Converts* (Figure 105, p. 202). Reflecting on the series as a whole, Beam wryly says, 'I tried to start a rumour that there was something meaningful going to come out of this.' In a somewhat more expansive appraisal, he adds: 'The idea was to address some of the larger issues over the past 500 years. Technology is pretty well covered [here], but I'm not qualifying it as good or bad. There are some real faces, the major European players, the underlying issues. It's a little compact group of works, a little snapshot for somebody who dropped in from another planet. That was a good series because it did all that stuff with great skill, finesse, masterfulness of the medium, and it was fairly generic. I've never seen work like this any place.'

133
Bill Powless
Welcome 1991
pen and ink cartoon on paper

134
Carl Beam
Columbus and Bees, 1990
etching on paper, 122 x 81 cm

juxtaposition of images acquires added dimension when understood as the symbolic pairing of a European passion for exploration and discovery with a parallel compulsion for analysis and classification – not to mention exhibition – of what has been discovered. That the objects depicted in the lower section of the print are the physical remains of once living creatures is no small part of the equation.[66] And, of course, bees are the ultimate colonizers.

Columbus and bees are seen again, along with several other familiar images, in Beam's works on canvas included in the 1992 exhibition *Land Spirit Power: First Nations at the National Gallery of Canada* (Nemiroff, Houle, and Townsend-Gault 1992, 106ff). The show also featured a version of *Burying the Ruler,* his ironically titled and politically pointed self-portrait, which appeared in different form but with the same title in the Canadian Museum of Civilization's *Indigena.*[67] In both venues the piece contested the authority of post-Columbian history with visual candour and acerbic wit, not to mention economy of form. This was especially so in *Indigena,* given the stated focus of the exhibition: 'perspectives of indigenous peoples on five hundred years.' In that show, the economy of Beam's work was reflected in his pithy artist's statement, posted on the gallery wall beside the actual piece – as concise a dissident narrative as the image it complemented. Cited earlier in a somewhat different context it is worth repeating: 'After five hundred years people should realize the world is round'[68]

In the same exhibition, Bob Boyer adds a not entirely unexpected playful edge to his painted wool blanket condemnation of Columbian colonialism by giving his three-panel installation the title *Trains-N-Boats-N-Plains: The Nina, the Santa Maria, and a Pinto* (Figure 135). It is a calculated gesture that paradoxically lightens *and* heightens the intensity of his deadly serious critique. Exploration and travel have never seemed so sinister.[69]

66 Cf. Beam's *Big Koan* and *Chronos 2* (Figures 76 and 77, pp. 148 and 149), and *Chronos 1* (Figure 106, p. 203). Also, *Still Life* by Peter B. Jones (Figure 73, p. 141).

67 See p. 51 regarding other versions of *Burying the Ruler* (Figures 21 and 22, pp. 52 and 53). See also McMaster and Martin (1992, 118-21).

68 Despite the frequency of irony in his work, Beam says, 'I can't be endlessly ironic because the irony goes two ways. There's a psychic price – it also implodes. Knowing the world is so shallow and stupid is emotionally draining.' Even so, art historian Ruth Phillips suggests that Beam has little choice in the matter: 'Carl Beam can't really decide *not* to be ironic because that's him.' Her words echo those of Alan Wilde, who views irony first and foremost 'as a mode of consciousness, an all-encompassing vision of life' and a series of strategies and techniques only in a secondary sense (1981, 3). Whether or not Beam is an ironic person, he insists, 'Don't paint me as an ironic artist ... Irony is just one of many aspects; there are other ones in there.'

69 The bleeding red crosses in this piece recall the graphic violence of Boyer's *Batoche Centennial* (Figure 50, p. 103) and *A Minor Sport in Canada* (Figure 94, p. 183), as

In a review of *Land Spirit Power* and *Indigena,* curator and art historian Scott Watson identifies artists Ron Noganosh and Shelley Niro as conspicuously absent from the Ottawa exhibitions (1993, 43). It is a notable observation and a notable omission; no doubt both would have made worthy contributions to either show.[70] Certainly both had given thought to the upcoming quincentenary celebrations, and coincidentally both had planned critically comic performances that would ideally be documented on video. In conversation, Noganosh explains what he had in mind:

> [My wife] Max and I were talking about doing a [video]. There's all these shows coming on for 1492, right, celebrations, and what we wanted to do – Max is from Jamaica and her aunt lives in Discovery Bay. That's where supposedly Columbus first landed, and what we wanted to do is go down there and shoot a videotape, a film, of the Indians holding an immigration hearing for Columbus, right, because there's no way the guy would have got in the country ... He was in debt, he didn't have relatives here, didn't know the language. Forget it! He was a 'write-off,' right [laughs]? That son of a bitch took a load of slaves back with him and sold them to make his money. Hero of the country ... great! A damned Italian working for a Spaniard who got lost! Became a hero. Now that's humorous and

well as the censure of Christian complicity in Native oppression symbolized by Jane Ash Poitras in *The Virgin Bullet* (Figure 101, p. 195) and Noganosh in *Dominus Vobiscum* (Figure 102, p. 196). Boyer's positioning of the German word *Verdrangung* (repression) above the words 'Turtle Island' in the central panel draws a disturbing parallel to Nazi cultural genocide not unlike that made by Noganosh in *The Final Solution* (Figure 122, p. 228). In light of such associations, Boyer's lilting title, playing as it does off the title of a popular song from the 1960s and a film comedy from the 1980s, is all the more jarring, and for this reason perhaps all the more necessary.

70 In the case of *Indigena,* it seems that their omission was due in part to a concern for regional representation and the limited number of Ontario artists allowed. Charlotte Townsend-Gault makes brief mention of Niro in her curatorial essay 'Kinds of Knowing,' in the *Land Spirit Power* catalogue. A reproduction of Niro's photographic triptych *I Enjoy Being a Mohawk Girl* accompanies the text (1992a, 93). In April 1998 Niro's work finally made an appearance at the Canadian Museum of Civilization, as part of the multi-installation exhibition *Reservation X.* Scheduled to run to March 1999, the show includes work by Mary Longman, Nora Naranjo-Morse, Marianne Nicolson, Jolene Rickard, Mateo Romero, and C. Maxx Stevens. Niro's second film, *Honey Moccasin,* was screened at the Museum in conjunction with the exhibition opening, and several objects from the film were featured in her installation (McMaster 1998.)

ironic [laughs]! This is their hero! I mean ... give us a break here! At least the Indians knew where they were going [laughs]![71]

A week earlier, Shelley Niro spoke with enthusiasm about a proposal she was writing and intended to submit to the Canada Council:

You've heard of all the 1992 celebrations going on in – I don't know if it's the world or North America or what – so a lot of galleries and people are jumping on the boat and they're going to exhibit the 'Native's' perspective. So, I've talked to other artists and some of them are kind of peeved ... that, again, it's the Native artists being used for a gallery to fill in that little bit of controversy for the year ... So, I was thinking, 'Well, you could do something on your own.' I've talked to a couple of other women [artists], Rebecca Belmore and Pat Deadman, and we were thinking of getting the last word in on 1992.[72]

135
Bob Boyer
Trains-N-Boats-N-Plains: The Nina, the Santa Maria, and a Pinto, second of three panels, 1991
wall installation, oil over acrylic blankets and other mixed media, approximately 549 x 305 cm installed

71 Unfortunately, Noganosh's Columbus project did not progress beyond the conceptual stage.

Also marking the quincentenary was Thomas King, who penned the seriously amusing children's book *A Coyote Columbus Story,* outrageously illustrated by Métis artist William Kent Monkman. In King's version of the familiar tale a female Coyote conjures up the European newcomers out of boredom. Tellingly, Columbus and his crew are portrayed as people with no manners, who act as if they have no relations. Dressed in ridiculous clothes – one crew member is an Elvis Presley lookalike – they search for things to sell, such as computer games and music videos, but settle on human beings, who are taken back to Spain and sold into slavery. 'Somebody has to pay for this trip,' Columbus says. 'Sailing over the ocean blue isn't cheap, you know. Grab some more Indians!' Another couple of trips like this, Columbus tells his friends, 'and I'll be able to buy a big bag of licorice jelly beans and a used Mercedes' (1992a, n.p.). The book was subsequently nominated for a Governor General's Award. A version of this story also appears in King (1993b).

Gerald Vizenor celebrated as well. In his novel *The Heirs of Columbus* (1991), the famed navigator is envisioned as a crossblood descendant of early Mayan explorers who returns to his homeland in the New World. The jacket blurb describes the book as the story of 'Stone Columbus, crossblood trickster and modern namesake of the great explorer [who] is born on a remote reservation and secures a fortune on a bingo barge, spreads his trickster wisdom on talk radio, and founds a new tribal nation where "humor rules and tricksters heal." Thus the heirs of Columbus enact and reclaim a misrepresented heritage.'

72 In the fall of 1991 Belmore described a quincentenary project of her own: 'I'm doing "Trauma Mama" in a performance with 7th Fire on Columbus Day. We've priced the tickets at $14.92 and $19.92 ... Right now, I'm working on a Santa Maria ship costume. It's like a gaudy Spanish ship, like a souvenir, tacky. My head is covered with a big sail and on the back it says, 'Hey sailor!' with a flap that flips up and underneath it says, 'Get lost!' ... A lot of people are thinking about [the anniversary] and they need something to touch. That's our job as artists – to articulate it.'

Belmore subsequently participated in *Land Spirit Power* at the National Gallery, contributing a performance to the opening festivities and an installation, *Mawuche-hitoowin: A Gathering of People for Any Purpose,* to the show itself. The cover of the exhibition catalogue features a photograph of Belmore in performance with a giant megaphone for the piece *Ayum-ee-aawach Oomama-mowan: Speaking to Their Mother,* presented at Banff, Alberta, in the summer of 1991.

This is kind of an outrageous part right here ... maybe somebody's already thought of it [laughs], but [at] quarter to twelve, 1992, December 31 ...

So we take a plane to Spain [laughs]. We'll be working on our outfits all year long. So we're going to invent costumes or an outfit, and it has to be so symbolic that everything has to be worked on right to a T. And then we'll climb up the rock of Gibraltar and have our little flag and plant it on the top of the mountain and claim Spain in the name of Elijah Harper [laughs] or whoever else is the 'King of Indians' at the time.[73] Do that and

73 Elijah Harper is a Cree Indian and former member of the Legislative Assembly of Manitoba. The Meech Lake Accord proposed an amendment to the Canadian Constitution Act and was opposed by Native peoples for its failure to recognize Native rights. As the 23 June 1990 deadline to ratify the Accord drew near, Manitoba had not yet voted on it. Accelerated introduction of the motion in the legislature required the unanimous consent of all MLAs. Harper voted no three times, delaying the debate beyond the deadline and effectively halting the change to the constitution.

To commemorate Harper's historic achievement, Tsimshian carver Ya'Ya created *Elijah Harper and the Deadheads* (Figure 136), a contemporary totem pole on which the politician appears as an eagle perched atop a ring of eleven white skulls, each bearing a fatal bullet hole. Representing then prime minister Mulroney and the ten provincial premiers, the brain-dead skulls encircle a large hollow, cut through the pole from front to back. In conversation the artist reveals the cavity's double reference: to Meech Lake, on whose shores the failed accord was hastily hammered together, and to the ubiquitous reserve outhouse, a culturally appropriate repository for the proposed legislation. At the base of the pole a small red figure represents the children and future generations who will benefit from Harper's actions. Ironically, this pole is now in the collection of the Department of Indian Affairs. Cf. *The Same Old Shit* (Figure 120, p. 225) and *It Takes Time* (Figure 152, p. 270), by Ron Noganosh, Ya'Ya's *Oka Golf Classic* (Figure 127, p. 235), and Hoesem-hliyawn's *Hole-through-the-Sky* pole (Figure 53, p. 111).

Bill Powless paid tribute to Harper by portraying him as a fringe-caped superhero (Figure 137) in a drawing that appeared in the *Tekawennake* newspaper on 27 June 1991. Powless is not alone in using this heroic analogy. In *Homage to Smallboy*, Joane Cardinal-Schubert's sensitive 1984 oil and acrylic portrait of the late Cree chief, Robert Smallboy (Podedworny 1985a, 32 figure 4), the artist cloaks the respected leader in a loosely drawn 'Superman' cape. It is clearly an inside joke, a semi-private allusion. 'That's the irony part,' she says. 'Nobody knows that [he's wearing a Superman cape]. It was funny.'

Generally speaking, caped crusaders are given a higher public profile. In the Canadian Arctic, for instance, television viewers have been treated to the live-action adventures of Super Shamou, an Inuit superhero who flies about the North saving the day while reinforcing traditional cultural values. (See Poisey and Hansen's documentary, *Starting Fire with Gunpowder*, 1991.) Outside the Arctic, the best-known Aboriginal superhero is probably Navajo artist Vincent Craig's wonderful creation, Muttonman. A lovable character with limited superpowers, Muttonman is the transformed persona of a Navajo sheepherder who consumed mutton from sheep that had watered at the Rio Puerco, a New Mexico river contaminated in the 1970s by a uranium tailings spill. *Muttonman Discovers*

[get] Indian organizations to give us something to bury in a time capsule. I think it will be really symbolic ... [because] ... we really don't want Spain [laughs] or anything else. We really don't want anybody else's continent, but it's a way of making that circle a full circle instead of being at the end of the line and being dumped on all the time. If we can continue the circle around or take it back, then from a spiritual point of view, it'll be a fresh start. We can start over again ... So I have to sit down and write the proposal and get a film maker to come and film it, and maybe have a travelling show from it.

As it turned out, Niro's project evolved into something decidedly different, but it still affirmed her belief in and commitment to the healing power of humour. With a partner, Anna Gronau, she spent much of 1992 writing, producing, and directing *It Starts with a Whisper,* a twenty-six-minute film portrayal of a young Native woman's sometimes comic journey of self-discovery. Offering her guidance along the way are three ancestral spirits, or matriarchal clowns, played with appropriate gusto by Niro's three sisters, Bunny, Betsy, and Beverley. It is a delightful piece of casting. Also proffering words of wisdom and encouragement is Native leader Elijah Harper in a surprise cameo appearance. The film ends with a memorable scene that recalls Niro's original proposal: At 11:55 P.M., 31 December 1992, the four women gather for a celebratory tea party at the brink of Niagara Falls, shown projected on a screen behind the actors. Following a reading from Mohawk poet E. Pauline Johnson's famous poem 'The Song My Paddle Sings,' the quartet joins together in a traditional drum song as fireworks explode in the sky above, creating, in the final frame, the image of an Iroquois celestial tree rising from the back of Turtle Island. Twinkling in the heavens, it ushers in a new year and a new era brimming with pride and promise.[74]

Columbus, a retrospective of Craig's cartoons, was a highlight of the 1992 quincentenary celebrations at the University of New Mexico (Figure 138). The show was widely covered in the media, and later travelled to the Smithsonian Institution in Washington, DC. See Jojola (1993), Landon (1991), Negri (1997), Traugott (1992), Villani (1993); also Basso (1979), Haederle (1995), Hess (1981), and Sneddon and Crawford (1995). Mention should also be made of Bill Powless's Superscone (Figure 139), whose name betrays a curious tribal/colonial taste for the traditional Scottish quick bread. While still in the developmental stages, Superscone clearly shares the same resolve as Lawrence Paul Yuxweluptun's wiry Red Man in *Leaving My Reservation, Going to Ottawa for a New Constitution* (Figure 114, p. 214). Both individuals are off to fight the good fight in the boardrooms of the nation.

One final note. It could be argued that a distinctly Aboriginal superhero would, of necessity, possess a healthy trickster spirit: a cultivated ability to outwit the forces of evil rather than merely to overpower them. That said, two new comic books have recently appeared that feature deadly serious SuperIndians displaying superhuman strength. See Morrisseau (1997). It is to be hoped that in future issues, characters in *Red Raven* and *Tribal Force* will tap into the trickster energy that is part of their shared indigenous heritage.

74 The same design appears on the beaded red loincloth worn by the ceremonialist in Carson Waterman's *The Senecas Have Landed, No. 2* (Figure 56, p. 114).

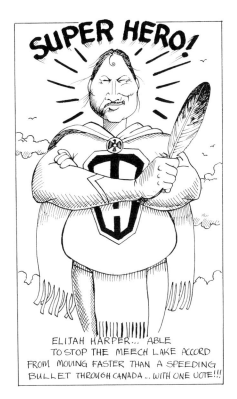

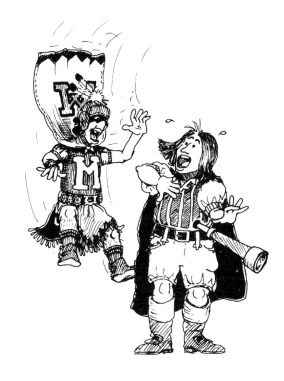

136 (facing page)
Ya'Ya
*Elijah Harper and the
Deadheads,* 1990
acrylic on red cedar, 241 x 66 x 49 cm

137 (above, left)
Bill Powless
SUPER HERO! 1990
pen and ink cartoon on paper

138 (above, right)
Vincent Craig
*Muttonman Discovers
Columbus,* 1992
pen and ink cartoon on paper

139 (right)
Bill Powless
Superscone, 1991
pencil sketch on paper

Still hoping to have the last word in 1992, Niro and Gronau scheduled a late-night preview of the film on New Year's Eve at the Six Nations Iroquois Lodge, only to find that their choice of venue – a senior citizen's home – necessitated a much earlier showing.[75] In fact, they had to be out by 8:30 P.M. Undaunted, they merely asked the audience of nearly 150 guests to imagine a later hour. According to Niro, the occasion was a resounding success and cause for much celebration.[76]

The many works in this chapter that mark this juncture in history with a mixture of humour and irony, anger and hope, signal a turning point in relations between Natives and non-Natives and imagine another way of being human. As Hill said in his New York City presentation, 'Let's use this time to rethink this, these ideas. Are we prepared to change? And if we don't change what does it mean? And if we do change what does it mean?' In recalling Hill's comments, it is perhaps appropriate to recall, as well, the way in which Niro couched the description of her comical 'claiming Gibraltar' project in terms of spiritual healing and circular time: 'It's a way of making that circle a full circle instead of being at the end of the line and being dumped on all the time. If we can continue the circle around or take it back, then from a spiritual point of view, it'll be a fresh start. We can start over again.' It is an approach to aesthetic and political practice shared by many within the Native community.

..

75 This is the same lodge depicted in Powless's *'Well, there's a sure sign ...'* cartoon (Figure 8, p. 22), and the home where the poster of his *Indians' Summer* painting (Figure 23, p. 54), was hung as a health warning to residents.

76 In the fall of 1993, *It Starts with a Whisper* won the Walking in Beauty Award at the Two Rivers Film and Video Festival in Minneapolis, Minnesota. It was also one of the first films broadcast on the newly created Women's Television Network cable channel, which went on the air in Canada in early 1995.

5 | **Double Play on the World Stage**

Stand on the back of the Turtle, our mother, and look at the land
and wonder what it would have been like if Columbus [had] been
successful in his pursuit of India and avoided the eastern shore of this continent.
Wipe your Indian hands on your Levi jeans, get into your Toyota pick-up.
Throw in a tape of Mozart, Led Zeppelin or ceremonial Sioux songs;
then throw back your head and laugh – you are a survivor of a colonized people.
Paint what you see, sculpt what you feel, and stay amused.

George Longfish and Joan Randall

The business of a trickster is to take her work very seriously.
It is to find a way to change the rhythm, to find a way to look at things differently.
If it works, and just one person smiles as a result, that smile is a blessing for all people.[1]

Sharon Manybeads Bowers

It will be obvious by now that what Nancy Oestrich Lurie said of Native humour in 1968 – 'It is strong on puns, word play in general, and stunning juxtapositions of seemingly unrelated concepts and contexts' (202-3) – is an equally fitting description of the works examined in the last three chapters. In many cases much of their emotional impact or 'ironic magic'[2] derives directly from the juxtaposition of *seemingly* unrelated concepts and contexts. Yet what is perceived as unrelated may merely reflect the viewer's, and sometimes the curator's, ignorance of historical and contemporary Native culture and a failure to recognize the hybrid nature and global context of present-day Aboriginal life.[3] Well aware of this, Native artists take full advantage of it. It is part of the subtle ambush, the coyote manoeuvre – and the trickster shift.

..

1 These are the concluding words of 'Louise Erdrich as Nanapush' (Bowers 1992), an essay on renowned Chippewa author Louise Erdrich that appeared in the anthology *New Perspectives on Women and Comedy* (Barreca 1992). For more on women and humour see Barreca (1988, 1991), Finney (1994), Kaufman (1991), and Walker (1988).

2 In a discussion of Beam's *The Columbus Project,* Ian McLachlan writes, 'All that counts is the power of the objects he makes, their ironic magic that enables us to see some of the lies we're not supposed to see and to make the connections we're never encouraged to make' (1990, 12). Cf. Beam's own reference to magic in the quotation cited at the top of Chapter 1, p. 3.

3 Cf. Robert Houle's rebuke of cultural institutions that refuse to let Native artists interpret 'the way our communities respond to everyday life,' p. 14.

Putting the lie to notions of unrelatedness is in fact a leading motivation for many Aboriginal artists. Increasingly, they seek to frame global issues culturally and cultural issues globally. This final chapter will first examine several works that put a global spin on a trickster's grin to address these themes, and then consider what might be expected in the future.

About the same time that Shelley Niro was plotting her New Year's assault on Gibraltar, Jim Logan was co-ordinating an Indian attack on Rome. His mixed-media painting *Unreasonable History* (Figure 140), from *The Classical Aboriginal Series*, portrays both an Indian attack that might have taken place had history unfolded otherwise and one that actually did. Such is the beauty of irony's double vision. The principal activity depicted in this painting is the sacking of ancient Rome by a group of armed and feathered 'wild Indians.' On the ground beside a fallen Roman soldier is the ashen image of the Minneconjou Sioux chief Big Foot, frozen in the snow, along with the words 'LET US NOT FORGET' and 'THIS IS REAL.'[4] Partially visible through the smoke rising from the burning buildings, like a spirit glimpsed in a dream, is a photograph of Logan's father as a young soldier, a bemused smile on his face.

Bemused he might well have been. Logan relates a wry observation that circulated among Native soldiers serving in Italy, 'the cradle of civilization,' during the Second World War and was told to him by his father: 'Here we are, Indians shooting White people and we're getting away with it!' The artist remarks:

It was sadistic, but at the same time it was like a shallow victory ... Being part of that part of history, wearing a Canadian uniform, made it legitimate to be an Indian and shoot White people and get away with it. [The joke] was a relief of anger, I guess, frustration, a shallow victory, sadistic as it may have been. Ah, it wasn't even a joke ... to kill somebody is sick ... but [it's] the thought behind it. If you lighten anything up in these times of trauma and despair, then you laugh about stuff like that because it's reflecting on the reality of the situation.

Another element in this painting is an excerpt from a poem by the artist, also titled 'Unreasonable History.' The words convey the idea, Logan says, that 'I wish that *we* could have discovered Europe. I wish *we* could have sacked London, Berlin, met the Romans head on and sacked Rome, then we could have had an effect on the Euro-Aboriginal world ... Maybe if we could have met Christ over there things would have been different.' In struggling with the injustice of history he asks, 'Why did it have to be the way it was? Why couldn't it be reversed? So I painted ... Indians sacking Rome.'

Beneath the portrait of Edward Logan included in *Unreasonable History* the artist has written, in the manner of a caption or identification label, 'WWII VICTIM.' Viewers might assume from this that the individual pictured (but not identified as the artist's father) was killed in action, a casualty of war. They would be only half right. Edward Logan was a Second World War victim but died many years later, after the war concluded.

4 See *Small Matters* (Figure 98, p. 190) and p. 191 n. 26.

140
Jim Logan
Unreasonable History, 1992
mixed media on canvas, 100 x 85 cm

In *Memorial Blanket for Eddy (My Marilyn)* (Figure 141), from the same series, Logan pays tribute to his father's memory and that of other Native veterans, whose contributions to the defence of home and country have long gone unrecognized. In the work he blends two very distinct cultural and artistic traditions for celebrating a person's life, one from northern Plains culture and the other from contemporary pop culture. Here, the military portrait seen in the previous piece is reproduced eight times in two rows of four panels.[5] It is contrasted with a second photograph of the artist's father in later years, reproduced below the first set in similar fashion. In this Logan echoes the style of American Pop artist Andy Warhol who, in the 1960s and 1970s, confirmed the celebrity status of individuals such as Marilyn Monroe by making them the subjects of his own subversive art. Overlaying and complementing the sixteen formally arranged portraits is a loosely rendered pattern of brightly coloured geometric shapes, reminiscent of those painted and beaded on traditional Plains robes to symbolically honour a life well lived, a deed well done.[6]

But the analogy between the soldier and the movie star does not end there. Explaining the somewhat puzzling title of this piece, Logan says:

> In a lot of ways, my dad and Marilyn Monroe have a lot in common. My dad always wanted to be 'somebody,' somebody famous or somebody known. He wanted that, and he thought that coming out of the war and being a veteran would gain him a lot of respect. However, that was never a reality. It never occurred. I think he was disillusioned when he returned, only to find himself being labelled 'Indian' again or 'Métis' – no specific rights, poorly educated, and begging for a job – rather than a hero that, I guess, he was kind of envisioning ... Marilyn Monroe was a person who attained fame and respect. She obtained it, my father didn't, but they both ended up killing themselves – my father killing himself through alcoholism, Marilyn Monroe through barbiturates and alcohol 'cause she couldn't handle her fame. And my dad couldn't handle *not* having the fame. He was fifty-eight [and] I was twenty-one when he died.

..

5 Logan utilized this photograph of his father on at least one other occasion, in *Father Image II,* one of seven paintings constituting *National Pastimes,* 1991, his contribution to the 1992 exhibition *Indigena* (see McMaster and Martin 1992, 142-7). As in *Unreasonable History,* the image of the young Logan senior appears as a pale apparition. Here, however, his face is painted with the almost-imperceptible red markings of a Plains Indian warrior. The image floats on the inside back wall of a small reserve house in which a young boy and his father sit together on a couch watching what the artist says in the catalogue text is a televised hockey game. Seated on the floor beside them is another young boy, a fiddle player, who appears in each painting in the series. Tellingly, the playful faux floral wallpaper pattern framing Logan's ghostly portrait is, on close inspection, seen to be a scattered assortment of flattened beer bottle caps. It takes little effort to imagine the fiddler's mournful lament.

6 Bob Boyer has also drawn inspiration from traditional blanket designs to create works honouring specific individuals. See, for example, *Lone Elk, Gerald Red Elk, We Miss You,* 1986, in Hoffmann (1988, 377).

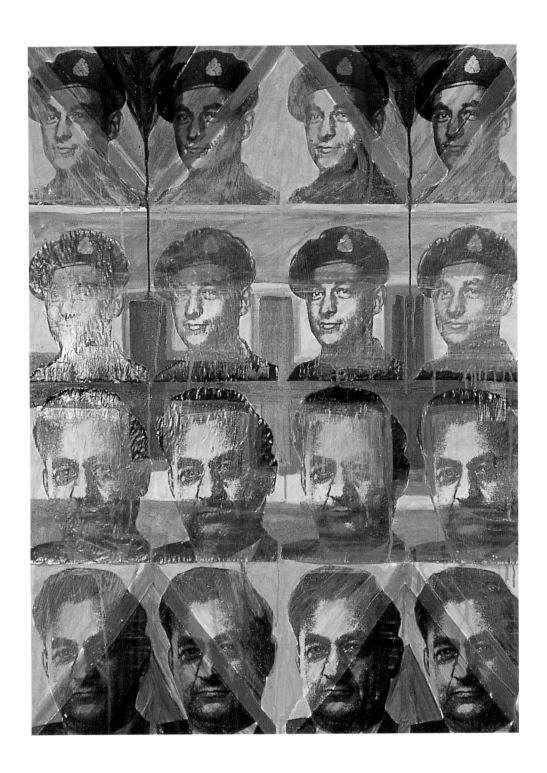

141
Jim Logan
*Memorial Blanket for Eddy
(My Marilyn)*, 1991
mixed media on canvas, 99 x 73 cm

Through the work of his son, and almost two decades after his death, Edward Logan may finally be granted the recognition he desired but was denied in life. Ironically, he may be accorded in death more than the fifteen minutes in the limelight that Warhol promised everyone.[7]

A Second World War victim who has been in the limelight ever since the posthumous publication of her war-time diary is the young Jewish schoolgirl, Anne Frank.[8] In his affecting ceramic bowl portrait of Frank (Figure 142), Carl Beam taps into the ancient Mimbres tradition of narrative pottery decoration to frame, both literally and figuratively, a comment on ethnic and cultural oppression outside North America.[9] Just as compelling is Beam's ceramic reframing of the 1981 assassination

7 Andy Warhol (1928-87) made an often-quoted prediction in the 1960s that 'in the future everyone will be famous for fifteen minutes' (Simpson 1988, 43).

In recent years the contributions of Aboriginal men and women to the nation's various military endeavours have slowly come to light. This is due in no small part to the efforts of Aboriginal artists and Native-run institutions. In 1986, for example, the Woodland Cultural Centre in Brantford, Ontario, mounted an exhibition titled *Warriors* and published a companion resource guide to celebrate the achievements and commemorate the sacrifices of six Aboriginal communities in southern Ontario whose members participated in military conflicts from the War of 1812 to the Vietnam War.

In 1995 Edward Poitras covered two walls of the Canadian pavilion at the Venice Biennale exposition with the names of Canadian Aboriginal veterans for all the world to see. (See also p. 282 n. 32). In 1996 the National Film Board of Canada premiered *Forgotten Warriors,* Métis director Loretta Todd's moving tribute to Canadian Native veterans. The film went on to win the award for Best Documentary Short Video at the American Indian Film Festival in San Francisco. In the fall of 1996 it was also announced that a monument honouring Canadian Aboriginal veterans would be erected in Ottawa near the National War Memorial. The chosen design was created by Lloyd Pinay, an artist of Plains Ojibway/Cree/Sioux ancestry (Logan 1996). In the United States, similar plans are under way to recognize American Indian veterans with a national memorial in Washington, DC.

8 Anne Frank kept a diary when she and her family went into hiding during the Nazi occupation of Holland. They were eventually discovered and imprisoned in concentration camps, where most of the family, including Anne, died. After the war her diary was published and has been in print ever since. The subject of numerous stageplays and films over the last half-century, Anne Frank was most recently profiled in *Anne Frank Remembered,* a film by Jon Blair, which was honoured with an Academy Award for Best Documentary Feature of 1995.

9 Four artists in this study have drawn parallels between Native and German history. In *The Final Solution* (Figure 122, p. 228) and *Trains-N-Boats-N-Plains: The Nina, the Santa Maria, and a Pinto* (Figure 135, p. 246), Noganosh and Boyer, respectively, make use of German historical reference to critique abuse of Aboriginal peoples. In his portrait of Anne Frank Beam utilizes Aboriginal history to contextualize Nazi mistreatment of the Jewish people. In *No Life Like It* (Figure 129, p. 238),

of Egyptian president Anwar Sadat, a victim, like Frank, of those who would impose their will on the world (Figure 143).[10]

Gerald McMaster contrasts a hopeful act of healing in the reunification of Berlin with a hateful act of violence in suburban Montreal. More recently, in a unique cross-cultural enterprise, Plains Cree artist George Littlechild and Okanagan/ Shuswap/Cree poet Gary Gottfriedson collaborated with Jewish artist Linda Frimer and Jewish poet Reisa Schneider on the book *In Honour of Our Grandmothers: Imprints of Cultural Survival* (Schneider et al. 1994), which commemorates the parallel histories and celebrates the cultural tenacity of both peoples.

10 The peace with Israel negotiated by Anwar Sadat ended centuries of conflict. He was assassinated by Egyptian religious extremists opposed to the peace.

In a review in the *Hamilton Spectator* art critic Grace Inglis said of Beam's earthenware bowls, 'Beam takes that which we know – old photos and printed images – and transposes them into something larger, more profound, disturbing, that we do not know ... The images take on an extraordinary three-dimensional effect within this deeply rounded space. The bowls are truly sculptural in that they create a significant space which was not there before, not only that, but they seem to hold, first and foremost, the spirit of whatever is portrayed there. They send shivers up the spine' (1987, n.p.).

Like the ancient Mimbres of the American Southwest, whose work he greatly admires, Beam considers his bowls to be 'anecdotal, presenting little stories in contemporary time.' He adds, 'If I've done anything important in the '70s and '80s the bowls will be an important part. They offer mute testimony. They're lasting.' Beam offers an amusing speculation on how these works might be viewed by art historians in years to come: 'Looking back from the future, people may see the bowls as an idiosyncratic response [and say]: "This was his 'Indian art' – uniquely Native at the time, reflecting a real love of the art of indigenous clays. He had a lot of fun with it. It was the only medium, when working with it, that took him back in time. It felt more 'Native' than working on canvas or etching. It was a nostalgic look back at the craft-art occurrence that didn't owe itself to high-tech. It was very humane and low-tech in an increasingly high-tech world."'

Cochiti Pueblo ceramic artist Diego Romero also continues the Mimbres practice of presenting 'little stories in contemporary time,' but in a manner markedly different from Beam's. In his *American Highway* series, for example, Romero comments on the social ills of the present day and the changing desert landscape through his portrayal of the tragicomic exploits of the fictional Chongo Brothers, a cartoon-like duo depicted with stylized Mimbres heads and facial features. See *Coyote and the Disciples of Vine Deloria Jr, American Highway Series* (Figure 144). At other times Romero employs ancient geometric designs to frame modern figures and events rendered in a comic-book style reminiscent of the late American Pop artist Roy Lichtenstein. In both cases sociopolitical critique is an important component (Nichols 1994, 14-5).

142
Carl Beam
Ann Frank portrait bowl, 1985
painted stoneware, 30 cm diameter

143
Carl Beam
Sadat assassination bowl, 1982
painted stoneware, 30 cm diameter

144
Diego Romero
Coyote and the Disciples of Vine Deloria Jr, American Highway Series, 1993
earthenware, 37 cm diameter

While Beam's 1991 shadow-box portrait of the recently released African National Congress leader Nelson Mandela (Figure 145) could be considered a commentary on victimization as well, it is more important as an expression of Aboriginal solidarity with indigenous freedom fighters elsewhere in the world and as a tribute to a man whose spirit was never broken through twenty-seven years of imprisonment.[11] That Mandela later became president of an inter-racial democratic government in South Africa can only encourage indigenous peoples in all corners of the globe.[12]

11 Cf. Beam's other shadow-box pieces discussed in this study, *Big Koan* (Figure 76, p. 148), *Chronos 2* (Figure 77, p. 149), and *Chronos 1* (Figure 106, p. 203).

12 A South African lawyer and political activist born in 1918, Mandela was imprisoned from 1962 to 1990 for his stand against the ruling National Party's policies of apartheid. In prison he became a celebrated symbol of the frustrated aspirations of South Africa's black majority. Released in 1990 by President F.W. de Klerk, Mandela became head of the African National Congress (ANC) the same year. In 1993 he and de Klerk shared the Nobel Peace Prize for their efforts to ensure a peaceful transition to non-racial democracy in their country. In 1994 Mandela was elected president in South Africa's first all-race elections.

Beam has also created shadow-box pieces that interrogate the historical practice of slavery in the United States. Whenever the subject of authoritative voice is raised Beam has a ready answer: 'To people who say that I don't know about the Black experience, I counter, "But I do know about slavery!"'

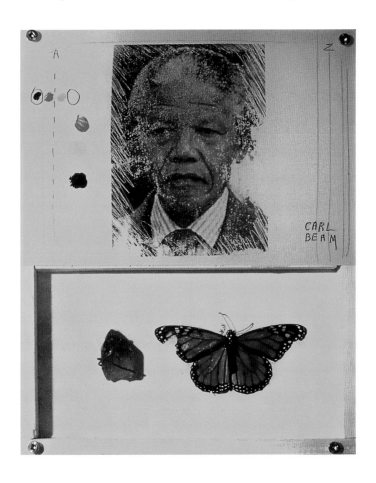

145
Carl Beam
Nelson Mandela shadowbox, 1990
mixed media, 30 x 23 cm

In recent years encouragement has also come from Eastern Europe, where a spirit of *glasnost*, or friendship and goodwill, has increasingly characterized the relationship between world superpowers. At the same time member states of the once powerful Soviet Union have been brazenly reclaiming their status as independent nations, at times at considerable risk. In his painting *Glasnost* (Figure 146), from *The cowboy/Indian Show*, Gerald McMaster recontextualizes the Russian word *glasnost* to call for a new commitment to friendship and co-operation in relations between the Canadian government and Aboriginal peoples and to align the Native struggle for sovereignty and self-determination with that of oppressed peoples in Europe. It is a shrewd and effective piece of cultural and textual appropriation, meant to disrupt and ultimately dislodge colonial attitudes.

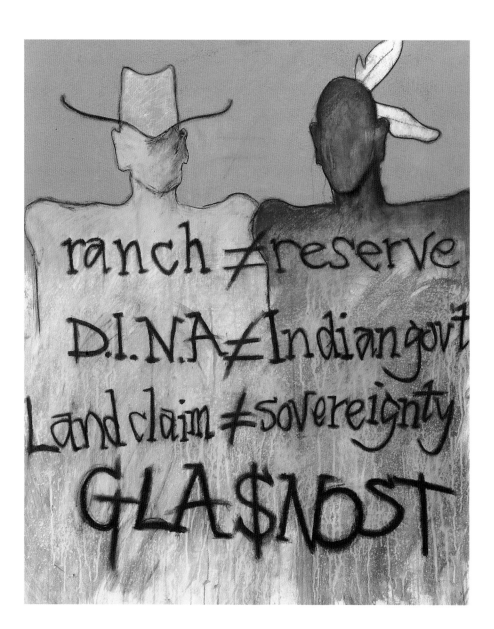

146
Gerald McMaster
Glasnost, 1990
acrylic and oil pastel on matt board,
114 x 94 cm

Glasnost
Gerald McMaster

In an October 1990 interview for *The cowboy/Indian Show* exhibition catalogue (Ryan 1991, 47), Gerald McMaster talks about the genesis of his painting, *Glasnost*.

The Red Man and the White Man – the two represent a power struggle. The equation that is presented by the notion of 'cowboy and Indian' you can see faintly at the top – 'cowboy' does not equal 'Indian.' I painted over it. It's barely discernible. Whether it's in the language, whether it's in the notion of how we see land, the Native person has never really had the choice of calling the shots. It's been the government.

'Certain lands will be called *reservations* and they will be for Indians.' Of course, the cowboys have this free range of land they can buy and keep adding on to called *ranches*. You cannot do that with reservations. It's one plot. That's it. Native people can't buy land and keep adding on to it and call it their reservation. So there are two different notions of land here.

There is the notion of the Department of Indian Affairs, which is a government *for* Indian people, and then this other notion that Indian people are talking about a lot today, 'Indian government.' So, you have one government governing Indians and another one which is Indians governing themselves. Again, there's an inequity of ideas here. Indian Affairs is still controlling the pot. They're still controlling how much money an Indian government would get. There will always be a Department of Indian Affairs.

And then there is the notion of 'land claims.' I think that Indian people would like to feel that they could get land claims *and* sovereignty, but that's not the case. 'We can give you land but we're not giving you sovereignty, because sovereignty means this, this, and this. If you give Indians sovereignty then that means giving them nationhood. We can't have that.'

Finally the idea of *glasnost* seemed like a good idea, but was it ever really a good idea? To me it means 'freedom.' I read it as 'freedom' but we're never really free. Freedom has its price. It seems to be fired by economics. We're always looking for words to express some idea. You could easily find an Indian word, but here is a word that's been used in a particular context. Is that the only context in which that idea can be used?

The other interesting thing about *glasnost* is that it's now the government talking about economic freedoms. Yet there are still a lot of problems ... there's still no food ... there's still no freedom. Sure, things are changing, but there must be some kind of double-talk going on here. When a group in power is saying these things there's got to be some other angle to this. There's got to be some controlling factor. There's no shift in power because the power remains at the top, or remains rooted within a certain group of people. They're not shifting power at all. What's the double-talk? What's actually being said in all this?

PROGRESS

147 (above)
Edward Poitras
Progress, 1991
mixed-media installation with 1986
coyote bone sculpture, *Coyote*

148 (right)
Edward Poitras
Creación O Muerte ¡venceremos! (Creation or death, we shall overcome!), 1991
plaster head, rope, plants, hammers

For *Marginal Recession,* his 1991 exhibition at the Dunlop Art Gallery in Regina, Saskatchewan, Edward Poitras also drew inspiration from recent political history in Eastern Europe – in particular, the toppling of monuments to Vladimir Lenin, the founder of the Soviet state – to issue a sobering warning to those who continue to ignore the demands of Native peoples for greater control of their individual and collective lives. Concerning the installations *Progress* (Figure 147) and *Creación O Muerte ¡venceremos!* (Creation or Death, we shall overcome! Figure 148), Poitras said:

What I was doing was using the fall of the Lenin statues in Russia and somehow drawing a parallel with the monuments that exist in Canada and the potential of them falling at some point. So what I used was all of this Lenin imagery[13] with a reproduction of what's up at the legislative building here [in Regina], the pediment, where ... there's three different characters: there's an Indian, a White woman who is the main character – supposed to represent Canada – and then there's a White guy on the other side[14] ... In the piece that I put up in the gallery [Figure 147] the heads are knocked off of the woman and the man, and underneath it is the *Coyote,* the coyote that's made out of bones.[15] Then, on the ground there's all of these little busted Lenin heads. They look like little eggs ... Inside the gallery there's a large Lenin head made out of plaster, a big 400 pound thing [Figure 148].

Reflecting on the suitability of these pieces for an approaching exhibition in Communist Cuba, Poitras added:

With the work that was in this show – with all the Lenin imagery – I know that it would be foolish to ... show it in Cuba. But yet I'd like to because of my reason for doing it here ... It's not that I'm attacking or making fun of Lenin. I'm pointing something out. If it can happen there [in Russia] it can happen here ... I think they [the Cubans] could make the connection, on a global scale. The whole fall of the socialist system over there I think that they [could] relate to more than the Native content, which was very subtle.

13 While visiting Finland in August 1991 for the opening of an exhibition of his work, Poitras acquired a considerable amount of Lenin memorabilia – posters, books, and small souvenir statues –from the Lenin museum in Tampere. Several of the items have been incorporated into the pieces in *Marginal Recession.*

14 In the course of researching this project, Poitras found that the pediment as constructed differs somewhat from the original concept: 'In the first proposal for this piece the Indian was holding this bow, and the main character, this woman, her hand was extended out towards this Indian and this White guy. She was also bare breasted. But in the piece that actually went up, the Indian's disarmed, the woman's breasts are covered up, [and] her hand's retracted away from the Indian [laughs].'

15 Made from the bones of seven coyotes, this 1986 sculpture was featured in the travelling exhibition *Stardusters,* and more recently in Poitras's 1995 show at the Venice Biennale. See Mainprize (1986, 68) and p. 282 n. 32. Harry Fonseca's work notwithstanding (Figures 82 and 83, pp. 160 and 162), this is one of the few instances in which the Trickster Coyote is actually visualized. Its incorporation into the *Progress* installation is unusual, even audacious, in that it clearly places Coyote 'at the scene of the crime,' impudently taking credit (or blame) for his subversive handiwork. Discussing this sculpture in the *Marginal Recession* catalogue, Cherokee artist and activist Jimmie Durham writes, 'Our Grandfather coyote has come to be a symbol of survival-with-hubris for most Indian people' (1994, n.p.).

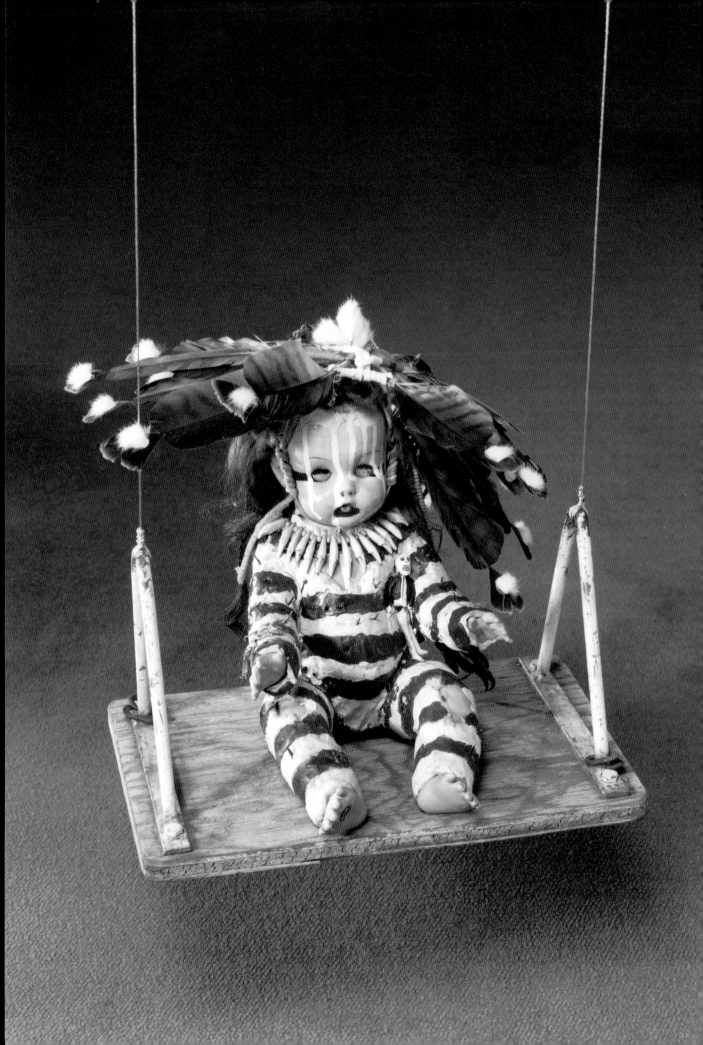

Included in *Marginal Recession* as well was the installation *Untitled (Over the Gulf)* (Figure 149). Consisting of a wrapped bison skull, an oil-filled lead basin in the shape of the Persian Gulf, and a child's doll suspended over the basin on a swing, it offered a uniquely Native perspective on the 1991 Gulf War. As Poitras tells it, the Iraqi destruction of the Kuwaiti oil fields and the deliberate oil pollution of the gulf waters parallels the wilful destruction of the Plains buffalo in the nineteenth century. He adds an interesting corollary: 'Just before the Gulf War there was a group of Sioux Indians that went to Baghdad to do a pipe ceremony to prevent the war from happening. This old man had this vision that they [the Iraqis] possessed some kind of weapon that would have brought about some kind of great destruction. So they were very concerned.'

149
Edward Poitras
Untitled (Over the Gulf),
detail, 1991
doll on swing, oil-filled lead basin,
wrapped bison skull

The most intriguing and certainly the most complex component of Poitras's installation is the befeathered doll, painted in the manner of a pueblo koshare clown.[16] It is not the first time the artist has employed this figure: a few months earlier it was featured in a Montreal exhibition in a piece titled *Self-Portrait* and before that it appeared in the Vancouver show *Et in America ego,* with the word 'witness' lettered across its forehead (Figure 150).[17] Poitras says that in *Marginal Recession* 'it's still acting as "witness" – over top of Babylon.' He also readily admits, 'Yeah, that's me in the swing!' Taken together these two statements illuminate an especially affecting and effective double metaphor. Rarely has an image of the artist as clown/trickster and witness to world history been portrayed so directly and with such clarity.[18] Ever conscious of the educational function of children's dolls, Poitras sees his adaptation and recontextualization of them as an opportunity both to teach and to learn, but especially to learn: 'I'm more the student; [I'm] teaching myself about, maybe, global issues where I'm creating pieces that I learn from.' In exhibiting such pieces, however, he is also a gifted educator.

As *Untitled (over the Gulf)* clearly illustrates, environmental abuse is a global issue of immense proportions. Several Native artists have addressed the subject with a cutting blend of irony and urgency and a dry, sardonic wit. Ron Noganosh, for example, in the title of his sculpture *Will the Turtle Be Unbroken?* (Figure 151), puts a downward spin on an uplifting country-and-western gospel song, 'Will the Circle Be Unbroken?' to lament the wanton destruction of Turtle Island, the Earth.[19] He

16 See the earlier discussion of Pueblo clowning, pp. 10 ff.

17 See Collins (1991). Included in the Montreal show was a piece titled *Cheese/Oil*, a double commentary on Oka and the Gulf War that combined the bison skull and lead basin from *Untitled (Over the Gulf)* with a sabre imbedded in a large block of Oka-brand cheese. See Figure 59, p. 119, for another component of the *Et in America ego* installation.

18 Clearly this case of self-imaging could just as easily have been included in Chapter 2, 'The Re/Creation of Identity.'

19 Shedding some light on Noganosh's penchant for wordplay in his titles, his wife Maxine Bedyn said: 'You know, Ron has a great, bizarre, off-the-wall sense of humour, and even our daughter finds it a little strange to live with all the time. And he wakes up in the middle of the night with puns, which gives you an idea what he's like. So if this is reflected in his work it's no surprise.'

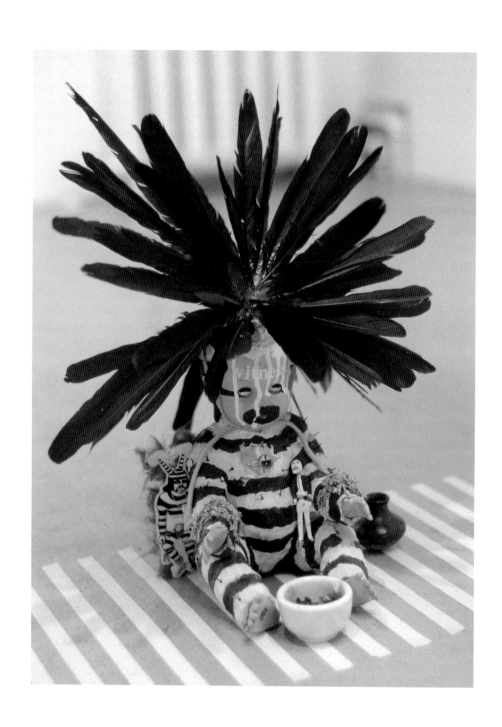

offers a grim prognosis for the future of the planet if current harmful practices aren't curtailed. Referring to this sculpture, Noganosh says: 'That's one hell of a bleak statement on the world. The Ojibway legend of creation is that the world is built on the back of a turtle. That's a turtle shell there [resting on the back of] the starship *Enterprise*. The Earth is moving through space ... on the back of a turtle. These are rainforests burning, there's oil slicks on it, half the God-damned world is turning into a desert!'[20]

One of the artist's chief concerns is the rapid depletion of fresh water in the world. He tells an hilarious story about the creation of the piece *It Takes Time* (Figure 152), which presents this problem in a most memorable manner:

I got [the idea for] that from Jacques Cousteau [laughs]. Jacques Cousteau ... he's explored every mudhole, creek, pond, swamp, sewer in the known world! ... I had picked up one of those student lamps at a junk sale one time so I figured, aha! – I've got a use for that, and I'm watching this thing on Cousteau and he said that there's no place that he went that he didn't run into pollution. Everywhere, oceans ... all the rivers, everywhere. I thought, 'Okay, I've got my student lamp. I need a toilet. Aha! I know where there's a toilet.' So I head up to Wakefield, [Ontario], 'cause I knew that there was a dirty old toilet up there. I get up there and the toilet that I wanted was positively ... *rotten*, but it was broke. Somebody broke it. So, I'm feeling kind of dejected and I'm headin' back down the old road and I'm drivin' along and I come around the corner and, God damn it! There's [this] old toilet sittin' beside the road. I said, 'Holy shit!' [laughs]. Stop the car, back up, grab her, and throw her in the back of the car. Whoever put it out there must have thought, 'This guy's really gone mad' [laughs]. So I took it, and I put the little stick up behind it, right? There's a big tap coming out of the Pacific Ocean, and that's blue Plexiglas there [for] the water. It's called *It Takes Time*.

150 (facing page)
Edward Poitras
'Witness' koshare clown doll, 1989
mixed-media installation detail from
Et in America ego

151
Ron Noganosh
Will the Turtle Be Unbroken?
1990
turtle shell, plastic model spaceships, cotton wool, plastic, coins,
46 x 30 x 25 cm

..

20 See also p. 113 n. 13 for a discussion of Star Trek inspiration and imagery.

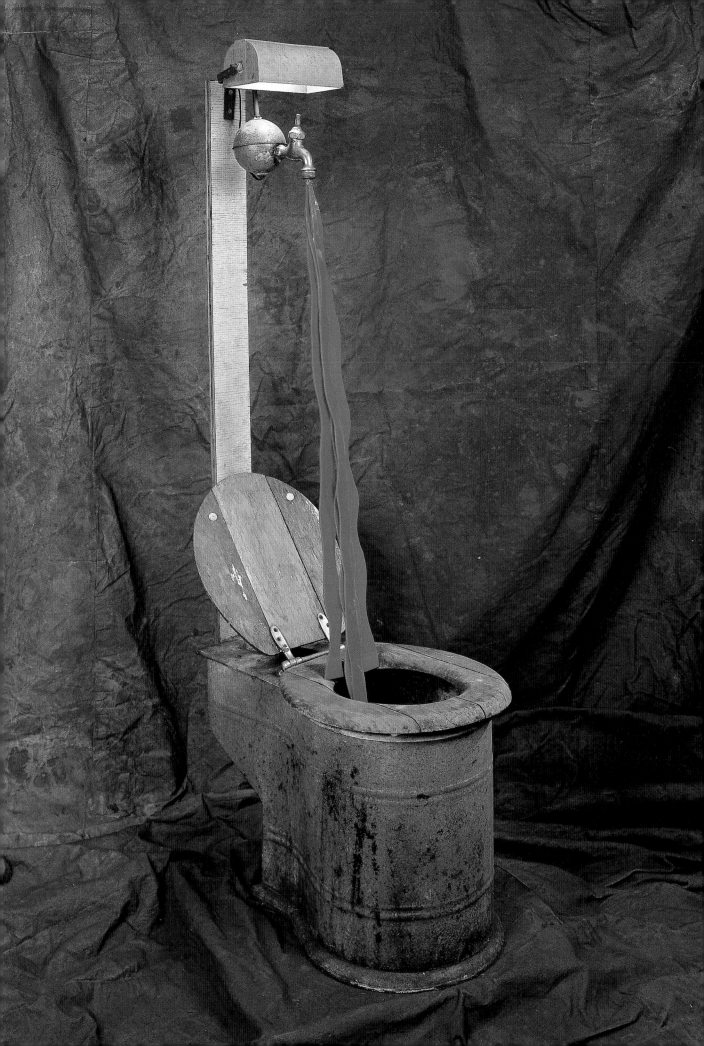

But when I picked it up, right, the inside was all full of spider webs and rust and everything else. So the [conservator at] the Museum [of Civilization] phoned me up one day ... [and] says, 'Are the spider webs part of the piece?' So me says, 'Oh yes. Yes, sure! I trained that spider to spin all those webs in there. Took me years!' But [my wife], Max, hates that piece because the toilet is so grubby and dirty. When they had it on exhibit [at the museum] and we're over there this lady's talking to me about [the] mysticism of the art. I was tired. I said, 'Lady, it's a dirty old toilet. How the hell can you get mystic about a toilet?' [laughs]. It sort of blew her away but that's how I was feeling ...

What I'm saying [in the title is that] it *doesn't* take time. It doesn't. We're just flushing all the fresh water down the toilet. It's ridiculous that we flush three gallons of fresh water to get rid of three ounces of urine. Piss on that![21]

152
Ron Noganosh
It Takes Time, 1983
toilet, Plexiglas, lamp, globe, tap,
155 x 36 x 49 cm

Water pollution takes many forms. One of the most damaging is acid rain, the result of thoughtless atmospheric contamination. It is the primary subject of Bob Boyer's blanket painting, *Let the Acid Queen Rain: The White Goop Devours All* (Figure 153). In conversation, Boyer said: 'I was just thinking about how, at one time, this land was beautiful, pure, nice bright colours, and gradually this land is just getting more and more rotten with pollution. [The coloured pieces falling from the sky] that was nice stuff, that part is the bright part ... Pollution [is] spilling out from the middle of it.'

Drawing a parallel between environmental abuse and cultural abuse not unlike that made by Poitras in *Untitled (Over the Gulf)* (Figure 149), Boyer has also painted two circular figures in the lower section of the piece to symbolize the demise of the buffalo.[22] In the upper section two similar barred circles – the internationally recognized sign for prohibition – have been superimposed over images of sacred pipes, an allusion to misguided bureaucratic attempts to combat air pollution by applying no smoking by-laws to Native ceremonies.[23]

Acid rain is also the subject of Lawrence Paul Yuxweluptun's painting *Native Winter Snow* (Figure 154), but the reference is more oblique and the beauty of the landscape cleverly deceptive. Yuxweluptun knows too much to be taken in by a beautiful face:

On a good day bad things can happen. On a sunny day I know that there's toxins and toxidities [sic] poured into the environment ... When acid rain comes from Japan then it's a social problem over there that we get over here. When Chernobyl happens over there and up North [we're told] 'Don't eat the snow,' then I find that a social problem.[24] Where these social problems come from is from their social order and their social attitudes

21 This piece is now in the collection of the Canadian Museum of Civilization, Quebec, where, on behalf of all Canadians, conservators are entrusted with the task of preserving it as a national and cultural treasure.

22 For further analysis of this piece see Duffek (1988).

23 See Boyer's description of one such attempt to prohibit a Native pipe ceremony, pp. 184-5.

24 In 1986 the nuclear reactor at Chernobyl in the Soviet Ukraine suffered a major meltdown and fire, resulting in widespread radiation contamination. As noted earlier, Kwagiutl artist David Neel created a *Chernobyl Mask* for the series *Spirit of the Earth*.

153 (facing page)
Bob Boyer
Let the Acid Queen Rain: The
White Goop Devours All, 1985
oil over acrylic on blanket, 185 x 127 cm

154
Lawrence Paul Yuxweluptun
Native Winter Snow, 1987
acrylic on canvas, 125 x 184 cm.

about this planet. When are we going to clean this planet? There's a lot of questions in my work ... If we get fish that are full of mercury and we're dying from it, then why should I paint a pretty picture of salmon swimming upstream?

In *Native Winter Snow* Yuxweluptun's bending and warping and melting of cultural symbols in the manner of Salvador Dali seems an especially apt use of visual and political metaphor. 'I think that dioxin bends and warps and distorts and kills,' he says bluntly. Toxic humour doesn't get much stronger or more literal than this.

When Yuxweluptun's surreal environment is not suffering the effects of chemical fallout it is frequently under attack from ravenous logging corporations. In his painting *Hole in the Sky* (Figure 52, p. 109), discussed earlier, the principal activity – an attempt to repair the tear in the earth's protective ozone layer – is set in the midst of a clearcut forest. A less surreal but still devastated clearcut forms the backdrop in Jim Logan's *The Three Environmentalists* (Figure 155), from *The Classical Aboriginal Series*. A wicked update of Raphael's famous painting *The Three Graces*, it exemplifies Linda Hutcheon's concept of parody as 'repetition with critical distance that allows ironic signalling of difference at the very heart of similarity' (1988a, 26).

In Logan's version three Native women are pictured frolicking together on a giant tree stump. The figure on the left ponders the significance of a turtle – ever a symbol of Turtle Island – which she holds suspended from a ball and chain. According to the artist, it signifies the earth's enslavement by Western thought and the profit motive. The woman in the centre contemplates a sacred heart, a reference to the biblical dictum to exercise dominion over the earth. The figure on the right considers a human skull, a prophetic omen signalling the inevitable result of human 'progress' unless our relationship to the earth is seriously re-evaluated. It is no accident that Logan executed this piece while protests were taking place against the logging of old growth forests in Clayoquot Sound on Vancouver Island. It is perhaps no accident as well that it was women who were at the forefront of those demonstrations and who were jailed for their moral stand. In his own way Logan pays tribute to them here.

Logging protests in another part of the country inspired Bob Boyer to create a three-blanket wall installation, *Imago Pietatis for a Dying Buffalo and Lost Treeties,* for the 1990 exhibition *Contemporary Rituals* at the White Water Gallery in North Bay, Ontario.[25] The show, which also featured work by Robert Houle and Edward Poitras, was organized in support of the Teme-Augama Anishnabai, who were trying to halt logging on disputed territory until land claims had been settled. As he did in *Let the Acid Queen Rain* (Figure 153), Boyer draws a parallel – this time in

25 *Imago for a dying buffalo and lost treeties* (Figure 156, p. 276), one of the three painted blankets in this installation, was later included in the 1991 show *Shades of Difference: The Art of Bob Boyer,* at the Edmonton Art Gallery. With its stylized woodland motifs rendered in warm browns and deep greens, the piece made a strong impression when it was reproduced on the exhibition catalogue cover. See Phillips (1991).

155
Jim Logan
The Three Environmentalists, 1993
acrylic on canvas, 183 x 152 cm

156

Bob Boyer

Imago for a dying buffalo and lost treeties, central panel of triptych, 1990

oil over pastel and acrylic on flannel blanket, 208 x 232 cm each panel

the title of the installation – between present abuse of the environment and past abuse of the buffalo. His double play on the word 'treeties' is a particularly effective pun. In his artist's statement for the show (in Collins 1990, n.p.), Boyer makes a surprising and somewhat troubling connection between literacy and environmental abuse:

The death and destruction of our forests is being spurred on by the proliferation of literacy. I find literacy a bit of a dilemma; illiterate societies do not pollute and destroy the world. The more educated societies become, the more destructive they seem to become. How many trees must bleed to put newspapers on the shelves? Perhaps more televisions, computers and bi-weekly newspapers could cut down on the amount of paper misuse. The Regina paper keeps getting bigger, not better, because of all the advertising and grocery store flyers. I am not saying 'Don't read' but on the other hand, what are you reading and are you reading all that you are buying?'

One of the most prevalent forms of paper mis-use is disregard for paper re-use. This is the theme of Gerald McMaster's mixed-media installation, *Bärk: The Great Tree of Life* (Figure 157), created for *Last Chance*, a 1990 group show at the Saw Gallery in Ottawa. From several hundred discarded telephone books McMaster fashioned two eight-foot columns wrapped in 'healing blankets' to call attention to wanton environmental waste and the rapid depletion of the earth's natural resources. Giving the piece added dimension and emotional power is the simultaneous affirmation of a widespread Native spiritual concept, the Great Tree of Life, using the unlikeliest materials.[26]

Perhaps no other Aboriginal artist has expressed the Native spiritual and cultural connection to the landscape as effectively as Lawrence Paul Yuxweluptun, nor advocated the need for drastic revision of environmental policy so fervently and consistently. His painting *The Environmentalist* (Figure 158) graphically symbolizes the sacred and symbiotic nature of humanity's relationship to Mother Earth.

The inherent familial bond is manifest in the features of the red man's face mirrored on the hillside in the background, in the clearing in the foreground, and wrapped about the branches of what might properly be understood as the sacred tree. Clearly the analogy could as easily be played out in reverse. The point is that the relationship is much more than custodial. Yet even that aspect is threatened. Yuxweluptun says: 'What I was showing was stripping [away] the social values of the Western world. [With] all these clothes on you don't see the ideology. [Here] you don't see Reeboks, you don't see cowboy boots, you don't see Levi's jeans, you don't see his black leather coat. You don't see any of the above mentioned; you see

..

26 Known to the Iroquois as the Great Tree of Peace and the Celestial Tree, the Great Tree of Life is symbolized by the Sun Dance pole among the Plains Cree. Cf. Niro's use of the celestial tree in her film *It Starts with a Whisper*, p. 249; p. 66 n. 45; and Waterman's use of the tree in his painting *The Senecas Have Landed, No. 2* (Figure 56, p. 114).

157
Gerald McMaster
Bärk: The Great Tree of Life, 1990
telephone books, wooden dowels, ribbons,
cloth, and twine, height 244 cm each

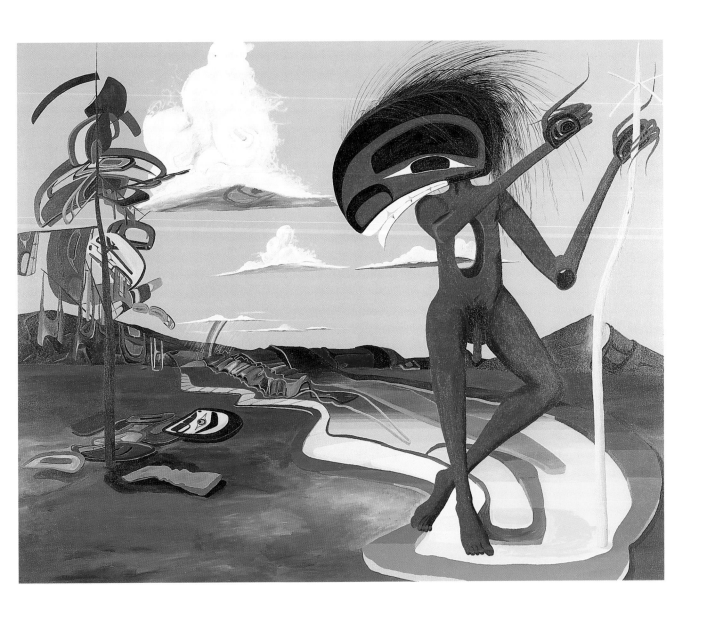

158

Lawrence Paul Yuxweluptun
The Environmentalist, 1985
acrylic on canvas, 168 x 213 cm

a cultural setting of a cultural person ... I was [also] showing that this person cares about the environment around him yet doesn't have those social rights as a human being in this country ... [nor] the right to control ... this land.'[27] This is arguably as much a portrait of the artist as witness/teacher and trickster/healer as is the doll in Poitras's *Untitled (Over the Gulf)* (Figure 149, p. 266).[28]

Like the brown man in Yuxweluptun's *Dance Me on Sovereignty, Dance Me Outside Anywhere I Want* (Figure 116, p. 216), the red man in *The Environmentalist* suffers the indignity of an imposed colonial identity that not only fails to recognize his spiritual nature but also denies his claim to a sacred and familial connection to the land as well.[29] No wonder Yuxweluptun portrays him with a huge cavity in his chest where his heart should be. Still, the figure's playful pose suggests the need for a comic disposition to ensure any semblance of cultural *or* physical survival. In an increasingly secular world, in which outdated notions of 'Indianness' still have power, Yuxweluptun endeavours to impart his vision of spiritual and environmental relatedness:

I'm just ... try[ing] to put a visual soul into people [so they] start to see everything in a Native perspective ... to put a feeling where no feeling has been before ... getting into their mind, trying to get into their soul. I do love this land. I'm not some heathen barbaric savage as I'm portrayed in a book, in a John Wayne movie. I do see. If I accidentally cut myself in the leg with a chainsaw I do bleed. I am human. I'm not something out of the Indian Act that is subject to a conforming structure ... I'm prepared to try to change that stereotypical ideology ... and then, getting over that, even going into the whole world to show them that we can't just let it go the way it is. We have to be accountable for our actions ... It's not an Indian issue any more.[30]

27 To paraphrase the title of the National Gallery's exhibition of First Nations art, this painting concerns 'Land Spirit and *No* Power.'

28 Or Beam's *Self-Portrait in My Christian Dior Bathing-Suit* (Figure 18, p. 46), Niro's *Portrait of the Artist Sitting with a Killer Surrounded by French Curves* (Figure 33, p. 73), or Belmore's *Exhibit 671B* (Figure 75, p. 147).

29 Cf. McMaster's contrast of the spiritual Indian with the secular cowboy, p. 29.

30 In June 1995 a major retrospective of Yuxweluptun's work inaugurated the newly constructed Morris and Helen Belkin Art Gallery at the University of British Columbia in Vancouver. Provocatively titled *Born to Live and Die on Your Colonialist Reservations,* the controversial show featured several of the paintings discussed in this book. The exhibition catalogue was edited by Charlotte Townsend-Gault, Scott Watson, and Yuxweluptun himself (1995). A few months earlier, Robin Laurence (1995) profiled Yuxweluptun and the upcoming show. Writing in the *Georgia Straight* in 1997, Laurence also documented the installation of the artist's massive new painting, *Burying Another Face of Racism on First Nations Soil,* in the Vancouver Art Gallery. Measuring 4.9 x 2.9 m, the piece was hung alongside several works by Emily Carr.

Like a skilfully constructed Coyote tale, Yuxweluptun's painting of *The Environ-mentalist* addresses all four of the principal themes discussed in this study: self-identity, representation, political power, and global presence. These themes are also touched on in the artist's words immediately above. It is therefore an appropriate point to bring to a temporary and provisional close a discourse that by its nature defies closure.

I will conclude with a few observations from art historian Ruth Phillips, Woodland Cultural Centre Director Tom Hill, and, to return to where we began, artist Carl Beam. In conversation, Phillips commented:

I am endlessly amazed at the control that Native people exert over their critique. It's extremely controlled. Partly it's been imposed on them by their particular historical experience – they have been disempowered in a certain way – and/or something in the Native tradition that has survived as a value, as a way of dealing with people in groups, is fundamentally non-confrontational, I think. There's a great emphasis on talking things out and arriving at consensus. And I think what [the artists] are doing is talking things out with us now ...

Why is it that they have chosen this [comic/ironic] mechanism? Yes, it's trendy now. Yes, it's part of the postmodern consciousness,[31] but there's something else going on, and I think

31 In 1988 Gerald McMaster created a series of small wooden sculptures adorned with sticks, feathers, ropes, and wire, which he called *Post-Moderns* (Figure 159). Their basic human form was derived from an image painted on an historical Blackfoot tipi. Why the *Post-Modern* title? It was a playful response to German colleague Gerhard Hoffmann's constant use of the word. 'What is postmodernism?' McMaster asks. 'Are Indians experiencing it? Nobody knows. Nobody knows what the term means.' McMaster's own understanding of postmodernism is bound up in the idea of reinterpreting and re-presenting ancient forms in contemporary materials to allow traditional values and beliefs to be seen as relevant once more. 'Certain objects have a quality to them, a look that speaks of a sense of spirit. These objects have that look. The past is starting to come through in various ways,' he says. Clearly McMaster's postmodern appropriation would have fit equally well in Chapter 3, 'Subverting the Systems of Representation.'

The qualities most often associated with artistic production in the 'postmodern moment' include: 'irony, playfulness, historical reference, the use of vernacular materials, the continuity of cultures, an interest in process over product, breakdowns of boundaries between art forms and between art and life, and new relationships between artist and audience' (Banes 1985, 82). It is no wonder then that Vizenor says the Trickster is postmodern (1989, 9). Is there, however, any advantage in theorizing contemporary Native artistic practice as postmodern? Perhaps, as anthropologist Regna Darnell suggests, post-modernism is merely our Euro-Canadian way of doing the hard way what the trickster shift paradigm just *does* (personal communication, 19 August 1995). For more on postmodernism, see the Suggested Reading section of the References.

that that has to do with both some kinds of traditions in Native culture and also with the Canadian experience, because Canadian society has also been non-confrontational.[32]

The 'something else going on' has in fact been the central focus of this book. Phillips's question about why the artists have chosen to address their concerns through humour and irony might best be answered by referring once again to Vizenor's theory of mythic verism. In light of the works examined and the conversations cited in the previous pages, it seems as applicable to the present discussion as it is to contemporary Native literature and bears repeating:

It is the attitude of the characters which gives it the mythic verism and that attitude is comic ... It is something that is alive ... the way time is handled and resolved, the tension in time, and the sense of comedy or comic spirit through imagination and a collective sense that people prevail and survive, get along, get by. They're not at war with the environment, they're not rising above, and there are no subtle references to manifest destiny [and] monotheistic superiority. All of that's very subtle, but it's there and I think you can find it and I think we can focus on it and I think we can make a theory of it.

The term 'subtlety' has recurred frequently in the discussion of Native humour and trickster practice. It accounts for much of the conceptual layering and multiple reference in the art and invariably confounds unsuspecting and uninformed viewers. Subtlety has become synonymous with aesthetic sophistication, another term increasingly used to describe the work and practice of Aboriginal artists. As Tom Hill makes clear, the word 'sophistication' is well chosen:

[The art] has become more sophisticated. The environment has changed to accommodate that sophistication. You have artists now who are more aware of the political climate and more aware that their presence or ... their personal point of view can in some way address some of those issues. There's no question that humour does play a role. And I think humour does one thing for an artist: it makes, sometimes, a very sensitive issue ... more palatable. You come in, you chuckle, you laugh and then you realize what he is really saying is something that is very, very serious, and he means to, through his art or his discussion, cause change ...

..

32 Comparative investigation of the non-confrontational character of both societies is beyond the scope of this book but could be given an interesting slant by considering the function and possible inter-relationship of irony in both groups. An obvious starting point would be Hutcheon's essay 'As Canadian as ... Possible ... Under the Circumstances' (1991, 1ff), which examines the role of irony as an expression of English-Canadian identity.

It is interesting to note that as the first Native artist to represent Canada at the Venice Biennale in 1995, Edward Poitras chose to explore the exposition theme of identity and otherness ('alterity') through the persona of the Trickster Coyote. His critically acclaimed exhibition, curated by Gerald McMaster, was documented in two television films, *The Trickster: Edward Poitras in Venice* (McLennan 1995) and *Place of Bones: The Voyage of Edward Poitras* (Macartney-Filgate 1996), and a catalogue written by McMaster (1995). See also Enright (1995) and Tousley (1995). In 1996 the show was remounted in expanded form as JAW REZ at the Canadian Museum of Civilization. See Baele (1996).

159
Gerald McMaster
Post-Modern, 1988
acrylic on wood and wire, 35 x 30 x 4 cm

I see it ... moving further to more sophistication. The double entendre will become more sophisticated, will appeal to more [levels of meaning], there'll be more metaphors, there'll be more anachronisms. All those kinds of things will come into play even more so visually, plus [there will be] the creation of new ones ... New things are being created, new images are coming on stream. New levels of consciousness are being appealed to, both by the artist and by the audience. You have to come in on those same terms.

As Carl Beam sees it, 'There's something concretely happening that has not happened at any [other] point in history – a great fusion, a synthesis of shamanic process and modern materials.' Echoing Vizenor's description of breaking from formula and breaking out of program as a spiritual quest Beam later adds, 'If you explain what's involved, being an artist can be seen as a real sacred mission. Those who don't see it say, "Get a job!" "Get a life!" ... *The Trickster shift, they can't recognize that thing.*'

Postscript

The difference, then, between Pure and Applied research
is primarily one of footnotes.

Pure has many footnotes, Applied has few footnotes.

Vine Deloria Jr

My friend, Nampiao, put the pot on for some tea.
I clean up all the coyote tracks on the floor.

Thomas King

References

Suggested Reading

For a general review of the literature on the Trickster, see The Trickster in Folklore, in Apte (1985). See also Babcock (1975) for Trickster as the ultimate 'marginal man,' Ballinger (1989) for Trickster as collective social conscience, Holden (1976) for Trickster as ironic symbol of cultural resistance, Ricketts (1966) for Trickster as spirited religious celebrant, and Toelken (1969) for Trickster as 'the exponent of all possibilities.'

Published collections of traditional Native American Trickster tales abound. Among them are Book Builders of 'Ksan (1977), Hill and Hill (1945), Lopez (1977), and Mourning Dove (1990). Artists Paul Goble (1988, 1991, 1994) and Bill Reid (1984) not only retell but also illustrate traditional Trickster narratives. Anthologies of contemporary Trickster prose and poetry include Blue Cloud (1990) and Koller et al. (1982). Bright (1993) features both traditional and contemporary stories. Trickster tales can also be found in Baker (1992), Brant (1992), Hilbert (1983), Holden (1976), Keeshig-Tobias (1991, 1992), King (1992b), Naranjo-Morse (1992), Poitras (1992), and Robinson (1989). King (1990, 1993a, 1993b) and Gerald Vizenor (1987, 1988, 1990, 1991) are equally prolific in their production of contemporary Trickster fiction. As well, the two award-winning plays by Tomson Highway (1988a, 1989) and the film by Richard Weise (1984) are all Trickster vehicles. Of note too are the urban Coyote drawings by Maidu artist Harry Fonseca (in Koller et al. 1982), which, along with the artist's Coyote paintings, are discussed in Archuleta (1986). Of course, there are many other works that betray a Trickster texture but do not feature Trickster characters. Taylor (1996) immediately springs to mind.

For ritual clowning in Native North America, see: Babcock (1984), Crumrine (1969), Dooling (1979), Hieb (1977), Honigmann (1942), King (1979), Levine (1961), Lomatewama (1988), McCoy (1988), Makarius (1970), Parsons and Beals (1934), Ray (1945), Sekaquaptewa (1979), Steward (1931), Sweet (1989), Tedlock (1979), and Titiev (1975).

For White conceptions of Indians, see: Berkhofer (1979, 1988), Bird (1996), Blundell (1989), Clifton (1990), Cook (1984), Ewers (1965b), Francis (1992), Green (1984, 1988), Hirschfelder (1982), Nicks (1990), Pakes (1985), and Stedman (1982).

For Native peoples on film, see: Bataille and Silet (1980), Berton (1975), Ellis (1992), Friar (1972), Lucas (1980), McLeod (1992), Marsden and Nachbar (1988), O'Connor (1980), and Price (1978).

For Native response to White conceptions of Indians, see: Burgess and Valaskakis (1995), Churchill, Hill, and Hill (1978), Crosby (1991), Doxtator (1988), Greer (1989), Hill (1989), Lippard (1992), Medicine (1971), and Scholder (1979).

For frontier painters, see Ewers (1965a) and Schimmel (1991). For artist Karl Bodmer, see Thomas and Ronnefeldt (1976); for George Catlin, see Halpin (1965), Hassrick (1977), and McCracken (1959); for Paul Kane, see Eaton and Urbanek (1995) and Harper (1971); for Charles Bird King, see Viola (1976). For frontier photographers, see Scherer and Walker (1982). For photographer Edward Curtis, see Davis (1985), Graybill and Boesen (1976), Holm and Quimby (1980), and Lyman (1982).

For ethnographic, journalistic, and popular publications on Native humour, see: Barnow (1957), Basso (1979), Bierhorst (1992), Burton (1935), Chamberlain (1912), Churchill (1979), Codere (1956), Deloria (1969), Easton (1970), Edmunds (1976), Evans-Pritchard (1989), Giago (1990), Hill (1943), Holden (1976), Horn (1974), Howard (1962), Jacobs (1960), Laurence (1992), Lincoln (1993), McLeod (1992), Miller (1967), Opler (1938), Parker (1941), Ryan (1996), Sapir (1932), Scott (1963), Skeels (1954), Susman (1941), Taylor (1944), Uncompromising (1993), Voeglin (1949), Wallace (1953), Wilson and Dennison (1970), Witt and Steiner (1972).

For Native cartoonists, see: Ahenakew (1974); Vincent Craig's work in Basso (1979), Haederle (1995), Hess (1981), Landon (1991), Jojola (1993), Negri (1997), Sneddon and Crawford (1995), Traugott (1992), and Villani (1993); Freeman (1971, 1974, 1989); Guiboche (1983); Hughte (1994) and Hughte's work in Jojola (1995) and Sneddon (1994); Soop (1990) and Soop's work in Anthony (1994), Greer (1998), and Red Crow (1987); and Two Bulls (1991) and Two Bulls' work in Giago (1990).

For a sampling of writings on postmodernism, see: Appignanesi (1989), Berger (1997), Britt (1989), Cheetham and Hutcheon (1991), Collins (1989), Connor (1989), D'haen (1986), Fischer (1986), Fokkema and Bertens (1986), Foster (1983), Galbo (1987-8), Harvey (1980), Hoffmann (1986), Hutcheon (1988a, 1988b, 1989, 1994a), Huyssen (1986), Jencks (1986, 1987), Kaplan (1988), Laga (1994), Lyotard (1984), Merrill (1988), Olsen (1990), Rabinow (1986), Sarup (1989), Silverman (1990), Tyler (1986), Vizenor (1989), and Wilde (1981).

Interviews

All interviews were conducted by the author.

Beam, Carl. Notes only. Peterborough, ON. 13-4 February 1991
–. Telephone conversation from Toronto to Peterborough, notes only. 3 October 1991
–. Notes only. Peterborough, ON. 16 October 1991
Belmore, Rebecca. Audiotape. Toronto, ON. 25 February 1991
–. Notes only. Toronto, ON. 7 October 1991
Boyer, Bob. Audiotape. Regina, SK. 5, 7, November 1991
Cardinal-Schubert, Joane. Audiotape. Calgary, AB. 12-3 November 1991
Farmer, Gary. Audiotape. Ottawa, ON. 19 February 1991
Gray, Viviane. Audiotape. Hull, QC. 10 October 1991
Harper, Vern. Audiotape. Scarborough, ON. 4 October 1991
Hill, Tom. Audiotape. Brantford, ON. 1 October 1991
Jonnie, Curtis 'Shingoose.' Audiotape. Toronto, ON. 3 July 1991

Littlechild, George. Audiotape. Vancouver, BC. 8 November 1996
Logan, Jim. Audiotape. Vancouver, BC. 26 January 1994
McMaster, Gerald. Audiotape. Vancouver, BC, and Ottawa, ON. 18-21, 28, October 1990
–. Audiotape. Ottawa, ON, and Hull, QC. 9, 11, October 1991
Niro, Shelley. Audiotape. Brantford, ON. 10 February 1991
–. Audiotape. Brantford, ON. 1 October 1991
Noganosh, Ron. Audiotape. Ottawa, ON. 17 February 1991
–. Audiotape. Ottawa, ON. 10 October 1991
Noganosh, Ron, and Viviane Gray. Also present: John Clifford, Viviane's husband; Maxine Bedyn, Ron's wife; and visiting Swedish scholar, Vanessa Vogel. Audiotape. Ottawa, ON. 15 February 1991
Phillips, Ruth. Audiotape. Ottawa, ON. 19 February 1991
Poitras, Edward. Audiotape. Regina, SK. 4, 5, 8, November 1991
Poitras, Jane Ash. Audiotape. Vancouver, BC. 22 October 1990
–. Audiotape. Vancouver, BC. 21 August 1991
–. Audiotape. Edmonton, AB. 9-10 November 1991
Powless, Bill. Audiotape. Brantford, ON. 11 February 1991
–. Audiotape. Brantford, ON. 1 October 1991
Yuxweluptun, Lawrence Paul. Audiotape. Vancouver, BC. 4 January 1990
–. Audiotape. Vancouver, BC. 1-2 November 1991
–. Telephone conversation. From Vancouver to the artist's home, Fort St James, BC. 14 September 1992

Published Sources

Adams, Robert S., director. 1997. Urban Elder. Video documentary, 30 mins. Toronto: Four Directions Studio
Ahenakew, Willard. 1974. Cartoons of Indian Politics and Indian Humour. [Saskatoon?]: Willard Ahenakew
Alexandrian, Sarane. 1970. Surrealist Art. London: Thames and Hudson
Anderson, Mike. 1990. Hard and Soft: Collaborative Works by Ottawa Artists Viviane Gray and Ron Noganosh. ARTSCRAFT 2 (1): 16-7
Ansen, David. 1990. Magnificent Maverick. Cosmopolitan, May, 308-11
Anthony, Leon. 1994. Simmer and Shake. Aboriginal Voices 1 (4): 13-4
Appignanesi, Lisa, ed. 1989. Postmodernism: ICA Documents. London: Free Association Books
Apte, Mahadev. 1985. Humor and Laughter: An Anthropological Approach. Ithaca, NY: Cornell University Press
Archuleta, Margaret L. 1986. Coyote: A Myth in the Making. Terra 25 (2): 13-9
–. 1989. The Fourth Biennial Native American Fine Arts Invitational at the Heard Museum. American Indian Art Magazine 15 (1): 54-61
Archuleta, Margaret, and Renard Strickland. 1991. Shared Visions: Native American Painters and Sculptors in the Twentieth Century. Phoenix, AZ: The Heard Museum

Atkins, Robert. 1990. *Artspeak: A Guide to Contemporary Ideas, Movements, and Buzzwords*. New York: Abbeville Press

Babcock, Barbara A. 1975. 'A Tolerated Margin of Mess': The Trickster and His Tales Reconsidered. *Journal of the Folklore Institute* 9: 147-86

–. 1984. Arrange Me into Disorder: Fragments and Reflections on Ritual Clowning. In *Rite, Drama, Festival, Spectacle: Rehearsals Toward a Theory of Cultural Performance*, edited by John J. MacAloon, 102-28. Philadelphia: Institute for the Study of Human Issues

Baele, Nancy. 1991. Native Artist Throws Comic Curves But with a Serious Twist. *Ottawa Citizen*, 24 February, p. D7

–. 1996. Coyotes and Culture: Métis Artist Explores Realities, Identities. *Ottawa Citizen*, 16 June, c2

Baillargeon, Morgan, and Leslie Tepper. 1998. *Legends of Our Times*. Vancouver: UBC Press

Baker, Marie Annharte. 1991a. An Old Indian Trick Is to Laugh. *Canadian Theatre Review* 68 (Fall): 48-9

–. 1991b. Carte Blanche: Angry Enough to Spit But with *Dry Lips* It Hurts More Than You Know. *Canadian Theatre Review* 68 (Fall): 88-9

–. 1992. Coyote Trail. In *An Anthology of Canadian Native Literature in English*, edited by Daniel David Moses and Terry Goldie, 168-9. Toronto: Oxford University Press

Ballinger, Franchot. 1989. Living Sideways: Social Themes and Social Relationships in Native American Trickster Tales. *American Indian Quarterly* (Winter): 15-30

Banes, Sally. 1985. Dance. In *The Postmodern Moment: A Handbook of Contemporary Innovation in the Arts*, edited by Stanley Trachtenberg, 82-100. Westport, CT: Greenwood Press. Quoted in Linda Hutcheon, *The Politics of Postmodernism* (London and New York: Routledge 1989), 9

Barbeau, Marius. 1929. *Totem Poles of the Gitskan, Upper Skeena River, British Columbia*. Bulletin 61. Ottawa: National Museum of Canada

Barnow, Victor. 1957. The Amiable Side of 'Patterns of Culture.' *American Anthropologist* 59: 532-5

Barreca, Regina. 1991. *They Used to Call Me Snow White ... But I Drifted: Women's Strategic Use of Humor*. New York: Viking

–, ed. 1988. *Last Laughs: Perspectives on Women and Comedy*. Studies in Gender and Culture 2. New York: Gordon and Breach

–. 1992. *New Perspectives on Women and Comedy*. Studies in Gender and Culture 5. New York: Gordon and Breach

Barthes, Roland. 1967. *Elements of Semiology*. Translated by Annette Lavers and Colin Smith. New York: Hill and Wang

–. 1973. *Mythologies*. Translated by Annette Lavers. London: Paladin

Basso, Keith. 1979. *Portraits of 'The Whiteman': Linguistic Play and Cultural Symbols among the Western Apache*. New York: Cambridge University Press

Bataille, Gretchen M., and Charles Silet, eds. 1980. *The Pretend Indians: Images of Native Americans in the Movies*. Iowa City: Iowa State University Press

Bates, Sara. 1995. *Indian Humor*. Exhibition catalogue. San Francisco: American Indian Contemporary Arts

Beal, Bob, and Rod Macleod. 1988. North-West Rebellion. In *The Canadian Encyclopedia*, edited by James H. Marsh, 1511-3. 2nd ed. Edmonton: Hurtig Publishers

Beam, Carl, and Shelagh Young. 1989. *The Columbus Project, Phase 1*. Exhibition catalogue. Peterborough, ON: Artspace and The Art Gallery of Peterborough

Beaucage, Marjorie. 1991. *Bingo*. 16 mm film, 16 mins. M.J.B. Entre-prises

Beauchamp, Elizabeth. 1991. Native Artist Shows Her Outrage. *Edmonton Journal*, 8 November, p. D13

Bentley Mays, John. 1992. Face to Face with Racism. *Globe and Mail*, 19 December, p. c4

Berger, Arthur Asa. 1997. *Postmortem for a Postmodernist*. Walnut Creek, CA: AltaMira Press

Berkhofer, Robert F., Jr. 1979. *The White Man's Indian: Images of the American Indian from Columbus to the Present*. New York: Vintage Books

–. 1988. White Conceptions of Indians. In *History of Indian-White Relations*, edited by Wilcomb E. Washburn, 522-47. Vol. 4 of *Handbook of North American Indians*, edited by William C. Sturtevant. Washington, DC: Smithsonian Institution

Bernstein, Bruce, and W. Jackson Rushing. 1995. *Modern by Tradition: The Studio Style of Native American Painting*. Santa Fe: Museum of New Mexico Press

Berton, Pierre. 1975. Primitive Passions in the Untamed North. Part 2 of *Hollywood's Canada: The Americanization of Our National Image*, 73-108. Toronto: McClelland and Stewart

Bierhorst, John, ed. 1992. *'Lightning inside You' and Other Native American Riddles*. Illustrated by Louise Brierley. New York: William Morrow and Company

Bird, S. Elizabeth, ed. 1996. *Dressing in Feathers: The Construction of the Indian in American Popular Culture*. Boulder: Westview Press

Blaeser, Kimberley. 1996. *Gerald Vizenor: Writing in the Oral Tradition*. Norman, OK: University of Oklahoma Press

Blair, Jon, director. 1995. *Anne Frank Remembered*. Documentary film. Jon Blair Film Company in association with the BBC and the Disney Channel

Blue Cloud, Peter (Aroniawenrate). 1990. *The Other Side of Nowhere: Contemporary Coyote Tales*. Fredonia, NY: White Pine Press

Blundell, Valda. 1989. The Tourist and the Native. In *A Different Drummer: Readings in Anthropology With A Canadian Perspective*, edited by Bruce Cox, Jacques Chevalier, and Valda Blundell, 49-58. Ottawa: Carleton University Anthropology Caucus

Book Builders of 'Ksan. 1977. *We-Gyet Wanders On: Legends of the Northwest*. Saanʔchton, BC: Hancock House

Bowers, Sharon Manybeads. 1992. Louise Erdrich as Nanapush. In *New Perspectives on Women and Comedy*, edited by Regina Barreca, 135-41. Studies in Gender and Culture 5. New York: Gordon and Breach

Brandes, Stanley H. 1977. Peaceful Protest: Spanish Political Humor in a Time of Crisis. *Western Folklore* 36 (4): 331-46

Brant, Beth. 1992. Coyote Learns a New Trick. In *An Anthology of Canadian Native Literature in English*, edited by Daniel David Moses and Terry Goldie, 148-50. Toronto: Oxford University Press

Bright, William. 1993. *A Coyote Reader*. Berkeley: University of California Press

Britt, David, ed. 1989. *Modern Art: Impressionism to Post-Modernism*. Boston, Toronto, and London: Bullfinch Press and Little, Brown and Company

Brody, J.J. 1971. *Indian Painters and White Patrons*. Albuquerque: University of New Mexico Press

Brown, Dee. 1972. *Bury My Heart at Wounded Knee*. Bantam Books: Toronto

Bruchac, Joseph. 1987. *Survival This Way: Interviews with American Indian Poets*. Tucson: Sun Tracks and University of Arizona Press

Burgess, Marilyn, and Gail Guthrie Valaskakis. 1995. *Indian Princesses and Cowgirls: Stereotypes from the Frontier*. Montreal: Oboro

Burton, Henrietta K. 1935. Their Fun and Humor. *Indians at Work* 3 (9): 24

Cardinal-Schubert, Joane. 1987. oh Canada. *Whetstone*, Native Issue (Spring): 28

Carroll, David. 1982. *The Subject in Question*. Chicago: University of Chicago Press

Chamberlain, Alexander F. 1912. Humor. *Handbook of American Indians North of Mexico*. Bureau of American Ethnology, Bulletin 30, Part 1, edited by F.W. Hodge, 578. New York: Pageant Books

Cheetham, Mark A., with Linda Hutcheon. 1991. *Remembering Postmodernism: Trends in Recent Canadian Art*. Toronto: Oxford University Press

Churchill, Ward. 1979. Charlie Hill: The Lennie Bruce of Native America. *Shantih* 4 (2): 57-8

–. 1992. *Fantasies of the Master Race: Literature, Cinema and the Colonization of American Indians*. Edited by M. Annette. Monroe, MN: Common Courage Press

Churchill, Ward, Norbert Hill, and Mary Ann Hill. 1978. Media Stereotyping and Native Response. *The Indian Historian* 11 (4): 45-56

Clifton, James A., ed. 1990. *The Invented Indian: Cultural Fictions and Government Policies*. New Brunswick, NJ: Transaction Publishers

Codere, Helen. 1956. The Amiable Side of Kwakiutl Life: The Potlatch and the Play Potlatch. *American Anthropologist* 58: 334-51

Coen, Rena Newmann. 1969. *The Indian as the Noble Savage in Nineteenth Century American Art*. PhD dissertation, University of Minnesota. Quoted in Fraser J. Pakes, Seeing with the Stereotypic Eye: The Visual Image of the Plains Indian, *Native Studies Review* 1, 2 (1985): 1-31

Cole, P., ed. 1981. *Radical Pragmatics*. New York: Academic Press

Collins, Curtis J. 1990. *Contemporary Rituals*, Exhibition catalogue. North Bay, ON: White Water Gallery

–. 1991. A Review of the *Edward Poitras* Installation/Exhibition at Articule. *Espace* 17 (Autumn): 19-22

Collins, Jim. 1989. *Uncommon Cultures: Popular Culture and Post-Modernism*. New York and London: Routledge

Connor, Steven. 1989. *Postmodernist Culture: An Introduction to Theories of the Contemporary*. Oxford: Basil Blackwell

Cooke, Katie. 1984. *Images of Indians Held by Non-

Indians: A Review of Current Canadian Research. Ottawa: Research Branch, Indian and Northern Affairs Canada

Costner, Kevin, director. 1990. *Dances with Wolves.* Feature film, 181 mins. Tig Productions

Cowling, Elizabeth. 1978. The Eskimos, the American Indians, and the Surrealists. *Art History* 1 (4): 485-99

Crosby, Marcia. 1991. Construction of the Imaginary Indian. In *Vancouver Anthology: The Institutional Politics of Art,* edited by Stan Douglas, 267-91. Vancouver: Talon Books

Crumrine, N. Ross. 1969. Capakoba, the Mayo Easter Ceremonial Impersonator: Explanations of Ritual Clowning. *Journal for the Scientific Study of Religion* 8: 1-22

Culler, Jonathan. 1981. *The Pursuit of Signs: Semiotics, Literature, Deconstruction.* Ithaca, NY: Cornell University Press

Davis, Barbara A. 1985. *Edward S. Curtis: The Life and Times of a Shadow Catcher.* San Francisco: Chronicle Books

Delany, Paul, and George P. Landow, eds. 1991. *Hypermedia and Literary Studies.* Cambridge, MA: MIT Press

Deloria Jr, Vine. 1969. *Custer Died for Your Sins: An Indian Manifesto.* London: Collier-Macmillan

Devine, David, director. 1988. *Indian Time.* Television special, 48 mins. Produced by Curtis Jonnie (Shingoose) and Don Marks. Winnipeg, MB: Native Multimedia Productions

D'haen, Theo. 1986. Postmodernism in American Fiction and Art. In *Approaching Postmodernism,* edited by Douwe Fokkema and Hans Bertens, 211-31. Amsterdam and Philadelphia: John Benjamins Publishing

Dooling, D.M. 1979. The Wisdom of the Contrary. *Parabola* 4 (1): 54-65

Douglas, Mary. 1968. The Social Control of Cognition: Some Factors in Joke Perception. *Man* 3: 361-76

Doxtator, Deborah. 1988. *Fluffs and Feathers: An Exhibit on the Symbols of Indianness. A Resource Guide.* Brantford, ON: Woodland Cultural Centre

Duffek, Karen. 1988. *Bob Boyer: A Blanket Statement.* UBC Museum of Anthropology Museum Note No. 23. Vancouver: University of British Columbia Museum of Anthropology

–. 1989. *Lyle Wilson: When Two Worlds Collide,* Exhibition brochure. Museum Note 28. Vancouver: University of British Columbia Museum of Anthropology

Duffek, Karen, and Tom Hill. 1989. *Beyond History.* Exhibition catalogue. Vancouver: Vancouver Art Gallery

Durham, Jimmie. 1986. Ni' Go Tlunh A Doh Ka. In *Ni' Go Tlunh A Doh Ka* (We Are Always Turning around on Purpose), by Jean Fisher, 1-4. Exhibition catalogue. Old Westbury, NY: Amalie A. Wallace Gallery and State University of New York College at Old Westbury

–. 1994. Essay. *Marginal Recession: An Installation by Edward Poitras.* Exhibition catalogue. Regina: Dunlop Art Gallery

Easton, Robert. 1970. Humor of the American Indian. *Mankind: The Magazine of Popular History* 2 (9): 37-41, 72, 73

Eaton, Diane, and Sheila Urbanek. 1995. *Paul Kane's Great Nor-West.* Vancouver: UBC Press

Eco, Umberto. 1976. *A Theory of Semiotics.* Bloomington, IN: Indiana University Press

Edmunds, R. David. 1976. Indian Humor: Can the Red Man Laugh? In *Red Men and Hat-Wearers: Viewpoints in Indian History: Papers from the Colorado State University Conference on Indian History (August 1974),* edited by D. Tyler, 141-53. Boulder, CO: Pruett

Ellis, Scott. 1992. Phantom Indians: Some Observations on Recent Cinema. *Border Crossings* 11 (4): 42-5

Enright, D.J. 1986. *The Alluring Problem: An Essay on Irony.* Oxford: Oxford University Press

Enright, Robert. 1995. The Incomparable Rightness of of in Between. *Border Crossings* 14 (4): 24-33

Erdrich, Louise. 1995. *The Bingo Palace.* New York: HarperCollins

Evans-Pritchard, Deirdre. 1989. How 'They' See 'Us': Native American Images of Tourists. *Annals of Tourism Research* 16: 89-105

Ewers, John C. 1965a. *Artists of the Old West.* Garden City, NJ: Doubleday

–. 1965b. The Emergence of the Plains Indian as the Symbol of the North American Indian. *Smithsonian Institution Annual Report 1964,* 531-44. Washington, DC: Government Printing Office. Reprinted in Arlene B. Hirschfelder, ed., *American Indian Stereotypes in the World of Children: A Reader and Bibliography,* 16-32. Metuchen, NJ: Scarecrow Press 1982

Farmer, Gary. 1994. The Shameman: Going beyond Indian – The Performance Art of James Luna. *Aboriginal Voices* 1 (4): 19-23

Finney, Gail, ed. 1994. *Look Who's Laughing: Gender and Comedy.* Studies in Humor and Gender 1. New York: Gordon and Breach

Fischer, Michael M.J. 1986. Ethnicity and the Post-Modern Arts of Memory. In *Writing Culture: The Poetics and Politics of Ethnography,* edited by James Clifford and George E. Marcus, 194-233. Berkeley: University of California Press

Fokkema, Douwe, and Hans Bertens, eds. 1986. *Approaching Postmodernism.* Amsterdam and Philadelphia: John Benjamins Publishing

Foster, Hal, ed. 1983. *The Anti-Aesthetic: Essays on Postmodern Culture.* Port Townsend, WA: Bay Press

Francis, Daniel. 1992. *The Imaginary Indian: The Image of the Indian in Canadian Culture.* Vancouver: Arsenal Pulp Press

Frederick, Joan, in cooperation with Walter Cannon. 1995. *T.C. Cannon: He Stood in the Sun.* Flagstaff, AZ: Northland Publishing

Freeman, Robert. 1971. *For Indians Only.* San Marcos, CA: Robert Freeman

–. 1974. *War Whoops and All That Jazz.* San Marcos, CA: Robert Freeman

–. 1989. *Rubber Arrows.* San Marcos, CA: Robert Freeman

Friar, Ralph, and Natasha. 1972. *The Only Good Indian: The Hollywood Gospel.* New York: Drama Book Specialists/Publishers

Galbo, Joe. 1987-8. Review of *The Postmodern Scene: Excremental Culture and Hyper-Aesthetics* by Arthur Kroker and David Cook. *BORDER/LINES* 9-10: 40-1

Gates, David. 1991. Who Was Columbus? *Newsweek* Columbus special issue (Fall-Winter): 29-31

Gerdts, William. 1992. Salvador Dali. *Encyclopedia Americana,* international edition, 8: 436-7. Danbury, CT: Grolier

Giago, Tim, Jr. 1990. My Laughter. Illustrations by Marty G. Two Bulls. *Native Peoples Magazine* 3 (3): 52-6

Gilchrist, Sylvene, producer. 1995. *Jane Ash Poitras: A Portrait in the First Person.* Television program, 30 mins. *Originals in Art* series. Executive producer Moses Znaimer. Toronto: Sleeping Giant Productions in association with BRAVO! TV

Gmelch, George. 1997. Baseball Magic. In *Conformity and Conflict: Readings in Cultural Anthropology,* edited by James Spradley and David W. McCurdy, 320-9. 9th ed. New York: Longman

Goble, Paul. 1988. *Iktomi and the Boulder.* New York: Orchard Books

–. 1991. *Iktomi and the Buffalo Skull.* New York: Orchard Books

–. 1994. *Iktomi and the Buzzard.* New York: Orchard Books

Grant, Agnes. 1988. *The Way to Rainy Mountain* in a Community-Based Oral Narratives Course for Cree and Ojibway Students. In *Approaches to Teaching Momaday's 'The Way to Rainy Mountain,'* edited by Kenneth M. Roemer, 138-44. New York: The Modern Language Association of America

Graybill, Florence Curtis, and Victor Boesen. 1976. *Edward Sheriff Curtis: Visions of a Vanishing Race.* New York: Thomas Y. Crowell

Green, Rayna. 1984. The Pocahontas Perplex: The Image of Indian Women in American Culture. *Sweetgrass* (July-August): 17-23

–. 1988. The Indian in Popular American Culture. In *History of Indian-White Relations,* edited by Wilcomb E. Washburn, 587-606. Vol. 4 of *Handbook of North American Indians,* edited by William C. Sturtevant. Washington, DC: Smithsonian Institution

–. 1989. Beaded Adidas. In *Time & Temperature: A Centennial Publication of the American Folklore Society,* edited by Charles Camp, 66. Philadelphia: American Folklore Society

Greer, Sandy. 1989. Stereotypes, Native Art, and Art. *ArtViews* (March, April, May): 18-23

–, director. 1998. *Soop on Wheels.* Video documentary, 52 mins. Toronto: Two Wheels Productions

Gritton, Joy. 1991. The Institute of American Indian Arts: A Convergence of Ideologies. In *Shared Visions: Native American Painters and Sculptors in the Twentieth Century,* edited by Margaret Archuleta and Renard Strickland, 22-9. Phoenix, AZ: The Heard Museum

–. 1992. Cross-Cultural Education vs. Modernist Imperialism: The Institute of American Indian Arts. *Art Journal* 51 (3): 28-35

Guiboche, Keiron. 1983. *Bufflo & Sprucegum.* Winnipeg: Pemmican Publications

Hackett, Regina. 1993. Confidence Is Fully Developed in Women's Photography Show. *Seattle Post-Intelligencer,* 24 February, C11

Haederle, Michael. 1995. Vincent Craig: Pondering the Imponderable. *El Palacio* (Spring): 34-9

Halpin, Marjorie. 1965. *Catlin's Indian Gallery: The George Catlin Paintings in the United States*

National Museum. Washington, DC: Smithsonian Institution

Hanna, Deirdre. 1991. McMaster Spotlights Racism in cowboy/Indian Exhibition. *Now*, 28 March-3 April, n.p.

Harper, J. Russell, ed. 1971. *Paul Kane's Frontier. Including Wanderings of an Artist among the Indians of North America* by Paul Kane. Austin and London: University of Texas Press

Harvey, David. 1980. *The Condition of Postmodernity*. Oxford: Basil Blackwell

Hassrick, Royal B. 1977. *The George Catlin Book of American Indians*. New York: Watson-Guptill Publications

Henry, Victoria, and Shelley Niro. 1994. *From Icebergs to Iced Tea*. Exhibition catalogue. Thunder Bay and Ottawa: Thunder Bay Art Gallery and Carleton University Art Gallery

Hess, Bill. 1981. A Navajo Laughs. *Nations* 1 (12): 14-20

Hieb, Louis. 1977. The Ritual Clown: Humor and Ethics. In *Forms of Play of Native North Americans*, edited by Edward Norbeck and Claire R. Farrer, 171-89. Proceedings of the American Ethnological Society. New York: West Publishing

Highway, Tomson. 1988a. *The Rez Sisters*. Saskatoon: Fifth House

—. 1988b. *Tomson Highway: Native Voice*. Interview by Phyllis Wilson. Thompson, MB: Native Communications

—. 1989. *Dry Lips Oughta Move to Kapuskasing*. Saskatoon: Fifth House

Hilbert, Vi. 1983. Poking Fun in Lushootseed. *Working Papers for the 18th International Conference on Salish and Neighbouring Languages*. Seattle: University of Washington Press

Hill, Tom. 1991. Looking back at Columbus: Alternative Perspectives. *Wadrihwa* 5 (2): 5-7

Hill, Richard. 1989. In Our Own Image: Stereotyped Images of Indians Lead to New Native Artform. *MUSE* 7 (4): 32-43

—. 1992. *Creativity Is Our Tradition: Three Decades of Contemporary Indian Art*. With essays by Nancy Marie Mitchell (Mithlo) and Lloyd New. Santa Fe, NM: Institute of American Indian and Alaska Native Culture and Arts Development

Hill, W.W. 1943. *Navaho Humor*. General Series in Anthropology, 9. Menasha, WI: George Banta

Hill, W.W., and Dorothy W. Hill. 1945. Navaho Coyote Tales and Their Position in the Southern Athabascan Group. *Journal of American Folklore* 58: 317-43

Hirschfelder, Arlene B. 1982. *American Indian Stereotypes in the World of Children: A Reader and Bibliography*. Metuchen, NJ: Scarecrow Press

Hodge, Robert, and Gunther Kress. 1988. *Social Semiotics*. Ithaca, NY: Cornell University Press

Hoebel, E.A. 1972. *Anthropology: The Study of Man*. New York: McGraw-Hill

Hoffmann, Gerhard. 1986. Frames of Reference: Native American Art in the Context of Modern and Postmodern Art. In *The Arts of the North American Indian: Native Traditions in Evolution*, edited by Edwin L. Wade, 257-82. New York: Hudson Hills Press

Hoffmann, Gerhard, ed. 1988. *Im Schatten der Sonne: Zeitgenossische Kunst der Indianer und Eskimos in Kanada*. Ottawa: Canadian Museum of Civilization

Holden, Madronna. 1976. Making All the Crooked Ways Straight: The Satirical Portrait of Whites in Coast Salish Folklore. *Journal of American Folklore* 89 (353): 271-93

Holm, Bill. 1965. *Northwest Coast Indian Art: An Analysis of Form*. Seattle and London: University of Washington Press

Holm, Bill, and George Irving Quimby. 1980. *Edward S. Curtis in the Land of the War Canoes: A Pioneer Cinematographer in the Pacific Northwest*. Seattle and London: University of Washington Press

Honigmann, John J. 1942. An Interpretation of the Social-Psychological Functions of the Ritual Clown. *Character and Personality* 10: 220-6

Horn, Patrice. 1974. Eskimo Humor – More than a Laughing Matter. *Psychology Today*, March, 14, 18

Houle, Robert. 1982. *New Work by a New Generation*. Exhibition catalogue. Regina, SK: Norman Mackenzie Art Gallery

Houle, Robert, with Clara Hargittay. 1988. The Struggle against Cultural Apartheid. *MUSE* 6 (3): 58-63

Howard, James H. 1962. Peyote Jokes. *Journal of American Folklore* 75: 10-4

Hughte, Phil. 1994. *A Zuni Artist Looks at Frank Hamilton Cushing: Cartoons by Phil Hughte*. Zuni, NM: Pueblo of Zuni Arts & Crafts and A:shiwi A:wan Museum and Heritage Center

Huizinga, Johan. 1955. *Homo Ludens: A Study of the Play Element in Culture*. Boston: Beacon Press

Hume, Christopher. 1979. The New Age of Indian Art. *Maclean's*, 22 January, 24-8

—. 1991. Native Painter's Criticism Packs a Strong Punchline. *Toronto Star*, 8 February, p. D14

Hutcheon, Linda. 1985. *A Theory of Parody: The Teachings of Twentieth Century Art Forms*. London and New York: Methuen

—. 1988a. *A Poetics of Postmodernism: History, Theory, Fiction*. New York and London: Routledge

—. 1988b. *The Canadian Postmodern: A Study of Contemporary English-Canadian Fiction*. Toronto, New York, Oxford: Oxford University Press

—. 1989. *The Politics of Postmodernism*. London and New York: Routledge

—. 1991. *Splitting Images: Contemporary Canadian Ironies*. Toronto, New York, Oxford: Oxford University Press

—. 1994a. The Post Always Rings Twice: The Postmodern and the Postcolonial. *Textual Practice* (Spring): 205-38

—. 1994b. *Irony's Edge: The Theory and Politics of Irony*. London and New York: Routledge

Hutcheon, Linda, ed. 1992. *Double-Talking: Essays on Verbal and Visual Ironies in Contemporary Canadian Art and Literature*. Toronto: ECW Press

Huyssen, Andreas. 1986. *After the Great Divide: Modernism, Mass Culture, Postmodernism*. Bloomington, IN: Indiana University Press

Hyers, Conrad. 1973. *Zen and the Comic Spirit*. Philadelphia: Westminster Press

—. 1981. *The Comic Vision and the Christian Faith*. New York: Pilgrim Press

Hyers, Conrad, ed. 1969. *Holy Laughter: Essays on Religion in the Comic Perspective*. New York: Seabury Press

Hymes, Dell. 1979. Foreword to *Portraits of 'The Whiteman': Linguistic Play and Cultural Symbols*

among the Western Apache, by Keith Basso, ix-xviii. New York: Cambridge University Press

—. 1987. A Theory of Irony and a Chinookan Pattern of Verbal Exchange. In *The Pragmatic Perspective: Selected Papers from the 1985 International Pragmatics Conference*, edited by Jef Verschueren and Marcella Bertuccelli-Papi, 293-337. Amsterdam and Philadelphia: John Benjamins Publishing

Inglis, Grace. 1987. A Native Experience: Carl Beam's Work Sends Shivers up the Spine. *Hamilton Spectator*, 21 March, n.p.

Jacobs, Melville. 1960. Humor and Social Structure in an Oral Literature. In *Culture in History: Essays in Honor of Paul Radin*, edited by S. Diamond, 180-9. New York: Columbia University Press

Janson, Horst and Dora. 1977. *History of Art: A Survey of the Major Visual Arts from the Dawn of History to the Present Day*. 2nd ed. New York: Harry N. Abrams

Jencks, Charles. 1986. *What Is Post-Modernism?* London: Academy Editions and St Martin's Press

—. 1987. *Post-Modernism: The New Classicism in Art and Architecture*. New York: Rizzoli

Johnson, Samuel. 1755. *Dictionary of the English Language*. Quoted in D.J. Enright, *The Alluring Problem: An Essay on Irony* (Oxford: Oxford University Press 1986)

Jojola, Ted. 1993. Native American Cartoonist Mines Tragedy for Humor. *Albuquerque Journal*, 2 August, p. A7

—. 1995. Exhibition review: *A Zuni Artist Looks at Frank Hamilton Cushing: Cartoons by Phil Hughte*, at the Maxwell Museum, University of New Mexico, Albuquerque, 1994-95. *Museum Anthropology* 19 (1): 54-6

Jonaitis, Aldona. 1981. Creations of Mystics and Philosophers: The White Man's Perceptions of Northwest Coast Indian Art from the 1930s to the Present. *American Indian Culture and Research Journal* 51: 1-45

Kaplan, E. Ann, ed. 1988. *Postmodernism and Its Discontents: Theories, Practices*. London: Verso

Kaufman, Gloria, ed. 1991. *In Stitches: A Patchwork of Feminist Humor and Satire*. Bloomington, IN: Indiana University Press

Keeshig-Tobias, Lenore. 1988. Let's Be Our Own Tricksters, Eh. *The Magazine to Re-Establish the Trickster* 1 (1): 2-3

—. 1991. Quest for Fire, or How the Trickster Brought Fire to the People. Script excerpt. *Canadian Theatre Review* 68 (Fall): 86-7

—. 1992. Trickster beyond 1992: Our Relationship. In *Indigena: Contemporary Native Perspectives*, edited by Gerald McMaster and Lee-Ann Martin, 101-13. Vancouver: Douglas and McIntyre

Kenagy, Suzanne G. 1990. Bob Haozous. *American Indian Art Magazine* 15 (3): 66-73

Kierkegaard, Søren. 1841. *The Concept of Irony*. Translated by Lee M. Capel, 1966. Quoted in D.J. Enright, *The Alluring Problem: An Essay on Irony* (Oxford: Oxford University Press 1986), 3

King, Arden R. 1979. North American Clowns and Creativity. In *Forms of Play of Native North Americans*, edited by Edward Norbeck and Claire R. Farrer, 143-51. Proceedings of the American Ethnological Society. New York: West Publishing

King, Thomas. 1990. Poems: Coyote Learns to

Whistle, Coyote Sees the Prime Minister, and Coyote Goes to Toronto. In *Native Writers and Canadian Writing*, edited by W.H. New, 250-3. Vancouver: UBC Press

–. 1991. Dances with the Truth. *Toronto Star*, 13 April, pp. G1, G16

–. 1992a. *A Coyote Columbus Story*. With illustrations by William Kent Monkman. Toronto and Vancouver: Groundwood and Douglas and McIntyre

–. 1992b. The One about Coyote Going West. In *An Anthology of Canadian Native Literature in English*, edited by Daniel David Moses and Terry Goldie, 180-7. Toronto: Oxford University Press

–. 1993a. *Green Grass, Running Water*. Toronto: HarperCollins

–. 1993b. *One Good Story, That One*. Toronto: HarperCollins

–. 1993-4. Author Thomas King of Medicine River. Interview by Gary Farmer. In *The Runner* 1 (1): 3-6

Kinsella, W.P. 1977. *Dance Me Outside*. Toronto: Oberon Press

Koller, James, 'Gogisgi' Carroll Arnett, Steve Nemirow, and Peter Blue Cloud, eds. 1982. *Coyote's Journal*. Berkeley, CA: Wingbow Press

Laga, Barry E. 1994. Gerald Vizenor and His *Heirs of Columbus*: A Postmodern Quest for More Discourse. *American Indian Quarterly* 18 (1): 71-86

Landon, Susan. 1991. Who Is That Masked Man? *Albuquerque Journal*, 14 July, pp. F1-2

Laurence, Robin. 1992. Punning Artist Uses Native Wit. *Georgia Straight* (Vancouver), 14-21 August, p. 27

–. 1995. Man of Masks. *Canadian Art* 12 (1): 50-5

–. 1997. Bitter Memories Purged in Paint. *Georgia Straight* (Vancouver), 13-20 March, p. 57

Levine, Jacob. 1961. Regression in Primitive Clowning. *Psychoanalytic Quarterly* 30: 72-83

Lincoln, Kenneth. 1993. *Indi'n Humor: Bicultural Play in Native America*. New York: Oxford University Press

Lippard, Lucy. 1990. *Mixed Blessings: New Art in a Multicultural America*. New York: Pantheon

–, ed. 1992. *Partial Recall: Photographs of Native North Americans*. New York: New Press

Littlebird, Barbara. 1981. Artist Profile: Harry Fonseca. *Four Winds* 2 (3): 10-5

Littlechild, George. 1993. *This Land Is My Land*. Emeryville, CA: Children's Book Press

–. 1996. *George Littlechild: Past & Recent Work*. Introducing the multi-media installation *Dis-Placed Indians: The Sixties Scoop*. Exhibition catalogue. Surrey, BC: Surrey Art Gallery

Logan, Marty. 1996. Monument Will Honor Contribution of Native Vets. *Windspeaker* (Edmonton), December, pp. 4-5

Lomatewama, Ramson. 1988. A Hopi Mirror. *Native Peoples – The Journal of the Heard Museum* (Summer): 8-13

Longclaws, Lyle. 1989. Epigraph. In Tomson Highway, *Dry Lips Oughta Move to Kapuskasing* (Saskatoon: Fifth House 1989)

Longfish, George C., and Joan Randall. 1983. Contradictions in Indian Territory. In *Contemporary Native American Art*, edited by Richard A. Bivins, n.p. Exhibition catalogue. Stillwater, OK: Oklahoma State University

Lopez, Barry. 1977. *Giving Birth to Thunder, Sleeping with His Daughter: Coyote Builds North America*. New York: Avon

Lucas, Phil. 1980. Images of Indians. *Four Winds* 1 (4): 69-77

Luna, James. 1992. In *Land Spirit Power: First Nations at the National Gallery of Canada*, edited by Diana Nemiroff, Robert Houle, and Charlotte Townsend-Gault, 190-5. Exhibition catalogue. Ottawa: National Gallery of Canada

Lurie, Nancy Oestrich. 1968. An American Indian Renascence. In *The American Indian Today*, edited by Stuart Levine and Nancy O. Lurie, 187-208. Deland, FL: Everett and Edwards

Lyman, Christopher M. 1982. *The Vanishing Race and Other Illusions: Photographs of Indians by Edward S. Curtis*. Washington, DC: Smithsonian Institution Press

Lyotard, François. 1984. *The Postmodern Condition: A Report on Knowledge*. Minneapolis: University of Minnesota Press

Macartney-Filgate, Terence, producer/director. 1996. *Place of Bones: The Voyage of Edward Poitras*. Television documentary, 35 mins. Executive producer Adrienne Clarkson. Toronto: Canadian Broadcasting Corporation (Television) Production

McCoy, Ron. 1988. Bring in the Clowns. *Native Peoples – The Journal of the Heard Museum* (Summer): 14-7

McCracken, Harold. 1959. *George Catlin and the Old Frontier*. New York: Bonanza Books

McDonald, Bruce, director. 1994. *Dance Me Outside*. Feature film, 85 mins. Yorktown/Shadows Shows production

McLachlan, Ian. 1990. Making *Mizzins* – Remaking History. *ARTSCRAFT* 2 (2): 10-2

McLaughlin, Madeleine, producer/director. 1995. *Mirror of the Heart: 9 Native Photographers*. Television documentary, approx. 60 mins. Canadian Broadcasting Corporation (Television) Production

McLennan, Gordon, writer/director. 1995. *The Trickster: Edward Poitras in Venice*. Television documentary, approx. 60 mins. Produced by Gordon McLennan and Lloyd Martell. Reel Eye Media

McLeod, Dan. 1992. Chipping away at the Stone-Faced Native: *Thunderheart* Star Graham Greene Aims to Dispel a Humourless Stereotype. *Georgia Straight* (Vancouver), 3-10 April, p. 15

McLuhan, Elizabeth. 1984. *Altered Egos: The Multi-media Work of Carl Beam*. Exhibition catalogue. Thunder Bay, ON: Thunder Bay Art Gallery

McLuhan, Elizabeth, and Tom Hill. 1984. *Norval Morrisseau and the Emergence of the Image Makers*. Toronto: Methuen

McMaster, Gerald. 1991. Artist's Statement and Commentaries. In *The cowboy/Indian Show: Recent Work by Gerald McMaster*, by Allan J. Ryan, 19-53. Exhibition catalogue. Kleinburg, ON: McMichael Canadian Collection

–. 1994. Beaded Radicals and Born-again Pagans: Situating Native Artists within the Field of Art. MA thesis, Carleton University, Ottawa, ON

–. 1995. *Edward Poitras: Canada XLVI Biennale di Venezia*. Ottawa: Canadian Museum of Civilization

–, ed. 1998. *Reservation X: The Power of Place in Aboriginal Contemporary Art*. Ottawa: Canadian Museum of Civilization and Goose Lane Editions

McMaster, Gerald, and Lee-Ann Martin, eds. 1992. *Indigena: Contemporary Native Perspectives*. Vancouver: Douglas and McIntyre

Maddox, Conroy. 1983. *Dali*. London: Hamlyn Publishing Group

Mainprize, Gary. 1986. *Stardusters: New Works by Jane Ash Poitras, Pierre Sioui, Joane Cardinal-Schubert and Edward Poitras*, Exhibition catalogue. Thunder Bay, ON: Thunder Bay Art Gallery

Mandelbaum, David G. 1979. *The Plains Cree: an Ethnographic, Historical and Comparative Study*. Regina, SK: Canadian Plains Research Center

Maracle, Brian, and Jacqueline Fry. 1989. *Decelebration*. Exhibition catalogue. Ottawa: Saw Gallery

Marcus, George E., and Michael M. J. Fischer. 1986. *Anthropology as Cultural Critique: An Experimental Moment in the Human Sciences*. Chicago: University of Chicago Press

Marsden, Michael T., and Jack Nachbar. 1988. The Indian in the Movies. In *History of Indian-White Relations*, edited by Wilcomb E. Washburn, 607-16. Vol. 4 of *Handbook of North American Indians*, edited by William C. Sturtevant. Washington, DC: Smithsonian Institution

Martin, Lee-Ann. 1991. Solidarity: Art after Oka. Curatorial statement. *Saw News* (May-June): n.p.

Mason, Tina. 1991. *Canadian Theatre Review* 68 (Fall): 52

Matejka, Ladislav, and Irwin R. Titunik, eds. 1976. *Semiotics of Art*. Cambridge, MA: MIT Press

Medicine, Bea. 1971. The Anthropologist as the Indian's Image-Maker. *Indian Historian* 4 (3): 27-37

Merrill, Robert, ed. 1988. *Ethics/Aesthetics: Post-Modern Positions*. Washington, DC: Maisonneuve Press

Midwicki, Marvin, Les Holdway, and Christopher Wilson, directors. 1978. *Wandering Spirit Survival School*. Documentary film, 28 mins. Ottawa: National Film Board of Canada

Miller, Frank C. 1967. Humor in a Chippewa Tribal Council. *Ethnology* 6: 263-71

Morreall, John. 1983. *Taking Laughter Seriously*. Albany: State University of New York

Morrisseau, Miles. 1997. SuperIndians! *Aboriginal Voices* 4 (1): 14-5

Mourning Dove (Humishuma). 1990. *Coyote Stories*. Edited and illustrated by Heister Dean Guie with notes by L.V. McWhorter (Old Wolf) Lincoln: University of Nebraska Press

Muehlenbachs, Lelde. 1989. Review. *Fort Chipewyan Breakfast Club*, Jane Ash Poitras at the Provincial Museum of Alberta, Edmonton, September-November, 1988. *Artpost* 32 (Spring): 37

Mulvey, Laura. 1995. *Jimmie Durham*. London: Phaidon

Naranjo-Morse, Nora. 1992. *Mud Woman: Poems from the Clay*. Vol. 20 of *Sun Tracks*. Tucson: University of Arizona Press

Negri, Sam. 1997. When Things Go Awry, Relax, Here Comes Muttonman. *Arizona Highways*, July, pp. 32-5

Nemiroff, Diana, Robert Houle, and Charlotte Townsend-Gault. 1992. *Land Spirit Power: First Nations at the National Gallery of Canada*. Exhi-

bition catalogue. Ottawa: National Gallery of Canada

New, W.H., ed. 1990. *Native Writers and Canadian Writing.* Vancouver: UBC Press

Nichols, Robert F. 1994. A Cross-Cultural Mix. *Focus Sante Fe,* October-December, pp. 14-5

Nicks, Trudy. 1990. Indian Handicrafts: The Marketing of an Image. *Rotunda* (Summer): 14-20

Niro, Shelley, and Anna Gronau. 1993. *It Starts with a Whisper.* 16mm film, 26 mins. Brantford, ON: Bay of Quinte Productions

Obomsawin, Alanis, director. 1993. *Kanehsatake: 270 Years of Resistance.* Documentary video, 119 mins. Ottawa: National Film Board of Canada

Obrdlik, Antonin J. 1942. 'Gallows Humor' – A Sociological Phenomenon. *American Journal of Sociology* 47: 709-16

O'Connor, John E. 1980. *The Hollywood Indian: Stereotypes of Native Americans in Films.* Trenton, NJ: New Jersey State Museum

Olsen, Lance. 1990. *Circus of the Mind in Motion: Postmodernism and the Comic Vision.* Detroit: Wayne State University Press

Opler, Morris Edward. 1938. Humor and Wisdom of Some American Indian Tribes. *New Mexico Anthropologist* 3 (1): 3-10

Owens, Louis. 1983. Humor in the Novels of James Welch. *WHIMSY* (Proceedings of the 1982 conference of the International Society for Humor Studies) 1: 140-2

Pakasaar, Helga. 1992. *Revisions.* Exhibition catalogue. Banff, AB: Walter Phillips Gallery

Pakes, Fraser J. 1985. Seeing with the Stereotypic Eye: The Visual Image of the Plains Indian. *Native Studies Review* 1 (2): 1-31

Parker, Arthur C. 1941. How Indians Cracked Their Jokes. Chapter 23 of *The Indian How Book.* New York: Doubleday, Doran & Company, 132-40

Parsons, Elsie Clews, and Ralph L. Beals. 1934. The Sacred Clowns of the Pueblo and Mayo-Yaqui Indians. *American Anthropologist* 36 (4): 491-514

Paskievich, John, director. 1995. *If Only I Were an Indian ...* Documentary film, 81 mins. Produced by John Paskievich, Joe MacDonald, and Ches Yetman. Ottawa: National Film Board of Canada

Penn, Arthur, director. 1970. *Little Big Man.* Feature film, 147 mins. Produced by Stuart Millar. Millar-Penn Productions

Phillips, Ruth. 1991. *Shades of Difference: The Art of Bob Boyer.* Exhibition catalogue. Edmonton: Edmonton Art Gallery

Podedworny, Carol. 1985a. *Joane Cardinal-Schubert: This Is My History.* Exhibition catalogue. Thunder Bay, ON: Thunder Bay Art Gallery

–. 1985b. *Riel Remembered: An Exhibition of Drawings on Paper by Gerald McMaster.* Exhibition brochure. Thunder Bay, ON: Thunder Bay National Exhibition Centre and Centre for Indian Art

Poisey, David, and William Hansen, directors. 1991. *Starting Fire with Gunpowder.* Documentary film, 57 mins. Ottawa: National Film Board of Canada

Poitras, Edward. 1992. The Big Picture. Artist's statement in *Indigena: Contemporary Native Perspectives,* edited by Gerald McMaster and Lee-Ann Martin, 162. Vancouver: Douglas and McIntyre

Price, John A. 1978. Native Studies: American and *Canadian Indians,* 200-25. Toronto: McGraw-Hill Ryerson

Quick-to-See Smith, Jaune. 1992. *The Submoluc Show/Columbus Wohs,* Exhibition catalogue. Phoenix: Atlatl

Quintilian. 1966. *The Institutio Oratoria.* Translated by H.E. Butler. Loeb Classical Library. London: Heinemann. Quoted in P. Cole, ed. *Radical Pragmatics* (New York: Academic Press 1981), 295

Rabinow, Paul. 1986. Representations Are Social Facts: Modernity and Post-Modernity in Anthropology. In *Writing Culture: The Poetics and Politics of Ethnography,* edited by James Clifford and George E. Marcus, 234-61. Berkeley: University of California Press

Radin, Paul. 1972. *The Trickster: A Study in American Indian Mythology.* 1st Schocken pbk. ed. New York: Schocken Books

Ray, Vern. 1945. The Contrary Behavior Pattern in American Indian Ceremonialism. *Southwestern Journal of Anthropology* 1: 75-113

Raziel, Ruth. 1993. Masks. *Shared Vision Magazine,* November, pp. 16-7

Red Crow, Jackie. 1987. The Two Sides of Everett Soop. *Windspeaker* (Edmonton), 25 December, p. 8

Reid, Bill. 1984. *Raven Steals the Light.* Drawings by Bill Reid, stories by Bill Reid and Robert Bringhurst. Vancouver: Douglas and McIntyre

Rhodes, Richard. 1992. *Carl Beam, The Columbus Boat.* Exhibition catalogue. Toronto: The Power Plant – Contemporary Art at Harbourfront

Ricketts, Mac Linscott. 1966. The North American Indian Trickster. *History of Religions* 5: 327-50

Robinson, Harry. 1989. *Write It on Your Heart: The Epic World of an Okanagan Storyteller.* Compiled and edited by Wendy Wickwire. Vancouver: Talon Books

Rodway, Allan. 1962. Terms for Comedy. *Renaissance and Modern Studies* 6: 102-25

Ryan, Allan J. 1991. *The cowboy/Indian Show: Recent Work by Gerald McMaster,* Exhibition catalogue. Kleinburg, ON: McMichael Canadian Collection

–. 1992. Postmodern Parody: A Political Strategy in Contemporary Canadian Native Art. *Art Journal* 51 (3): 59-65

–. 1994a. *Jim Logan: The Classical Aboriginal Series.* Exhibition catalogue. Whitehorse: Yukon Arts Centre

–. 1994b. I Enjoy Being A Mohawk Girl: The Cool and Comic Character of Shelley Niro's Photography. *American Indian Art Magazine* 20 (1): 44-53

–. 1996. Humor and Play in Native American life. Review of *Indi'n Humor: Bicultural Play in Native America,* by Kenneth Lincoln. *Humor* 9 (2): 215-20

Sainte-Marie, Buffy. 1974. *Native North American Child: An Odyssey.* Vanguard audio recording VSD.79340, VSQ.40027

Sapir, Edward. 1932. Two Navaho Puns. *Language* 8: 217-9

Sarup, Madan. 1989. *An Introductory Guide to Post-Structuralism and Post-Modernism.* Athens, GA: University of Georgia Press

de Saussure, Ferdinand. 1974. *Course in General Linguistics.* Edited by Jonathan Culler, translated by W. Baskin. London: Fontana

Scherer, Joanna Cohan, with Jean Burton Walker. 1982. *Indians: The Great Photographs That Reveal North American Indian Life, 1847-1929, from the Unique Collection of the Smithsonian Institution.* 1973. Reprint, New York: Bonanza Books.

Schimmel, Julie. 1991. Inventing 'the Indian.' In *The West as America: Reinterpreting Images of the Frontier, 1820-1920,* edited by William H. Truettner, 149-89. Washington, DC: Smithsonian Institution Press

Schneider, Reisa, and Garry Gottfriedson with artwork by George Littlechild and Linda Frimer. 1994. *In Honour of Our Grandmothers: Imprints of Cultural Survival.* Penticton, BC: Theytus Books

Scholder, Fritz. 1979. *Indian Kitsch.* Flagstaff, AZ: Northland Press

Scholes, Robert. 1982. *Semiotics and Interpretation.* New Haven, CT: Yale University Press

Scott, Charles T. 1963. New Evidence of American Indian Riddles. *Journal of American Folklore* 76: 236-41

Scott, Jay. 1985. I Lost It at the Trading Post. *Canadian Art* 2 (4): 33-9

Sekaquaptewa, Emory. 1979. One More Smile for a Hopi Clown. *Parabola* 4 (1): 6-9

Shadbolt, Doris. 1988. Emily Carr. *The Canadian Encyclopedia,* 1: 366. Edmonton: Hurtig Publishers

Silverman, Hugh J., ed. 1990. *Postmodernism – Philosophy and the Arts.* New York and London: Routledge

Simpson, James B. 1988. *Simpson's Contemporary Quotations.* Boston: Houghton Mifflin Company

Sinclair, Lister, and Jack Pollock. 1979. *The Art of Norval Morrisseau.* Toronto: Methuen

Skeels, Dell. 1954. A Classification of Humor in Nez Percé Mythology. *Journal of American Folklore* 67: 57-63

Slatin, John. 1991. Reading Hypertext: Order and Coherence in a New Medium. In *Hypermedia and Literary Studies,* edited by Paul Delany and George P. Landow, 153-69. Cambridge, MA: MIT Press

Sneddon, Matthew, producer. 1994. *The Other Side of the Story.* Video, 30 mins. *Colores* series. Albuquerque: KNME-TV

Sneddon, Matthew, and Doug Crawford, producers. 1995. *Vincent Craig: Weaver of Tales, Tears and Laughter.* Video, 30 mins. *Colores* series. Albuquerque: KNME-TV

Soop, Everett. 1990. *I See My Tribe Is Still behind Me.* Calgary: Glenbow Museum

Spradley, James, and David W. McCurdy, eds. 1997. *Conformity and Conflict: Readings in Cultural Anthropology.* 9th ed. New York: Longman

Stanley, George F.G. 1988. Louis Riel. *The Canadian Encyclopedia,* 3: 1,871. Edmonton: Hurtig Publishers

Stedman, Raymond William. 1982. *Shadows of the Indian: Stereotypes in American Culture.* Norman: University of Oklahoma Press

Steiner, Wendy. 1985. Intertextuality in Painting. *American Journal of Semiotics* 3-4: 57-67

Steward, Julian H. 1931. The Ceremonial Buffoon of the American Indian. *Papers of the Michigan Academy of Science, Arts, and Letters* 14: 187-207

Sullivan, Lawrence. 1982. Multiple Levels of Religious Meaning in Culture: A New Look at Winnebago Sacred Texts. *Canadian Journal of Native Studies* 2 (2): 221-47

Surtees, Robert J. 1988. Canadian Indian Policies.

In *History of Indian-White Relations*, edited by Wilcomb E. Washburn, 81-95. Vol. 4 of *Handbook of North American Indians*, edited by William C. Sturtevant. Washington, DC: Smithsonian Institution

Susman, Amelia. 1941. Word Play in Winnebago. *Language* 17: 342-4

Sweet, Jill D. 1989. Burlesquing 'The Other' in Pueblo Performance. *Annals of Tourism Research* 16: 62-75

Tanner, Clara Lee. 1973. *Southwest Indian Painting*. 2nd ed. Tucson: University of Arizona Press

Taylor, Archer. 1944. Riddles among the North American Indians. *Journal of American Folklore* 57: 1-15

Taylor, Drew Hayden. 1996. *Funny You Don't Look Like One: Observations from a Blue-Eyed Ojibway*. Penticton, BC: Theytus Books

Tedlock, Barbara. 1979. Boundaries of Belief. *Parabola* 4 (1): 70-7

Tétreault, Pierre-Léon. 1992. *New Territories: 350/500 Years After: An Exhibition of Contemporary Aboriginal Art of Canada*. Exhibition catalogue. Montreal: Vision Planétaire

Thomas, Davis, and Karin Ronnefeldt, eds. 1976. *People of the First Man: Life among the Plains Indians in Their Final Days of Glory*. The firsthand account of Prince Maximilian's expedition up the Missouri River, 1833-4. Text by Prince Maximilian zu Wied, watercolors by Karl Bodmer. New York: E.P. Dutton

Titiev, Mischa. 1975. Some Aspects of Clowning among the Hopi Indians. In *Themes in Culture*, edited by Mario D. Zamora, J.M. Mahar, and H. Orenstein, 326-36. Quezon City, Philippines: Kayumanggi

Todd, Loretta, director. 1996. *Forgotten Warriors*. Video, 48 mins. Produced by Carol Geddes, Michael Doxtater, and Jerry Krepakevich. Ottawa: National Film Board of Canada

Toelken, J. Barre. 1969. The 'Pretty Language' of Yellowman: Genre, Mode, and Texture in Navaho Coyote Narratives. *Genre* 2 (3): 212-35

–. 1977. Foreword to *Giving Birth to Thunder, Sleeping with His Daughter: Coyote Builds North America*, by Barry Lopez, xi-xiv. New York: Avon

Tousley, Nancy. 1995. The Trickster. *Canadian Art* 12 (2): 36-45

Townsend, Mary Lee. 1992. *Forbidden Laughter: Popular Humor and the Limits of Repression in Nineteenth-Century Prussia*. Ann Arbor: University of Michigan Press

Townsend-Gault, Charlotte. 1991. Having Voices and Using Them: First Nations Artists and 'Native Art.' *Arts Magazine*, February, 65-70

–. 1992a. Kinds of Knowing. In *Land Spirit Power: First Nations at the National Gallery of Canada*, edited by Diana Nemiroff, Robert Houle, and Charlotte Townsend-Gault. 75-101. Exhibition catalogue. Ottawa: National Gallery of Canada

–. 1992b. Stereotypes under (De)construction. *Border Crossings* 11 (4): 76-7

Townsend-Gault, Charlotte, Scott Watson, and Lawrence Paul Yuxweluptun. 1995. *Lawrence Paul Yuxweluptun: Born to Live and Die on Your Colonialist Reservations*. Exhibition catalogue. Vancouver: Morris and Helen Belkin Art Gallery

Traugott, Joseph. 1992. *Muttonman Discovers Columbus*. An exhibition of cartoons by Navajo artist Vincent Craig. Exhibition catalogue. Albuquerque: Jonson Gallery and University of New Mexico

Tremblay, Gail. 1993. Constructing Images, Constructing Reality: American Indian Photography and Representation. *Views* (Winter): 11-2

Trevelyan, Amelia M. 1993. *Seeing a New World: The Works of Carl Beam and Frederick Remington*. Exhibition catalogue. Gettysburg, PA: Gettysburg College Art Gallery

Trueblood, Elton. 1964. *The Humor of Christ*. San Francisco: HarperCollins

Truettner, William H., ed. 1991. *The West as America: Reinterpreting Images of the Frontier, 1820-1920*. Washington, DC: Smithsonian Institution Press

Turk, Rudy. 1972. *Scholder/Indians*. Flagstaff, AZ: Northland Press

Two Bulls, Marty Grant. 1991. *Ptebloka: Tails from the Buffalo*. Vermillion, SD: Dakota Books/University of South Dakota Press and the Institute of American Indian Studies

Tyler, Stephen. 1986. Post-Modern Ethnography: From Document of the Occult to Occult Document. In *Writing Culture: The Poetics and Politics of Ethnography*, edited by James Clifford and George E. Marcus, 122-40. Berkeley: University of California Press

Uncompromising Charlie Hill, The. 1993. *Nativebeat* 2 (12): 8-11

Valpy, Michael. 1991. Peeping across Ignorance Barriers. *Globe and Mail*, 26 March, p. A13

Vastokas, Joan. 1973-4. Shamanic Tree of Life. *artscanada*, Stones, Bones and Skin: Ritual and Shamanic Art issue (December-January): 125-49

Venturi, Robert. 1968. *Complexity and Contradiction in Architecture*. New York: Museum of Modern Art. Quoted in Alan Wilde, *Horizons of Assent: Modernism, Postmodernism, and the Ironic Imagination* (Baltimore: Johns Hopkins University Press, 1981), 133

Villani, John. 1993. Look up in the sky: It's a lamb, it's a goat, hey, it's Muttonman. *Santa Fe New Mexican*, Pasatiempo section, 26 March-1 April, p. 40

Viola, Herman J. 1976. *The Indian Legacy of Charles Bird King*. Washington, DC: Smithsonian Institution Press

Vizenor, Gerald. 1978. *Wordarrows: Indians and Whites in the New Fur Trade*. Minneapolis: University of Minnesota Press

–. 1987. *Griever: An American Monkey King in China*. Minneapolis: University of Minnesota Press

–. 1988. *The Trickster of Liberty: Tribal Heirs to a Wild Baronage*. Minneapolis: University of Minnesota Press

–. 1990. *Bearheart: The Heirship Chronicles*. Afterword by Louis Owens. Minneapolis: University of Minnesota Press. First published in 1978 as *Darkness in Saint Louis Bearheart*, Truck Press

–. 1991. *The Heirs of Columbus*. Hanover, NH: Wesleyan University Press

Vizenor, Gerald, ed. 1989. *Narrative Chance: Postmodern Discourse on Native American Literatures*. Albuquerque: University of New Mexico Press

Voeglin, E.W. 1949. Humor (North American Indian). In *Funk and Wagnall's Standard Dictionary of Folklore, Mythology and Legend*, ed. Maria Leach, 510-1. New York: Harper and Row

Wacks, Jonathan, director. 1988. *Powwow Highway*. Feature film, 91 mins. Handmade Films

Wade, Edwin L., ed. 1986. *The Arts of the North American Indian: Native Traditions in Evolution*. New York: Hudson Hills Press

Walker, Nancy A. 1988. *A Very Serious Thing: Women's Humor and American Culture*. Minneapolis: University of Minnesota Press

Wallace, William. 1953. The Role of Humor in the Hupa Indian Tribe. *Journal of American Folklore* 66: 135-41

Watson, Scott. 1993. Whose Nation? Exhibition review of *Land Spirit Power: First Nations at the National Gallery of Canada*, Ottawa, Ontario, and *Indigena: Perspectives of Indigenous Peoples on Five Hundred Years* at the Canadian Museum of Civilization, Hull, Quebec. *Canadian Art* 10 (1): 34-43

Weise, Richard, director. 1984. *Harold of Orange*. 16mm film, 32 mins. Produced by Diane Brennan. Minneapolis, MN: Film in the Cities

Wilde, Alan. 1981. *Horizons of Assent: Modernism, Postmodernism, and the Ironic Imagination*. Baltimore: Johns Hopkins University Press

Wilson, Alan, with Gene Dennison. 1970. *Laughter: The Navajo Way*. Gallup: University of New Mexico

Witt, Shirley H., and Stan Steiner, eds. 1972. *An Anthology of American Indian Literature*. New York: Knopf

Woodland Cultural Centre. 1986. *Warriors: A Resource Guide*. Brantford, ON: Woodland Indian Cultural Educational Centre

–. 1987. *Reserve Communities: A Six Nations History Unit*. Brantford, ON: Woodland Indian Cultural Educational Centre

York, Geoffrey, and Loreen Pindera. 1991. *People of the Pines: The Warriors and the Legacy of Oka*. Toronto: Little, Brown and Company (Canada)

Zepp, Norman, and Michael Parke-Taylor. 1984. *Horses Fly Too: Bob Boyer and Edward Poitras*. Exhibition catalogue. Regina, SK: Norman Mackenzie Art Gallery

Zolten, J. Jerome. 1988. Humor and the Challenger Shuttle Disaster: Joke-Telling as a Reaction to Tragedy. *WHIMSY* 6: 134-6

Credits

A reasonable attempt has been made to secure permission to reproduce all material used. If there are errors or omissions they are wholly unintentional and the publisher would be grateful to learn of them.

The following people kindly gave permission for parts of their interviews with the author to be reproduced here: Carl Beam, Rebecca Belmore, Bob Boyer, Joane Cardinal-Schubert, Gary Farmer, Viviane Gray, Vern Harper, Tom Hill, Curtis Jonnie (Shingoose), George Littlechild, Jim Logan, Gerald McMaster, Shelley Niro, Ron Noganosh, Ruth Phillips, Edward Poitras, Jane Ash Poitras, Bill Powless, and Lawrence Paul Yuxweluptun.

Text

3-4 Excerpt from *Tomson Highway: Native Voice,* an interview with Tomson Highway produced by Phyllis Wilson for Native Communications Inc., and first broadcast in 1988. Reprinted with the permission of Native Communications Inc.
4, 5 Excerpts from 'Follow the Trickroutes,' an interview with Gerald Vizenor, from *Survival This Way: Interviews with American Indian Poets,* by Joseph Bruchac (Tucson: University of Arizona Press 1987), 295, 309. Reprinted with the permission of Gerald Vizenor.
6-7 Excerpts from Paul Radin, *The Trickster: A Study in American Indian Mythology* (New York: Schocken Books 1972), pp. xxiii, 155. Republished with the permission of Routledge Ltd., 11 New Fetter Lane, London EC4P 4EE. Originally published in 1956.
8-9 Excerpt from Lawrence Sullivan, 'Multiple Levels of Religious Meaning in Culture: A New Look at Winnebago Sacred Texts,' *Canadian Journal of Native Studies* 2, no. 2 (1982): 238-9. Reprinted with the permission of *Canadian Journal of Native Studies.*
9, 72, 89, 181 Excerpts reprinted with the permission of Simon & Schuster from *Custer Died for Your Sins: An Indian Manifesto,* by Vine Deloria, Jr. Copyright © 1969 by Vine Deloria, Jr.
10-1 Excerpt from 'The Wisdom of the Contrary: A Conversation with Joseph Epes Brown.' Reprinted from *Parabola: The Magazine of Myth and Tradition,* Vol. IV, No. 1 (Spring 1979).
15 Excerpt from Fraser J. Pakes, Seeing with the Stereotypic Eye: The Visual Image of the Plains Indian, *Native Studies Review* 1, no. 2 (1985): 4-5. Reprinted with permission of Fraser J. Pakes.
36-7 Lyrics to 'Natural Tan,' 'Reservations Blues,' and 'Indian Time.' 1988. *Natural Tan.* Words and music by Shingoose. Headband Records, a subsidiary of 555 Corporation. Native Multi-Media Productions audiocassette HC-8801. Lyrics to 'It's Hard to Be Traditional,' words and music by Shingoose, transcribed from audiotape of live performance at the 10th Annual First Peoples' Cultural Festival, Capilano Longhouse, North Vancouver, 25 May 1991. Reprinted with the permission of Curtis Jonnie (Shingoose).
38-9 Artist's statement by Gerald McMaster for *The cowboy/Indian Show,* an exhibition at the McMichael Canadian Collection, Kleinburg, ON, February to April 1991. Reprinted with the permission of the McMichael Canadian Art Collection, Kleinburg, ON.
40 Excerpt from 'Native Painter's Criticism Packs a Strong Punch,' by Christopher Hume, *The Toronto Star,* February 8, 1991. Reprinted courtesy of The Toronto Star Syndicate.
40 Excerpt from 'Native Artist Throws Comic Curves But with a Serious Twist,' by Nancy Baele, published February 24, 1991. Reprinted with the permission of the *Ottawa Citizen.*
41 Excerpt from *Green Grass, Running Water,* by Thomson King. Published by HarperCollins Publishers Inc. Copyright © 1993 by Thomas King.
45 Artist's statement by Rebecca Belmore for *See Jane Sew Strontium,* an exhibition of non-traditional quilts dedicated to Joyce Wieland, Definitely Superior Gallery, Thunder Bay, ON, 1988. Reprinted with the permission of the artist.
56-7 Letters to the editor, 29 May 1985 and 5 June 1985. Reprinted with the permission of *Tekawennake: Six Nations and New Credit Reporter.*
74 Lyrics to '(I'm a) High-Tech Teepee Trauma Mama,' 1990, words by Rebecca Belmore, music by Rebecca Belmore and Allen Deleary. From Rebecca Belmore and the 7th Fire Band, *Well, What Does It Take?* Technabe Sound, Ottawa, ON, audiocassette. Reprinted with permission of Rebecca Belmore.
89 Excerpt from lecture given at University of British Columbia, 10 November 1992. Reproduced with the permission of Daniel David Moses.
100 'Point of View,' by Ron Noganosh printed with his permission.
115 Excerpt from 'Coyote Plays a Dirty Trick,' by Harry Robinson, in *Write It on Your Heart: The Epic World of an Okanagan Storyteller,* by Harry Robinson and Wendy Wickwire (Vancouver: Talon Books 1989). Reprinted with the permission of Wendy Wickwire and Talon Books.
132 Joane Cardinal-Schubert, 'oh Canada,' *Whetstone* (Spring 1987): 28. Reprinted with permission of the author.
151-2 Excerpt from 'Seeing a New World: The Works of Carl Beam and Frederick Remington,' published in the catalogue to an exhibition of the same name at the Gettysburg College Art Gallery, Gettysburg, Pennsylvania, September-October 1993. Reprinted with the permission of Amelia Trevelyan.
156 Lyrics to 'Moonshot,' by Buffy Sainte-Marie. © 1971 Caleb Music (ASCAP). All rights reserved. Intl. © secured. Used with permission.
158 'Anthropologitis' by Peter Blue Cloud (Aroniawenrate), from *The Other Side of Nowhere: Contemporary Coyote Tales,* pp. 63-4. Copyright 1990. Reprinted with the permission of White Pine Press, 10 Village Square, Fredonia, NY 14063, USA.
159 This passage by Barre Toelken appeared in the foreword of the book *Giving Birth to Thunder, Sleeping with His Daughter.* Copyright 1977 Barry Holstun Lopez. Reprinted with permission of Andrews McMeel Publishing. All rights reserved.
161 Excerpt from a performance by Charlie Hill on the television show *Indian Time,* produced by Don Marks and Curtis Jonnie (Shingoose), Native Multimedia Productions, Winnipeg, MB, 1988. Reproduced with the permission of the performer.
166 Artist's statement by Edward Poitras for *The Big Picture,* 1991, in *Indigena: Perspectives of Indigenous Peoples on Five Hundred Years,* an exhibition at the Indian and Inuit Art Gallery, Canadian Museum of Civilization, Hull, QC, 16 April-12 October 1992. Reprinted with the permission of the artist.
168 'Coyote Sees the Prime Minister,' by Thomas King. © 1990 by Dead Dog Café Productions Inc. Reprinted by permission of the author.
180 Excerpt from *Laughter: The Navajo Way,* by Alan Wilson with Gene Dennison (Gallup: University of New Mexico 1970). Reprinted with the permission of Alan Wilson, Gallup, NM.
181 Excerpt from interview with Thomas King by Gary Farmer, *The Runner* (Winter 1993-4): 4. Reprinted with the permission of Thomas King.
189 Excerpt from 'Beyond History,' published in the catalogue to an exhibition of the same name at the Vancouver Art Gallery, Vancouver, BC, 1989. Reprinted with the permission of Karen Duffek and the Vancouver Art Gallery.
191 Excerpt from Dee Brown, *Bury My Heart at Wounded Knee* (Bantam Books: Toronto 1972), 418. Reprinted with the permission of Henry Holt and Company, Inc., and Sterling Lord Literistic, Inc.
201 Excerpt from 'Making *Mizzins* – Remaking History: The Columbus Project of Carl Beam' *ARTSCRAFT* (Summer 1990). Reprinted with the permission of Ian McLachlan.
229 Excerpt from 'Gallows Humor – A Sociological Phenomenon,' by Antonin Obrdlik, published in *The American Journal of Sociology* 47 (1942): 712-5. © 1942 by The University of Chicago. All rights reserved.
277 Artist's statement by Bob Boyer for *Contemporary Rituals* exhibition, White Water Gallery, North Bay, ON, June 1990. Reprinted with the permission of the artist.

Illustrations

Artist, title, date, media, dimensions (height precedes width), initial exhibition and/or source of image. In some cases the data available or supplied by the artist are incomplete. Dimensions are rounded to the nearest centimetre.

1 Bill Powless, *Beach Blanket Brave,* 1984, acrylic on canvas board, 51 x 41 cm. Exhibited in *Art of the Seventh Generation: Iroquois Symbols on Canvas and Paper,* Roberson Centre for the Arts and Sciences, Binghamton, NY, May-July 1986. Courtesy of Dolores Elliott, photograph: Dennis Dunda. Reproduced with permission of the artist / 16
2 Bill Powless, *Home of the Brave,* 1986, acrylic on masonite, 61 x 76 cm. Exhibited in *Indian Art '86,* Woodland Cultural Centre, Brantford, ON, May-July 1986. Photograph: Allan J. Ryan. Reproduced with permission of the artist / 17
3 Bill Powless, *Self-Portrait as April Fool,* 1995, graphite on paper, 29 x 22 cm. In self-published

1996 Native Calendar. Courtesy of Allan J. Ryan. Reproduced with permission of the artist / 18

4 Bill Powless, *Welcome to Our Reserve,* 1987, acrylic on masonite, 81 x 52 cm. Exhibited in *Indian Art '87,* Woodland Cultural Centre, Brantford, ON, May-July 1987. Courtesy of the Woodland Cultural Centre. Reproduced with permission of the artist / 19

5 Bill Powless, *'So ... what do you think ...'* 1989, pen and ink cartoon on paper. Courtesy of the artist / 21

6 Bill Powless, *'Have you seen ...'* 1991, pen and ink cartoon on paper. Courtesy of the artist / 21

7 Bill Powless, *'I thought "we" were ...'* 1988, pen and ink cartoon on paper. Courtesy of the artist / 22

8 Bill Powless, *'Well, there's a sure sign ...'* 1989, pen and ink cartoon on paper. Courtesy of the artist / 22

9 Gerald McMaster, *Counting Coup,* 1990, acrylic and oil pastel on matt board, 96 x 116 cm, private collection. One of sixteen images in *The cowboy/Indian Show,* exhibited at the McMichael Canadian Art Collection, Kleinburg, ON, February-April 1991. Courtesy of the McMichael Canadian Art Collection, photograph: Larry Ostrom, Christie Lake Studios. Reproduced with permission of the artist / 25

10 Gerald McMaster, *What becomes a Legend most?* 1990, acrylic and oil pastel on matt board, 94 x 114 cm, private collection. In *The cowboy/Indian Show.* Courtesy of the McMichael Canadian Art Collection, photograph: Larry Ostrom, Christie Lake Studios. Reproduced with permission of the artist / 26

11 Woodrow Crumbo, *Land of Enchantment,* c. 1946, watercolour on board, 44 x 58 cm, gift of Clark Field, The Philbrook Museum of Art, Tulsa, OK / 28

12 Gerald McMaster, *Shaman explaining the theory of transformation to cowboys,* 1990, diptych, acrylic and oil pastel on matt board, 114 x 94 cm each. In *The cowboy/Indian Show.* McMichael Canadian Art Collection, photograph: Larry Ostrom, Christie Lake Studios, courtesy of the artist / 30-1

13 Gerald McMaster, *How do you explain the theory of relativity to a 20-game winner, and still expect him to keep his concentration ... ?* 1989, mixed media, 46 x 122 cm. Courtesy of the artist / 32

14 Gerald McMaster, *Kaupois-uk,* 1990, acrylic and oil pastel on matt board, 114 x 94 cm, private collection. In *The cowboy/Indian Show.* Courtesy of the McMichael Canadian Art Collection, photograph: Larry Ostrom, Christie Lake Studios. Reproduced with permission of the artist / 35

15 Gerald McMaster, *Mamas, Don't Let Your Babies Grow Up to Be Cowboys,* 1983, graphite on paper, 127 x 97 cm. Exhibited in *Indian Art '83,* Woodland Cultural Centre, Brantford, ON, May-June 1983. Courtesy of the Woodland Cultural Centre. Reproduced with permission of the artist / 39

16 Carl Beam, *Self-Portrait as John Wayne, Probably,* 1990, etching on paper, 122 x 81 cm. One of twelve images in *The Columbus Suite* series. A print from the same plate, using different colouring and titled *Self-Portrait as John Wayne,* forms

part of the series owned by the Agnes Etherington Art Centre Museum, Queen's University, Kingston, ON, which was exhibited at The Gettysburg College Art Gallery, Gettysburg, PA, September-October 1993. Courtesy of the artist / 42

17 Rebecca Belmore, *True Grit (A Souvenir),* 1988-9, sewn fabric with acrylic on canvas panel, fringe, stuffing, 178 x 183 x 25 cm. In *See Jane Sew Strontium,* an exhibition of non-traditional quilts dedicated to Joyce Wieland, Definitely Superior Gallery, Thunder Bay, ON, February-March 1988. Courtesy of the artist / 43

18 Carl Beam, *Self-Portrait in My Christian Dior Bathing-Suit,* 1980, watercolour on paper, 106 x 69 cm. Exhibited in *Altered Egos: The Multimedia Work of Carl Beam,* Thunder Bay Art Gallery, Thunder Bay, ON, October-December 1984. Courtesy the Thunder Bay Art Gallery. Photograph: Thunder Bay Photographics. Reproduced with permission of the artist / 46

19 Ron Noganosh, *I Couldn't Afford a Christian Dior Bathing-Suit,* 1990, oil, cardboard, Plexiglas, 142 x 86 cm. Exhibited in *Hard and Soft,* University of Sherbrooke Cultural Centre, Sherbrooke, QC, December 1989. Photograph: Allan J. Ryan. Reproduced with permission of the artist / 48

20 Viviane Gray, *Carl, I Can't Fit into My Christian Dehors Bathing Suit!* 1989, mixed media, 193 x 61 x 193 cm. In *Hard and Soft.* Courtesy of the artist / 49

21 Carl Beam, *Burying the Ruler,* 1991, photo emulsion and ink on paper, 104 x 75 cm. Indian Art Centre, Department of Indian and Northern Affairs #306451, photograph: Lawrence Cook. Reproduced with permission of the artist / 52

22 Carl Beam, *Burying the Ruler,* 1991, photo emulsion and acrylic paint on wooden cabinet, 39 x 19 x 15 cm. Ufundi Gallery, Ottawa, ON. Photograph: Allan J. Ryan / 53

23 Bill Powless, *Indians' Summer,* 1984, acrylic on canvas, 177 x 97 cm. Exhibited in *Indian Art '85,* Woodland Cultural Centre, Brantford, ON, May-June 1985. Courtesy of the Woodland Cultural Centre. Reproduced with permission of the artist / 54

24 Gallery overview, *Fluffs and Feathers: An Exhibit on the Symbols of Indianness,* Woodland Cultural Centre, Brantford, ON, September-December 1988. Courtesy of the Woodland Cultural Centre / 59

25 Bill Powless, *Runs with Roosters,* 1991, acrylic on canvas, 114 x 102 cm. Exhibited in *First Nations Art '91,* Woodland Cultural Centre, Brantford, ON, May-July 1991. Photograph: Allan J. Ryan. Reproduced with permission of the artist / 60

26 Bill Powless, *Home Boy,* 1991, pen and ink drawing on paper. Courtesy of the artist / 62

27 Shelley Niro, *The Rebel,* 1987, hand-tinted black-and-white photograph, 17 x 24 cm. Exhibited in *Changers: A Spiritual Renaissance,* touring exhibition coordinated by the National Indian Arts and Crafts Corporation, Ottawa, ON, 1989-92. Photograph: Allan J. Ryan. Reproduced with permission of the artist / 63

28 Rebecca Belmore, *Coyote Woman,* 1991, graphite on paper, 33 x 50 cm. Courtesy of the artist / 65

29 Shelley Niro, *The Iroquois Is a Highly Developed Matriarchal Society,* 1991, three hand-tinted black-and-white photographs mounted horizontally in

a single matte, 20 x 25 cm each photograph. Exhibited in *Mohawks in Beehives,* Ufundi Gallery, Ottawa, ON, October-November 1991. Indian Art Centre, Department of Indian and Northern Affairs #306992, photograph: Lawrence Cook. Reproduced with permission of the artist / 67

30 Richard Hill, woman's dress with beaded sky-dome and celestial tree motifs, detail, 1973-4, glass beads and satin ribbon on black velvet. Courtesy of the artist / 68

31 Shelley Niro, *Mohawks in Beehives I,* 1991, black-and-white hand-tinted photograph, 20 x 25 cm. In *Mohawks in Beehives.* Photograph: Allan J. Ryan. Reproduced with permission of the artist / 70

32 Shelley Niro, *In Her Lifetime,* first and second frames, 1991, six hand-tinted black-and-white photographs with handwritten text mounted horizontally in a single matte, 20 x 25 cm each photograph. Exhibited in *Exposed,* Niroquois Gallery, Brantford, ON, September-October 1991. Photograph: Allan J. Ryan. Reproduced with permission of the artist / 71

33 Shelley Niro, *Portrait of the Artist Sitting with a Killer Surrounded by French Curves,* 1991, hand-tinted black-and-white photograph, 28 x 36 cm, full matte shown. Exhibited in *Mohawks in Beehives.* Photograph: Allan J. Ryan. Reproduced with permission of the artist / 73

34 Shelley Niro, *Love Me Tender,* first frame, 1992, hand-coloured gelatin silver print, sepia-toned gelatin silver print, and a gelatin silver print in a hand-drilled overmatte, 36 x 28 cm each photograph. Exhibited in *This Land Is Mime Land,* Ufundi Gallery, Ottawa, ON, December 1992. Courtesy of the artist / 76

35 Shelley Niro, *500 Year Itch,* 1992, hand-coloured gelatin silver print, sepia-toned gelatin silver print, and a gelatin silver print in a hand-drilled overmatte, 36 x 28 cm each photograph. In *This Land Is Mime Land.* Courtesy: Canadian Museum of Contemporary Photography, EX-95-132. Reproduced with permission of the artist / 78

36 Shelley Niro, *500 Year Itch,* first frame. Courtesy of the artist / 79

37 Jane Ash Poitras, *History 1990,* 1990, mixed media on canvas, 122 x 91 cm. Courtesy of the artist / 80

38 Jim Logan, *Venus Myth,* 1993, mixed media on canvas, 153 x 91 cm. In *The Classical Aboriginal Series,* Yukon Arts Centre, Whitehorse, YT, May-July 1994. Courtesy of Yukon Arts Centre Gallery; photo: Joanne Jackson Johnson. Reproduced with permission of the artist / 81

39 Jane Ash Poitras, *Monetary Blackboard,* 1989, mixed media on paper, 76 x 56 cm. In *Changers: A Spiritual Renaissance.* Courtesy of the artist / 82

40 Jane Ash Poitras, *Monetary Blackboard,* detail / 83

41 Lawrence Paul Yuxweluptun, *Face Painting of a Woman,* 1988, acrylic on canvas, 99 x 91 cm. Courtesy of the artist / 84

42 Lawrence Paul Yuxweluptun, *The Boy Toy,* 1988, acrylic on canvas, dimensions unknown. Courtesy of the artist / 86

43 Viviane Gray, *Self-Portrait: But, You Don't Look Indian ...* 1989, mixed media, 61 x 62 cm. In *Hard and Soft.* Photograph: Allan J. Ryan. Reproduced with permission of the artist / 87

44 George Littlechild, *Just Because My Father Was a Whiteman Doesn't Mean I'm Any Less an Indian*, 1987, acrylic on paper, 76 x 81 cm. Courtesy of the artist / 91

45 Jane Ash Poitras, *Fort Chip Dog Show*, 1988, oil on paper, 56 x 76 cm. In *Fort Chipewyan Breakfast Club* series. Exhibited at the Provincial Museum of Alberta, Edmonton, AB, September-November 1988. Courtesy of the artist / 93

46 Jane Ash Poitras, *Fort Chip Sewing Club*, 1988, oil on board, 76 x 76 cm. In *Fort Chipewyan Breakfast Club.* Courtesy of the artist / 94

47 Ron Noganosh, *Shield for a Modern Warrior, or Concessions to Beads and Feathers in Indian Art*, 1984, metal, beer cans, feathers, 125 x 59 cm. Exhibited in *In the Shadow of the Sun*, Canadian Museum of Civilization, Hull, QC, 1988. Indian Art Centre, Department of Indian and Northern Affairs #152522, photograph: Lawrence Cook. Reproduced with permission of the artist / 97

48 Ron Noganosh, *Shield for a Yuppie Warrior*, 1991, metal, silk, hide, fur, 102 x 64 cm. Ufundi Gallery, Ottawa, ON. Photograph: Allan J. Ryan. Reproduced with permission of the artist / 98

49 Ron Noganosh, *That's All It Costs*, 1991, blanket cloth, plastic, stuffed bear, flag, 102 x 64 cm. Ottawa, ON. Photograph: Allan J. Ryan. Reproduced with permission of the artist / 99

50 Bob Boyer, *The Batoche Centennial*, 1985, oil over acrylic on satin quilt, with nylon flags, 150 x 92 cm. Exhibited in *Beyond History*, Vancouver Art Gallery, May-July 1989. Photograph: Allan J. Ryan. Reproduced with permission of the artist / 103

51 Salvador Dali, *The Persistence of Memory* (Persistance de la mémoire), 1931, oil on canvas, 24 x 33 cm. The Museum of Modern Art, New York. Given anonymously. Photograph © 1999, The Museum of Modern Art, New York / 107

52 Lawrence Paul Yuxweluptun, *Hole in the Sky*, 1989, acrylic on canvas, dimensions unknown. Courtesy of the artist / 109

53 Hoesem-hliyawn, *Hole-through-the Sky* pole, Kitwankool, BC. Courtesy of the Museum of Anthropology, University of British Columbia, Vancouver, Canada. Uncatalogued. Photograph: Wilson Duff / 111

54 Lawrence Paul Yuxweluptun, *Throwing Their Culture Away*, 1988, acrylic on canvas, 91 x 66 cm. Exhibited in *Crossed Cultures*, Seattle Art Museum, April-May 1989. Courtesy of the artist / 112

55 Shelley Niro, *Final Frontier*, first frame, 1992, hand-coloured gelatin silver print, sepia-toned gelatin silver print, and a gelatin silver print in a hand-drilled overmatte, 36 x 28 cm each photograph. In *This Land Is Mime Land.* Courtesy of the artist / 113

56 Carson Waterman, *The Senecas Have Landed, No. 2*, 1982, polymer acrylic on canvas, 61 x 46 cm. Exhibited at the Native American Center for the Living Arts, Niagara Falls, NY, c. 1983. Photograph: Allan J. Ryan. Reproduced with permission of the artist / 114

57 John Kahionhes Fadden, *Wouldn't It Be Funny?* 1983, acrylic on canvas, 64 x 53 cm. Exhibited in *Indian Art '84*, Woodland Cultural Centre, Brantford, ON. Courtesy of the Woodland Cultural Centre. Reproduced with permission of the artist / 116

58 Lyle Wilson, *Ode to Billy Holm ... Lalooska ... Duane Pasco ... & Johnathon Livingston Seagull*, 1980, etching on handmade paper, 28 x 24 cm. Exhibited in *Lyle Wilson: When Worlds Collide*, University of British Columbia Museum of Anthropology, 1989. Photograph: Bill McLennan, UBC Museum of Anthropology. Reproduced with permission of the artist / 118

59 Edward Poitras, *Et in America ego*, detail, 1989, mixed-media installation. Artspeak Gallery, Vancouver, BC, September 1989. Photograph: Allan J. Ryan. Reproduced with permission of the artist / 119

60 Jim Logan, *The Annunciation*, 1992, acrylic and gold leaf on masonite, 61 x 61 cm. In *The Classical Aboriginal Series.* Courtesy of Yukon Arts Centre Gallery; photo: Joanne Jackson Johnson. Reproduced with permission of the artist / 121

61 Jim Logan, *Jesus Was Not a Whiteman*, 1992, acrylic and mixed media on canvas, 100 x 84 cm. In *The Classical Aboriginal Series.* Courtesy of Yukon Arts Centre Gallery; photo: Joanne Jackson Johnson. Reproduced with permission of the artist / 122

62 Peter B. Jones, *Bingo Dauber Fetish, Indian Brand Series, Part II*, 1994, mixed-media stoneware, 53 x 15 x 15 cm. Courtesy of American Indian Contemporary Arts, San Francisco, CA. Reproduced with permission of the artist / 123

63 Ken Syrette, *Soupbone and Skawndawg*, 'Djermawgo ...' 1992, pen and ink cartoon on paper. In *Native Canadian*, Newsmagazine of the Native Canadian Centre of Toronto 5 (4): 3. Courtesy of the artist / 124

64 Perry McLeod-Shabogesic, *Baloney & Bannock*, 'Hockey game? ...' 1992, pen and ink cartoon on paper. In *Anishinabek News*, November 1992. Courtesy of the artist / 124

65 Jim Logan, *A Rethinking on the Western Front*, 1992, acrylic on canvas, 167 x 244 cm. In *The Classical Aboriginal Series.* Courtesy of Joanne Jackson Johnson, Yukon Arts Centre, Whitehorse, YT / 127

66 Jim Logan, *The Diners Club (No Reservation Required)*, 1992, acrylic on canvas, 89 x 135 cm. In *The Classical Aboriginal Series.* Courtesy of the artist / 128

67 Edouard Manet, *Le Déjeuner sur l'herbe*, 1863, oil on canvas, 213 x 269 cm. Musée d'Orsay. L'Agence photographique de la réunion des musées nationaux, Paris, © Photo RMN / 129

68 Joane Cardinal-Schubert, *Beginning of Life*, 1991, acrylic and conte collagraph on rag paper, 102 x 127 cm. Exhibited in *The Birchbark Letters to Emily Carr*, Vik Gallery, Edmonton, AB, November 1991. Courtesy of the artist / 133

69 Joane Cardinal-Schubert, *Contemporary Artifact – Medicine Bundles: The Spirits Are Forever Within*, 1986, plaster on wire mesh, oil, graphite, urethane, 69 x 38 x 24 cm and 104 x 46 x 18 cm. Exhibited in *Stardusters*, Thunder Bay Art Gallery, Thunder Bay, ON, November-December 1986. Courtesy the Thunder Bay Art Gallery. Photograph: Justin Wonnacott, Ottawa, ON. Reproduced with permission of the artist / 135

70 Joane Cardinal-Schubert, *Remember Dunbow, Preservation of a Species: Warshirt Series*, detail, 1988, wall installation, oil, conte, charcoal on rag paper, found objects, clear vinyl, wood, 102 x 91 cm each. In *Beyond History*. Photograph: Allan J. Ryan. Reproduced with permission of the artist / 136

71 Gallery overview, Joane Cardinal-Schubert, *Preservation of a Species: Deep Freeze*, 1988-9, installation, wire mesh, plaster, oil, varethane, found objects; with *Preservation of a Species: Warshirt Series.* In *Beyond History*. Photograph: Allan J. Ryan. Reproduced with permission of the artist / 137

72 Joane Cardinal-Schubert, 'Cultural Baggage,' detail, *Preservation of a Species: Deep Freeze.* Photograph: Allan J. Ryan. Reproduced with permission of the artist / 140

73 Peter B. Jones, *Still Life*, 1990, stoneware, clay, 51 x 47 x 19 cm. Exhibited in *First Nations Art '90*, Woodland Cultural Centre, Brantford, ON, 1990. Photograph: Allan J. Ryan. Reproduced with permission of the artist / 141

74 Robert Houle, *Everything You Ever Wanted to Know about Indians from A to Z*, 1985, acrylic, rawhide, wood, linen, approximately 46 x 993 cm, each parfleche 41 x 25 cm. Exhibited at the Brignall Gallery, Toronto, on, 1985. Photograph: George Gooderham. Courtesy of the artist / 142

75 Rebecca Belmore, *Exhibit 671B*, 12 January 1988, performance, Thunder Bay Art Gallery, Thunder Bay, ON. Photograph: Bill Lindsay. Courtesy of the artist / 147

76 Carl Beam, *Big Koan*, 1989, mixed media on Plexiglas, 122 x 91 cm. Exhibited in *The Columbus Project, Phase 1*, Artspace/The Art Gallery of Peterborough, Peterborough, ON, November-December 1989. Courtesy of the artist / 148

77 Carl Beam, *Chronos 2*, 1989, mixed media on Plexiglas, 122 x 91 cm. In *The Columbus Project, Phase 1.* Courtesy of the artist / 149

78 Carl Beam, *The Proper Way to Ride a Horse*, 1990, etching on paper, 109 x 84 cm. In *The Columbus Suite* series. Courtesy of Art Gallery of Ontario, Toronto. Elsewhere titled *How to Ride a Horse Properly.* A print from the same plate, titled *Riding Demonstration*, forms part of the series owned by the Agnes Etherington Art Centre Museum, Queen's University, Kingston, ON. Reproduced with permission of the artist / 150

79 Phil Hughte, Zuni Pueblo, *Reminiscing Cushing*, black ballpoint pen cartoon on paper, 41 x 30 cm, from *A Zuni Artist Looks at Frank Hamilton Cushing*, Zuni A:Shiwi Publishing, © 1994, p. 103 / 153

80 Gerald McMaster, *Cowboy Anthropology*, 1990, acrylic and oil pastel on matt board, 116 x 96 cm. In *The cowboy/Indian Show.* McMichael Canadian Art Collection, photograph: Larry Ostrom, Christie Lake Studios, courtesy of the artist / 155

81 Jane Ash Poitras, *A Sacred Prayer for a Sacred Island*, first of three panels, 1991, mixed media on canvas, 188 x 127 cm. Exhibited in *Indigena: Perspectives of Indigenous Peoples on Five Hundred Years*, Canadian Museum of Civilization, Hull, QC, April-October 1992. Courtesy of Canadian Museum of Civilization, CMC s98-4104, photograph: Harry Foster. Reproduced with permission of the artist / 157

82 Harry Fonseca, *Wish You Were Here*, c. 1986, acrylic on canvas, 61 x 76 cm. Courtesy of the artist / 160

83 Harry Fonseca, *Rose and the Res Sisters*, 1982, edition of 75, lithograph, 76 x 56 cm. Courtesy of the artist / 162

84 Bill Powless, *Tourists,* 1982, pen and ink on illustration board, 41 x 51 cm. Photograph: Allan J. Ryan. Reproduced with permission of the artist / 163

85 Bill Powless, *Strange Rituals,* 1978, pastel on paper, 51 x 66 cm. Exhibited in *Indian Art '78,* Woodland Cultural Centre, Brantford, ON, May-June 1978. Courtesy of the artist / 164

86 Jim Logan, *It's a Kodak Moment,* 1991, acrylic on canvas, 91 x 152 cm. Courtesy of the artist / 165

87 Edward Poitras, artistic conception, Don Hall, photographer, *The Big Picture,* 1991, back-lit Cibachrome photograph, 183 x 366 cm. In *Indigena: Perspectives of Indigenous Peoples on Five Hundred Years.* Courtesy of Canadian Museum of Civilization, CMC s98-4108. Reproduced with permission of the artist / 167

88 Gerald McMaster, *Changing the Guard,* 1983, graphite on paper, 76 x 56 cm. Exhibited in *Indian Art '83,* Woodland Cultural Centre, Brantford, ON, May-June 1983. Courtesy of the Woodland Cultural Centre. Reproduced with permission of the artist / 171

89 Gerald McMaster, *RCMP and Their World-Famous Dogs,* 1983, graphite on paper, 56 x 76 cm. Courtesy of the artist / 172

90 George Littlechild, *Mountie and Indian Chief,* 1991, acrylic on paper with mirrors, 76 x 112 cm. Courtesy of the artist / 173

91 Gerald McMaster, *In His Hands He's Got the Whole World,* 1984, graphite on paper, 76 x 56 cm. Exhibited in *Riel Remembered,* Thunder Bay Art Gallery, Thunder Bay, ON, July-August 1985. Courtesy of the artist / 175

92 Gerald McMaster, *Trick or Treaty,* 1990, acrylic and oil pastel on matt board, 116 x 96 cm, purchased 1991. In *The cowboy/Indian Show.* Courtesy of the McMichael Canadian Art Collection, photograph: Larry Ostrom, Christie Lake Studios. Reproduced with permission of the artist / 177

93 Gerald McMaster, *Hau! The Ouest Was One,* 1990, acrylic and oil pastel on matt board, 114 x 94 cm, private collection. In *The cowboy/Indian Show.* Courtesy of the McMichael Canadian Art Collection, photograph: Larry Ostrom, Christie Lake Studios. Reproduced with permission of the artist / 179

94 Bob Boyer, *A Minor Sport in Canada,* 1985, oil over acrylic on cotton blanket, 188 x 221 cm. In *In the Shadow of the Sun.* National Gallery of Canada #29757, Ottawa / 183

95 Bob Boyer, *A Government Blanket Policy,* 1983, oil on cotton blanket, 122 x 196 cm. In *In the Shadow of the Sun.* Courtesy of Canadian Museum of Civilization, CMC s94-13510. Reproduced with permission of the artist / 186

96 Shelley Niro, *Standing on Guard for Thee,* 1991, hand-tinted black-and-white photograph, 36 x 28 cm. In *Mohawks in Beehives.* Photograph: Allan J. Ryan. Reproduced with permission of the artist / 187

97 Shelley Niro, *Red Heels Hard,* fourth frame, 1991, six hand-tinted black-and-white photographs with handwritten text, mounted horizontally in a single matte, 20 x 25 cm each photograph. Exhibited in *Mohawks in Beehives.* Indian Art Centre, Department of Indian and Nor-thern Affairs #306464, photograph: Lawrence Cook. Reproduced with permission of the artist / 188

98 Edward Poitras, *Small Matters,* detail, 1988-9, nails, wire, paper, Instasign. 75 x 176 x 5 cm. Installation recreated in *Beyond History.* Collection of the Mendel Art Gallery, purchased 1989. Reproduced with permission of the artist / 190

99 Carl Beam, *Calvary to Cavalry,* c. 1989-90, etching on paper, 122 x 81 cm. In *The Columbus Suite.* Courtesy of the artist / 192

100 Jim Logan, *Let Us Compare Miracles,* 1992, acrylic on canvas, 100 x 84 cm. In *The Classical Aboriginal Series.* Courtesy of Yukon Arts Centre Gallery; photo: Joanne Jackson Johnson. Reproduced with permission of the artist / 193

101 Jane Ash Poitras, *The Virgin Bullet,* fifth of five panels, 1991, mixed media on canvas, 61 x 46 cm each. Exhibited in *Who Discovered the Americas: Recent Work by Jane Ash Poitras,* Thunder Bay Art Gallery, Thunder Bay, ON, March-May 1992. Courtesy the Thunder Bay Art Gallery, photograph: Janet Anderson. Reproduced with the permission of the artist / 195

102 Ron Noganosh, *Dominus Vobiscum,* 1988, .44 magnum bullets, .22 casings, silver dollar, plastic G.I. Joe doll, wood, velvet, Plexiglas, 57 x 57 cm. In *Beyond History.* Courtesy: Vancouver Art Gallery, photograph: Helena Wilson. Reproduced with permission of the artist / 196

103 Ron Noganosh, *Daryl,* 1988, plastic, leather, hide, beads, feathers, 13 x 10 x 6 cm. In *La Fraise (The Strawberry)* at Galerie l'Imagier, Aylmer, QC, June-August 1988. Ottawa, ON, photograph: Allan J. Ryan. Reproduced with permission of the artist / 198

104 Carl Beam, *Forced Ideas in School Days,* 1991, photo emulsion and ink on paper, 74 x 55 cm. From the collection of the Canada Council for the Arts, Art Bank. Photograph: Christopher MacKay, Ottawa, ON. Reproduced with permission of the artist / 200

105 Carl Beam, *Semiotic Converts,* 1989, etching on paper, 122 x 81 cm. In *The Columbus Suite.* Courtesy of the artist / 202

106 Carl Beam, *Chronos 1,* 1989, mixed media on Plexiglas, 122 x 91 cm. In *The Columbus Project, Phase 1.* Courtesy of the artist / 203

107 George Littlechild, *I Looked out My Teepee One Day and All I Saw Was This,* 1987, acrylic on paper, 76 x 56 cm. Courtesy of the artist / ii and 205

108 George Littlechild, *Boarding School Wallpaper,* 1987, acrylic on paper, 56 x 76 cm. Courtesy of the artist / 206

109 Jane Ash Poitras, *Family Blackboard,* 1989, mixed media on paper, 58 x 58 cm. Exhibited in *The Fourth Biennial Native American Fine Arts Invitational at the Heard Museum,* Phoenix, AZ, 1989-90. Courtesy of The Heard Museum, Phoenix, Arizona, IAC2383. Reproduced with permission of the artist / 208

110 Jane Ash Poitras, *Family Blackboard,* detail / 209

111 Jane Ash Poitras, *A Sacred Prayer for a Sacred Island,* detail of second of three panels, 1991, mixed media on canvas, 198 x 178 cm. Exhibited in *Indigena: Perspectives of Indigenous Peoples on Five Hundred Years.* Courtesy of Canadian Museum of Civilization, CMC s98-4106, photograph: Harry Foster. Reproduced with permission of the artist / 210

112 Rebecca Belmore, *Rising to the Occasion,*

mixed-media performance in *Twelve Angry Crinolines,* 17 July 1987, Thunder Bay, ON. Dress reconstructed 1991 for the travelling exhibition *Interrogating Identity,* originating at Gray Art Gallery, New York University, New York, NY. Photograph: Michael Beynon. Courtesy of the artist / 211

113 Lawrence Paul Yuxweluptun, *The Universe Is So Big the White Man Confines Me to My Reservation,* 1987, acrylic on canvas, 183 x 228 cm. Exhibited in *In the Shadow of the Sun.* Courtesy of the artist / 213

114 Lawrence Paul Yuxweluptun, *Leaving My Reservation, Going to Ottawa for a New Constitution,* 1986, acrylic on canvas, 249 x 173 cm. Exhibited in *Crossed Cultures.* Courtesy of the artist / 214

115 Beau Dick, articulated ceremonial puppet, pre-1981, wood, leather, paint, synthetic cloth, metal, glue, cord, thread, glass, quill, 63 x 16 x 8 cm, University of British Columbia Museum of Anthropology cat. # Nb3.1404, Photograph: Bill McLennan, UBC Museum of Anthropology. Courtesy of the artist / 215

116 Lawrence Paul Yuxweluptun, *Dance Me on Sovereignty, Dance Me Outside Anywhere I Want,* 1985, 249 x 173 cm. Elsewhere known as *Redman: Dance on Sovereignty.* Indian Art Centre, Department of Indian and Northern Affairs #152783, photograph: Lawrence Cook. Reproduced with permission of the artist / 216

117 Lawrence Paul Yuxweluptun, *D.I.A. Secretary,* detail, 1987, acrylic on canvas with plastic wire, 70 x 160 cm. Exhibited in *Crossed Cultures.* Courtesy of the artist / 217

118 Shelley Niro, *Waitress,* 1987, oil on canvas, 122 x 91 cm. Exhibited in *Changers: A Spiritual Renaissance.* Courtesy of the artist / 221

119 Shelley Niro, *Judge Me Not,* 1992, hand-coloured gelatin silver print, sepia-toned gelatin silver print, and a gelatin silver print in a hand-drilled overmatte, 36 x 28 cm each photograph. In *This Land Is Mime Land.* Courtesy: Canadian Museum of Contemporary Photography, EX-95-141. Reproduced with permission of the artist / 224

120 Ron Noganosh, *The Same Old Shit,* detail, 1990, wood, acrylics, plastic, coins, 168 x 30 x 38 cm. Ottawa, ON, photograph: Allan J. Ryan. Reproduced with permission of the artist / 225

121 Bob Boyer, *No E & H Please, We're Treaty,* 1985, oil over acrylic on blanket, 127 x 185 cm. Exhibited at the Brignall Gallery, Toronto, ON, 1986. Courtesy of the Assiniboia Gallery. Reproduced with permission of the artist / 227

122 Ron Noganosh, *The Final Solution,* 1991, photo collage on camouflage fabric, 229 x 171 cm. Exhibited in *New Territories: 350/500 Years After,* Montreal, QC, June-August 1992. Courtesy of the artist / 228

123 Bob Boyer, *FUSQ: Tanks for the Memories,* 1991, mixed media on paper, four panels, 152 x 91 cm each. Exhibited in *Okanata,* Workscene/A-Space Galleries, Toronto, ON, August-September 1991. Courtesy of the Assiniboia Gallery. Reproduced with permission of the artist / 230-1

124 David Neel, *Life on the 18th Hole,* 1990, serigraph, 91 x 76 cm. Exhibited in *Solidarity: Art after Oka,* Saw Gallery, Ottawa, ON, May-June 1991. Courtesy of the David Neel Studio / 233

125 Peter B. Jones, *Par for the Course*, 1991, stoneware, 49 x 15 x 14 cm. Exhibited in *First Nations Art '91*, Woodland Cultural Centre, Brantford, ON, May-July 1991. Photograph: Allan J. Ryan. Reproduced with permission of the artist / 234

126 Peter B. Jones, *Par for the Course*, back. Photograph: Allan J. Ryan / 234

127 Ya'Ya Ts'itxstap Chuck Heit, *The Oka Golf Classic (He fell out of a tree and shot himself)*, 1991, mixed media, painted red cedar housepost, 244 x 122 cm. Exhibited in *Okanata*. Photograph: Harold J.T. Demetzer 1998. Reproduced with permission of the artist / 235

128 Gerald McMaster, *Oka-boy/Oh! Kowboy*, 1990, acrylic and oil pastel on matt board, 94 x 114 cm, purchased 1991. In *The cowboy/Indian Show*. Courtesy of the McMichael Canadian Art Collection, photograph: Larry Ostrom, Christie Lake Studios. Reproduced with permission of the artist / 237

129 Gerald McMaster, *No Life Like It*, 1990, acrylic and oil pastel on matt board, 116 x 96 cm, private collection. In *The cowboy/Indian Show*. Courtesy of the McMichael Canadian Art Collection, photograph: Larry Ostrom, Christie Lake Studios. Reproduced with permission of the artist / 238

130 Bill Powless, 1990, *'We'll just have to finish our game ...'* pen and ink cartoon on paper. Courtesy of the artist / 241

131 Bill Powless, 1990, *Loony*, pen and ink cartoon on paper. Courtesy of the artist / 241

132 Bill Powless, 1990, *'What are you going to the party as?'* pen and ink cartoon on paper. Courtesy of the artist / 241

133 Bill Powless, 1991, *Welcome*, pen and ink cartoon on paper. Courtesy of the artist / 242

134 Carl Beam, *Columbus and Bees*, 1990, etching on paper, 122 x 81 cm. In *The Columbus Suite*. Indian Art Centre, Department of Indian and Northern Affairs #306395, photograph: Lawrence Cook. Reproduced with permission of the artist / 243

135 Bob Boyer, *Trains-N-Boats-N-Plains: The Nina, the Santa Maria, and a Pinto*, second of three panels, 1991, wall installation, oil over acrylic blankets and other mixed media, approximately 549 x 305 cm installed. In *Indigena: Perspectives of Indigenous Peoples on Five Hundred Years*. Courtesy of Canadian Museum of Civilization, CMC S98-4110, photograph: Harry Foster. Reproduced with permission of the artist / 246

136 Ya'Ya, *Elijah Harper and the Deadheads*, 1990, acrylic on red cedar, 241 x 66 x 49 cm. Indian Art Centre, Department of Indian and Northern Affairs #306457, photograph: Lawrence Cook. Reproduced with permission of the artist / 250

137 Bill Powless, *SUPER HERO!* 1990, pen and ink cartoon on paper. Courtesy of the artist / 251

138 Vincent Craig, *Muttonman Discovers Columbus*, 1992, pen and ink cartoon on paper. Signature (cover) image for *Muttonman Discovers Columbus*, an exhibition of cartoons by Craig at the Jonson Gallery, University of New Mexico, 1992. Courtesy of the artist / 251

139 Bill Powless, *Superscone*, 1991, pencil sketch on paper. Courtesy of the artist / 251

140 Jim Logan, *Unreasonable History*, 1992, mixed media on canvas, 100 x 85 cm. In *The Classical Aboriginal Series*. Courtesy of Yukon Arts Centre Gallery; photo: Joanne Jackson Johnson. Reproduced with permission of the artist / 255

141 Jim Logan, *Memorial Blanket for Eddy (My Marilyn)*, 1991, mixed media on canvas, 99 x 73 cm. In *The Classical Aboriginal Series*. Courtesy of Yukon Arts Centre Gallery; photo: Joanne Jackson Johnson. Reproduced with permission of the artist / 257

142 Carl Beam, Ann Frank portrait bowl, 1985, painted stoneware, 30 cm diameter. Exhibited at the Beckett Gallery, Hamilton, ON, March 1987. Photograph: Allan J. Ryan. Reproduced with permission of the artist / 260

143 Carl Beam, Sadat assassination bowl, 1982, painted stoneware, 30 cm diameter. Woodland Cultural Centre, Brantford, ON, photograph: Allan J. Ryan. Reproduced with permission of the artist / 260

144 Diego Romero, *Coyote and the Disciples of Vine Deloria Jr, American Highway Series*, 1993, earthenware, 37 cm diameter. Courtesy of the Robert F. Nichols Gallery. Reproduced with permission of the artist / 261

145 Carl Beam, Nelson Mandela shadowbox, 1990, mixed media, 30 x 23 cm. Photograph: Allan J. Ryan. Reproduced with permission of the artist / 261

146 Gerald McMaster, *Glasnost*, 1990, acrylic and oil pastel on matt board, 114 x 94 cm, private collection. In *The cowboy/Indian Show*. Courtesy of the McMichael Canadian Art Collection, photograph: Larry Ostrom, Christie Lake Studios. Reproduced with permission of the artist / 262

147 Edward Poitras, *Progress*, 1991, mixed-media installation with 1986 coyote bone sculpture, *Coyote*. Exhibited in *Marginal Recession*, Dunlop Art Gallery, Regina, SK, October-November 1991. Photograph: Patricia Holdsworth. Reproduced with permission of the artist / 264

148 Edward Poitras, *Creación O Muerte ¡venceremos!* (Creation or Death, we shall overcome!), 1991, mixed-media installation: plaster head, rope, plants, hammers. In *Marginal Recession*. Photograph: Patricia Holdsworth. Reproduced with permission of the artist / 264

149 Edward Poitras, *Untitled (Over the Gulf)*, detail, 1991, mixed-media installation: doll on swing, oil-filled lead basin, wrapped bison skull. In *Marginal Recession*. Photograph: Patricia Holdsworth. Reproduced with permission of the artist / 266

150 Edward Poitras, 'Witness' koshare clown doll, 1989, mixed-media installation detail. In *Et in America ego*. Photograph: Allan J. Ryan. Reproduced with permission of the artist / 268

151 Ron Noganosh, *Will the Turtle Be Unbroken?* 1990, turtle shell, plastic model spaceships, cotton wool, plastic, coins, 46 x 30 x 25 cm. In *Hard and Soft*. Courtesy of the artist / 269

152 Ron Noganosh, *It Takes Time*, 1983, toilet, Plexiglas, lamp, globe, tap, 155 x 36 x 49 cm. In *In the Shadow of the Sun*. Courtesy of Canadian Museum of Civilization, CMC S94-13696. Reproduced with permission of the artist / 270

153 Bob Boyer, *Let the Acid Queen Rain: The White Goop Devours All*, 1985, oil over acrylic on blanket, 185 x 127 cm. Exhibited in *Bob Boyer: A Blanket Statement*, University of British Columbia Museum of Anthropology, Vancouver, BC, January-April 1988. Photograph: Bill McLennan, UBC Museum of Anthropology. Reproduced with permission of the artist / 272

154 Lawrence Paul Yuxweluptun, *Native Winter Snow*, 1987, acrylic on canvas, 125 x 184 cm. Elsewhere known as *Native Winter Snowfall*. Courtesy of the Staaliche Museen zu Berlin, Museum für Völkerkunde. Photograph courtesy of Morris and Helen Belkin Art Gallery, University of British Columbia. Reproduced with permission of the artist / 273

155 Jim Logan, *The Three Environmentalists*, 1993, acrylic on canvas, 183 x 152 cm. In *The Classical Aboriginal Series*. Courtesy of Yukon Arts Centre Gallery; photo: Joanne Jackson Johnson. Reproduced with permission of the artist / 275

156 Bob Boyer, *Imago for a dying buffalo and lost treeties*, central panel of triptych, 1990, oil over pastel and acrylic on flannel blanket, 208 x 232 each panel. In *Shades of Difference: The Art of Bob Boyer*, Edmonton Art Gallery, Edmonton, AB, September-October 1991. An expanded version of this installation was exhibited as *Imago Pietatis for a Dying Buffalo and Lost Treeties* at the White Water Gallery, North Bay, ON, June 1990. Courtesy of Assiniboia Gallery. Reproduced with permission of the artist / 276

157 Gerald McMaster, *Bärk: The Great Tree of Life*, 1990, mixed-media installation: telephone books, wooden dowels, ribbons, cloth, and twine, height 244 cm each. Exhibited in *Last Chance*, Saw Gallery, Ottawa, ON, May 1990. Courtesy of the artist / 278

158 Lawrence Paul Yuxweluptun, *The Environmentalist*, 1985, acrylic on canvas, 168 x 213 cm. Exhibited in *Indianische Künstler der Westküste Kanadas*, Ethnological Museum of the University of Zurich, Zurich, Switzerland, 1989. Courtesy of the Völkerkundemuseum der Universität Zürich. Reproduced with permission of the artist / 279

159 Gerald McMaster, *Post-Modern*, 1988, acrylic on wood and wire, 35 x 30 x 4 cm. Photograph: Richard Garner, Ottawa. Courtesy of the artist. / 283

160 Harry Fonseca, Personalized drawing of Coyote, pen and ink on paper, 15 December 1993, 21 x 14 cm. Courtesy of Allan J. Ryan. Reproduced with permission of the artist / 284

Artists Interviewed

Carl Beam, Ojibway, was born in 1943 in West Bay, Manitoulin Island, Ontario. In British Columbia, he studied art at the Kootenay School of Art in Nelson, and at the University of Victoria, where he completed a Bachelor of Fine Arts degree in 1974. He continued his studies at the University of Alberta in Edmonton in the Master of Fine Arts program. He lives and works in West Bay, Ontario.

Rebecca Belmore, Ojibway, was born in 1960 in Upsala, Ontario. She studied at the Ontario College of Art in Toronto and is frequently asked to create site-specific performances to complement gallery exhibitions. Continually searching for new ways to incorporate the voices of Aboriginal community members into her work, she currently lives in Toronto, Ontario.

Bob Boyer, Métis, was born in 1948 near Prince Albert, Saskatchewan. He attended the University of Saskatchewan, Regina campus, and in 1971 received a Bachelor of Education degree with an art major. Since 1981 he has been professor and head of the Department of Indian Art at the Saskatchewan Indian Federated College, University of Regina.

Joane Cardinal-Schubert, Blood, was born in 1942 in Red Deer, Alberta. She studied Fine Arts at the Alberta College of Art in Calgary and received a Bachelor of Fine Arts degree in painting and printmaking in 1977 from the University of Calgary. Her writing has been published internationally in art magazines, catalogues, and books. She has worked professionally as a curator, artist, lecturer, and most recently a director of video and Native theatre. She was elected to the Royal Canadian Academy in 1985 and received the Commemorative Medal of Canada in 1993 for her contribution to the arts. A retrospective of her work is touring nationally into the year 2000. She lives and works in Calgary.

Gary Farmer, Mohawk, was born in 1953 and raised on the Six Nations Reserve, Ohsweken, Ontario. He studied photography at Ryerson Polytechnical Institute in Toronto, Ontario, graduating in 1975. His acting career has encompassed stage, film, and television. His better-known film roles include Philbert Bono in *Powwow Highway* (1988), Nobody in *Dead Man* (1996), and Arnold Joseph in *Smoke Signals* (1998). *The Gift*, his first film as director, was screened at the 1998 Vancouver Film Festival. Currently editor-in-chief of the magazine *Aboriginal Voices*, he lives in Toronto.

Viviane Gray, Mi'gmag, was born in Campbelton, New Brunswick, in 1947. She received a diploma in Community Development and Social Leadership from St Francis Xavier Univeristy in Antigonish, Nova Scotia, a BA from Carleton University in Ottawa, and studied at the Nova Scotia College of Art and Design in Halifax. Her work has been exhibited in Ontario, Quebec, and New Brunswick. She has been with the Indian Art Centre in Ottawa for eleven years and is currently Chief of the Indian and Inuit Art Centres.

George Littlechild, Plains Cree, was born in 1958 in Edmonton, Alberta. He obtained a diploma in Art and Design from Red Deer College, Alberta, in 1984 and a Bachelor of Fine Arts degree in 1988 from the Nova Scotia College of Art and Design in Halifax. As a former fosterchild raised apart from his ancestral Cree community, Littlechild today creates art that documents his journey of cultural reclamation and connection. Since the early 1990s, he has lived and worked in Vancouver, British Columbia.

Jim Logan, Métis (Cree/Sioux/Scottish), was born in 1955 in New Westminster, British Columbia. In 1983 he received a certificate in Graphic Design from the Kootenay School of Art in Nelson, British Columbia. Before embarking on a career as a painter, he worked as a lay minister in the North and a graphic designer for the *Yukon Indian News*. A long-time resident of Kamloops, British Columbia, Logan now lives in Tatamagouche, Nova Scotia.

Gerald McMaster, Plains Cree, was born in 1953 in Saskatchewan and grew up near North Battleford on the Red Pheasant reserve. He studied Fine Arts at the Institute of American Indian Art in Santa Fe, New Mexico, from 1973 to 1975 and completed a Bachelor of Fine Arts degree at the Minneapolis College of Art and Design in Minnesota. From 1977 to 1981 he was the Indian Art Program coordinator and instructor at the Saskatchewan Indian Federated College, University of Regina, Saskatchewan. In 1994 he completed a Master of Arts degree in Anthropology and Sociology at Carleton University in Ottawa, Ontario. Since 1981 he has been curator of Contemporary Indian Art at the Canadian Museum of Civilization in Ottawa.

Shelley Niro, Mohawk, was born in 1954 in Niagara Falls, New York. She studied art at Durham College in Oshawa, Ontario, the Banff School of Fine Arts in Banff, Alberta, the Algoma School of Landscape Painting in Spruce Lake, Ontario, and the Ontario College of Art in Toronto. She recently completed a Master of Fine Arts degree at the University of Western Ontario in London, Ontario. Her film *Honey Moccasin* was shown at the 1998 Vancouver Film Festival. A painter, sculptor, photographer, and film maker, she lives in Brantford, Ontario.

Ron Noganosh, Ojibway, was born in 1949 on the Magnetawan Reserve near Parry Sound, Ontario. He received diplomas in welding in 1968 and graphic design in 1970 from George Brown College in Toronto, Ontario, and studied Fine Arts at the University of Ottawa. He has taught courses in sculpture, printmaking, and design at Heritage College in Hull, Quebec. He lives in Ottawa, Ontario.

Edward Poitras, Métis, was born in 1953 in Regina, Saskatchewan. In 1974 he studied with Sarain Stump in the Indian Art Program at the Saskatchewan Indian Cultural College in Saskatoon, Saskatchewan. In 1976 he studied at Manitou College in Quebec with Domingo Cisneros. He has taught Indian Art courses at the University of Manitoba and the Saskatchewan Indian Federated College and has worked as a graphic artist for *The New Breed* magazine. In 1995 he became the first Aboriginal artist to represent Canada at the Venice Biennale exposition in Italy. He lives in Regina.

Jane Ash Poitras, Cree/Chipewyan, was born in 1951 in Fort Chipewyan, Alberta. She studied at the University of Alberta in Edmonton receiving a Bachelor of Science degree in Microbiology and later a Bachelor of Fine Arts degree. She received a Master of Fine Arts degree in printmaking from Columbia University, New York, in 1985. She lives in Edmonton, where she has been a sessional instructor at the University of Alberta.

Bill Powless, Mohawk, was born in 1952 on the Six Nations Reserve in Ohsweken, Ontario, and studied art at Mohawk College in Brantford, Ontario. He is museum design preparator at the Woodland Cultural Centre in Brantford and has been a regular contributor of editorial cartoons to the *Tekawennake-Six Nations and New Credit Reporter*. He lives in Ohsweken.

Lawrence Paul Yuxweluptun, Salish/Okanagan, was born in 1957 in Kamloops, British Columbia, and raised in Richmond, British Columbia. In 1987 he graduated with honours in painting from the Emily Carr College of Art and Design in Vancouver, British Columbia. He lives and works in Vancouver.

Index

Visit the UBC Press website at
www.ubcpress.ubc.ca
for information and detailed descriptions of other UBC Press books.

If you liked this book, look for these related titles:

George F. MacDonald
Haida Monumental Art: Villages of the Queen Charlotte Islands

'I cannot think of another book that takes a reader so intimately into the culture of a First Nations people.' DANIEL FRANCIS, *Geist*

'What emerges as a result of MacDonald's extraordinary effort and dedication is an absorbing recreation of a life now lost. The glory of MacDonald's enterprise lies not just in the fascination of an organised historical photo-study but in the assiduous attention to detail, with which the book is replete.' BRYAN N.S. GOOCH, *Canadian Literature*

Diane Eaton and Sheila Urbanek
Paul Kane's Great Nor'West

'More than most art books, *Paul Kane's Great Nor'West* takes us into the soul of its subject.' DAN HAYS, *Statesman Journal*

'All in all, this handsome and interesting volume does well by Paul Kane, in both pictures and text.' VIRGINIA BYFIELD, *Alberta Report*

'*Paul Kane's Great Nor'West* is a well written and well illustrated addition to the corpus of writings on artists of the North American frontier. Eaton and Urbanek provide a dynamic and enjoyable examination of the activities of this nineteenth century figure and the images he preserved.' JONATHAN R. DEAN, *Oregon Historical Quarterly*

Ask for UBC Press books in your bookstore or contact us at

Toll-free fax: 1-800-668-0821
Toll-free phone: 1-UPRESS-WEST
E-mail: info@ubcpress.ubc.ca

DATE

JUL 0 1

Demco, Inc. 38-293